Confronting Identities in German Art

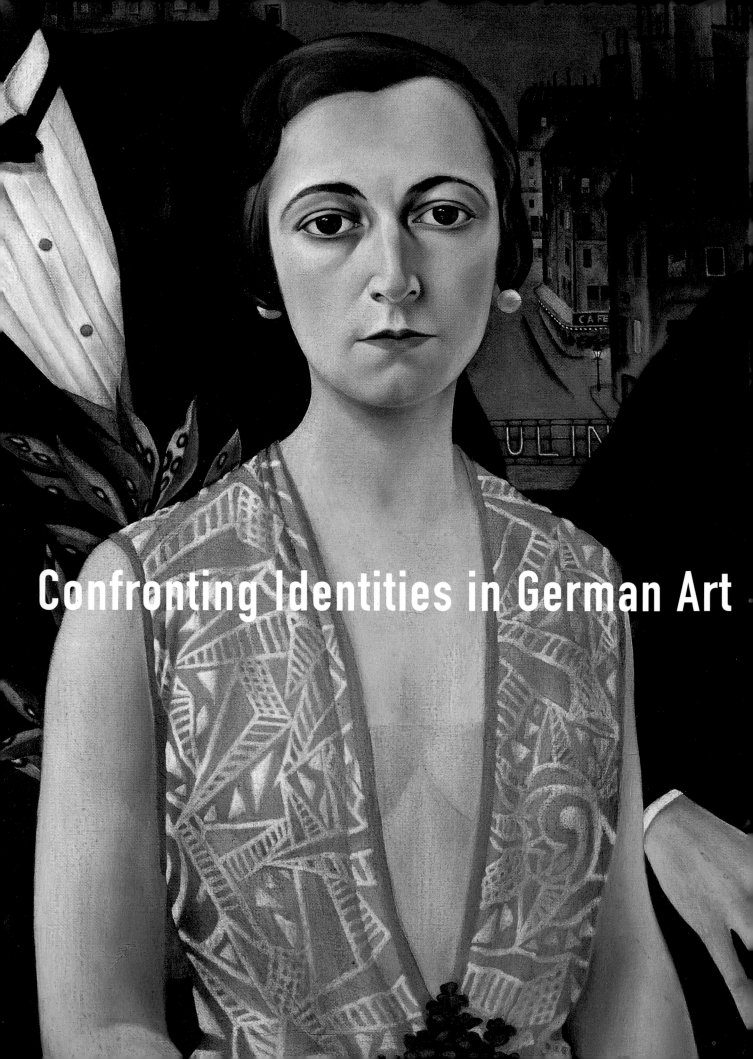

Confronting Identities in German Art

Reinhold Heller

with contributions by

Naomi Hume

Allison Morehead

Celka Straughn

Sabine Wieber

Myths, Reactions, Reflections

**The David and Alfred Smart
Museum of Art**

The University of Chicago

Catalogue of an exhibition at
The David and Alfred Smart
Museum of Art
The University of Chicago
3 October 2002—5 January 2003

This catalogue was funded by an endowment from the Andrew W. Mellon Foundation that supports the interdisciplinary use of the Smart Museum's collections by University of Chicago faculty and students both in courses and through the format of special exhibitions. Additional funders include the Smart Family Foundation; the Elizabeth F. Cheney Foundation; the Eloise W. Martin Fund; the Rhoades Foundation; the German Consulate General; Goethe-Institut Inter Nationes Chicago; the Office of the Provost, and the Center for the Interdisciplinary Study of German Literature and Culture, University of Chicago.

The exhibition and related programs are also supported by Nuveen Investments; the Institute of Museum and Library Services, a federal agency that fosters innovation, leadership, and a lifetime of learning; the Chicago Community Trust; the Illinois Arts Council, a state agency; the JCCC Foundation of the Japanese Chamber of Commerce and Industry of Chicago; and the Regents Park/University of Chicago Fine Arts Partnership. Family programming is supported by Target Stores. Additional funding is provided by the Visiting Committee on the Visual Arts, the Franke Institute for the Humanities, and the Department of Art History, University of Chicago; the Friends of the Smart Museum; and Susan and Allison Davis.

Design and typesetting: Joan Sommers Design, Chicago
Production and Copy Editing: Elizabeth Rodini and Britt Salvesen
Printed in China through Asia Pacific Offset, Inc.

Cover: Joseph Beuys, *Felt Suit*, 1970 (cat. no. 10); Felix Nussbaum, *Portrait of a Young Man (Karl Hutloff)*, 1927 (cat. no. 85a); Georg Baselitz, *The Drinker*, 1982 (cat. no. 4)
Reverse Cover and page ii: Christian Schad, *Portrait of Baronessa Vera Wassilko*, 1926 (cat. no. 101)
Page v: Max Pechstein, *Head of a Girl* (detail), 1910 (cat. no. 87)
Page vi: Lovis Corinth, *In the Studio*, 1920 (cat. no. 13)

Library of Congress Control Number: 2003104618
ISBN: 0-935573-36-4

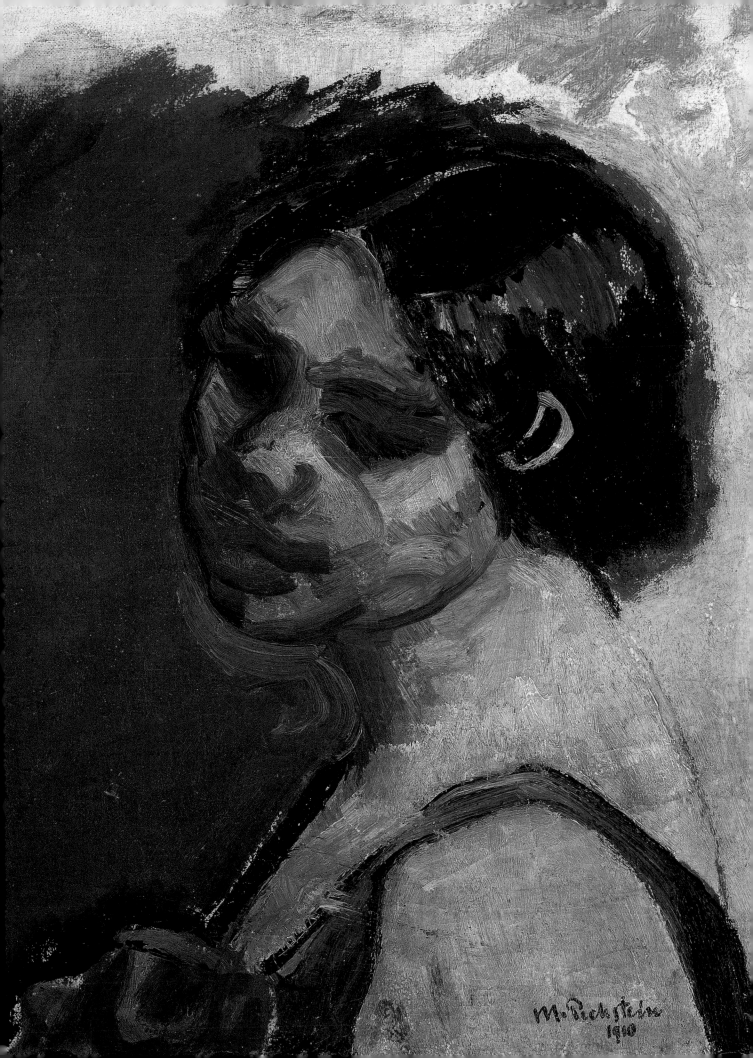

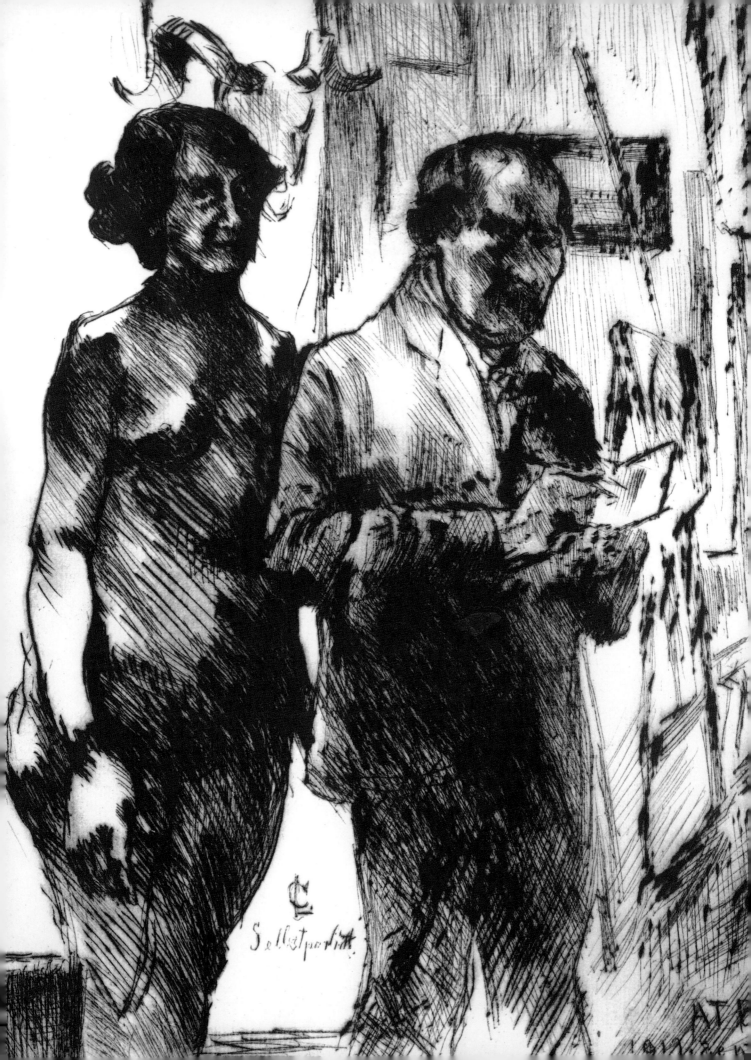

Selbstporträt

Contents

Preface and Acknowledgments

Over the last two centuries, dramatic social, political, and economic shifts have both consolidated and fragmented German identity. Artists from the period of Caspar David Friedrich to that of Anselm Kiefer have grappled, sometimes very directly and sometimes indirectly, with the question of what it means to be German. *Confronting Identities in German Art: Myths, Reactions, Reflections* examines the many and varied artistic expressions of this concern, as manifested in the work of a wide range of German artists. Identity, as it is understood here, is a multifaceted notion: it might be shaped by geography, politics, self-perception, or, in an essentialist formulation, by the notion of an inherent national spirit. As the works and the essays presented here reveal, a concern for identity infuses German art, even when its form or subject—from realist landscapes to abstract invention—might suggest otherwise.

Curated by Reinhold Heller, Professor of Art History and Germanic Studies at the University of Chicago, with the close collaboration of Smart Museum Mellon Projects Curator Elizabeth Rodini, *Confronting Identities* represents a continuation—but also a significant maturation, in terms of scale and ambition—of a series of faculty-curated exhibitions held at the Smart Museum since the mid-1990s. With the generous support of the Andrew W. Mellon Foundation, the Smart Museum has been able to actively engage faculty and students in the development and implementation of public exhibitions. *Confronting Identities* exemplifies the possibilities of an academically driven exhibition, grounded in serious research and challenging ideas, to engage a broad range of viewers, from University of Chicago students, community members, and local school children to international art audiences.

Many individuals and institutions came together to make this exhibition and catalogue possible. Our greatest thanks go to our long-time collaborator and supporter Reinhold Heller, who had the vision to make this Mellon exhibition bigger and more ambitious than earlier projects. In addition to curating the show, writing a significant portion of the catalogue, and participating in many related public programs, Professor Heller was instrumental in involving University of Chicago students at all levels in the project. During the run of the exhibition, he taught an undergraduate course on the subject of identity and German art with Nina Zimmer, visiting professor of German art history, whose tenure at the university was supported by the Robert Bosch Foundation. We also received generous assistance from four of Professor Heller's advanced graduate students, Naomi Hume, Allison Morehead, Celka Straughn, and Sabine Wieber, who researched and authored this catalogue. Without their time, effort, and general good humor, neither the exhibition nor the catalogue could have been realized.

At the University of Chicago, we received valuable advice and assistance from across campus. Eric L. Santner, Chair of the Department of Germanic Studies and Harriet and Ulrich E. Meyer Professor of Modern European Jewish History, and David J. Levin, Assistant Professor in the Department of Germanic Studies and the Committee on Cinema and Media Studies, generously offered their time and expertise, providing insightful commentaries on the exhibition and bringing an important perspective to the project. We also appreciate the support of David Wellbery, Leroy T. and Margaret Deffenbaugh Carlson

University Professor in the Department of Germanic Studies. James Cantarella, Ph.D. Candidate, Germanic Studies and Cinema Studies, organized our film series on "Post-War German Identity" at the University's DOC Films.

Confronting Identities was enriched by a number of public programs and we are grateful to all those who participated. In particular, we thank Jay A. Clarke and Claire Kunny of The Art Institute of Chicago, who worked with us to organize a lecture and panel discussion featuring Professor Charles W. Haxthausen of Williams College. We are also grateful to Professor Margaret Olin, School of The Art Institute of Chicago; Stephanie D'Alessandro, Assistant Curator in the Department of Modern and Contemporary Art, The Art Institute of Chicago; Françoise Forster-Hahn, Professor of Art History at the University of California-Riverside; and Lisa Saltzman, Associate Professor in the History of Art at Bryn Mawr College, for their engaging presentations and lectures, which invited a reexamination of both individual works and the exhibition as a whole. For his support of the exhibition and its opening program and festivities, we thank Consul General of Germany Dr. Alexander Petri.

Confronting Identities would not have been possible without the many generous individuals and institutions that lent works. We thank The Art Institute of Chicago, James N. Wood, Director and President, Jay A. Clarke, Associate Curator of Prints and Drawings, Suzanne Folds McCullagh, Anne Vogt Fuller and Marion Titus Searle Curator of Earlier Prints and Drawings, and David Travis, Curator of Photography; the Harvard University Art Museums, James Cuno, Elizabeth and John Moors Cabot Director, Peter Nisbet, Daimler-Benz Curator at the Busch-Reisinger Museum, and William Robinson, Maida and George Abrams Curator of Drawings at the Fogg Art Museum; the Milwaukee Art Museum, Russell Bowman, Director, Brian J. Ferriso, Senior Director of Curatorial Affairs, Kristin Makholm, Curator of Prints and Drawings, and Laurie Winters, Curator of Earlier European Art; the Museum of Contemporary Art in Chicago, Robert Fitzpatrick, Pritzker Director, and Jude Palmese, Assistant Registrar; the Special Collections Research Center at the University of Chicago Library, Alice Schreyer, Director, Valarie Brocato, Exhibitions and Preservations Manager, and Jay Satterfield, Head of Reader Services; and the Krannert Art Museum, University of Illinois, Urbana-Champaign, Director Josef Helfenstein and Curator Kerry Morgan. For their loans we also thank the estate of Edna Freehling and Susan and Paul Freehling; Laura and Marshall Front; Jack and Helen Halpern; Nancy and Anatole Gershman; Joel and Carol Honigberg; Bodo Korsig; Mrs. Wallace Landau; Susan and Lewis Manilow; Diane S. and Robert M. Newbury; Philip J. and Suzanne Schiller; Joseph P. Shure; Marcia and Granvil Specks; and several anonymous lenders.

For their assistance in the preparation of the exhibition and catalogue, we are grateful to Christine Conniff-O'Shea, Joseph Scott, and Smart Museum volunteers Helen Halpern, Joseph P. Shure, and Agnes Zellner, and particularly to Britt Salvesen for her expert assistance in organizing and editing this catalogue. The entire Smart Museum staff contributed to the success of *Confronting Identities*; we single out in particular Rudy I. Bernal, Chief Preparator and Facilities Manager; Richard A. Born, Senior Curator; Sarah Cree, Membership and Development Coordinator; Christine Du Rocher, Public Relations and Marketing Manager; John Knuth, Preparation Assistant; Lia Markey, Mellon Projects Assistant; Jennifer Widman

Moyer, Registrar; Tania Pachof, former Public Relations and Marketing Manager; David Robertson, former Associate Director; Simone Tai, Mellon Projects Assistant; and Jacqueline Terrassa, Education Director.

Among the many funders of the exhibition, we thank in particular the Andrew W. Mellon Foundation and Angelica Zander Rudenstine, Senior Advisor for Museums and Conservation. Their vision for fruitful faculty-student-museum collaborations and their ongoing support of the Smart Museum have been invaluable. A number of other supporters contributed generously to the exhibition and catalogue, including the Smart Family Foundation; the Elizabeth F. Cheney Foundation; the Eloise W. Martin Fund; the Rhoades Foundation; the German Consulate General; Goethe-Institut Inter Nationes Chicago; and the Office of the Provost, the Center for Interdisciplinary Research in German Literature and Culture, the Franke Institute for the Humanities, and the Department of Art History at the University of Chicago. The exhibition and related programming were also supported by Nuveen Investments; the Institute of Museum and Library Services, a federal agency that fosters innovation, leadership, and a lifetime of learning; the Chicago Community Trust; the Illinois Arts Council, a state agency; the JCCC Foundation of the Japanese Chamber of Commerce and Industry of Chicago; and the Regents Park/University of Chicago Fine Arts Partnership. Family programming is supported by Target stores. Additional funding is provided by the Visiting Committee on the Visual Arts, University of Chicago; the Friends of the Smart Museum; and Susan and Allison Davis.

Kimerly Rorschach
DANA FEITLER DIRECTOR

Elizabeth Rodini
MELLON PROJECTS CURATOR

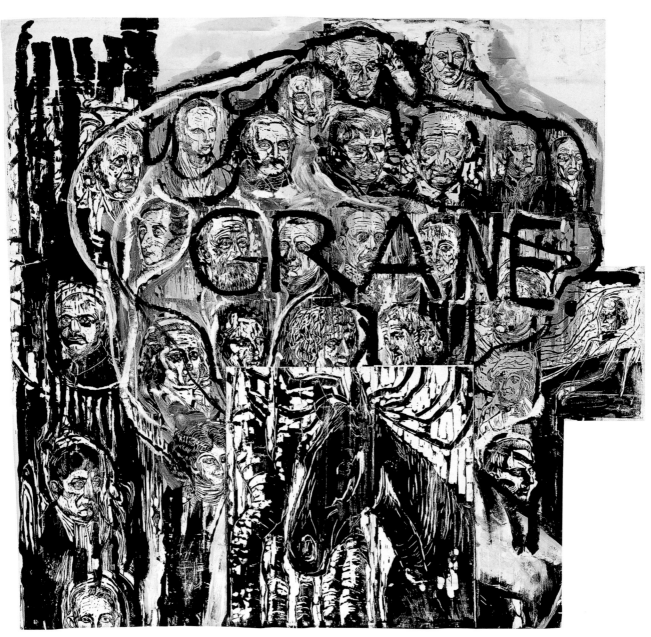

Fig. 1.
Anselm Kiefer (b. 1945),
Grane, 1980. Woodcut, oil, and
varnish on paper mounted on
canvas; 117 x 120 ¾ in.
Lent by Collection Susan and
Lewis Manilow
[Cat. no. 44]

German Identities, German Art, German Artists
Some Preliminary Considerations

German self-reflection took place before the mirror of art, even when the mirror was not oriented to confirm the Germanness of the viewer.
—HANS BELTING[1]

REINHOLD
HELLER

In 1977 the German artist Anselm Kiefer produced the first of a group of massive woodcuts on the theme *Grane* [SEE FIGURE 1]. First, Kiefer imprinted separate sheets of paper with different woodblock images; then, he irregularly collaged them together to shape the full image; finally, he further unified the composition by painting on it with oil, varnish, gouache, and shellac. Kiefer subsequently returned repeatedly to the motif, varying the image, title, and configurations of paint at least eighteen times.[2] Each of the *Grane* prints is unique, even though it shares its major elements and components with the others and, moreover, employs imagery derived from Kiefer's woodcut book *Die Hermannsschlacht* (*The Battle of the Teutoberg Forest*, 1977 and 1979), which the artist had also used to form the even larger composite woodcut of 1978, *Wege der Weltweisheit: Die Hermannsschlacht* (*Paths of World Wisdom: The Battle of the Teutoberg Forest*). Here, the title *Grane*—inscribed in large block letters onto the woodcut just above the central bottom image of a horse, brushed so as to spread darkly but without destroying the legibility of the underlying figures—references the Valkyrie Brünhilde's steed in the medieval German saga, the *Nibelungenlied*. However, Kiefer's *Grane* is linked less to the original inspiring epic than to Richard Wagner's massive nineteenth-century opera cycle *Der Ring des Nibelungen* (*The Ring of the Nibelung*), which has since eclipsed its thirteenth-century source in general consciousness and historical reference. In the final drama of the series, *Götterdämmerung* (*The Twilight of the Gods*), Brünhilde discovers that Siegfried was killed by the treacherous Hagen, to whom she herself, during a vengeful fit of jealousy, had revealed the sole vulnerable spot remaining on her lover's body after he bathed in the blood of the dragon Fafnir. She builds a massive funeral pyre for the dead hero, and then rides Grane into the raging blaze. The flames, fed by horse and Germanic demigoddess, flare up violently as the Rhine rises to drown Hagen and to permit the Rhine Maidens to swim away, singing and bearing the magic Ring stolen from them in the first opera in the cycle, *Das Rheingold*. The fire continues to spread rapidly, engulfing the heavens, setting alight the great World Ash Tree, Yggdrasil, and finally reaching to the home of the gods, Valhalla, to destroy them and their corruption in a mighty concluding, purifying apocalyptic conflagration. Kiefer did not depict this tempting dramatic inferno with its extensive cast directly, however. He reduced

the conflagration to a bouquet of stylized tongues of flame near the horse, which appears alone in the print, without Brünhilde and the various other protagonists of Wagner's music drama.[3] Instead of Wagner's operatic supporting cast, Grane is accompanied by rows of portrait heads and busts that represent numerous figures from German history from antiquity to the twentieth century.

Kiefer's unique graphic staging of this fiery drama is, I believe, an apt introduction to issues of identity as manifested in German art since Romanticism. Few other artists active today have referenced major components of the German cultural heritage and have addressed the problematics of German self-perceptions—and the perceptions of Germany and German identity by others—as consistently and frequently as has Kiefer since the late 1960s.[4] "When we start to work, we always have the huge baggage of culture on our shoulders," Kiefer once remarked.[5] But he has not worked with a comprehensive inventory of German history's major protagonists, focusing rather on those aspects of cultural and political tradition that were appropriated and exploited in the teachings and propaganda of National Socialism and the Third Reich. Thus the inhabitants of *Grane*—beginning implicitly with Richard Wagner himself—are, with only one or two exceptions, all derived from the pantheon of imagined ancestry constructed by the Nazis themselves.[6] Centered above the steed, the appropriated Nazi family tree begins chronologically, with Armenius (or Hermann), the leader of the Cheruscan Germanic tribe that defeated the troops of the Roman Empire in 9 A.D. at the Battle of the Teutoberg Forest. Immediately next to him is the Markgrave Wiprecht von Groitzsch (circa 1050–1124), whose addition of Bohemian lands to his realm inspired the Nazis to recruit him as a forerunner of their expansionist *Drang nach Osten* (Drive to the East) policies. The chronology breaks down into more erratic references after this, skipping the remainder of the Middle Ages to jump to the seventeenth-century mystic Jacob Böhme (at the far right of the second row from the top), and then to the Enlightenment philosopher Immanuel Kant. Kant shares the top of the somewhat triangular composition rather incongruously with the nineteenth-century poet and novelist Annette von Droste-Hülshoff, ironically not notably celebrated by the Nazis although her novel *Die Judenbuche* (*The Jew's Beech*, 1841) focused on the murder of a Jew and its consequences.

If Droste-Hülshoff does not fit comfortably into the Hitlerean model of Germany's cultural elite presented by Kiefer, the remaining portraits in *Grane*—patriotic poets, militaristic novelists, arms manufacturers, a Prussian queen, Prussian generals, and Nazi "martyrs"— were readily drafted into the fascist genealogy.[7] The seemingly random arrangement of heads and busts may not offer a chronologically or conceptually ordered structure or even ready criteria for the selection itself, but it does posit a view of a tellingly compromised German past. Some of these major cultural and political figures have suffered, at the very least, despite both West and East German postwar reclamation efforts, from a heavy guilt by association impossible to ignore today. The purifying fires decorously erupting around Grane—the sole unifying component of the composition as they encircle the grouped portraits of German heroes and anti-heroes—must necessarily continue to burn.

In 1884, nearly a century and a half before Kiefer began work on his *Grane* imagery, the Bavarian painter and graphic artist Eugen Napoleon Neureuther, in a steel engraving for the Munich Dürer-Verein (Dürer Association), offered a similarly complex, multifigural view of German history, in which historical and mythical personages mingle together around a collective experience [F I G U R E 3 1].[8] The apocalyptic fires of a *Götterdämmerung* were not Neureuther's concern, however, for he sought a more constructive paradigm, envisioning a German identity that extended into both future and past. At a time when a German nation-state did not yet exist but popular sentiments for political and cultural unification—initiated during the era of Romanticism and the anti-Napoleonic "Wars of Liberation"— remained high, Neureuther conjured forth a collective experience of the late fifteenth century as a prototype for the nineteenth-century present. The image's ostensible premise was an 1840 carnival, or Munich artists' costume festival, which adopted as its theme Dürer and his time. In the central portion of the engraving, we witness the meeting of the legendary Holy Roman Emperor Maximilian I—the popular Kaiser Max—and the equally celebrated artist Albrecht Dürer on the plain before the city of Nuremberg. The two figures appear as paradigms of a munificent, unifying German ruler and the proto-typical German artistic genius. Indicative of the recognition and status granted Dürer and, through him, the pictorial arts, the emperor and his extensive retinue have come to Nuremberg to pay the artist homage, implicitly declaring an equality between the two. According to legend, Maximilian presented a coat of arms for artists to Dürer, marking the nobility of the profession and of art—spiritual and artistic nobility again recognized as equivalent to the nobility of birth. But this particular heraldry, three blank shields on a similarly blank shield, did not become Dürer's personal coat of arms, but that of the pictorial arts, employed in the nineteenth century by associations of artists and patrons such as the Dürer-Verein to identify their dedication to the arts.[9] In essence, the meeting of emperor and artist represents the highpoint of German culture within a system of royal patronage, a golden age that was emulated—even duplicated, according to contemporary perception—by Bavaria's King Ludwig I (r. 1825–48), known as a generous and enthusiastic supporter of the visual arts.[10] Joining together Dürer, Maximilian I, Ludwig I, and the Dürer-Verein, Neureuther suggested a renaissance of German art supported by the fusion of Bavarian royal and secular bourgeois patronage.

Neureuther's and Kiefer's attitudes toward the German past are dramatically antithetical. The nineteenth-century artist looked at the past as a transparent, utopian prototype for present and future, while his late twentieth-century counterpart fatally forces German history through the horrific filter of the Third Reich before allowing it to re-emerge in the present irreparably tainted, deeply problematic, and ambivalent. Of course, Neureuther's hopes were imperfectly fulfilled. The liberal revolutions of 1848 failed to bring about German national unity, and when the separate German states (with the exception of Austria) did join together in 1871 to form the second Reich, the self-proclaimed successor to Maximilian's first Reich, it was not a union under the aegis or according to the proto-type of Bavarian artistic patronage. Rather, it was a union achieved under Prussian domina-tion, based on economic and military strength rather than cultural heritage.[11]

There has been an extended discourse on Germany as a *verspätete Nation* (delayed nation) as a means of confronting the vicissitudes of German history since 1871, most notably the emergence of the ideology and state of National Socialism.[12] Less noted is Germany's ongoing sense of itself as lacking a defined national style in the visual arts, a self-perception leading to willful efforts to shape one, largely by looking to the past for prototypes. In 1850–51, for example, Bavaria's King Maximilian II sponsored a competition "to attain a new style" that would be appropriate for the nation and the time. The winning style—which, significantly, would be named *Maximilianstil* (Maximilian Style), a Bavarian rather than broadly German nominal identity—could develop from a single historical style or could combine elements of various previously existing ones. The present should model itself on the past and thereby shape the art of the future, following the formulation that Johann Winckelmann initially provided in his eighteenth-century tract, *Thoughts Concerning the Emulation of Greek Works in Painting and Sculpture* (1755). Winckelmann's followers relativized his teachings, however, deeming styles other than Greek and Roman worthy of emulation. Most notably, in 1772 the young poet Johann Wolfgang von Goethe identified the Gothic as the style of German architecture in his panegyric to Erwin von Steinbach and Strasbourg Cathedral.[13] After the defeat of Napoleon and his allies at the Battle of Nations near Leipzig, the architect Karl Friedrich Schinkel proposed a design for a German national cathedral nestled in a grove of oak trees in a richly intricate Gothic style intended to commemorate the French defeat, rally patriotic feeling, and also predict a future united German nation [SEE FIGURE 17].[14] Ruined medieval churches with plants weaving themselves among the pillars and arches became favored motifs in paintings, prints, and drawings [SEE FIGURE 18 and cat. no. 93], signifying the passage of time and history, the triumph of nature over human construction, and a new German life emerging from the glories of the past, while simultaneously referencing the Romantics' belief that the Gothic style itself, with its pillars emulative of tree trunks, was a kind of forest rendered in architectural stone. As artists sought to re-animate long-dormant links to a mythologized medieval German tradition, they conjured forth historical events and imagined scenes starring newly relevant heroes, such as Neureuther's Emperor Maximilian I or Schnorr von Carolsfeld's sleeping Emperor Barbarossa [FIGURE 19], addressing them to middle-class and aristocratic viewers yearning to discover an idyllic national identity for themselves. While King Maximilian II technically remained open to any conceivable synthesis of past styles, he believed that the Gothic, the style of German art's golden age in the time of Dürer, would be the appropriate answer to his quest.

Shortly after the publication of the first history of modern German art, Athanasius Count Raczynski's *Geschichte der neueren deutschen Kunst* (History of Recent German Art, 1837), Neureuther made his effort to emulate the drawing style of Dürer and his contemporaries in his Dürer-Verein print. Both Neureuther and Raczynski recognized the style of the era of Holy Roman Emperors Maximilian I and Charles V as the prototype for the stylistic vocabulary of modern German art. Later in the century, however, as the aesthetics of naturalism and realism forced artists to turn to contemporary life for motifs and subject matter, such determined quotation from past prototypes ceased to be an accepted norm. The overtly German landscape could continue to serve as an index of identity addressed to the German *Heimatgefühl*, or innate sense of the homeland, as it had especially since

Romanticism. The characteristic woods and fields, mountains and valleys, trees and grassy plains could offer a utopian refuge from the turmoils of modern wars, revolutions, commerce, industry, and urbanization. This sentiment is literally expressed in the poem "O Täler weit, o Höhen" by Romantic poet Joseph von Eichendorff (1788–1857), which in Felix Mendelssohn-Bartholdy's musical setting gained the popularity of a folksong, especially as it became a standard in the repertoire of German massed choirs (*Männerchöre* and *Gesangsvereine*) that proliferated since Romanticism:

O Täler weit, o Höhen,
O schöner, grüner Wald,
Du meiner Lust und Wehen
Andächtger Aufenthalt!
Da draußen stets betrogen,
Saust die geschäftge Welt;
Schlag noch einmal die Bogen
Um mich, du grünes Zelt![15]

(Oh valleys wide, oh hillsides,
Oh forests, so beautiful and green,
You, the reverend repose
Of all my joys and woes!
Out there persistently betraying
Resides the busy world;
Receive me once again, oh greenest canopy,
Within your embracing boughs!)

Such sentimental identification with the native landscape is the motivating force (for both artist and potential purchaser of the print) behind Johann Wilhelm Schirmer's roughly contemporary view of the old mill, nestling amidst the embracing foliage of a luxuriantly expansive forest (cat. no. 104). The idyll of the *Heimat*'s peaceful, welcoming, and pictur-esque landscape could become a trite pictorial formula. With its pervasive presence in German consciousness, this imagery lent itself readily to the propaganda purposes of sell-ing war bonds during World War I (cat. no. 108), when the military defense and protection of the land and its people were offered as the emotion-laden justification for continuing the slaughter. Modernist, progressive artists also incorporated the German landscape to signal national identity and tradition within a stylistic vocabulary of innovation. Gabriele Münter's numerous scenes of Alpine village of Murnau—a market center for nearby farmers that dates back to the time of the Romans, with a population in 1908 of about 2500, but increas-ingly also a summer resort—are painted in an Expressionist mode, but they continue to echo Romantic and later nineteenth-century themes [SEE FIGURES 40 AND 42].[16] "Ever more I grasped the clarity and simplicity of this world," she observed later. "Especially when the *Föhn* winds blew the mountains stood as a powerful closing in the picture, deeply black-blue."[17] In her views of village streets, fields, moors, and mountains, Münter pro-jected a realm of simplicity with clear distinctions, positioning German humanity in a utopian symbiosis with the magnificence of nature.

This formulation also applies well to Erich Heckel, who offered a view of the Baltic Sea that likewise celebrates the relationship between German nature and its German inhabitants; in

East Baltic Seacoast of 1911 [FIGURE 46], the fragile figures of bathers and bathing structures are gently encompassed into the realm of the shining silvery-white sands of the seashore and the beckoning blue-green of the massive sea. Some twenty years later, Heckel applied a transformed stylistic vocabulary to his watercolor *Gray Slopes (Lesser Walser Valley)* [FIGURE 86], which continues to celebrate native nature through visual references to nineteenth-century landscape ideals, but injects as well an implicit commentary or response to the altered German identity enforced by Adolf Hitler's new Nazi regime.[18] Indeed, the sentimental identification with German nature, while constant since Romanticism, manifests a malleability and persistent adaptability to transformed attitudes, situations, and content. As was the case with Germany's historic heroes and cultural paradigms, the imbrications of the landscape with Nazi ideological configurations also altered the landscape's artistic reception.

After World War II, as artists in West Germany followed the international trend toward gestural abstraction, the landscape motif could be avoided, but beginning in the 1960s, when figuration re-emerged as a viable option, it returned as a repeated concern. Particularly in the imagery of Anselm Kiefer, nature now offers witness to the staging of historical horrors. No longer a utopian idyllic retreat from the turmoil and violence of modern experience, the landscape instead shows the scars of its own abuse or reveals itself as complicit in murderous events and deeds, fed by blackened blood yet remaining barren. Identity necessarily remains, but it is a provoked identity that demands the recognition of the problematics of postwar German existence. The massive, monumental painting *Light Trap* [FIGURE 2] participates in a fascination with night and its emblematic significance that has featured centrally in German poetry and art, particularly since Romanticism.[19] *Nocturnal View of Meissen in Winter* [FIGURE 15] by Ernst Ferdinand Oehme, a Dresden artist associated with the circle of Romantic landscape painters there, exemplifies this theme. Oehme's canvas depicts the snow-covered city of Meissen, near Dresden, noted as the site of the first European porcelain manufactory. On a Christmas Eve night, worshipers return quietly from church to their homes, illuminated by the candles of Christmas trees and by a single bright star that accents the dark blue sky. Oehme cloaked this symbolism in sentiment by setting the scene in the past; the clothing and wigs worn by the figures suggest Meissen a century before the city began to undergo industrialization. For the bourgeois German public of the 1850s, *Meissen in Winter* offered a recollection of a golden age when Meissen's royal porcelain manufactory was founded under the legendary reign of the Saxon Elector and King of Poland Augustus the Strong.

Kiefer's painting, in contrast, bears none of the gentle nostalgia of Oehme's nocturnal view. With seemingly innumerable small marks and seeds to identify stars against a variegated but somberly black field or sky, *Light Trap* follows a formulation Kiefer began to employ in the early 1980s, initially in his photographs, and then in a series of paintings that he exhibited in Paris in 1996 under the title *Cette obscure clarté qui tombe des étoiles* (That dim clarity which falls from the stars), quoting a well-known line from the French Baroque playwright Corneille's *Le Cid* (1637).[20] The "stars," moreover, are accompanied by paper labels on which they are numbered in a system citing NASA's numbering practice, but the numbers fail to correspond to actual stars. It is a sky filled with potential stars, imagined

Fig. 2.
Anselm Kiefer,
Light Trap, 1999. Shellac,
emulsion, glass, wood, and
steel trap on linen; 156 x 216 in.
Lent by Collection Susan and
Lewis Manilow
[Cat. no. 46]

celestial fires that are connected by white lines to one another into a likewise invented constellation-like configuration.

Light Trap is an image of unrealized potential, and it is tempting to find in its numbers—and in the shards of glass in the centrally placed wire animal trap—a reference to the numbered inmates and victims of Hitler's concentration camps,[21] as well as to the infamous *Kristallnacht* ("Night of Crystals" or "Night of Broken Glass") of November 9–10, 1938, during which Nazi mobs broke the display windows of Jewish shops, ransacked the shops, burnt synagogues, and arrested several thousand Jews (in addition to killing a number). The Jews and other victims of the Holocaust and of Nazi persecution are the most tragic human examples of the unfulfilled potential implied by Kiefer's composition and title, but the artist's practice of overlaying meaning, aura, and association in his imagery rejects such clarity of signification. The "scientific" numbering, the "Romantic" night, and the magical constellation are conjoined with the ghost image of a Meso-American pyramid, over which the nocturnal sky has been painted or built up. The mysterious astrology suggested by the conflation of constellations and pyramid confounds the meanings otherwise provided. So too does the massive painting's overall resemblance to a landscape, with its deeply scarred topographical surface and shaded configurations of hues of blackness, its contours seemingly held down by groupings of heavy nails at the lower corners. Burnt, exploded, ploughed,

silted, encrusted, and coagulated—this is Kiefer's construction, both conceptual and material, of a landscape that survived Nazism and its war but was forever marked and transformed by the experience. Night and the landscape here wear the black cloth of mourning and loss and traumatic memory, doomed to share their color with the black uniforms of the SS.

If there is a counterpoint to Kiefer's pessimistic, blackened landscape among contemporary artists, it is to be found in Gerhard Richter's small, gem-like green abstraction simply entitled *Abstract Picture* [FIGURE 3]. This work, however, represents landscape even more indirectly than *Light Trap*. A subtly hued green smoothly fills virtually the entire canvas, leaving only touches of other colors at its edges that seem to ooze out from beneath the satiny covering layer. Following Richter's assertion that "there is no color on canvas that means nothing but itself and nothing beyond it,"[22] landscape emerges in the green itself, the deep color of grass or the leaves of trees and bushes sated with the rain and nutrients of early summer, and in the subtle horizontality of the painting's format. Richter has rendered the aura of landscape allusion. In the virtual monochrome of the painting and its existence on the edge of signification there is, ironically, a strange resurrection of the German utopian vision of landscape that Kiefer declared dead or disfigured into unrecognizability. "What strengthens me is the certainty that painting is not a strange hobby; it is a fundamental human activity, and so it has qualities that can be distinguished and identified," Richter has observed. "And that also confirms me in the certainty that despite all the errors, painting can on principle make manifest our best, our most human and most humane qualities."[23] This may no longer be the embracing landscape of the German *Heimat*, hailed by poets such as Eichendorff or depicted by painters such as Schirmer, Münter, Heckel, and innumerable others, but it likewise celebrates a recognition of a human and humane reality beyond the horrors of history or the trials of modernity.

Kiefer's heavy, personal dramatizations of history and myth do meet with Richter's subtly modulated significant emptiness: both artists are concerned with allowing the materials they employ to form fundamental components in the expressiveness of their works. The self-conscious inclusion of the medium in the generation of meaning and image is certainly one of the hallmarks of Modernism, but Kiefer and Richter invert this aesthetic's system by persistently shifting styles and modes to avoid Modernism's celebration of the static existential individual whose constancy of style serves as an index of identity. Indeed, their concern with retaining the trace of the image's material makeup can be recognized as a specific constant in German art, akin to the conscious search for a German style. The deliberate referencing of existing prototypes brought with it a fundamental awareness of the means of pictorial production and of how these operate to generate meaning. Impressionism and Fauvism, imported manners of painting, exerted such a strong appeal to German Modernists around 1900 in part because they feature subjectively accentuated strokes of paint as primary components in the final image. Similarly, media such as pastel, which both reveals the process of making and retains a unique material presence, attracted highly disparate artists, such as the artistically conservative Hanns Fechner [SEE FIGURE 33] and the avant-garde Expressionist Ernst Ludwig Kirchner [SEE FIGURE 35].

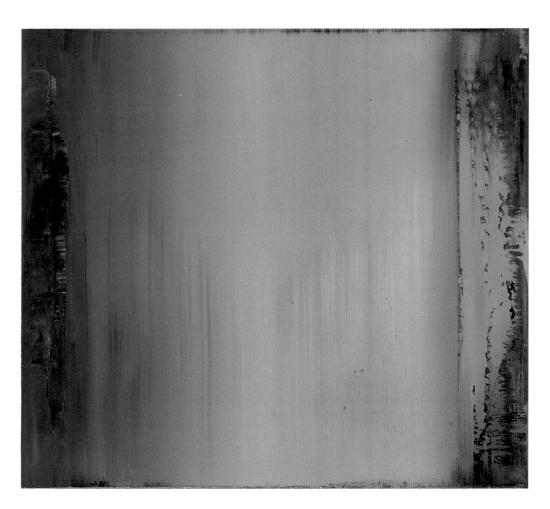

Fig. 3.
Gerhard Richter (b. 1932),
Abstract Picture (836-3), 1996.
Oil on linen; 18 ⅛ x 20 ⅛ in.
Lent by Mr. and Mrs. Robert
M. Newbury
[Cat. no. 95]

In reaction to Expressionism's conscious, personalized manipulation of medium, a renewed apparent objectivity emerged. The "New Objectivity" painters, looking back to the paintings of Albrecht Dürer and the German Renaissance, necessarily and ironically accented the painting's material presence. Only through heightened awareness of paint handling could the artist eliminate the visible tracks of the brush and achieve a meticulous surface, as did Christian Schad in his 1926 *Portrait of Baronessa Vera Wassilko* [FIGURE 68].

The process-oriented abstraction that became dominant in western Europe and the United States after World War II strongly attracted German artists such as Fritz Winter to once again exploit the marked visual and tactile presence of medium and support. His evocative *Figure* [FIGURE 4] is a refined rendering in minimal gestures, established with strokes of white pastel crayon and touches of oil paint on a dark ground. Later, Helmut Middendorf's wild gesticulations and employment of harshly mixed media (watercolor, gouache, inks, graphite, and crayon) in seemingly primal scenes of passion and performance [SEE FIGURE 5] provide yet another variant of this German urge to make medium and materials visible participants in the communication of meaning for the viewer. In the case of Joseph Beuys, the materials of fat and felt—with their links to his own biography and primordial mystical

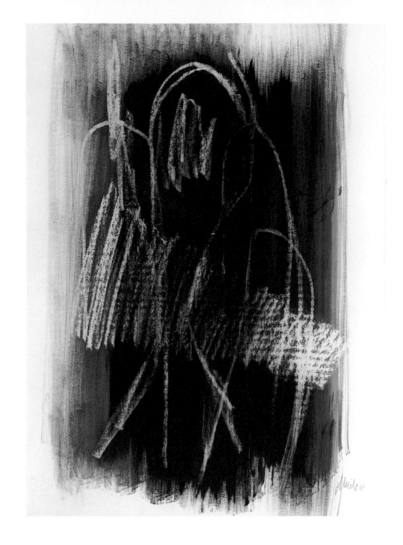

Fig. 4.
Fritz Winter (1905–1976),
Figure, 1964. White crayon
and oil on paper; 27 ½ x 19
⅝ in. Lent by Jack and Helen
Halpern
[Cat. no. 112]

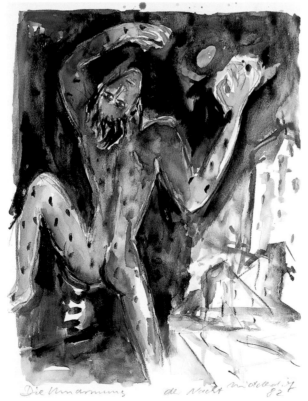

Fig. 5.
Helmut Middendorf (b. 1953),
Embrace of the Night, 1982.
Watercolor, gouache, and
charcoal; 18 ¾ x 14 in. Lent by
Marcia and Granvil Specks
Collection
[Cat. no. 73]

Fig. 6.
Joseph Beuys (1921–1986),
Felt Suit, 1970. Felt;
67 ½ x 30 ¼ x 8 ½ in.
Collection Museum of
Contemporary Art, Chicago,
Partial gift of Dr. Paul and
Dorie Sternberg
[Cat. no. 10]

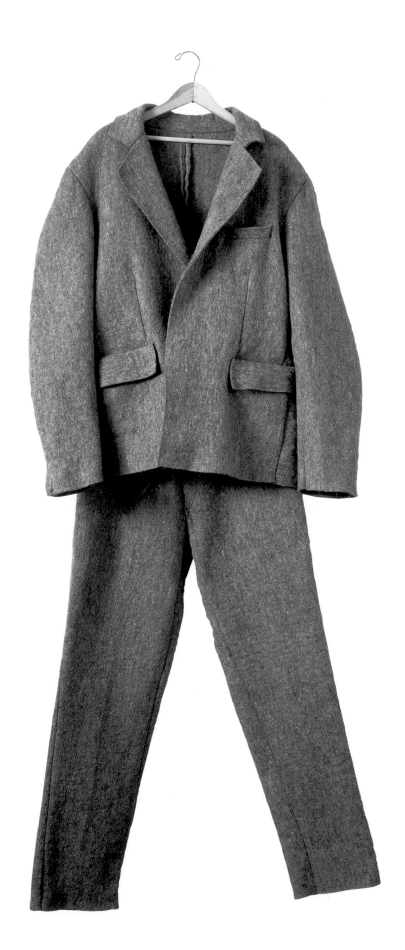

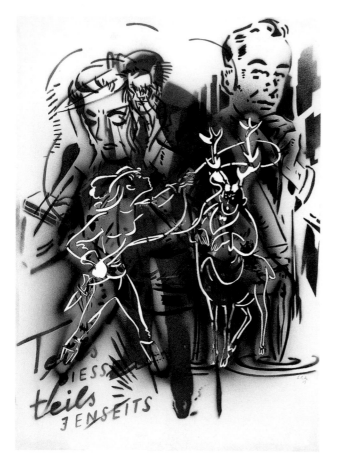

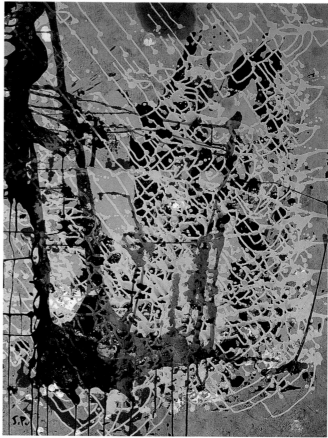

Fig. 7.
Sigmar Polke (b. 1941),
*Partially on This Side, Partially
on the Other Side*, 1979.
Sprayed acrylic on paper, with
linear cutouts; 39 x 27 ½ in.
The Art Institute of Chicago,
Gift of Susan and Lewis
Manilow, 2000.714
[Cat. no. 91]

Fig. 8.
Sigmar Polke, *Untitled*, 1967.
Gouache, watercolor, and
spraypaint; 39 x 29 ⅜ in. Lent
by Laura and Marshall Front
[Cat. no. 92]

Fig. 9a–d.
Rosemarie Trockel (b. 1952),
Untitled, 1996. Four works on
paper. Lent by Laura and
Marshall Front

a. Cibachrome; 11 ⅜ x 11 ⅜ in.
[Cat. no. 111a]

b. Ink; 11 ⅛ x 8 ⅛ in.
[Cat. no. 111b]

c. Gouache; 17 ⅜ x 13 ⁷/₁₆ in.
[Cat. no. 111c]

d. Black-and-white photograph;
11 ⅜ x 11 ⅜ in.
[Cat. no. 111d]

overtones of survival and shelter—comprise the signature appearance and functional content of his work more definitively than any stylistic hallmarks [SEE FIGURE 6]. Sigmar Polke, in his 1979 painting *Partially on This Side, Partially on the Other Side* [FIGURE 7] and untitled drawing of 1967 [FIGURE 8], rejects any continuity of appearance, shifting readily and repeatedly among varied types of configurative rendering (even employing different modes within a single work) and seeming abstraction. He rejects the signal unity of an individual stylistic vocabulary in favor of a veritable inventory of contrasting modes of picture-making, which share only their eschewal of a traditional personal touch: Polke takes distance through techniques such as air brush, imprinting forms from paint-drenched netting and other materials, manipulating flows and drips of liquid paint, transferring blow-ups of previously existing commercial imagery, and using such materials as fibered paper board or imprinted tablecloths for his supports. Likewise, Rosemarie Trockel employs seemingly any image-generating means available to her—whether standard drawing materials, photographs, wool knitting, various pre-existing objects, or performances and their traces. The materials that make up her work thus do more than constitute an image; they are functions of the image or, indeed, they *are* the image [SEE FIGURE 9]. All this rejection of a unique, singular authorial voice can definitely be seen as a manifestation of postmodernist attitudes and strategies shared by contemporary artists worldwide, and yet the untempered, unremitting accentuation of the very materials of artistic production extends certain key interests and practices already manifest in German art.

Conceivably, German artists' awareness and exploitation of their work's material and medium has a source in their tendency to work in multiple media. Painters in particular have placed equal or even superior weight on their production of prints, thereby becoming aware of the independent expressive potential provided by graphic media. While certainly

artists of other ethnic and national groups worked across various media, the extent and degree to which this has been and remains a major or even dominant focus for German artists seems unique. Max Klinger [SEE FIGURES 24–28] and Käthe Kollwitz [SEE FIGURES 56 AND 87–88] are notable artists who focused predominantly on printmaking, subordinating painting or sculpture and thus reversing the standard values associated with the various media. As Klinger argued in his influential 1891 treatise *Malerei und Zeichnung* (*Painting and Drawing*), painting proved inferior to printmaking and drawing because its chromatic component rendered it too dependent on the sensual, visual world, while the draftsman's work could be freely inventive, a site of absolute fantasy:

> It is not possible to express the difference between the painter and the draughtsman more precisely. The former reconstructs form, expression, color in totally objective fashion. . . . In contrast, the draughtsman is situated before the eternally unfilled gaps of what is yearned for and what is attainable, and he has no choice but to come to terms personally with the realm of irreconcilable powers. The works of the one [the painter] speak of optimism, of the pleasures of the world, … while the other [the draftsman] is pressured by comparison to go beyond the viewing of forms to a negating process of observation.[24]

In Klinger's articulation, the media themselves supply content and meaning, beyond the subject that may be depicted. The print then supplies a vocabulary of free invention, its inherent black-and-white abstraction offering liberation from the tactile referentiality insisted upon by colored paint.

Today, as the formerly divided eastern and western sections of Germany continue to proceed in an often painful process of unification, the print has been called into service as a national medium of artistic reconciliation. In 1999, as part of an ongoing effort to retrieve its own past after long years of repression, first by Hitler and then by the Communist regime, the East German city of Chemnitz (known from 1954 to 1990 as Karl-Marx-Stadt) sponsored an exhibition of Edvard Munch's art that documented the Norwegian artist's activities in the city and reconstructed the epochal exhibition he had there in 1929.[25] Since the beginning of the century, Munch and other pioneers of modern art had received major commissions from industrialists in Chemnitz, and both the 1929 and 1999 exhibitions served to honor and commemorate the lively interchange between the artist, his patrons, and this Saxon manufacturing center. In conjunction with the 1999 exhibition, the city commissioned *Homage to Edvard Munch*, a portfolio of twelve prints by six contemporary Chemnitz artists, as another symbol of the city's desire to form a bridge between past and present [SEE FIGURES 10 AND 11]. The portfolio is thus a unique effort honoring Edvard Munch, commemorating Chemnitz's own artistic history, and signaling the city's re-entry into the international community of contemporary art. Most of these artists were members of the group "CLARA MOSCH" (an anagram of the first letters of the names of Carlfriedrich Claus, Thomas Ranft, Michael Morgner, and Dagmar Ranft-Schinke), which had mounted radical opposition to the official art of the German Democratic Republic during the late 1970s and 1980s, organizing a cooperative art gallery to show their work as they had but limited access to state-sponsored venues.[26] In communal performances and in prints, the CLARA MOSCH artists rejected the values of socialist realism, even in the highly modified forms it took on in the last years of the GDR, and instead posited a dual accentuation of process and material. This attitude paralleled that of their West German contempo-

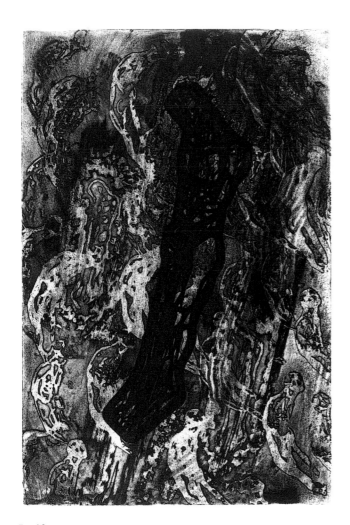

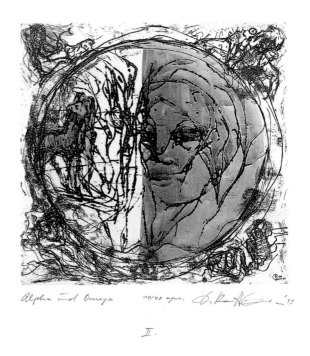

Fig. 11.

Dagmar Ranft-Schinke (b. 1944), *Alpha and Omega*, from *Homage to Edvard Munch*, 1999. Two-color etching and aquatint; 11 ⅝ x 11 ⅝ in. Smart Museum of Art, University of Chicago, Gift of the Kunstsammlungen Chemnitz, Germany, 2000.60h

[Cat. no. 113f]

Fig. 10.

Michael Morgner (b. 1942), *Untitled*, from *Homage to Edvard Munch*, 1999. Etching, engraving, and aquatint with lavage; 19 ⅝ x 12 ¹¹⁄₁₆ in. Smart Museum of Art, University of Chicago, Gift of the Kunstsammlungen Chemnitz, Germany, 2000.60c

[Cat. no. 113a]

raries, but while many of these artists explored non-traditional techniques and processes, the Chemnitz group maintained adherence to such historic media as engraving, woodcut, and lithography, injecting into them a sense of restless experimentation and a renewed dedication to revealing the unique qualities of each medium.

Among print techniques, the woodcut has been favored most consistently by German artists of the past two centuries. Shortly after 1800, Caspar David Friedrich employed the then still relatively new technique of wood engraving, developed by Thomas Berwick in England, for a group of scenes apparently intended to be included in a book of poetry [FIGURE 29]. Throughout the nineteenth century, other artists exploited the potential of wood engraving—a relief process in which the matrix is the fibered end of the wood rather than the plank side, as in woodcut—to produce cheap and relatively large editions, often for use as book illustrations. Woodcut re-emerged as an independent fine-art medium during the 1890s; inspired by the examples of Paul Gauguin and Edvard Munch, many Expressionist artists enthusiastically adopted it shortly after the turn of the century.[27] The Russian, Wassily Kandinsky, one of the founders of the Blaue Reiter group in Munich in 1911, rejected Klinger's adulation of black-and-white print vocabularies by employing color to

render his apocalyptic motifs, such as *Great Resurrection* [FIGURE 45]. But Kandinsky evaded the illusionistic sensuality that Klinger attributed to painting by using color as part of a non-mimetic, highly personal system of musical allusion, and he employed flattened, unpredictably exaggerated forms and residues of the wood-carving process. A similar accentuation of splintering, jagged, edgy figures characterizes Karl Schmidt-Rottluff's woodcut *Three People at the Table* [FIGURE 48], part of a portfolio of prints united by their woodcut technique more than by shared subject matter. Max Beckmann, although a prolific printmaker, practiced woodcut less frequently than his Expressionist contemporaries. Nonetheless the few woodcuts he produced in the early 1920s [SEE FIGURE 69] demonstrate his fluency in a vocabulary whose broad planes, harsh contours, and sharp incisions define a post-Expressionist concern with heavy volume and conflicted spatial structures. Beckmann's engravings and lithographs maintain these formal hallmarks, coupled with a tendency toward caricature that he shared with artists working in other media in the 1920s, such as Otto Dix, George Grosz, and Christian Schad.

During the 1930s and 1940s, several artists maintained the woodcut as a form of resistance to the anti-modernist art doctrines of National Socialism. Viewing the woodcut medium as deeply entwined with the history of German art and its identity, they practiced it in order to reject the imposed German identity of Hitler's regime. Later, Georg Baselitz [FIGURE 13], A. R. Penck, Jörg Immendorff, and Anselm Kiefer again proposed woodcut (or the related linocut) as a technique of opposition and of individual German identity. Their monumental prints in stark black and white or symbolically significant unmodulated primary colors, with dark planar forms, dynamically cut lines, and splintered contours, consciously echo and replicate Expressionist precedents in a post-modern process of formal citation. As already noted in terms of Kiefer's *Grane* and *Light Trap*, however, the content shifts, and the heavy black hand—to borrow Kandinsky's pregnant phraseology from a different context[28]—of recent German history imposes itself in persistent reference and critical quotation. The Third Reich haunts Immendorff's *Hail Victory* [FIGURE 12]; Penck cites the postwar division of the nation according to the power blocs of the Cold War in *The Work Goes On* (cat. no. 89). Both artists significantly employ verbal propaganda slogans: of Nazism, in Immendorff's case, or the institutionalized socialism of the GDR in Penck's. For the latter artist, the slogan is transposed into an autobiographical reference to his own move over the barrier of the Berlin Wall from the Communist East to the capitalist West.

The contemporary artists considered so far employ woodcut in terms of depersonalized, post-modern stylistic citation, achieving the look of Expressionist work while injecting the sometimes gargantuan monumentality and demonized German history of the post-Nazi era. Bodo Korsig's employment of woodcut, by contrast, manifests a renewed accentuation of formal invention and experimentation with the medium as such. Using large planks of plywood, Korsig cuts forms with sources in today's urban environment. Photographed by him, then submitted to a process of drawn and printed transformation, these sources lose the traces of their original identities to reshape themselves into delicate, tenuous, yet powerfully defined configurations that exist on the edge of legibility. Tendrilled forms, simple and attenuated, are situated against large fields of intense crimson or muted gray, sometimes emerging from a massive mottled black area like thin mushrooms or feathers from

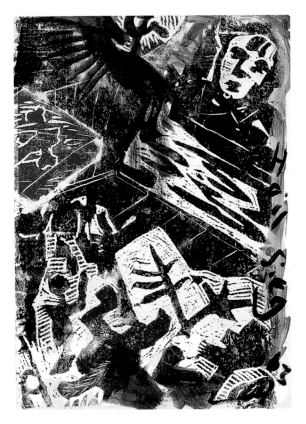

Fig. 12.
Jörg Immendorff (b. 1945),
Hail Victory, 1983. Color
linocut with gouache;
33 x 23 ¼ in. Lent by Marcia
and Granvil Specks Collection
[Cat. no. 39]

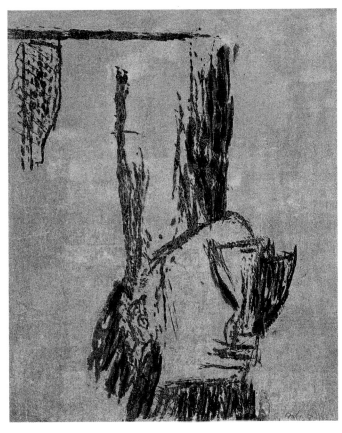

Fig. 13.
George Baselitz (b. 1938), *The Drinker*, 1982. Color woodcut; 39 ½ x 31 ½ in.
Lent by Marcia and Granvil Specks Collection
[Cat. no. 4]

an ebony meadow—this is the realm of the woodcut series *Timechange* [FIGURE 14].
Korsig works in serial imagery, varying an invented hieroglyphics of shapes and lines,
sometimes evoking memories of objects and things. Repetitive and ordered, like sugges-
tions for a new alphabet, the signs remain elusive, communicating a still-unknown sen-
tence. More than any other German artist now working, Korsig has granted a new syntax
and appearance to the medium so often identified as appropriately German. Not seeking
legitimation in citations of the past, he instead re-invents the medium, investing it with an
identity that recognizes but overcomes the weight of historical precedent. Monumental and
brash yet whimsical and lyrical, Korsig's woodcuts give testimony to a transformed, trans-
forming identity perhaps engaged in an effort to restore the utopian vision otherwise pre-
dominantly lacking among contemporary German artists.

In its selective sampling of German artistic production over the course of two centuries,
Confronting Identities in German Art: Myths, Reactions, Revisions set itself a task ulti-
mately not totally realizable. In its rich diversity, however, it presents a variety of the shifts
and constants of aesthetic production and attitude that I have attempted to sketch out in
this essay, and which the succeeding essays expand and augment. The exhibition and cata-

Fig. 14.
Bodo Korsig (b. 1962),
Timechange, 2000. Four
woodcuts printed in oil;
55 ⅝ x 39 ¾ in. (each).
Lent by the artist
[Cat. no. 64]

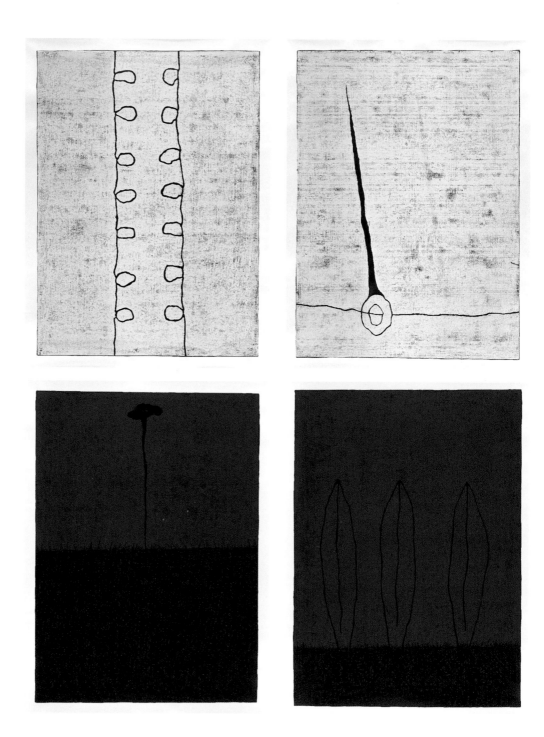

logue are not meant to answer the hoary question "What is German in German art?", which builds on false universalizing assumptions, but to offer a preliminary exploration of how identity manifests itself in visual art. Paradoxically, German identity emerges as a unique multiplicity, its shape and content undergoing continual shifts, mutations, fusions, and separations—rejecting fixity yet maintaining a continuity of historical consciousness and material aesthetic that possibly define a tradition marked by milestones of shared memory and experience.

1. Hans Belting, *Identität im Zweifel: Ansichten der deutschen Kunst* (Cologne: DuMont Buchverlag, 1999), 7. Unless otherwise indicated, all translations into English are my own. Several other recent books have focused on issues of identity and German art, most notably Hans Belting, *The Germans and Their Art: A Troublesome Relationship*, tr. Scott Kleager (German ed. 1993; New Haven and London: Yale University Press, 1998); and Werner Hofmann, *Wie deutsch ist die deutsche Kunst? Eine Streitschrift* (Leipzig: E. A. Seemann, 1999). Also compare the controversial, highly problematic thesis linking German progressive modernism to Nazi ideology provided by Jean Clair, *La responsabilité de l'artiste: Les avant-gardes entre terreur et raison* (Paris: Gallimard, 1997).

 For her reading of this essay and her comments concerning it, I wish to thank Nina Zimmer.

2. James Hyman, "Anselm Kiefer as Printmaker I: A Catalogue, 1973–1993," *Print Quarterly* 14, 1 (March 1997): 64. Nos. 38–55 identify the *Grane* print images from the years 1977 to 1993.

3. Among the prints related to *Grane* are a number that pair the words "Grane" and "Brünhilde," but in these too the horse is depicted alone, not accompanied even by the portrait images present in the other images. See Hyman (note 2), nos. 40–41, 47–49, and 51–53. Several prints (Hyman, nos. 43–43) are also identified as *Brünhilde's Death (Brünhildes Tod)*. For a discussion of *Brünhilde/Grane*, see Nan Rosenthal, *Anselm Kiefer: Works on Paper in The Metropolitan Museum of Art* (New York: The Metropolitan Museum of Art, 1998), 117–25.

4. The most accessible review of Kiefer's career remains Mark Rosenthal's catalogue for the exhibition *Anselm Kiefer* (Philadelphia/Chicago/New York: Philadelphia Museum of Art/The Art Institute of Chicago/Te Neues, 1987). Also see Daniel Arasse, *Anselm Kiefer* (New York: Harry N. Abrams, 2001). Kiefer's prints are catalogued by James Hyman (note 2). For an extensive, but nonetheless selective, listing of exhibitions and bibliography, see Christoph Ransmayr et al., *Anselm Kiefer: Die sieben Himmelspaläste 1973–2001* (Riehen/Basel/Ostfildern-Ruit: Fondation Beyeler/Hatje Cantz, 2001), 104–09.

5. Anselm Kiefer, cited in Jean-Christophe Ammann, ed., *Ein Gespräch/Una Discussione: Joseph Beuys, Enzo Cucchi, Anselm Kiefer, Jannis Kounellis* (Zurich: Parkett, 1986), 55.

6. Among the figures depicted, the Existentialist philosopher Martin Heidegger figures not as a precursor or ancestor of Nazism so much as someone who joined and supported the Nazi Party and carried out its policies while rector at the University of Heidelberg in the 1930s. The fact that his work nonetheless became a major component of both Existentialism and critical theory after World War II is indicative of the problematics of the influence and sometimes sublimated continuation of Nazi ideology, a phenomenon that Kiefer explores. On Heidegger and Nazism, see especially the documents and discussion compiled by Gunther Neske and Emil Kettering, *Martin Heidegger and Nazism*, trans. Lisa Harries (New York: Paragon House, 1990); and Richard Wolin, ed., *The Heidegger Controversy: A Critical Reader* (Cambridge: MIT Press, 1993). Concerning Kiefer and Heidegger, compare Matthew Biro, *Anselm Kiefer and the Philosophy of Martin Heidegger*, Contemporary Artists and Their Critics (Cambridge: Cambridge University Press, 1998). Another figure in Kiefer's print, arguably not a "hero" in Nazism's version of history but, like Heidegger, a supporter and beneficiary of Hitler and the Third Reich, is the industrialist and arms manufacturer Alfred Krupp.

7. Reading the print from top to bottom, the Prussian military theorist Karl von Clausewitz (1780–1831) appears beneath Kant and Annette von Droste-Hülshoff in an intermediate field between the two top rows. In the second row, from left to right, we see: the Romantic novelist Jean Paul (1763–1825), the Romantic dramatist Christian Dietrich Grabbe (1801–1836), the Prussian field marshal of the Napoleonic Wars Gebhard Leberecht von Blücher (1742–1819), the Romantic dramatist and poet Heinrich von Kleist (1777–1811), the Existentialist philosopher and sometime Nazi supporter Martin Heidegger (1889–1976), the Prussian Minister of War Albrecht von Roon (1803–1879), and Jacob Böhme. The third row from the top, left to right, features: the Romantic composer Carl Maria von Weber (1786–1826), the industrialist

and arms manufacturer Alfred Krupp
(1906–1967), Eduard Mörike (1804–1875), the
military tactician Alfred von Schliefen
(1883–1913), the poet Adalbert Stifter
(1805–1868), and the poet and dramatist
Friedrich Klopstock (1724–1805). Beneath him
is Hoffman von Fallersleben (1789–1814) and,
as an extension of the print's field, the poet
Stefan George (1868–1933). In the register
below this row, on the left is the philosopher
Johann Fichte (1762–1814), celebrated for his
nationalistic *Speeches to the German Nation*
during the resistance to Napoleon, immediately
above the Nazi Party member Leo Schlageter
(1894–1921), executed for his opposition to the
French occupation of the Rhineland during the
early 1920s. Next to them is Queen Luise of
Prussia (1776–1810), who reigned during the
Napoleonic Wars and was the mother of the
first German Kaiser, William I. Finally, at the
bottom right, Horst Wessel (1907–1930) is
depicted; a Nazi Storm Trooper thug and pimp
killed during a barroom brawl, then heralded
by Goebbels as a Nazi martyr who died in a
Communist ambush, Wessel also authored the
Nazi anthem "The Horst Wessel Song."

8. On Neureuther, see particularly Ernst Wilhelm
Bredt, *Das Neureuther-Album mit 78 Tafel-
Abbildungen und den Briefen Goethes an
Neureuther* (Munich: Hugo Schmidt, 1918).

9. On the 19th-century Dürer reception, see Peter
Vugnau-Wilberg, "Von der Dürer-Verehrung
zum Dürer-Kult," *Mitteilungen der
Gesellschaft für vergleichende Kunstforschung
in Wien* 51, no. 1 (1999): 3–5; and Richard
Wegner, "Dürerkult in der Romantik: Das
Mittelalterbild der Nazarener," *Anzeiger des
Germanischen Nationalmuseums* (1998):
25–27.

10. The link between the Ludwig I's Bavaria and
Maximilian I's Holy Roman Empire is further
indicated in the print by means of the coats of
arms at the top center: the eagle of the Holy
Roman Empire of the German Nation is
flanked below by the coats of arms of Munich
and Nuremberg.

11. The argument for an economic rather than cul-
tural or even predominantly military determi-
nation of German unity is offered succinctly by
Harold James, *A German Identity 1750–1990*
(London: Phoenix, 1994).

12. Helmut Plessner, *Die verspätete Nation. Über
die politische Verführbarkeit bürgerlichen
Geistes,* expanded ed. (Stuttgart: W.
Kohlhammer, 1959). For arguments against
Plessner's thesis, see especially David
Blackbourn and Geoff Eley, *The Peculiarities of
German History: Bourgeois Society and
Politics in Nineteenth-Century Germany*
(Oxford/New York: Oxford University Press,
1984); and Helga Grebing, *Der "deutsche
Sonderweg" in Europa 1806–1945: Eine Kritik*
(Stuttgart: W. Kohlhammer, 1986).

13. A perceptive summary of Goethe's youthful
adulation of the Gothic and its impact on
German art is provided by Françoise Forster-
Hahn, "Art without a National Center: German
Painting in the Nineteenth Century," in *Spirit
of an Age: Nineteenth-Century Painting from
the Nationalgalerie, Berlin,* exh. cat.
(London/Washington, D.C.: National
Gallery/National Gallery of Art, 2001), 19ff.

14. For extensive consideration of the many
designs for a German national cathedral and/or
monument, see Thomas Nipperdey,
"Nationalidee und Nationaldenkmal in
Deutschland im 19. Jahrhundert," *Historische
Zeitschrift* 206 (1968): 529–85; and Helmut
Scharf, *Kleine Kunstgeschichte des deutschen
Denkmals* (Darmstadt: Wissenschaftliche
Buchgesellschaft, 1984). Also see Forster-Hahn
(note 13), 20–21.

15. Josef von Eichendorff, "O Täler weit, o Höhen,"
with music by Felix Mendelssohn-Bartholdy, in
Willy Schneider, comp., *Deutsche Weisen: Die
beliebtesten Volkslieder für Klavier mit Text*
(Stuttgart: Lausch & Zweigle, 1958), 197.

16. On Münter's depiction of scenes from Murnau,
see especially Brigitte Salmen, *Gabriele
Münter malt Murnau: Gemälde 1908–1960
der Künstlerin des "Blauen Reiters"* (Murnau:
Schloßmueum Murnau, 1996). Also compare
Reinhold Heller, *Gabriele Münter: The Years of
Expressionism 1903–1920* (Milwaukee/ Munich:
Milwaukee Art Museum/Prestel, 1997).

17. Gabriele Münter, cited in Annegret Hoberg,
"Gabriele Münter in München und Murnau
1901–1914," in Annegret Hoberg and Helmut
Friedel, eds., *Gabriele Münter, 1877–1962:
Retrospektive* (Munich: Prestel, 1992), 31.

18. See the essay "Resistance and Exile: Artistic Strategies under National Socialism" in this catalogue.

19. A handy, if very partial, overview of nocturnal imagery and its ideological ramifications is provided by the section "Hymnen an die Nacht—Traum und Unbewußtes" in *Ernste Spiele: Der Geist der Romantik in der deutschen Kunst 1790–1990*, exh. cat. (Munich: Haus der Kunst, 1995), 313–50, 538–56.

20. Arasse (note 4), 20.

21. The lengthy numbers of *Light Trap*, however, do not derive directly from the system of numbers tattooed on the arms of Nazi concentration camp inmates. It is a question of numbers themselves sufficing, especially in the context of Kiefer's works, to give rise to such an association.

22. Gerhard Richter, cited in Benjamin H. D. Buchloh, "Gerhard Richter's Facture: Between the Synecdoche and the Spectacle," in *German Art Now*, Art & Design Profile 16 (New York/London: St. Martin's Press/Academy Group Ltd., 1989), 43.

23. "Gerhard Richter in Conversation with Wolfgang Pehnt," in *German Art Now* (note 22), 50. For a fuller account of Richter's work, recognizing its ambiguous vacillation between optimism and pessimism, see Robert Storr, *Gerhard Richter: Forty Years of Painting* (New York: The Museum of Modern Art, 2002).

24. Max Klinger, *Malerei und Zeichnung, Tagebuchaufzeichnungen und Briefe*, ed. Anneliese Hübscher (Leipzig: Philipp Reclam, 1985), 44.

25. See Ingrid Mössinger, Beate Ritter, and Kerstin Drechsel, eds., *Edvard Munch in Chemnitz* (Chemnitz/Cologne: Kunstsammlungen Chemnitz/Wienand, 1999).

26. *CLARA MOSCH 1977–1982: Werke und Dokumente: Claus, Ranft-Schinke, Ranft, Morgner, Schade* (Altenburg/Chemnitz/Berlin: Lindenau-Museum/Städtische Kunstsammlungen and Galerie Oben/Galerie Gunnar Barthel, 1997).

27. For an extended consideration of the "woodcut renaissance," see Robin Reisenfeld, "The Revival of the Woodcut in Germany, 1890–1920," Ph.D. diss. (Chicago: The University of Chicago, 1993).

28. Wassily Kandinsky, "On the Question of Form," in Kenneth Lindsay and Peter Vergo, eds., *Kandinsky: Complete Writings on Art* (New York: Da Capo Press, 1994), 235–36. The essay first appeared in the *Blue Rider Almanac* in 1912, where Kandinsky employed the metaphoric image as a reference to hatred, "the black, death-dealing hand."

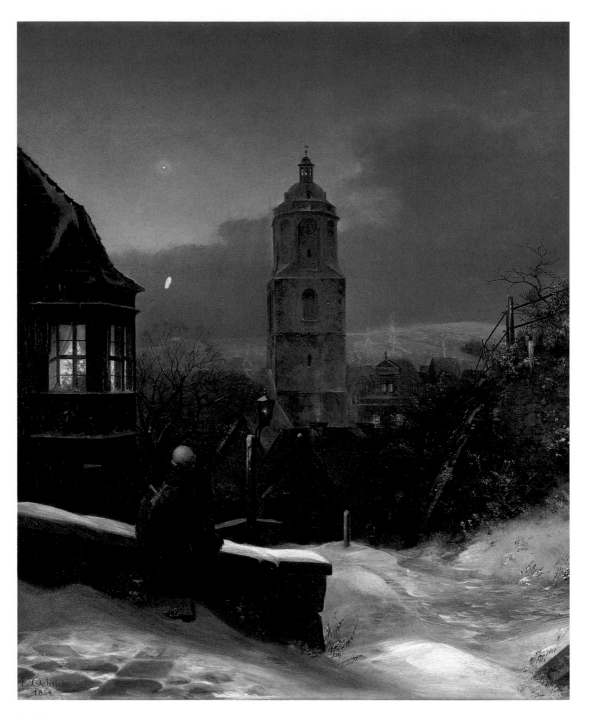

Fig. 15.
Ernst Ferdinand Oehme
(1797–1855), *Nocturnal View
of Meissen in Winter*, 1854.
Oil on canvas; 27 x 23 in.
Milwaukee Art Museum,
Gift of the René von Schleinitz
Foundation, M1962.105
[Cat. no. 86]

From Kulturnation to Staatsnation

German National Identity, 1800–90

SABINE WIEBER

Any discussion of German national identity during the nineteenth century must take into account the fact that Germany was unified politically as a nation only in 1871. Up until this point, lacking a hegemonic dynasty such as the Tudors and Hanovers in Britain or the Bourbons in France, the German-speaking inhabitants of central Europe resided in separate, independent kingdoms, principalities, dukedoms, cities, or other political units. Some of these, but not all of them and only parts of several of them, were loosely collected within the Holy Roman Empire of the German Nation, which traced its founding to Charlemagne and which was dissolved in 1806 when Francis II relinquished his German imperial title to become emperor of Austria. In 1815 thirty-nine independent German states and cities (later joined by two others) formed the German Confederation, a loose confederacy that lasted until 1865, when Prussia and Austria, the Confederation's most powerful members, went to war against each other.

Within this peculiar political configuration (which included, for example, the kings of England, Denmark, and the Netherlands in their roles as German landed nobility but excluded vast segments of Prussia and Austria), the overlapping ideas of national unity and identity served as powerful spiritual and cultural points of discussion throughout the nineteenth century. Even after unification became a political reality in 1871, debate oscillated between the two interconnected paradigms of a *Staatsnation* and a *Kulturnation*. The term *Staatsnation* described a unified political and legal body—a sovereign nation-state, composed of citizens living within an established geographical area. The *Kulturnation*, by contrast, represented a much more subjective configuration in which membership depended on shared culture, language, and history rather than on defined boundaries or a single government. Deeply entrenched in nineteenth-century discourse, these two concepts—Germany and Germanness—resurfaced with particular urgency in the political debates surrounding Germany's re-unification in 1990 and the ensuing problems. Not unlike today, the notion of a German *Kulturnation* was regularly posited during the nineteenth century as either a precondition or a recompense for Germany's ostensible inability to attain political unification under the auspices of a *Staatsnation*.[1]

Political Mobilization and the Return of the Old Guard, 1800–30

The French Revolution of 1789 sparked the idea of political self-determination among many German liberals and fueled hopes for a unified nation-state, yet these nationalistic ambitions did not gain significant popular following until Napoleon imposed French hege-

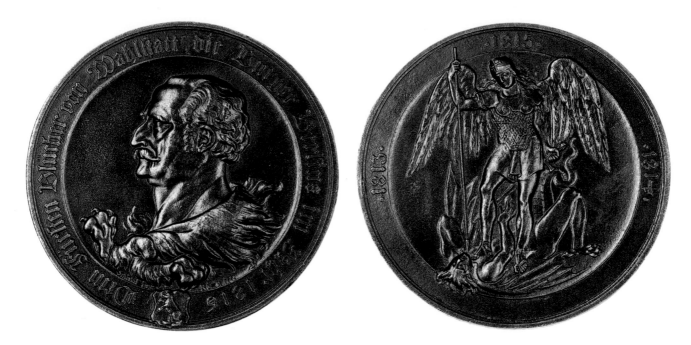

Fig. 16a.
Karl Friedrich Schinkel
(1781–1841) and Friedrich
Anton König (1794–1844),
*Prince Gebhard Leberecht von
Blücher*, 1816.
Cast iron; diam. 3 ⅛ in.
Smart Museum of Art, University
of Chicago, Purchase, the
Cochrane-Woods Collection,
1977.113
[Cat. no. 103a]

Fig. 16b.
The Archangel Michael
(reverse of Fig. 16a)
[Cat. no. 103b]

mony on central Europe in 1806–07. The French occupation recast Germany's quest for sovereignty into a powerful patriotic resistance against foreign exploitation and suppression.[2] This politicization of national consciousness helped mobilize troops across Germanic central Europe to fight Napoleon's armies during the Wars of Liberation of 1813–14. In the aftermath of these wars, various German military leaders were widely celebrated for their discipline and patriotic dedication to the liberation from French occupying armies. For example, a commemorative medal sponsored by the citizenry of Berlin, designed by the architect Karl Friedrich Schinkel and cast in iron by Anton Friedrich König the Younger in 1816 [FIGURE 16], features on its face a portrait of Freiherr (Baron) Gebhard Leberecht von Blücher, popularly called "Marshal Forward." One of Prussia's most prominent military leaders during the anti-Napoleonic campaigns, Blücher appears here in profile, according to antique prototypes, and he displays a lion skin draped over his shoulders, an attribute identifying him as a Prussian Hercules. On the medal's obverse, the Archangel Michael is shown defeating Lucifer, a scene repeatedly used by Schinkel and other artists in analogy to Prussia's defeat of Napoleon. Thus, the iconography establishes the Archangel Michael, Blücher, and Prussia in overlapping identification, against the evil of Lucifer, Napoleon, and France.

The medal conveys meaning in material as well as allegorical terms, celebrating military victory in its very substance: it is made of iron, rather than the more common commemorative metal of bronze. Clearly associated with the production of cannons, spears, swords, guns, and other weaponry and armor, iron moreover was particularly linked to Prussia's capital, Berlin, an early nineteenth-century center of industrial and artistic iron casting. Through its material and manner of manufacture, therefore, the medal embodies the civic pride and local patriotism of the Berlin burghers who commissioned it.[3]

Significantly, this object celebrates Blücher as a Prussian, rather than German, war hero. The victories identified by the dates 1813 (the Battle of Nations in Leipzig), 1814 (Blücher's entry into Paris), and 1815 (the Battle of Waterloo) were all triumphs of Prussia and its allies in battles that saw the various German states divided as they either supported or opposed Napoleon. They were not German victories. Indeed, once Napoleon was safely exiled to Elba and the Bourbons were restored to the throne of France, King Frederick William III's Prussia ceased to be supportive of calls for a unified German nation-state and sought to suppress the demands for it. The medal commissioned by the burghers of Berlin was an iron visualization, replete with the coat of arms of Prussia's capital, of Prussian patriotism and identity forcefully opposed to the sentiments announced earlier by advocates of German unity such as Ernst Moritz Arndt: "[We are] not Bavarians, not Hanoverians, not Holsteiners—nor are we Austrians, Prussians, Swabians, or Westphalians, all of whom may call themselves German, not one against another—[we all are] Germans for Germans."[4]

Schinkel masterfully applied the style seen in the Blücher medal to public buildings in and around Berlin. In effect, this mode of neo-classicism functioned as a sign of Prussian national identity, clearly distinguishable from the neo-Gothic style applied by Schinkel in other buildings and monuments he designed at the same time, great cathedrals set in oak forests that served rather to visualize German identity [SEE FIGURE 17]. In the effort to posit a German *Kulturnation* against French cultural and political dominance, artists and intellectuals turned to Germany's hitherto neglected medieval past. Neo-Gothic modes and motifs, together with elements drawn from late medieval and Northern Renaissance art, were viewed as a means to revitalize German art and culture and to free them from French and Italian artistic influence. Thus the polemicist Wilhelm Heinrich Wackenroder, associated with the first circle of German Romantic writers in the city of Jena, wrote in his short book, *Effusions from the Heart of an Art-Loving Monk* (1797): "Not only under the Italian sky, among majestic domes and Corinthian columns, but also under pointed arches, intricately decorated buildings, and Gothic towers true art grows."[5] The validation of the Middle Ages, an era associated not coincidentally with the greatness of the Holy Roman Empire of the German Nation, could be linked as well to a new advocacy of the landscape— and, by extension, of feeling, fantasy, and dream—as sources of transcendental experience. German pensiveness, inwardness, and irrationality countered Gallic rationality and analysis. Here, in the context of German Romanticism, the embrace of subjectivity and emotion functioned as a patriotic act.

Following Napoleon's ultimate defeat in 1815, the victorious powers—Great Britain, Russia, Austria, and Prussia—met in Vienna, where Austrian chief minister Prince Clemens von Metternich (1773–1859) engineered the reorganization of Europe's territories, the restoration of order, and the suppression of revolutionary tendencies. Metternich was especially concerned to stifle the liberal calls for German national unity that had emerged after Napoleon's defeat.[6] Believing that the *ancien régime* represented the pinnacle of statesmanship, and loathing the liberal ideals of the French Revolution, Metternich manipulated the Congress of Vienna to impose a reactionary, often repressive order on post-Napoleonic central Europe. Under his guidance, the German Confederation as well as the "Holy Alliance" of

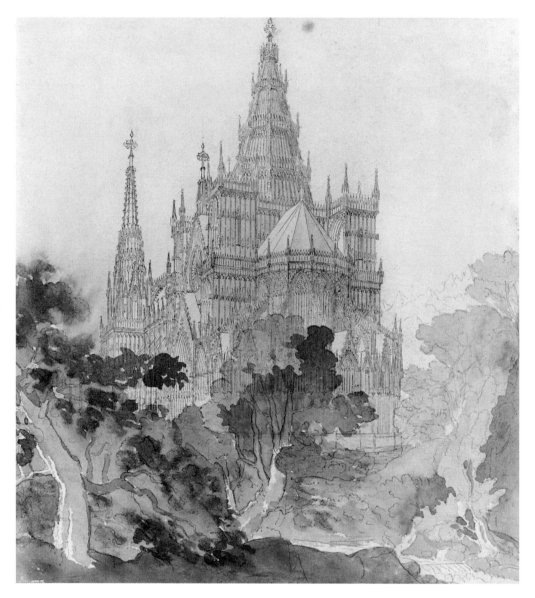

Fig. 17.
Karl Friedrich Schinkel,
*A Gothic Cathedral behind
Trees*, ca. 1813/1815. Pen and
gray ink and watercolor over
graphite; 9 ¾ x 9 in. Milwaukee
Art Museum, Purchase, René
von Schleinitz Memorial Fund,
M1995.285
[Cat. no. 102]

the Prussian, Austro-Hungarian, and Russian empires—a "fraternity of monarchs"—were conceived as a conservative force dedicated to enforcing a politics of stability. Pillaged by years of foreign occupation and warfare, Germany entered a period of serious economic hardship that further cemented the stronghold of conservative politics.[7] Given these political and economic conditions, the idea of pan-German unity no longer evoked the kind of political mobilization that liberal intellectuals and artists had attempted to incite during Napoleon's occupation. Ultimately, the German *Kulturnation* conjured up by the Romantics failed to materialize into a *Staatsnation*.

Economic Liberalism and Repressive Vormärz[8] Politics, 1830–48

The eighteen-year period between renewed political tensions caused by the aftershocks of France's July Revolution in 1830 and the outbreak of revolutions across central Europe in

1848 can also be characterized as the economic coming-of-age of Germany's middle classes. Political attitudes did not evolve at the same rate. It is true that immediately after 1830, liberal opposition forced several major German states to adopt constitutions that limited the feudal power of their rulers, calling on Germans to "fight to shake off the shackles of internal and external power" and to struggle for "the day when a common German fatherland will arise that greets all its sons as citizens."[9] But Metternich, with the support of Prussia, soon restricted the implementation of constitutional reforms; imposed bans on political parties, public political activity, and freedom of the press; and expanded his network of spies and agents throughout the Confederation. As stringent laws and institutions were put into place to quell civil disobedience, entrepreneurial and industrial undertakings enjoyed free rein. In 1834 the new German Customs Union, guided by Prussia, abolished internal tariffs between most German states (while significantly excluding Austria) and actively fostered trade activities. The first German railway line opened between Nuremberg and Fürth in 1835, followed by another linking Leipzig and Dresden in 1837; by 1847 it was possible to travel directly by rail from Berlin to Antwerp. Even as joint-stock companies flourished, however, economic and social crises were a constant of the time, brought on by increasing mechanical industrialization, the stagnation of traditional crafts, and a series of poor harvests that aggravated the impoverishment of small farmers and peasants while leading to starvation and increasing pauperism in the expanding cities. Nonetheless, historians have characterized this period as one in which the German middle classes turned their social and political consciousness inward, retreating into the seeming safety of their capitalist successes.[10]

Fig. 18.
Karl Blechen (1798–1840),
Figure amidst the Ruins of a Gothic Abbey, ca. 1825. Pen and sepia ink and wash over graphite; 6 x 7 ⅞ in.
Milwaukee Art Museum, Purchase, René von Schleinitz Memorial Fund, M1996.50
[Cat. no. 11]

Radical calls for political unity and democratization continued to be articulated by intellectuals, poets, and students, but the most effective expression of German communal identity remained limited to the realms of culture and the arts. Romanticism's adulation of the German past became more sharply focused into a historicist, utopian vision of a past era of calm stability, community, and super-human mythical heroes that contrasted to post-Napoleonic turbulence, division, and lack of charismatic leaders. The visual arts of this period attest to an increased interest in genre and landscape imagery, frequently combined in fanciful reconstructions of the German past, particularly the medieval past [SEE FIGURE 18], to be purchased primarily by newly wealthy middle-class patrons.

Julius Schnorr von Carolsfeld's painting of the Holy Roman Emperor Frederick I Barbarossa (1122?–1190) asleep in the Kyffhäuser, a mythical cave in the Harz Mountains of eastern Thuringia—completed in the mid-1830s while the artist was working in Munich on a series of frescoes depicting German history and legend for King Ludwig I of Bavaria—is indicative of these altered attitudes [FIGURE 19]. While the earlier generation of Romantic painters had revived the German Middle Ages as a call to arms during a moment of foreign occupation, in Schnorr von Carolsfeld's painting, Germany's past functions primarily as a vehicle into the realm of subjective experience. This is not to suggest that the Middle Ages no longer signified national identity and political prowess, or to deny the presence of spiritual concerns in the Romantic enterprise, but rather to propose a shift in balance. During the 1830s Frederick Barbarossa claimed two distinct sites in the German imagination: he was exalted in contemporary historiography as an important historical agent, while popular literature celebrated him as a fabulous, mythical figure. Schnorr von Carolsfeld clearly represented his subject in the latter mode, referring to a popular legend dating back to the thirteenth century. According to this legend, Frederick Barbarossa did not drown during the Third Crusade to Asia Minor in 1190, as history recorded; instead he was put under a spell that kept him asleep in the Kyffhäuser until such time as Germany would once again need his leadership and military might. With his red beard and a flock of ravens in attendance as messengers from the world beyond his mountain, Barbarossa is here clearly associated, through an inventive amalgam of Germanic myth, with the chief of the Nordic gods ruling in Valhalla, Odin or Wotan, who displayed similar attributes. Painted at the moment when the Polish revolution of 1830 against Austrian, Prussian, and Russian imperial dominance inspired German liberal sympathizers to agitate for revolution and democracy in their own land, this depiction of an imperial protector of the German realm, asleep but prepared for battle at its eastern borders, embodied for Schnorr von Carolsfeld's Munich patrons a reassuring message of stability significantly guaranteed by royal protection.

In Schnorr von Carolsfeld's painting, Barbarossa is completely unaware of the viewer and conveys a sense of relaxation and sound sleep even as he holds his sword unsheathed in readiness. The figure thus embodies the message of social peace, calm, and quiet—defended, if necessary, with armed force—as opposed to the turmoil, unrest, and anarchy that would result from revolutionary democratic and pan-German movements. The cavernous space, directly linked to the Kyffhäuser legend, also connotes nighttime on a more symbolic level. Since its initial employment by Romantic painters and writers, the trope of nighttime rep-

Fig. 19.
Julius Veit Hans Schnorr von
Carolsfeld (1794–1872),
*The Sleep of Emperor Frederick
Barbarossa*, ca. 1835–1837.
Oil on wood panel; 18 ¾ x 14 in.
Smart Museum of Art, University
of Chicago, Purchase, the
Cochrane-Woods Collection,
1980.3
[Cat. no. 107]

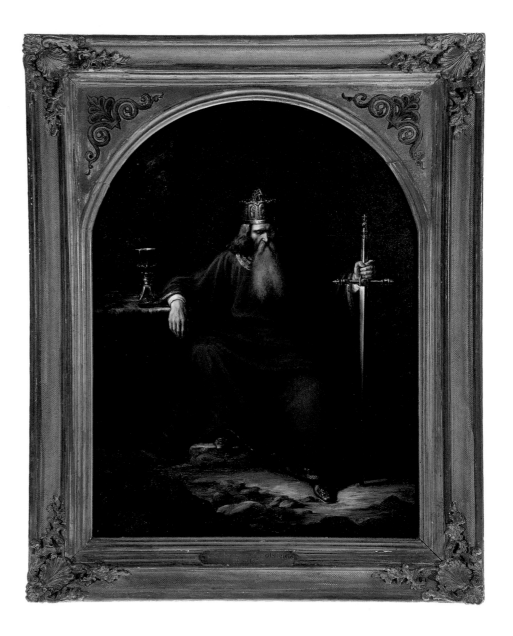

resented a desired mental state beyond graspable rational thought, namely, the mysterious, the illogical, the solanaceous poetics of the paradox.[11] Asleep and embraced by darkness, Schnorr von Carolsfeld's Barbarossa transcends his earthly existence and reaches a superior metaphysical state of mind. By identifying with Barbarossa on an emotional level, viewers were encouraged to retrace his journey, a journey that acknowledged Germany's historical past but culminated in individual subjective experience rather than political action.

Revolution and Prussia's Bid for Hegemony, 1848–71

Inspired by the success of their French counterparts who drove King Louis Philippe from power in Paris on February 24, 1848, members of the radical and moderate opposition to the German state governments united to demand political and social reform, initiating a

wave of unrest, organized protest, and armed insurrection that spread eastward from the German southwest to the frontiers of Russia.[12] As James J. Sheehan has observed, "there is no other period in German history so full of spontaneous social action and dramatic political possibilities," other than the months immediately after the end of the First World War.[13] As revolutionary movements gained in intensity throughout March, established powers were forced repeatedly to make concessions and to submit to their demands. In Vienna, Metternich—the implementer and symbol of the post-Napoleonic conservative restoration—resigned his posts and fled into exile in England. Meanwhile, in Berlin a widespread insurrection was instigated after royal troops fired into crowds of civilian demonstrators. As barricades multiplied throughout the city, King Frederick William IV was forced to issue a famous self-recriminatory proclamation addressed "To my dear Berliners!" that accepted the insurgents' key demands, notably the withdrawal of his troops from the city; then, submissively silent, he participated in a public ceremony honoring the revolutionary victims of his own army.

The newly appointed moderate and liberal "March governments" sought to profit from their apparent triumphs by quickly organizing an election for a German National Parliament to meet in the Paulskirche (the Church of St. Paul) in Frankfurt, where the Holy Roman Emperors once were crowned. Symbolically and politically, the Paulskirche Parliament set out to forge a united Germany. Questions of identity—national, religious, social, and political—as well as the formulation of a German constitution divided the liberal, moderate, and radical representatives of the Parliament; meanwhile, counter-revolutionary forces reconnoitered in the state courts and in the military, and political unrest continued to erupt in Germany's streets and countryside. Within the Parliament the debate finally focused on whether the unified German Empire would be *grossdeutsch* or *kleindeutsch*, that is, whether it would be expansive and incorporate all major German states, including Austria (but not non-German-speaking nations such as Hungary that formed part of the Austrian Empire), or alternatively whether it would contract and exclude Austria in a smaller, more restricted German Empire. After nearly a year's debate, at the end of March 1849 the Parliament adopted the *kleindeutsch* solution and offered the new imperial crown to King Frederick William IV of Prussia. The king, however, rejected the proffered crown, insisting he could only wear it if selected by his brother monarchs "by the grace of God"; in private, he expressed disdain for the parliamentary crown of "dirt and clay [that] is not really a crown at all, but actually a dog-collar, with which they want to leash me to the revolution of 1848."[14] With his answer the counter-revolution regained its strength.

Despite desperate efforts to keep the Parliament alive and to implement its German constitution after the Prussian king's refusal, "the fruits of the stalled revolution, constitution and unity, slipped away," as Thomas Nipperdey succinctly formulated the situation.[15] Major rebellions—led by radical leftist workers, craftsmen, intellectuals, and artists who called for the establishment of a democratic republic—erupted in Saxony and southwestern Germany in April and May 1849. By the beginning of June, however, Prussian troops ruthlessly crushed these final, futile revolutionary efforts, which in any case lacked significant bourgeois support. The revolution, with its call for representative German national unity, was defeated.

Although several of the failed revolution's demands had been implemented (albeit in modified and restricted form), Germany's old political orders were largely re-established, with the major difference that now the previously dormant rivalry between Prussia and Austria for dominance among the states of the German Confederation was reactivated. The fragile balance of power between Austria and Prussia began to shift in favor of Prussia. After Prussia and its northern German allies defeated Austria and its southern German allies in the Seven Weeks' War of 1866, also known as "The German War," Austria was excluded from the newly formed North German Confederation, and Prussia annexed vast sections of central Germany.

As Prussia accelerated its bid for hegemony in German political affairs, industrial development and economic modernization continued throughout Germany. The prosperity achieved by the enterprising middle classes directly affected the art market. From the 1830s onward, while grandiose treatments of historical and allegorical themes continued to attract official patronage, the market was increasingly dominated by genre scenes, landscape images, and portraiture. Through varying means, these modes granted the German burghers a mythical new identity that belied the modern drama of radical, fundamental change on which their economic success was founded. As was the case virtually everywhere in the western world where capitalism and industrialization were emerging triumphant and supplanting traditional ways of life, painters of sentimental domestic anecdotes were in particular demand and amassed unprecedented fortunes. Georg Meyer von Bremen's *Young Girl Reading* [FIGURE 20] provides an interesting insight into the popular tastes of an increasingly urban bourgeoisie during the 1850s and 1860s. Focusing on lyrical representations of children in domestic settings, this artist earned the nickname "Kindermeyer."[16] Like their counterparts across Europe, many German artists deployed a heightened naturalism to depict idealized peasants in rural settings, adding details based on local customs and regional attire to set their subjects apart both nationally and internationally. To a French or Italian viewer, for example, Meyer von Bremen's figures were recognizably German; in a German context, a peasant from the Munich region looked decisively different and engaged in decisively different agricultural practices than a peasant from the Lübeck region.

The Smart Museum's painting by Meyer von Bremen is one of a number of almost identical versions of a stock motif. While this indicates the success of Meyer von Bremen's practice, it also points to its formulaic nature. A young girl of peasant origin (to judge by her attire and the rural setting) sits in the protective interior of a family home and reads a book, perhaps a Bible. She has paused in her endeavor to look up at the viewer with a smile on her face. A sense of serenity and innocence surrounds her interaction with the onlooker, an emotional cadence further emphasized by Meyer von Bremen's use of warm colors and soft lighting, which suggest a temporary refuge from the harsh realities of everyday life for both the girl and the viewer. These subtle chiaroscuro effects, combined with a palette of muted brown and red tones, create a mood of quiet lyricism typical of Meyer von Bremen's paintings.[18] The sentimental scene, capturing both the perceived innocence of childhood and an idyllic fiction of life in the country, appealed particularly to an urban population that sought respite from the unpredictable flux and turmoil of modern city life.

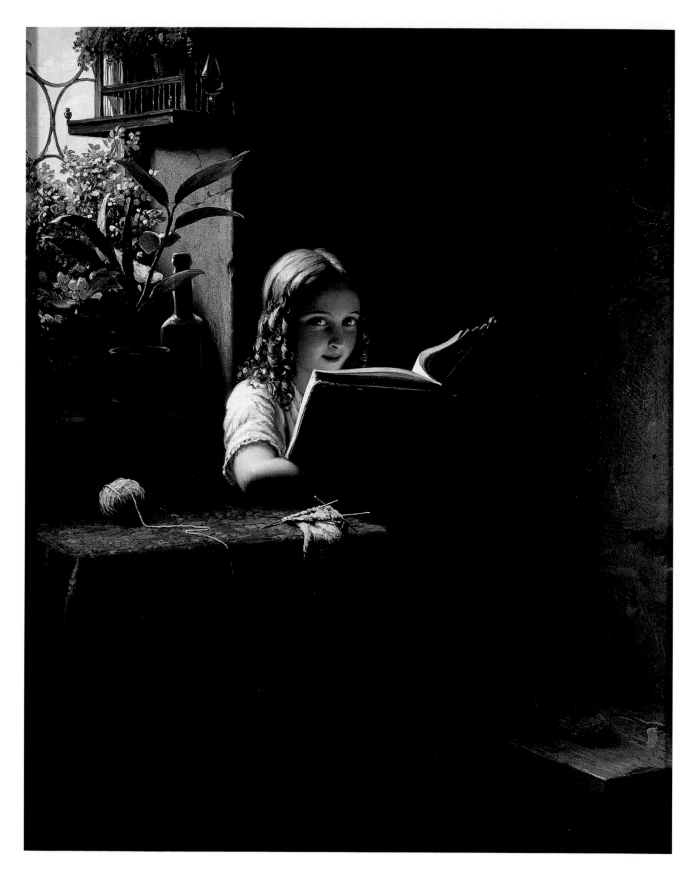

Another painter whose commercial success coincided with the middle-class retreat into the private sphere was Ernst Ferdinand Oehme. Oehme specifically targeted bourgeois audiences with paintings that made the visual modality of German Romantic painters such as Caspar David Friedrich palatable for much broader audiences. Oehme's *Nocturnal View of Meissen in Winter* [FIGURE 15], for example, exhibits many visual tropes of German Romanticism but lacks its overtly political inferences. The dark-blue evening sky dominates the composition; a lone male figure, clad in what looks like a military coat, leans against a low stone wall and gazes over the city of Meissen, which he left behind in his trek up a steep, snow-dusted path.[18] Oehme here deployed the iconic Romantic pictorial device of a *Rückenfigur* (a figure seen from behind), used repeatedly by Friedrich and Carl Gustav Carus to foster an almost physical identification of viewer and subject through which the individual can become one with nature and eternity.[19] Unlike his Romantic predecessors, however, Oehme supplied his viewers with an anecdotal reprieve from some of the existential questions that could have been raised by the solitary figure contemplating the wintry night sky. To the man's immediate left, a bay window offers a cheery view of a brightly lit room with a decorated Christmas tree. Ultimately, then, Oehme's painting functioned along the lines of Meyer von Bremen's *Young Girl Reading* in providing middle-class audiences with an idyllic vision of their mores and traditions.

Unification and the Reign of Bismarck, 1871–90

Germany's political unification in 1871 came about rather differently than liberals anticipated. In contrast to the attempts made in 1815, 1830, and 1848, the German *Staatsnation* was neither founded democratically nor born through revolution, but rather resulted from international political conflicts and extended domestic negotiations of a primarily economic nature. It was Prussian prime minister Otto von Bismarck (1815–1898) who tied the German states, excluding Austria, to Prussia through a brilliant combination of duplicitous intrigue, threats, and diplomatic maneuvering. After instigating the Franco-Prussian War, Bismarck took advantage of the general euphoria over the defeat of Germany's longstanding (i.e. since Napoleon) "archenemy" and engineered the proclamation of William I of Prussia as German Emperor at the Hall of Mirrors in the Palace of Versailles on January 18, 1871. Although Germany remained culturally diverse, its political identity under the Second Empire was inextricably fused with Prussian ambition. It was an ironic and—from the hindsight provided by twentieth-century developments—ultimately tragic conclusion to a process that began with liberal demands for freedom, emancipation, and democracy.

Prussia's political and economic primacy in relation to the other German states was not mirrored in Germany's cultural and and artistic life.[20] Despite economic fluctuations throughout the 1870s and 1880s, Germany's art market flourished. Students from all over western and eastern Europe (excluding France) as well as the Americas sought out Munich's Academy of Fine Arts. Patrons flocked to German art exhibitions, artists' studios, dealers, and art associations to purchase German art. Indeed, until the late 1880s, German artists exported more works than did the artists of any other European nation. Rather than being commissioned by the aristocracy or state institutions, these objects were purchased by the middle-class patrons who had become increasingly active throughout the nineteenth century

Fig. 20.
Johann Georg Meyer von Bremen (1813–1886),
Young Girl Reading, 1868.
Oil on canvas; 16 ½ x 13 in.
Smart Museum of Art,
University of Chicago,
University Transfer, 1967.29
[Cat. no. 70]

Fig. 21.
Heinrich Johann Zügel
(1850–1941), *The Ox Cart*,
ca. 1890. Oil on canvas;
13 ½ x 19 ⅜ in.
Smart Museum of Art,
University of Chicago, Gift of
Andre Emmerich, 1980,
1980.49
[Not in exhibition]

as their wealth grew and they recognized art as a mark of social status, education, and taste. Meyer von Bremen was one of the artists favored since mid-century for his escapist genre scenes; Heinrich Johann Zügel's *Ox Cart* [FIGURE 21] represents a new aspect of contemporary taste that emerged after the founding of the Second Empire among a class of entrepreneurs who had profited from French war reparations payments. Zügel, the son of a sheep wholesaler who had trained at Munich's prestigious academy, specialized in paintings of sheep and cattle; like other artists throughout Europe, he adopted the motifs and broadly naturalist style of the French Barbizon painters and Rosa Bonheur. *The Ox Cart* celebrates the primeval power of the monumental animals, which seem to dominate the driver struggling to control them. The entire image is rendered in muted shades of brown, as if painted with the very ground and mud of the countryside through which the oxen pull the cart.

The massive animals and the earthen palette bespeak a new ideology of the originary, related to Romanticism's adulation of nature and celebration of Germanic and Nordic pasts, but now focused on a mythos of the land as a primeval source of identity and strength [SEE ALSO FIGURE 22]. Ironically, the formulation for this monumentalized, heroicized conflation of German peasant and German nature depended on French prototypes: the paintings of Jean-François Millet and the doctrines of historian Hippolyte Taine, who maintained that geographic locality shaped its inhabitants. Even more than Zügel's *Ox*

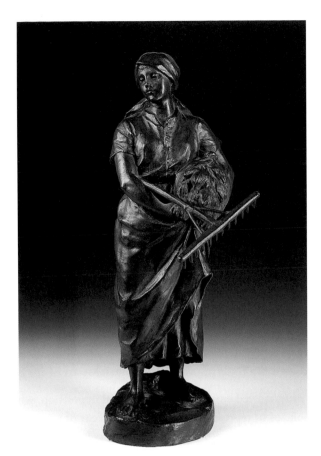

Fig. 22.
Heinz Mueller (1872–??),
Rake and Scythe, c. 1900.
Cast bronze; h. 14 13/16 in.
Smart Museum of Art,
University of Chicago,
Gift of John Stern, 1993.39
[Not in exhibition]

Fig. 23.
Hans Thoma (1839–1924),
The Sower, 1898.
Etching; 11 11/16 x 9 7/8 in.
Smart Museum of Art,
University of Chicago, Gift of
Mr. J. Patrice Marandel, 1975,
1975.45
[Not in exhibition]

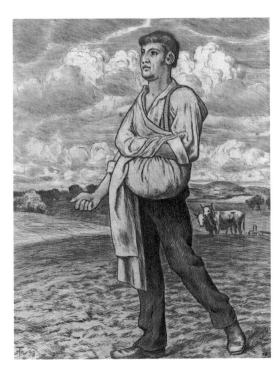

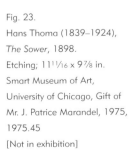

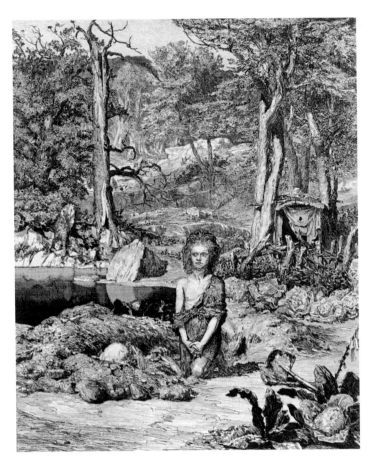

Fig. 24.
Max Klinger (1857–1920),
*Simplicius at the Grave of
the Hermit*, from *Intermezzi,
Opus IV*, 1881. Engraving
and aquatint; 11 ½ x 9 ⅛ in.
University of Chicago Library,
Special Collections Research
Center, Gift of Berthold and
Else Regensteiner
[Cat. no. 56d]

music consistently postulated in German aesthetics. In his insightful 1891 treatise *Malerei und Zeichnung (Painting and Drawing)*, Klinger described the possibilities inherent in black-and-white graphic media:

> [The artist] depicts his world and his way of looking at things, . . . his own personal observations concerning the process transpiring within him and about him, and the only thing he needs to concern himself with is to find an appropriate artistic response to the nature of his impressions and to his own capacities. . . . The comparison with piano music and poetry strongly suggests itself here. In both cases the artist is released from the strict demands of scenery and orchestra, is capable of giving free artistic rein to his ownmost joy and pains, to his most fleeting and profoundly felt emotions in a spontaneous sequence and structure dictated solely by the force and power of the former.[25]

Klinger thus rejected standard nineteenth-century views of the graphic arts as reproductive media inferior to painting or sculpture and instead announced their equality, even superiority, to other media. Independent of the demand to imitate nature, the graphic arts allowed the artist to portray his individual vision. "This manner of depiction is in itself abstract," agreed the influential critic Karl Scheffler, "because it translates all sensual representations into pictorial concepts . . . since it projects the plastic life of things into the realm of the spiritual."[26] Finally, by indicating the prototype of Albrecht Dürer as an artist who, like himself, recognized the independence and difference of the print medium, Klinger postulated a historically valid German print tradition, in effect granting the graphic arts the aura

Fig. 25.
Max Klinger, *Love, Death, and the Future*, from *Intermezzi, Opus IV*, 1881. Engraving and aquatint; 6 ⅛ x 16 ⅛ in. University of Chicago Library, Special Collections Research Center, Gift of Berthold and Else Regensteiner
[Cat. no. 56f]

of a uniquely national association. Prints and drawings addressed, so Klinger and others believed, particular needs of the German temperament.

Although Klinger occupied fantasy realms in the *Intermezzi*, he was also one of the few German artists to confront social problems within the empire, notably in its cities. Contrary to someone like Zügel, who lived in an urban environment yet chose to supply the middle-class market with escapist country scenes, Klinger directly addressed the perceived ills of modern urban life in his prints. The 1883 portfolio *Dramas, Opus IX* includes three prints of *Days in March* that track the progress of revolution from celebrations of initial triumph and looting [FIGURE 26], through battles on barricades, to final military suppression. According to Klinger, the prints do not refer to the March Revolution of 1848, despite the title and the aptness of their account, but to the potential for revolution that he recognized in his own time, as the proletarian population of German cities expanded rapidly, the promise of prosperity was undercut by the reality of economic depression, and tensions were exacerbated by Bismarck's draconian laws.[27] In other words, Klinger did not undertake a historical reconstruction of the past, but rather depicted the present and the future, in terms of subjectively experienced myth and reality.

Klinger shaped his aesthetic and his existential pessimism through the philosophy of Arthur Schopenhauer as well as the novels of Émile Zola and Gustave Flaubert, both of whom may have inspired the *Days of March* prints, especially as Klinger moved his studio from Berlin to Paris for several years in the early 1880s. But life experiences had a still more profound effect. "The need to see something real, to see life and yet to be able to disappear in the crowd," he wrote, "makes it necessary for me to seek out the large cities."[28] During his time in Paris, he began work on another portfolio, *A Love, Opus X*, which he completed in 1887 [FIGURES 27–28]. *A Love's* ten prints trace a doomed love affair between a man and a woman of the upper middle class from its beginning to its tragic end. The dedicatory page preceding the narrative honors the Swiss painter Arnold Böcklin (1827–1901), the neo-romantic painter of fanciful, subjectively interpreted mythological scenes whom critics and curators were beginning to recognize as a major representative of Germanic idealism and invention [FIGURE 27]. Klinger met Böcklin in 1887 and was

intrigued by his adaptation and recombination of tropes from classical art in order to create strange fantasy-scapes located somewhere between subjective and objective experience of the phenomenological world. Paraphrasing Böcklin's imagery, Klinger here depicted the three Fates on a rocky seashore, hovering in clouds above a similar "real" seashore. In the middle of the group, Aphrodite teaches Eros to shoot his bow and arrow. Three vultures in the background indicate the ultimately fatal result of this first amorous shooting lesson, for this arrow—so Klinger's dedication page indicates—will initiate the love affair that unfolds in the sequence of prints. Tracked by Klinger in remarkably detailed renderings, the grave collision between social convention and sexual desire plays itself out from the initial encounter between a man and woman in a park, where vulva-like roses and phallic chestnut blossoms offer a not too subtle pre-Freudian symbolic commentary, to a first meeting, first kiss, and first sexual embrace, accompanied by the song of a nightingale. At this point two allegorical or symbolic prints interrupt the story. *New Dreams of Happiness* shows the naked lovers above the landscape of the dedicatory page, afloat on clouds and a dark heavy drapery pulled by an angel. The man sees himself in a mirror held by the angel, while the woman continues to gaze only on him: the dreams of new happiness are hers, while he faces away from her and toward the reflected reality of himself alone. *Intermezzo* shifts away from the two lovers to a paradigmatic tableau of "Adam and Eve and Death and the

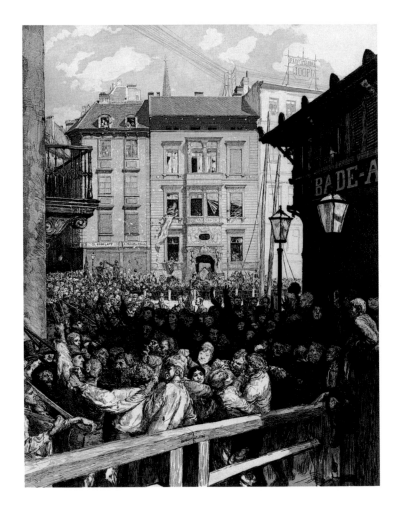

Fig. 26.
Max Klinger, *Days in March I*,
from *Dramas, Opus IX*, 1883.
Engraving and aquatint;
16 ¾ x 12 ¹⁵⁄₁₆ in.
Private Collection
[Cat. no. 55]

Fig. 27.
Max Klinger, *Dedication*, from
A Love, Opus X, 1907 (4th ed.).
Etching and engraving;
16 ½ x 12 ⅞ in.
Smart Museum of Art,
University of Chicago, Purchase,
Unrestricted Funds, 1983.49a
[Cat. no. 57a]

Fig. 28.
Max Klinger, *Scandal*, from
A Love, Opus X, 1907 (4th ed.).
Etching, engraving, and
aquatint; 16 ⁵/₁₆ x 10 ½ in.
Smart Museum of Art,
University of Chicago, Purchase,
Unrestricted Funds, 1983.49i
[Cat. no. 57e]

Devil," further inscribed in Latin "cachinnus auditur diaboli" ("Then the mocking laughter of the devil is heard"). A strangely undernourished Adam and Eve kneel, naked and imploring, on Klinger's rocky promontory before a fantastic figure personifying Death and a muscular, turbaned Devil, the latter holding a scroll aloft in apparent triumph. After this pair of allusions to the eventual fate of the lovers, in *Awakening* the woman realizes she is pregnant. In *Scandal* [FIGURE 28] she walks alone, abandoned by her lover, her pregnant figure casting a shadow on a wall, while a psychic demon, which casts no shadow and wears a torn caricature of the hat the woman wore at the beginning of the narrative, appears pointing beside her and other women gape from above, scandalized, mocking and taunting. In the final plate, *Death*, the woman's corpse lies on the ground, while Death holds her stillborn child and beckons to the man, who kneels in a last remorseful embrace with the woman he loved and abandoned. There is, in Klinger's pessimistic narration, no sentimental happy end reuniting the two lovers, no final allegory of them rising together to a paradise of eternal love. Instead, the prints offer an indictment of contemporary German morality which would deny human passions: the cold reality of hypocritical social ostracism over-comes dreams of happiness and brings about the diabolic triumph of death. Although the German Empire had triumphed in military and economic terms, Klinger suggested that it remained tied to petty and destructive mores that stifled human desires in longstanding postures of blind self-righteousness.

1. The notions of the *Kulturnation* and the *Staatsnation* have been central in German historiography from the nineteenth century to the present. For recent discussions, see John Breuilly, *The State of Germany* (London: Longman, 1992); Michael Hughes, *Nationalism and Society: Germany 1800–1945* (London: Arnold, 1988); and Harold James, *A German Identity 1770–1990*, rev. ed (London: Weidenfeld and Nicolson, 1994).

2. The historian Joseph Görres (1776–1848) and the philosopher/publicist Johann Gottlieb Fichte (1762–1814) were two key German figures to denounce French occupation and call for the mobilization of a national movement to drive out Germany's oppressor. Both men had initially embraced the French Revolution, but in light of the subsequent Terror and Napoleon's conquest of Europe, their cosmopolitanism was transformed into German patriotism. See Joseph Görres, *Gesammelte Schriften*, ed. Görres Gesellschaft (Cologne: Bachem, 1926–36); Johann Gottlieb Fichte, *Addresses to the Nation*, trans. R. F. Jones and G. H. Turnbull (Chicago/London: Open Court Publishing Company, 1922).

3. For more information on this medal, see *Kunst in Berlin 1648–1987* (Berlin: Staatliche Museen zu Berlin, 1987), 219, 224; and Michael Snodin, ed., *Karl Friedrich Schinkel: A Universal Man* (New Haven/London: Yale University Press, 1991), 106.

4. Ernst Moritz Arndt, *Catechism for the German Landwehr Man*, as cited by Thomas Nipperdey, *Germany from Napoleon to Bismarck, 1800–1866*, tr. Daniel Nolan (Princeton, N.J.: Princeton University Press, 1996), 68–69.

5. Wilhelm Heinrich Wackenroder, *Effusions from the Heart of an Art-Loving Monk*, as cited and translated by Elizabeth Gilmore Holt, ed., *A Documentary History of Art*, vol. 3, *From the Classicists to the Impressionists: Art and Architecture in the Nineteenth Century* (Garden City, N.Y.: Anchor Books/Doubleday, 1966), 68.

6. The Congress of Vienna began in 1814 but was interrupted by Napoleon's return from exile in Elba in 1815. After Napoleon's ultimate defeat at Waterloo, the diplomatic negotiations resumed.

7. During this time, the radical liberal pan-German movement was concentrated in *Turner* (gymnastic societies), German societies, and university students' *Burschenschaften* (fraternities), groups that advocated freedom, national unity, a national constitution, and a national representative system. Such organizations represented a major threat to the restored German monarchies. Metternich used the assassination of the reactionary writer August von Kotzebue by a radical student, Karl Ludwig Sand, in 1819 to promulgate the "Carlsbad Decrees" that outlawed the fraternities, excluded former members from public office, imposed severe censorship of the press, and initiated surveillance of universities. The Decrees also (and ironically, in that this contributed in some sense to further unification) established central executive powers within the Confederation to aid member states seemingly threatened by revolution.

8. This term, literally meaning "the pre-March period," describes the time period between 1815 and 1848 and has no English equivalent.

9. Philipp Siebenpfeiller, speech at the National German Festival, Hambach Castle, 1832, as cited by Nipperdey (note 4), 327.

10. See, for example, Georg Himmelheber, *Biedermeier* (Munich: Prestel, 1989); Werner Conze, ed., *Staat und Gesellschaft im deutschen Vormärz 1815–1848* (Stuttgart: E. Klett, 1978).

11. Two literary figures of this mode, closely associated with German Romanticism, were Friedrich von Hardenberg (1772–1801), better known as Novalis, and Friedrich Hölderlin (1770–1843). It also gained widespread popularity in more accessible poetry and songs.

12. While supportive of the workers' plight, German liberals were primarily interested in re-establishing freedom of the press, political representation, and the German parliament as an institution of German unity. While not necessarily insincere, their alliance with the radical cause was based more on opportunism than conviction.

13. James J. Sheehan, *German History 1770–1866*, The Oxford History of Modern Europe (Oxford: Clarendon Press, 1989), 658.

14. Frederick William IV of Prussia, letter to Ernest August of Hanover, as cited by Sheehan (note 13), 691.

15. Nipperdey (note 4), 588.

16. Rudolf M. Bisanz, *The René von Schleinitz Collection of the Milwaukee Art Center* (Milwaukee: The University of Wisconsin Press, 1980), 176.

17. Meyer von Bremen was more popular in the United States than in his native Germany. After the failed revolutions of 1848 and the return of reactionary governments, an unprecedented number of Germans emigrated to the United States. These emigrants collected paintings such as *Young Girl Reading* to nurture their nostalgic longings for the *Heimat* (homeland) they had left behind.

18. The figure's clothing can be read as *altdeutsche Tracht* (an old-German outfit) of the sort that had served as an important signifier of German identity and patriotism during Napoleon's occupation and which had been outlawed after the Congress of Vienna. Unlike Friedrich's overtly political employment of this clothing, however, Oehme's bearer of this attire (if this is indeed what he is wearing) fails to convey such strong patriotic connotations.

19. Friedrich used this figure most famously in his 1818 painting *Wanderer above the Sea of Fog* (Kunsthalle, Hamburg); Carus evoked it in his *Neun Briefen* when he wrote that "Your entire being experiences a calm and purification. Your ego vanishes, you are nothing, God is all"; cited by Roger Cardinal, "Nacht und Traum," in *Ernste Spiele: Der Geist der Romantic in der deutschen Kunst, 1790–1990* (Munich: Haus der Kunst, 1995), 540. See also Sabine Rewald, *Caspar David Friedrich: Moonwatchers* (New Haven: Yale University Press, 2002).

20. Germany's new constitution was a modified version of the constitution of the North German Confederation of 1866/67, a merger of all German states north of the Main River, with the exceptions of Saxony and Hesse-Darmstadt, under the leadership of Prussia.

21. Rainer Maria Rilke, *Worpswede: Fritz Mackeusen, Otto Modersohn, Fritz Overbeck, Hans am Ende, Heinrich Vogeler* (Bielefeld/Leipzig: Velhagen and Klasing, 1903), 13.

22. Karl Marx and Friedrich Engels, "The Communist Manifesto," in *The Marxist Reader: The Most Significant and Enduring Works of Marxism*, ed. Emile Burns (New York: Avenel Books, 1982), 26.

23. Cited by Gordon A. Craig, *Germany 1866–1945* (New York: Oxford University Press, 1978), 146.

24. Heinrich von Treitschke, *Ein Wort über unser Judentum* (Berlin, 1881), as cited and translated by Ruth Gay, *The Jews of Germany: A Historical Portrait* (New Haven/London: Yale University Press, 1992), 218.

25. Max Klinger, *Malerei und Zeichnung* (Leipzig: Insel, 1891), as translated in *Art in Theory 1815–1900: An Anthology of Changing Ideas*, ed. and comp. Charles Harrison and Paul Wood with Jason Gaiger (Oxford/Malden: Blackwell, 1998), 1054.

26. Karl Scheffler, "Max Klinger," in *Deutsche Maler und Zeichner im neunzehnten Jahrhundert* (Leipzig: Insel, 1911), 69.

27. Max Klinger, *Briefe aus den Jahren 1874–1919*, ed. Hans W. Singer (Leipzig: Seemann, 1924), 208.

28. Klinger, *Briefe* (note 27), 41–42.

Caspar David Friedrich

1774–1840

Woman with Raven at the Abyss, 1803

Wood engraving; 6 ¾ x 4 ¹¹⁄₁₆ in.

Milwaukee Art Museum, Purchase, René von Schleinitz

Memorial Fund, M2001.54

[Cat. no. 23]

On October 7, 1801, Caspar David Friedrich drew an image of a woman holding open the lid of a large, simple chest in one of his sketchbooks. The female figure—standing, turned to face the viewer, one arm stretched across her torso—reappears in this wood engraving, poised at the edge of an abyss in a barren mountain landscape. Friedrich's brother Christian executed the print after the drawing. First exhibited in March 1804 as one of a group of three wood engravings, the print transforms what was initiated as a simple genre scene into an allegorical composition. Employing a process that would become characteristic of his mature work, Friedrich shifted a closely observed aspect of the experienced visual world into an emblematic, psychologically charged image of symbolic fantasy. Friedrich thereby fulfilled one of his own central dicta: "Close your bodily eye so as to first observe your image with your spiritual eye; then bring to light what you saw in the dark, so that it then can impact others, acting from the exterior onto the interior."

A major Dresden-based contributor to German Romanticism in painting and literature, Friedrich was born in 1774 in the town of Greifswald, located in a North German region then ruled by Sweden. The artist maintained a certain allegiance to Sweden, although close friends, such as the painter Carl Gustav Carus, recalled him as being otherwise "German through and through." Swedish flags appear regularly in Friedrich's paintings, and in 1824 he named his son Gustav Adolf in honor of Sweden's heroic king Gustavus Adolphus (1594–1632), the leader of Protestant forces during the Thirty Years' War. Gustavus Aldophus's intervention in the war ensured the survival of Protantism in Germany at a time when

Fig. 29.

Catholic Habsburg forces appeared on the verge of triumph, and it is surely this accomplishment that Friedrich, a fervent Protestant, revered deeply. It can be argued that these multiple, intermingled allegiances—to Germany (at a time when it was not a nation-state), to Sweden, and to Protestantism—define Friedrich's sense of identity and, by extension, point toward complex issues in German identities considered more broadly.

An interaction between apparent clarity and fundamental ambiguity characterizes the print *Woman with Raven at the Abyss*. The woman's serious, even distraught, facial expression;

windblown hair; and position at the edge of a rocky void offer a ready picture of someone contemplating suicide. Moreover, the image abounds with emblems of death. Among the barren mountain peaks, only a few scraggly, isolated fir trees cling precariously to life; most of the trees here have died already, their dark leafless branches scratching into the chalky white sky or reaching into the emptiness of the abyss. Ravens, popular emblems of death, open their beaks to caw out their malignant message, while a small snake slithering in the grass is an apt memento of the Serpent who tempted Adam and Eve and, through their sin, introduced death to humanity.

The print's emphatic threnodic pronouncement is undercut, however, if we submit it to more nuanced observation. Rather than preparing to jump into the chasm, the woman appears to be turning away from it, turning from its emptiness toward the living presence and witness of the viewer. Although her right hand still grasps the uncertain support of a lifeless tree branch (its dangerous unreliability increased by the fact that the slithering snake seems to be its only anchor), her left hand releases the branch and begins to reach out, again toward the viewer, whose implicit presence offers rescue and continued life. As she swivels, she will put the barren mountain peaks behind her, and face the grass, ivy, and blossoming flowers—emblems of cyclical growth—that cover the right foreground area. And if the lone pine tree behind her can be perceived as an extension of, or even stand-in for, her human presence, as is frequent in Friedrich's work, the young branches crowning a series of withered, broken ones bespeak a triumph over death, the overcoming of illness or personal tragedy and continued existence in a hopeful future.

Woman with Raven at the Abyss thus presents antithetical meanings, resolving them in an internal visual and associative synthesis, one that illuminates a view of the ambiguities and contradictions in German identity.
—*Reinhold Heller*

Nepomuk Strixner

(after Jan von Melem, Dutch, 16th century)
1782–1855
Portrait of a Man, 1837
Mezzotint and stipple engraving; 16 ⅞ x 10 ⅝ in.
Smart Museum of Art, University of Chicago, University Transfer from Max Epstein Archive, 1976.145.389
[Cat. no. 110]

Born in Altötting in 1782, Strixner began his artistic career in 1797, when he went to study with Herman Josef Mitterer at the polytechnical school in Munich at age seventeen. During his

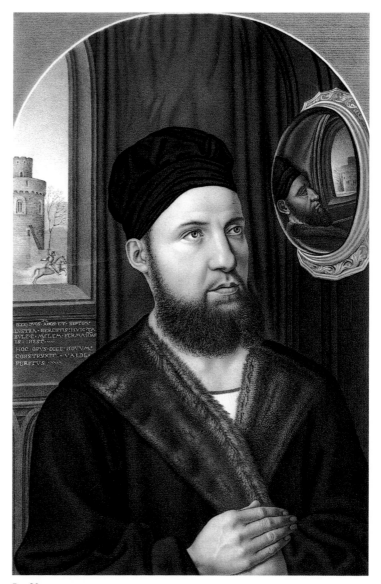

Fig. 30.

first year in Munich, Strixner gained employment as a draftsman in the gallery of Elector Maximilian Joseph, and received a brief instruction in copper engraving from Johann Jakob Dorner the Elder, who was then in charge of the electorial gallery's *Kopierstudien*. After he had gained this experience in copying paintings, Strixner was hired by Johann Christian von Mannlich, director of all Bavarian art galleries, cabinets, and art institutes, to engrave twenty of Mannlich's drawings made after Raphael. These engravings were published in 1804 under the title *Zeichnungsbuch für Zöglinge der Kunst und für Liebhaber, aus Rafaels Werken gezogen* (Book of Drawings for Students of Art and Connoisseurs, derived from Raphael's works). In 1808 Strixner supplied a set of lithographic copies of the ink drawings by Dürer that appear in the margins of Emperor Maximilian's 1515 prayer book for a facsimile reproduction of the volume. This facsimile, considered the first publication of Dürer drawings, can be said to have ushered in the medieval artist's subsequent popularity in Germany throughout the nineteenth century. It also marks an important early example of the medium of lithography, invented by Alois Senefelder in Solnhofen, Germany, just nine years earlier.

The Raphael and Dürer publications established Strixner's reputation as an engraver and lithographer of Old Master paintings, and he participated in a number of large-scale projects, such as the reproduction of the most important paintings in the royal painting galleries in Munich and Schleissheim. In 1820 Strixner accepted an invitation from the Boisserée brothers of Stuttgart, who were avid collectors of German medieval and Renaissance art, to lithograph their immense collection of paintings. After 1827, when the Bavarian King Ludwig I bought the Boisserée collection and amalgamated it with the Old Pinakothek, Strixner returned to Munich and for several years dedicated himself to the monumental *Pinakothek in München*, published by Germany's famous Cotta Verlag.

This *Portrait of a Man* dates from 1837, within the period of Strixner's association with the Pinakothek, and it serves as an important example of Strixner's superior technical abilities. As the engraving clearly shows, Strixner was able to capture the form and pictorial character of the original paintings he reproduced, without turning the engraving into a lifeless copy of the painting. In this portrait, the viewer gains a sense of the sitter's personality and status. Strixner grasped and conveyed important visual aspects of the Old Masters he reproduced—such as the all-important naturalism of Northern Renaissance paintings, evidenced here in the lifelike fur collar of the sitter and in his detailed beard—with such skill that the engraving has artistic merit in its own right. With this singular and highly specialized proficiency, Strixner played an important role in the gradual aesthetic emancipation of engraving and lithography in the first part of the nineteenth century.

Despite Strixner's important contributions to reproductive engraving and lithography and his continued output throughout the 1830s, he spent the final years of his life almost forgotten and died completely impoverished in 1855. Strixner had responded to an institutional need to have private and public collections inventoried in reproductive media, but surrendered his dominance of this arena, first to a younger generation of German engravers and lithographers who supplied a growing private art market, and finally to those who practiced these techniques as fully independent, fine-art media.—*Sabine Wieber*

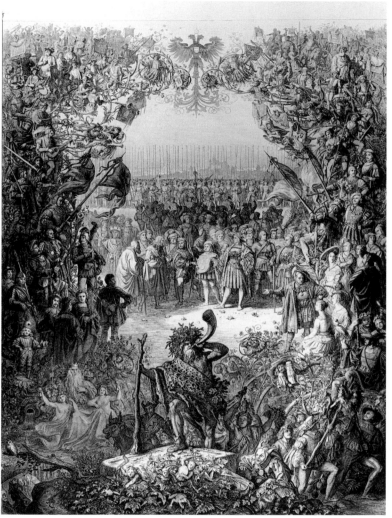

Fig. 31.

Eugen Napoleon Neureuther

1806–1862

Memorial Print in Remembrance of the Munich Artists'
Masked Procession, 1841–1843

Steel engraving; 21 ⅝ x 16 ½ in.

Milwaukee Art Museum, Purchase, René von Schleinitz
Memorial Fund, M1996.256

[Cat. no. 80]

As the son of painter and printmaker Ludwig
Neureuther and older brother of architect
Gottfried Neureuther, Eugen Napoleon
Neureuther came of a prominent Munich artist
family. Today he is primarily known as a painter
and book illustrator, but he was also involved in
the decorative arts and proficient as a mural

painter, embellishing several of his brother's
buildings. He received his initial training from
his father and subsequently studied under Peter
von Cornelius, with whom he decorated the
Glyptothek in Munich, and with famed Munich
landscape painter Wilhelm Kobell. During the
1830s, Neureuther became entangled in revolu-
tionary politics and moved to Paris in support of
the July Revolution. After various trips to Rome
between 1836 and 1838, Neureuther returned to
Munich and, in 1848, became the director of the
Nymphenburg porcelain factory; from 1868 to
1878, he taught mural painting at the Munich
applied arts school.

Neureuther's most famous book illustrations
are the forty-six lithographs he made for
Goethe's *Ballads and Romances,* published by
Cotta in five volumes between 1829 and 1839.
Goethe himself was so taken by these illustra-
tions that he publicly compared them to Dürer's
marginal drawings in Emperor Maximilian's
prayer book of 1515. When Neureuther made
this etching for the Albrecht Dürer-Verein of
Munich in 1841–43, he was a well-established
artist with firm ties to Germany's most influen-
tial art associations, or *Kunstvereine.* Such asso-
ciations were middle-class institutions that
emerged in Germany throughout the 1820s and
1830s, serving as venues for its educated mem-
bers to converse about literary as well as artistic
matters, while supporting local artists through
regular exhibitions. In many ways, these associ-
ations were important precursers to the private
art market during a time when state-sponsored
academic Salons represented the only other
exhibition venues for artists. With the critical
and historical rediscovery of Albrecht Dürer in
the first half of the nineteenth century, associa-
tions dedicated to the celebrated medieval artist
came to see themselves as patriotic organiza-
tions engaged in the conscious revival of a
specifically German national past.

In accord with standard practice of the day,
the Albrecht Dürer-Verein commissioned
Neureuther's print as a year-end present for its

members. Often these annual editions were reproductions of an oil painting that had been purchased by the association for that year's annual raffle, but here Neureuther constructed an elaborate composition of his own that relates to the association's namesake. Dozens of highly detailed figures—many of them portraits, others imaginary and mythological creatures, all of them embedded in teeming flora and fauna— form a living frame that offers a kind of synopsis of German emergence from primitive Druidic tribes to the late medieval civilization of Dürer's time. At the center is a stately gathering of sixteenth-century soldiers and burghers. Dürer, a tall, bare-headed figure facing to the left, bows forward slightly to receive from the legendary Holy Roman Emperor Maximilian I the coat of arms of Art, three empty shields on a blank shield, held aloft by a young page. The great artist's public recognition marks a pinnacle of German cultural achievement, coinciding with the dynastic unity attained under Maximilian, an ideal symbolized by the coat of arms of the Holy Roman Empire of the German Nation that presides at the top of the image.

Combining sheer fantasy and historical reconstruction, and rendered with a precision that both charms and unsettles, Neureuther's image has more in common with the graphic production of Max Klinger, still fifty years in the future, than it does with the work of his own academic contemporaries. Yet this highly subjective, idiosyncratic rendition of Germany's artistic past is firmly of its own time and place. Neureuther, who played several roles in Munich's active cultural community, here responded to the twin currents of Realism and Romanticism that were transforming the art world before his eyes.—*Sabine Wieber*

Fig. 32.

Adolph Menzel
1815–1905
An Elderly Man in a Military Topcoat, 1881
Graphite; 7 7/8 x 4 15/16 in.
Courtesy of the Fogg Art Museum, Harvard University Art Museums, Bequest of Meta and Paul J. Sachs, 1965.0347
[Cat. no. 69]

This sitter, seen from below—Adolph Menzel, one of the major realist artists of the nineteenth century, was less than four-and-a-half feet tall and would necessarily have to look up at the man towering before him—seems to bend down to fit onto the page, his upper torso and lowered head cut off by the left-hand edge. The figure

thus achieves a sense of monumentality as it crowds against the limits of the paper, barely contained and ready to spill beyond the edges, except that to the right a section of blank space seems to open the composition, offering room to maneuver and transforming cramped containment into potential movement. What could have been a static, lifeless representation instead embodies a pent-up tension and energy. The man is a muscular force, with difficulty contained by the straining military topcoat and the confining sheet of paper.

It has been suggested that the man portrayed in this remarkable fashion is Otto von Bismarck, the "Iron Chancellor" of Prussia who instigated the unification of Germany by means of the Franco-Prussian War in 1871 and who served as chancellor of the new German empire until 1890. Menzel painted a larger-than-life-sized portrait of Bismarck in 1871 (Neues Palais, Potsdam-Sansouci) as part of the festive decorations of the Berlin Academy of the Arts on the occasion of the return of the victorious Prussian troops to Berlin. In 1885 the artist visited Bismarck's estate in Kissingen with the intention of making studies for a painting or series of paintings devoted to the legendary chancellor, but the project was never realized, and Menzel later laconically remarked that he never saw Bismarck once during his time there. On other occasions too he characterized his contacts with Bismarck as limited to "incidental handshakes when he happened upon me in the crush of a court reception." Predating the projected Kissingen sittings, this drawing, with its informality of pose, would seem consistent with these passing interactions in Berlin. Moreover, given the massiveness and strength of the man depicted, it is tempting to identify him as the powerful historic politician credited with creating the empire, seen uncharacteristically in a temporary moment of contemplation. Certainly the mustache, receding hairline, bushy eyebrows, and jowled cheeks—features of Bismarck's visible in other portraits and photo-

graphs—all support this identification. Other features, notably the nose and ear, do not match those of Bismarck as closely, however, and the radical foreshortening introduced by Menzel's erratic viewpoint also makes an absolute identification difficult. Other sketches of the Berlin court milieu by Menzel feature officers sharing many of Bismarck's features, imitating especially the style of his famed mustache, and this drawing may represent one of these now-forgotten court personages rather than the noted Iron Chancellor.

Menzel, a keen and close observer, recorded his surroundings and acquaintances in thousands of drawings. He would then tack these pictorial fragments together into painted compositions, much like a montage or as if fitting pieces of a puzzle together, in the apt description of the Menzel scholar Françoise Forster-Hahn. "All *drawing* is useful, and drawing *everything* likewise," Menzel once pronounced, a pithy formulation that characterizes his inclusive realism. This 1881 drawing of the elderly military man—especially if he is *not* Bismarck—attests to the artist's gargantuan visual appetite, which encompassed historical themes from the life of Prussia's great eighteenth-century monarch, Frederick II, as well as mundane objects such as bookcases or bicycle seats. They all share Menzel's focused gaze and eccentric, unexpected perspective. Indeed this example subordinates the portrait likeness to the mass of the coat, which pushes forward and virtually fills the field of vision, so that the head seems an almost incidental continuance, a suggestively shaped mass of wrinkles and curving surfaces echoes the forms of the more expressive coat and collar. The dichotomy between expectation and Menzel's eccentric perspective is never resolved.
—*Reinhold Heller*

Fig. 33.
Hanns Fechner (1860–1931),
Portrait of Agnes Samson, 1896.
Pastel and brushed pastel, over
charcoal underdrawing, on artist's
board, mounted on canvas;
49¼ x 40¾ in. Smart Museum
of Art, University of Chicago,
Gift of Mr. W. R. Magnus, 1983.116
[Cat. no. 18]

Portraits of Social Transformation

Modernizing Identities in Late Wilhelmine Germany

CELKA STRAUGHN

Late Wilhelmine Germany is frequently described as a period overwhelmed by political, economic, social, and cultural crises, conflicts, and uncertainties. The reign of Emperor William II (1888–1918), punctuated at the beginning by a profound economic depression and at the end by a devastating world war, also embraced two decades of relative economic prosperity and the gradual consolidation of a still-young nation. Berlin, named the capital of Germany in 1871, evolved into a dynamic metropolis, embodying the nation's tensions and transformations. The capital's rapid industrial expansion and swelling population, with an increasingly influential bourgeoisie and extensive working class, appeared to artists and writers as a site of both vital intensity and anarchic rootlessness.[1]

In his famous essay, "The Metropolis and Mental Life" (1903), the German sociologist and cultural critic Georg Simmel examined the individual's struggle to exist independently amidst the overwhelming variety of impressions and stimuli present in the modern urban context. Simmel identified art, particularly portraiture, as a respite from the chaos of city life—the equivalent of a place where the scattered and hopeless individual can feel truly at home. His 1905 essay, "Aesthetics of the Portrait," argues that the portrait achieves a unity between body and soul because it interprets a person's external characteristics through internal qualities. According to Simmel the artistic composition of a portrait gathers together numerous particulars, both physical features and psychic impressions, to reveal the significance of appearance (*der Sinn einer Erscheinung*) and to portray inner character.[2]

Simmel's analysis draws on basic principles of portraiture as defined in western art.[3] The evocation of a sitter's inward identity gained greater emphasis with the emergence of photography, which was perceived to depict a more exacting external appearance. Developing new artistic means to portray an inner spirituality and unity amidst modern life's sense of disintegration became an increasing concern at the turn of the twentieth century, particularly for modern artists associated with Expressionism. Portraiture, along with landscape and the nude, served as a primary genre for vanguard experimentation, manifesting a freedom from convention, both aesthetic and social.[4] This essay will examine transformations in the styles and functions of portraiture in late Wilhelmine Germany, and the corresponding reconfiguration of modern German identities.

Hanns Fechner's 1896 *Portrait of Agnes Samson* [FIGURE 33] reveals some of the tensions between tradition and modernity that affected turn-of-the-century Berlin, particularly among the bourgeoisie. Agnes Samson (ca. 1860–1920), married to a private banker, was a

Berlin socialite and lavish hostess whose industrialist family had contributed to the new capital's metropolitan transformation.[5] The choice of Fechner—known for his portraits of royalty, statesmen, and cultural personages, as well as of elegant society women—affiliated Samson with Germany's elite, an indication of shifting social hierarchies.[6] In accordance with academic conventions for portraiture, Samson occupies the center of the picture, her posture upright, balanced, and gracefully decorous. Yet Fechner lent the pose a certain modernity and informality, so that Samson conveys self-confidence rather than stiff, solid bourgeois propriety; her head tilts slightly toward the viewer, and one gloved arm is placed lightly on the chair while the other, bare, rests in her lap. Fechner worked in pastel, with a quick, bravura technique similar to that of Lovis Corinth and recalling such successful portraitists as Giovanni Boldini and John Singer Sargent. Delicately balancing shades of white and gray with golden and pinkish hues, Fechner created a harmonious pictorial unity and an image of understated opulence. His careful rendering of the elegant silk gown, with its details of fur and lace, attests not only to Samson's material wealth, but also to Fechner's own artistic mastery. As a representation of stylish urban modernity, the portrait of Agnes Samson captures the upper class—and the art of painting—in the process of reconfiguration.

While Fechner's portrait is rooted in the established tradition of grand manner portraiture, his use of pastels, with their capacity to present a sense of rapid execution, relates to modernist experiments by artists such as Edgar Degas. By the 1890s in Germany the technique had been adopted by artists working in an Impressionist mode, like Max Liebermann and Max Slevogt. It was also employed, however, by young but more academic realists such as Fechner, who enjoyed the medium's aura of fluidity and modernity (but likewise the recollection of eighteenth-century pastel portraits) without succumbing to modernist, anti-realist practice. Fechner's technique thus bespeaks modernity, even a highly modified Impressionism, but rejects its radicality and overt anti-traditionalism. As already noted, he compares readily to Boldini and Sargent, both cosmopolitan artists with certain avant-garde connections who achieved considerable fame at the turn of the century for their portraits of beautiful society women. Fechner elongated the figure of Samson to dominate the canvas and accentuated her radiant form against the darkened background, but he stopped short of the dynamic, flamboyant effects that Sargent and Boldini achieved with their sketchier brushwork and asymmetrical or cropped compositions. Fechner's *Portrait of Agnes Samson*, a relatively progressive exercise in a highly traditional genre, points toward the significant shifts that even pronounced conservative artists underwent around 1900.

Although Fechner's technique suggests an openness toward experimentation, his own writings and contemporary reviews of his work aligned him with academic traditions, particularly Prussian ones.[7] The conservative art critic Paul Warnke praised Fechner's portraits for combining a sitter's individuality with high artistry to create a true impression.[8] Warnke further lauded Fechner as one of the few Berlin artists whose work retained Prussian qualities. "The old Prussian city had become a young German city," he wrote, "her entire character had gained a new direction, she began to develop into a world city in an unprecedented fashion." Moreover, according to Warnke, a "great German art" should retain specifically Prussian characteristics of "modesty, honor, and solidity united with iron diligence," which would survive the contemporary atmosphere of upheaval.[9] Implicit in

Warnke's appeal for a great German art is his rejection of international artistic developments such as Impressionism, the French style that had gained increasing success and acceptance in Germany (and elsewhere) during the 1890s. The notion that Impressionism, and also Realism, were foreign influences that hampered the growth of a patriotic "German" art was espoused not only by critics and artists like Warnke and Fechner, but also by William II, whose conservative taste and strong personal influence on the Berlin art world affected the policies of museums, commissions, and state-sponsored exhibitions.

This political polarization of "German" academic art and "foreign" modern art contributed to the formation and early reception of the Berlin Secession (1898–1934), an organization that directly challenged the imperial influence on art through its exhibition policies and through the work shown. Many of the artists associated with the Secession practiced a form of Impressionism; Liebermann (president of the Secession from 1898 to 1910) and Corinth are two artists whose experimental techniques were adopted by artists like Fechner despite their opposing views on Impressionism. One of the Secession's aims was to introduce foreign artistic directions—not just French Impressionism, but also Post-Impressionist tendencies such as those found in the works of Vincent van Gogh—but it was not founded solely as a rejection of academic art. Just as importantly, the Berlin Secession also sought to provide the capital's first major alternative to the state-supported exhibitions of the Royal Academy of Arts and the Verein Berliner Künstler (Association of Berlin Artists). These official exhibitions, which featured massive numbers of works hung on overcrowded walls, had received criticism from all artistic directions in the Berlin art world. Fechner, a regular contributor to such exhibitions, published a report in 1895 proposing various reforms, which included not only limitations on the number of foreign works, but also changes to jury procedures and suggestions for suitably designed and properly lit exhibition spaces.[10] Financial concerns were paramount, for academic exhibitions formed "the trading floor for the art market," as Fechner sarcastically stated in the introduction to his report.[11] For many Berlin artists, these huge annual displays provided the main opportunity to show their work and to attract purchasers or commissions. Fechner seems to have achieved recognition as a portrait painter through this means, showing compositions similar to the *Portrait of Agnes Samson* in several such exhibitions. [12] The Berlin Secession, displaying fewer works under better conditions, offered greater visibility and increased opportunities for sales. Moreover, the well-connected dealers Paul and Bruno Cassirer served as early secretaries of the association, affiliating it more closely to Berlin's emerging private art market, supported primarily by the expanding bourgeoisie rather than imperial or state agencies.[13]

The success of the Berlin Secession encouraged the formation of other alternative exhibition groups, as well as a growing network of dealers and galleries from whom these groups sought support. Several of these organizations—most famously Herwarth Walden's Sturm gallery (1912–32) in Berlin, which was closely tied to his journal *Der Sturm* (1910–32)—fostered and promoted new artistic directions, including Expressionism.[14] The term Expressionism emerged around 1910 as a unifying but multifaceted concept used to distinguish new art, particularly German, from Impressionism, and also to define a *Weltanschauung* (worldview) that embraced notions of renewal, inner unity, *Pathos* (a combination of inner suffering and spiritual fervor), and a universal *Geist* (spirit, intellect).[15] These

ideas formed the basis for a range of artistic approaches, most fully represented in the art of Brücke (Bridge) (1905–13), founded in Dresden, and the Munich-based Blaue Reiter (Blue Rider) (1911–14). These groups gained a significant presence through exhibitions at Der Sturm and also with the Neue Secession (1910–14), an association similar in conception to the Berlin Secession but organized in opposition to it, which presented some of the earliest exhibitions of Expressionism in Berlin.[16]

Max Pechstein, a member of Brücke, had already achieved a degree of recognition with the Berlin Secession when he became a co-founder and first chairman of the Neue Secession in 1910. *Head of a Girl* [FIGURE 34] portrays the painter Charlotte ("Lotte") Kaprolat, Pechstein's first wife (they were married from 1911 until 1921) and frequent model.[17] Wives and companions frequently served as models for Brücke artists, who often rendered them as generalized female types rather than as individualized portraits.[18] It is difficult to say if Kaprolat forms or conforms to what was characterized as the "Pechsteinish standard woman," which the artist seems to have formulated around 1910. Described in a 1922 biography as "amply wide, round and fleshy," these female figures present "an embodiment of innate and instinctual life."[19] Pechstein himself later wrote in his auto-biography that around the time of his marriage to Kaprolat he had "the great joy of having someone around me in full naturalness all the time, whose movements I could absorb. Thus I was enabled to continue my aim of comprehending humanity and nature as one, intensely and intimately."[20]

In its attempt to achieve a unity between humanity and nature through the portrayal of a female type, *Head of a Girl* strikingly transforms some aspects of academic portraiture while at the same time retaining other elements associated with the genre. Although Kaprolat is positioned slightly to the left, she still occupies most of the compositional space and appears in a conventional bust-length pose with her head turned to reveal a three-quarter profile. Dark outlines, carefully applied brush strokes, and contrasting tonalities construct a sense of three-dimensional corporeality. However, Pechstein flattened the background through bold areas of primary colors. These colorful areas, seemingly roughly applied with uncontained brush strokes, and the visible patches of unprimed canvas around the upper edges defy the polish and unified finish of traditional academic practice. Thickly applied reds and blacks further emphasize the figure's exoticized appearance, with her blue-black hair, stylized dark crescent eyes, and full red lips. A contemporary reviewer described works similar to *Head of a Girl* as "brutal up to the extremes, a wild, raw style of a fun-fair booth, exotic, colorful, provocative (to the point of inspiring assassinations), but neverthe-less, in the rhythm and color of the [painting], despite all their clumsiness, there flashes forth from them something of the racial litheness and grace of savage tribes."[21] This refer-ence to a "fun-fair booth" has a double-edged implication: it criticizes Pechstein's images for lacking the professionalism of fine art, yet also links them positively with forms of pop-ular entertainment, as a type of "people's art."

Popular urban entertainment, particularly the cabaret and the circus, provided subject matter and models for the artists of Brücke, whose core members, in addition to Pechstein, included Ernst Ludwig Kirchner, Karl Schmidt-Rottluff [SEE FIGURE 48], Erich Heckel [SEE FIGURE 46], Otto Mueller, and briefly Emil Nolde, whose *Tingel-Tangel II* [FIGURE 63]

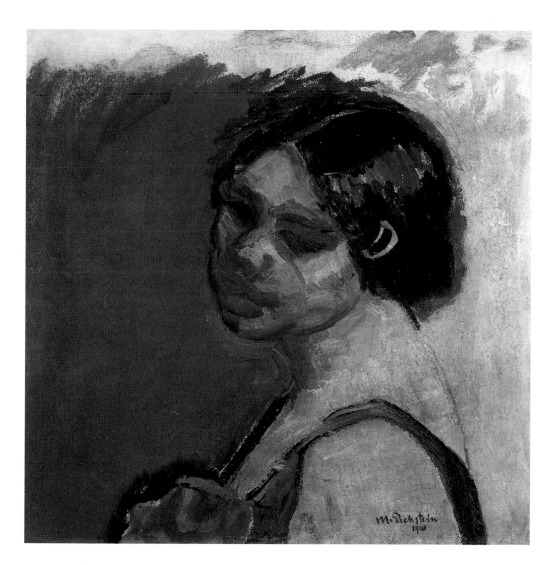

Fig. 34.
Max Pechstein (1881–1955),
Head of a Girl, 1910.
Oil on canvas; 20½ x 20 in.
Smart Museum of Art,
University of Chicago, Gift of
Mr. and Mrs. Joseph Randall
Shapiro, 1992.19
[Cat. no. 87]

depicts a music-hall scene. Brücke artists found additional sources in exhibitions of "primitive" peoples at fairs and circuses and of "primitive" art (African, Polynesian, Indian) in ethnographic collections. Such entertainments and exhibitions, in addition to offering content that challenged bourgeois notions of civility, suggested alternative formal approaches.[22] Drawing on non-western images and techniques, representating dance subjects, taking rural retreats—the Brücke artists sought to regenerate life through art and vice versa. The resulting images express vitality and immediacy by means of bright colors, energetic brush strokes, and alternative perspectives that construct new relationships between figures and space. Ultimately, this turn to the "primitive," to a more instinctual and fundamental art, was an attempt to turn forcefully away from imperial hierarchies, conventional bourgeois values, and a rationalized approach to psychic wholeness.

As part of this attempt to reintegrate art and life, several Brücke members decorated their Dresden studios with batiks and carved wooden sculptures that they created by referring imaginatively to "primitive" sources, constructing an "artificial world . . . for explorations

of art and sensual celebration."[23] Kirchner's pastel *Dodo in the Studio* [FIGURE 35] depicts Doris ("Dodo") Grosse, the artist's companion at the time and frequent model, against the background of his studio decorations. Kirchner often portrayed Dodo nude in an open expression of sensuality, but in this intimate drawing she is fully clothed and urbane, in contrast to the "primitive" nudes of the carved sculpture and the wall hanging, a juxtaposition that challenges the repression of sensuality by Wilhelmine social norms. The refined interplay between Dodo and the studio decorations mediates "the contradictions between *körperliche* [corporeal] and *geistige* [spiritual, intellectual] existence."[24] Dodo adopts a pose of serious thought, her concentrated gaze directed outside her immediate surroundings, yet through careful balancing of forms and color Kirchner subtly connected her to the nude figures. The curve of Dodo's brow and nose echo the triangular breasts of the sculpture, and her headband not only shares the same orange color of the nudes, but merges her head with that of the sculpture. Works like Kirchner's *Dodo in the Studio* and Pechstein's *Head of a Girl* portray—through different means—a primitivized, exoticized, and sexualized femininity, representing women as mediators between "primitive" nature and the modern city.[25]

The artist, too, could be such a mediator, and self-portraits constitute a significant part of many Expressionist artists' oeuvres. Emil Nolde's *Self-Portrait with Pipe* [FIGURE 36] dates from his brief period of activity with Brücke (1906–07), during which he gained increased recognition and success in Berlin by exhibiting with the Berlin Secession and at

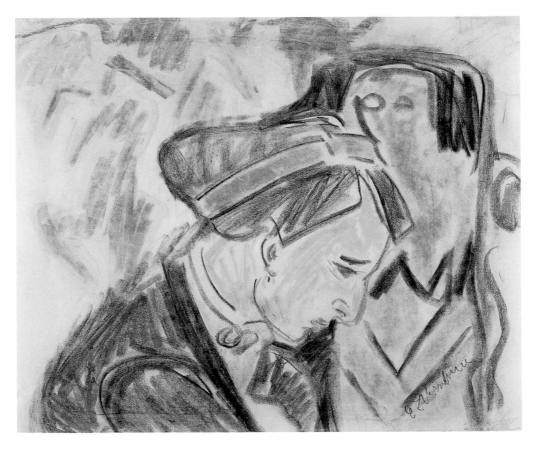

Fig. 35.
Ernst Ludwig Kirchner
(1880–1938), *Dodo in the Studio*, 1910.
Pastel, charcoal, and crayon;
19 x 22 ¾ in. Lent by the estate of Mrs. Edna Freehling, 4.2000
[Cat. no. 50]

Fig. 36.
Emil Nolde (1867–1956),
Self-Portrait with Pipe, 1907.
Transfer lithograph;
15 ¾ x 11 ¼ in.
Lent by Joseph P. Shure
[Cat. no. 82]

Paul Cassirer's gallery. Around 1905 Nolde had begun to experiment with various print media, primarily etching and woodcut, which offered him new means for technical and formal innovation as well as opportunities to make his work better known through reproduction. His association with the Brücke artists increased his interest, and he wrote to his friend Hans Fehr in late 1906 that "We all cultivate—even I—graphic media with much interest and search for new material to achieve new heights and make new additions to already available techniques."[26]

Of the graphic media, lithography most closely resembles drawing and can produce the most painterly effects. Nolde, Kirchner, and Heckel all produced their first lithographs in 1907, most likely prompted by Schmidt-Rottluff's 1906 lithographic portfolio (which included a self-portrait).[27] For *Self-Portrait with Pipe*, Nolde first produced a preparatory ink drawing, an intermediate step that was unusual for him, although he often carried a theme or motif across media.[28] In his lithographs from this period, Nolde employed the technique of transfer lithography, which allows the artist to draw or paint freely with a greasy crayon, tusche, or other material on specially prepared paper. Here the result is painterly rather than linear, boldly revealing the wetness and movement of the brush and expressing a sense of creative freedom.[29] Nolde's face, largely obscured by dark areas of

ink, reveals its shape and volume through the contrast with the white background. The brimmed hat and elongated pipe, accoutrements suggestive of bourgeois leisure, convey an air of detached ease, an effect further emphasized by their partially indicated, open forms. One of Nolde's most successful lithographs, particularly in terms of its stark contrasts between light and dark, this self-portrait exists in several variant impressions, some with broad strokes of watercolor added to the face and background.

Schmidt-Rottluff likewise experimented with different media and formal questions in a watercolor self-portrait of 1913 [FIGURE 37]. Similar to Nolde, he began with strong simple lines for the contours of his face and neck, here drawn in graphite. He also played with the relationship between support and mark, but instead of contrasting dark ink with white paper, he selected a brown paper and exploited its coloration as a tonal base for the yellows, oranges, reds, and blues that model and highlight his facial features. The seemingly hastily applied bright colors and vigorously drawn black lines and squiggles produce an effect of vibrant immediacy. Schmidt-Rottluff's concentrated gaze, with his eyes accented by the transparent lenses of his glasses, communicates a seriousness and directness, while his flat cap (*Schiebermutze*) suggests a working-class association, unlike Nolde's brimmed hat.

Fig. 37.
Karl Schmidt-Rottluff
(1884–1976),
Self-Portrait, 1913.
Watercolor and graphite on
brown paper; 16 ¾ x 13 in.
Courtesy of the Busch-Reisinger
Museum, Harvard University
Art Museums, Gift of Mr. and
Mrs. Lyonel Feininger,
BR54.0119
[Cat. no. 105]

Schmidt-Rottluff's self-portrait provides a physical likeness, yet transgresses traditional physiognomic renderings in its use of arbitrary color to explore the effects and relations of different emotions and traits. Two earlier self-portraits show the artist experimenting in different directions, adopting Post-Impressionist techniques and related modes of self-expression. In a 1906 oil (Nolde-Museum, Stiftung Seebüll Ada und Emil Nolde, Neukirchen, Germany), Schmidt-Rottluff employed thick, wavy strokes of paint reminiscent of van Gogh, clearly aligning himself with the expressive intensity of the acclaimed artist. In *Self-Portrait with a Monocle* of 1910 (Neue Nationalgalerie, Berlin), he set himself against a stage-like background and flattened the space with thick black outlines and bright patches of color in a depiction of bohemian theatricality. These canvases, and the watercolor seen here, show Schmidt-Rottluff using his most readily available model—himself—to explore different techniques, an exercise that allowed him to reveal different aspects of his identity.

Ludwig Meidner, a contemporary of the Brücke artists, also created numerous works devoted equally to emotional self-exploration and artistic experimentation. *Interior (The Artist's Bedroom)* [FIGURE 38], one of his earliest known paintings, can also be considered one of his earliest self-portraits. Rather than a literal depiction of his features, the painting subjectively represents the artist through an intimate portrayal of his physical space and his psychological relation to it.[30] To underscore his intent, Meidner deliberately cited two similar compositions, well known in Berlin at the time, Adolph Menzel's *The Artist's Bedroom in Ritterstrasse* (1847) [FIGURE 39] and van Gogh's *The Bedroom* (1889; The Art Institute of Chicago).[31] This clear referencing allowed Meidner, then just beginning his career, to locate himself within parallel artistic lineages: an "older," established German tradition and a "younger," progressive, international direction.

Menzel, a pre-eminent figure of nineteenth-century German art, had recently been celebrated by an extensive retrospective exhibition at the National Gallery in Berlin following his death in 1905; the Ritterstrasse bedroom scene was included in the retrospective, and the National Gallery took the opportunity to acquire it. The work was again shown in the *Ausstellung deutscher Kunst aus der Zeit von 1775–1875* (Exhibition of German Art from the Period 1775–1875), a showcase for art of the unified German nation, held at the National Gallery. Whereas Menzel was acknowledged to be a highly talented and distinguished German artist, van Gogh's reputation was still under construction. His works first appeared in Germany at the spring exhibition of the Berlin Secession in 1901, and then with increasing frequency in Berlin and other German cities. Expressionists in Germany perceived the Dutch artist's overt and stylized emphasis on subjectivity, in theme but also in the manner of painting, which drew attention to itself and the artist, as a precedent for their own innovations. One of the versions of *The Bedroom* was displayed in several of these exhibitions and appeared at Galerie Paul Cassirer's eighth exhibition, held in March 1908, where Meidner may have viewed it.[32]

Meidner not only borrowed from van Gogh's composition, but he also employed similar thick, heavy brush strokes to convey a sense of anguished and vibrant energy. The quotation of van Gogh also identifies Meidner with the much-mythologized prototype of the struggling modern artist and his unstable existence.[33] In other ways, however, Meidner's painting engages in a complex dialogue with Menzel's image. Like Menzel's scene, Meidner's

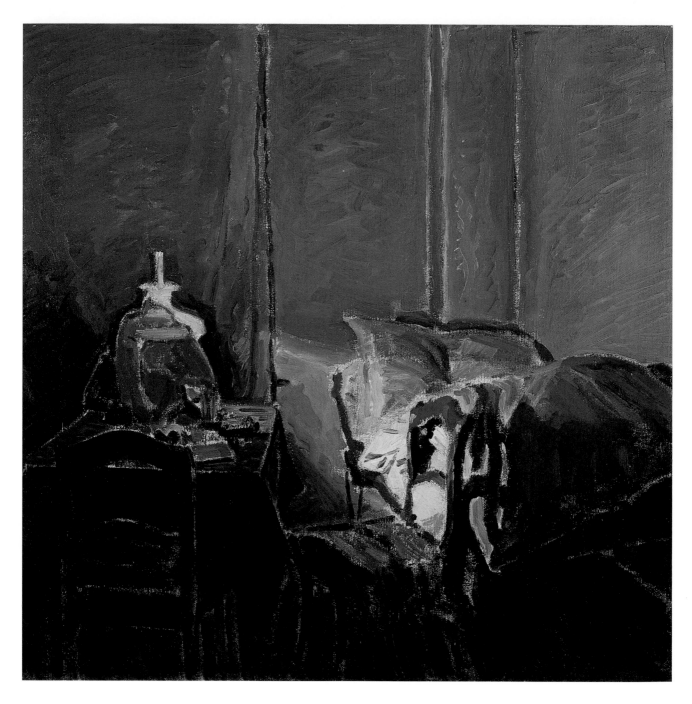

Fig. 38.
Ludwig Meidner (1884–1966),
Interior (The Artist's Bedroom), 1909.
Oil on canvas; 23 ⅝ x 23 ⅝ in.
Smart Museum of Art, University of
Chicago, Gift of Ruth Mayer Durchslag,
from the Robert B. Mayer Collection,
1991.405
[Cat. no. 68]

Fig. 39.
Adolph Menzel (1815–1905),
*The Artist's Bedroom in
Ritterstrasse*, 1874. Oil on
canvas; 22 x 18 ¼ in. Alte
Nationalgalerie, Preußischer
Kulturbesitz, Berlin
[Not in exhibition]

bedroom is disorderly, with objects strewn on the table and the duvet a crumpled mass at the bottom of the bed, suggestive of an intimate presence.[34] Instead of van Gogh's bright primary colors, Meidner's palette evokes Menzel's, particularly the darkened red walls that define a central area of brightness.

Both Menzel and van Gogh extended the space in their compositions—the former through a glimpse of the city beyond the window; the latter through exaggerated linear perspective—but Meidner's interior appears cramped, with the overlapping furniture filling the lower half of the canvas. This crowding creates a more dynamic relation between the few objects and the space they occupy, enhanced by the luminous color and agitated brushwork, and suggesting an intensified, close-up view of Meidner's own ecstatic state of being. With its distinction between the dark, disorderly bedroom and the bright, sunlit world outside, Menzel's *Bedroom* has been interpreted as exemplary of a Romantic "venue for 'disturbing strangeness,' for dreams and for anxiety."[35] Meidner's twentieth-century variation intensifies this linking of physical and psychological interiority. A small, cloth-covered gas lamp emits an acid glow onto the white of the bed, replacing natural light and casting the scene as a nocturnal vision. Night, in the German Romantic tradition, represents the domain of dreams, of unconscious, transcendental revelation and poetic musings, offering access to more profound meditations and visionary intensity.[36] In his writings Meidner frequently described his nocturnal working habits, drawing on Romantic associations and exaggerating the character of the artist as a suffering, isolated seer.[37]

Meidner's painting offers a transformed portrayal of the respite from chaos and sense of "home" that Simmel ascribed to art. Meidner and other Expressionist artists can be seen as incorporating some of the stimulating aspects of external life, combined with more passionate internal qualities, to achieve a renewed inner unity. However, the upheavals

and uncertainties that characterize modern identity in transition resonate not only in such overtly modern portraits, but also in more traditional, academic examples like Fechner's *Portrait of Agnes Samson*. By both affirming and challenging traditional portraiture, the late Wilhelmine images discussed here exemplify varying artistic attempts to achieve worldly and spiritual unity, aesthetic efforts that took on broader significance in the struggle to negotiate changing social structures and transforming identities.

1. On Wilhelmine Germany, particularly art and culture, see Volker R. Berghahn, *Imperial Germany, 1870–1914: Economy, Society, Culture and Politics* (Providence: Berghahn Books, 1996); Françoise Forster-Hahn, ed., *Imagining Modern German Culture: 1889–1910* (Washington, D.C.: National Gallery of Art, 1996); Charles Haxthausen and Heidrun Suhr, eds., *Berlin: Culture and Metropolis* (Minneapolis: University of Minnesota Press, 1990); Robin Lenman, *Artists and Society in Germany 1850–1914* (Manchester: Manchester University Press, 1997); and Nicolaas Teeuwisse, *Vom Salon zur Secession. Berliner Kunstleben zwischen Tradition und Aufbruch zur Moderne 1871–1900* (Berlin: Deutscher Verlag für Kunstwissenschaft, 1986). For a more overall view of this period, see Eric Hobsbawm, *The Age of Empire 1875–1914* (New York: Vintage Books, 1989).

2. Georg Simmel, "Die wahre Einheit," in *Ästhetik des Porträts* (1905); reprinted in part and discussed in Rudolf Preimesberger, Hannah Baader, and Nicola Suthor, eds., *Porträt* (Frankfurt: Reimer, 1999), 416–24. Georg Simmel, "Das Problem des Porträts," in *Die neue Rundschau* 29 (October 1918): 1336–44. Simmel's ideas provide the basis for Margaret Jarislowsky, "Das 'individuelle Gesetz' in seiner Anwendung auf die Kunst des Porträts," Ph.D. diss. (Berlin: Friedrich-Wilhelms-Universität, 1926).

3. Linda Nochlin, "Impressionist Portraits and the Construction of Modern Identity," in Colin Bailey, ed., *Renoir's Portraits: Impressions of an Age* (New Haven: Yale University Press, 1997), 66.

4. Gary Reynolds, *Giovanni Boldini and Society Portraiture 1880–1920* (New York: Gray Art Gallery at New York University, 1984), 14.

5. Smart Museum files.

6. Hanns Fechner (né Johannes Fechner) was the son of the Berlin painter and photographer Wilhelm Fechner. Fechner studied at the Royal Academy of Arts in Berlin and also in Munich with the painter Franz von Defregger. In 1887 the Academy awarded him the Michael Beer Rome Prize. His early works included anecdotal genre scenes, but portraiture soon formed his main focus. He remained active in Berlin, frequently exhibiting at Academy exhibitions, until an eye disease blinded him in 1914. No longer able to paint, Fechner retired to the country in Silesia and turned to writing. See Hannah Fechner, ed., *Hanns Fechners Lebensabend* (Berlin: Rembrandt, 1932).

7. For Fechner's views on German art and Impressionism, see for example Hanns Fechner, *Kommende Kunst??* [sic] (Halle: Buchhandlung des Waisenhauses, 1915); and his essays in Hanns Fechner, ed., *Bekenntnisse Deutscher Künstler* (Leipzig: Kurt Vieweg, 1920).

8. Paul Warnke, "Hanns Fechner," *Zeitschrift für bildende Kunst*, n.s. 12, 5 (1901): 97–98.

9. Warnke (note 8), 102.

10. See transcript of a lecture given on November 29, 1895, Hanns Fechner, *Ein Beitrag zur Kunst-Ausstellungs-Frage* (Berlin: Rudolf Mosse, 1895).

11. Fechner, *Beitrag* (note 10), 3.

12. The same year as the Samson portrait was painted, Fechner won the "II Medaille" (second-place medal) at the 1896 Münchener

Jahres Ausstellung (Annual Munich Exhibition) at the Glaspalast for a *Portrait of a Woman* very similar in composition to that of Samson. Fechner frequently contributed portraits to the Grosse Berliner Kunst-Ausstellung (Great Berlin Art Exhibition) between 1893 and 1910; a *Portrait of a Woman* exhibited in 1903 also closely resembles the Samson portrait.

13. For accounts of the Berlin Secession, see Peter Paret, *The Berlin Secession: Modernism and Its Enemies in Imperial Germany* (Cambridge, Mass.: The Belknap Press of Harvard University Press, 1980); and Werner Doede, *Die Berliner Secession. Berlin als Zentrum der deutschen Kunst von der Jahrhundertwende bis zum ersten Weltkrieg* (Berlin: Propyläen, 1977).

14. For one of the most recent of the many accounts and analyses of Der Sturm, both the journal and gallery, see Barbara Alms and Wiebke Steinmetz, eds., *Der Sturm im Berlin der zehner Jahre* (Bremen: Städtische Galerie Delmenhorst, 2000).

15. For general discussions of Expressionism, see Shulamith Behr, *Expressionism* (Cambridge: Cambridge University Press, 1999); Stephanie Barron and Wolf-Dieter Dube, eds., *German Expressionism: Art and Society* (New York: Rizzoli, 1997); and Annie Pérez, ed., *Figures du Moderne: L'Expressionnisme en Allemagne 1905–1914—Dresde, Munich, Berlin* (Paris: Musée d'Art Moderne de la Ville de Paris, 1992). On the term Expressionism, see Ron Mannheim, "Expressionismus—zur Enstehung eines kunsthistorischen Stil- und Periodbegriffes," in Tayfun Belgin, ed., *Von der Brücke zum Blauen Reiter. Farbe, Form und Ausdruck in der deutschen Kunst von 1905 bis 1914* (Heidelberg: Edition Braus, 1996); Marit Werenskiold, *The Concept of Expressionism: Origins and Metamorphoses* (Oslo: Universitets Forlaget, 1984); and Donald Gordon, "Origin of the Word 'Expressionism,'" *Journal of the Warburg and Courtauld Institutes* 29 (1966): 368–85.

16. Artists later associated with the Blaue Reiter and members of Brücke also exhibited earlier in Berlin with the Berlin Secession, but only in the winter graphics exhibitions. For a full accounting and analysis of the Neue Secession, see Anke Daemgen, "The 'Neue Secession' in Berlin 1910–1914. An Artist's Association in the Rise of Expressionism," Ph.D. diss. (London: Courtauld Institute of Art, 2002).

17. The identification of Charlotte Kaprolat as the model has only recently been made by scholars; see David Morgan, "Empathy and the Experience of 'Otherness' in Max Pechstein's Depictions of Women: The Expressionist Search for Immediacy," *The Smart Museum of Art Bulletin 1992–1993* 4 (1993): 13. Kaprolat is identified as a painter in Hermann Gerlinger and Herwig Guratzsch, eds., *Frauen in Kunst und Leben der "Brücke"* (Schleswig: Stiftung Schleswig-Holsteinische Landesmuseum, 2000), 251. Kaprolat also served as the model for Georg Kolbe's *Dancer* (1912; Neue Nationalgalerie, Berlin), a sculpture that quickly made him famous. See *Prestel Museumsführer, Neue Nationalgalerie Berlin* (Munich: Prestel, 1998), 17; thanks to Roland März and Anke Daemgen at the Nationalgalerie for providing me with this information. Other than a mention by Reinhold Heller that Kaprolat was just eighteen at the time of her marriage to Pechstein, none of the literature consulted provides any additional information about her; see Reinhold Heller, *Brücke: German Expressionist Prints from the Granvil and Marcia Specks Collection* (Evanston, Ill.: Mary and Leigh Block Gallery, Northwestern University, 1988), 210.

18. Heinz Speilmann, "Gefährtinnen in Leben und Kunst—Frauengestalten aus dem Kreis der 'Brücke,'" in Gerlinger and Guratzsch (note 17), 18.

19. Max Osborn, *Max Pechstein* (Berlin: Propyläen, 1922), 172, 170.

20. Max Pechstein, *Errinerungen*, ed. Leopold Reidemeister (Wiesbaden: Limes, 1960), 50, as cited in Morgan (note 17), 17–18 n. 22. Translation from Heller, *Brücke* (note 17), 210.

21. Erich Vogeler in *Der Kunstwart und Kulturwart* 23, 23 (September 1910): 314; Quoted and partially translated in Daemgen (note 16), 199. Vogeler's comments specifically refer to Pechstein's painting *Pause* (1909), which depicts two female dancers. According to Daemgen (189 n. 40), *Pause (Rest/Break)* may be the painting now known as *Dance (Tanz)* at the Brücke Museum, Berlin (on permanent loan from a private collection).

22. For an analysis of Brücke's engagement with primitivism, see Jill Lloyd, *German Expressionism: Primitivism and Modernity* (New Haven: Yale University Press, 1991).

23. Bessie Tina Yarborough, "*Fingerspielende Dodo*," in Heller, *Brücke* (note 17), 128.

24. Bettina Gockel, "Vom Geschlecht zum Geist: Körpererfahrungen und -konzeptionen im Werk Kirchners," in Birgit Dalbajewa and Ulrich Bischoff, eds., *Die Brücke in Dresden 1905–1911* (Cologne: Verlag der Buchhandlung Walther König, 2001), 305.

25. Lloyd (note 22), 39.

26. Emil Nolde to Hans Fehr, November 29, 1906, cited in Andreas Fluck, " '. . . Jenseits von Zwist und Lärm': Emil Nolde und Edvard Munch," in Magdalena M. Moeller and Manfred Reuther, eds., *Emil Nolde Druckgraphik* (Munich: Hirmer, 1999), 64. On Expressionism and printmaking, see Ida Katherine Rigby, "The Revival of Printmaking in Germany," in Stephanie Barron et al., *German Expressionist Prints and Drawings* (Los Angeles: Los Angeles County Museum of Art, 1989), 39–65; and Heller, *Brücke* (note 17).

27. Magdalena M. Moeller, "Zu Noldes Druckgraphik" in Moeller and Reuther (note 26), 19. Schmidt-Rottluff produced another lithographic self-portrait in 1907, *Man with Pipe (Self-Portrait)*. Self-portraits with pipes are frequent among the Brücke artists in the prewar period and appear in a variety of media, including paintings.

28. Victor Carlson, "Kopf mit Pfeife E.N. [Selbstbildnis]," entry in Clifford S. Ackley, Timothy O. Benson, and Victor Carlson, *Nolde: The Painter's Prints* (Boston: The Museum of Fine Arts, 1995), 154–55, cat. nos. 32–33b.

29. For a more detailed discussion of transfer lithography and Nolde's lithographs in general, see Victor Carlson, "The Lithographs," in Ackley et al. (note 28), 47–56.

30. For a more detailed discussion of this painting as a self-portrait, particularly in relation to the German artistic tradition of *Zimmermalerei* (room painting), see Stephanie D'Alessandro, "Testament and Providence: Ludwig Meidner's *Interior* of 1909," *The Smart Museum of Art Bulletin 1992–1993* 4 (1993): 2–11. On Meidner's early self-portraits, including the influence of van Gogh, see Claudia Marquart, "Die frühen Selbstbildnisse 1905–1925," in Gerda Breuer and Ines Wagemann, eds., *Ludwig Meidner: Zeichner, Maler, Literat 1884–1966* (Stuttgart: Gerd Hatje, 1991), 28–39; and Reinhold Heller, *Art in Germany, 1906–1936: From Expressionism to Resistance. The Marvin and Janet Fishman Collection*, exh. cat. (Milwaukee: Milwaukee Art Museum, 1990), 202–03, 210–14.

31. Van Gogh produced three versions of his bedroom at Arles, beginning in September 1888 with the example now in the Van Gogh Museum, Amsterdam. In 1889 he painted two additional versions based on the first: one is in the Musée d'Orsay, Paris, and the other in The Art Institute of Chicago.

32. Five paintings of van Gogh's were shown at the Berlin Secession's third exhibition in the spring of 1901; see Walter Feilchenfeldt, *Vincent van Gogh and Paul Cassirer, Berlin: The Reception of van Gogh in Germany from 1901 to 1914*, Cahier Vincent Series, no. 7 (Zwolle: Uitgeverij Waanders, 1988), 144. On van Gogh and his reception in Germany, see Feilchenfeldt; and Museum Folkwang Essen and Van Gogh Museum, Amsterdam, *Vincent Van Gogh and the Modern Movement, 1890–1914*, exh. cat. ed. Inge Bodesohn-Vogell (Freren: Luca, 1990).

33. Marquart (note 30), 33.

34. See Claude Keisch, "*The Artist's Bedroom in Ritterstrasse*," in Claude Keisch and Marie Ursula Riemann-Reyher, *Adolph Menzel 1815–1905: Between Romanticism and Impressionism* (New Haven: Yale University Press, 1996), 210–11.

35. Keisch (note 34), 210. Van Gogh also represented interior night scenes, exemplified by *The Night Café* (1888; Yale University Art Gallery, New Haven), painted about a month before his first bedroom depiction. Meidner's nocturnal interior can also be seen in contrast to the Impressionist emphasis on daylight and painting out of doors.

36. Roger Cardinal, "Night and Dreams," in Keith Hartley et al., eds., *The Romantic Spirit in German Art 1790–1990* (London: Thames and Hudson, 1994), 191–95.

37. Heller, *Art in Germany* (note 30), 213.

Gabriele Münter

1877–1962

Fall Landscape, Study (Yellow Trees), 1908
Oil on paperboard; 13 x 17 ⅛ in. (sight)
Private Collection
[Cat. no. 77]

Yellow Still Life, 1909
Oil on paperboard; 16 ½ x 13 in.
Milwaukee Art Museum, Gift of Mrs. Harry Lynde Bradley,
M1975.156
[Cat. no. 76]

The Blue Gable, 1911
Oil on canvas; 34 ¹⁵⁄₁₆ x 39 ⅝ in.
Krannert Art Museum and Kinkead Pavilion, University of
Illinois, Urbana-Champaign, Gift of Albert L. Arenberg,
1956.13.1
[Cat. no. 75]

Together with her companion, Wassily Kandinsky, Gabriele Münter first visited Murnau—a small market town in the foothills of the Bavarian Alps, just a half hour's train ride from Munich—in 1908. It marked a decisive turn in both artists' work. In the ensuing years, they returned repeatedly to the town, where Münter bought a summer house in 1909, and the landscape as well as the folk art they encountered contributed to the formation of a radical new painting

vocabulary for them both. While artistic influences ranging from Impressionism and *art nouveau* to Henri Matisse and Fauvism can be traced in their work, it was the experience of Murnau that shaped their mature artistic identities. "After a brief time of experimentation," Münter recalled in 1911, "I took a major leap there—from painting after nature, more or less impressionistically, to the feeling of a content to abstracting to the presentation of an extract."

Her expressionistic landscape renditions are precisely such "extracts," based on the radical simplification and reduction of forms, abstracted from the experience of the landscape. The topographic and atmospheric conditions of Murnau particularly lent themselves to such a process. Located on an extended terrace stretched between Lake Staffel and the Murnau moors, the southern horizon is marked by the abrupt, dramatic rise of a spectacular ring of massive, tree-lined Alps. As Kandinsky scholar Peg Weiss sensitively observed, "The pure air and the glowing light typical of the subalpine climate seemed to compress the perspective so that the hills and mountains appeared to spread out over an indeterminate distance as if on a small, crystalline plain." The landscape itself is, in effect, pictorial in a modernist sense, in that the atmosphere and light subdue the overpowering grandeur of the Alps and cause them to appear as relatively flat, monochromatic forms arranged around the table-top plane of the moors. The moors do not appear in Münter's *Fall Landscape*, but the foreground vista of a hayfield dotted by small piles of hay serves as a near compositional equivalent, against which or from which the dramatic blue and blue-violet massifs of the Alps emerge suddenly as broad, flat, darkly outlined shapes. The result is a fascinating and playful interaction between the hieroglyph of perspective offered by the merging diagonals that mark the edges of the field—the one side punctuated by a row of lollipop-like birch trees reminiscent of a child's drawing in their rendition—and the curving planes signifying the individual mountain peaks.

Fig. 40. *Fall Landscape, Study (Yellow Trees)*

Fig. 41. *Yellow Still Life*

characterizations. Clearly he wished to reject any negative connotations of weakness or lack of virility that might have been suggested by the idea of a "feminine" art. It would also seem—judging from the context within this fragmentary, unpublished essay—that he had in mind a certain mellifluous ease, a lack of the overtly ambitious construction that he saw among her male colleagues. *Yellow Still Life* might well serve to embody such a perception. Its few objects are distributed almost haphazardly, yet the arrangement achieves a sense of quiet balance. Kandinsky would have identified the painting's effect of modest simplicity as feminine, achieved through bold chromatic reductivity in an almost totally yellow field, which Münter subdivided only with freely drawn black lines and a few starkly but softly injected tones of red, blue, and white. Because Kandinsky felt, based on the intimacy of some ten years of life together with Münter, that he could read her identity as a woman through the very appearance and construction of her images, he gave her art his highest critical and artistic valuation as visualizations of her "pure inner drive."

Kandinsky, writing about Münter in 1913, observed: "Here we can not emphasize enough that the elemental, inner-oriented—let us say it right away: the truly German talent of Gabriele Münter may not at any time be labeled as a manly or even 'almost manly' talent. Her talent—and we emphasize this repeatedly with pleasure—is from its very beginnings and solely to be recognized as purely and solely feminine [*weibliche*]." He went on to assure us that this is not due to either "feminine" motifs or "feminine" subject matter, but rather that her artworks derive solely from a "pure inner drive [*rein innerem Trieb*]," in short, that they are shaped by the duality of her national and gender identity. Kandinsky never fully explained what he meant by these provocative

Kandinsky, a native of Russia, equated the second component of Münter's artistic identity with her Germanness. Here too, he offered only a few explanatory hints, characterizing her talent as "elemental [*urwüchsige*]" and "inner-oriented [*innerliche*]," but it may be possible to extrapolate what he meant. *The Blue Gable* (the title seems not to be Münter's own)—with its highly reduced, perhaps even "elementary" forms of houses, walls, fences, a path, a massive snow-covered pile of straw, and a tree—bespeaks a kind of originary vision, as Kandinsky would have perceived it. Münter derived her technique of simplifying the outlines of objects into primary shapes, just descriptive enough to provide the necessary visual hints for identification (a tree would consist of a straight trunk from which branches fork out in zigzagging repetition, for example) from Bavarian folk art and,

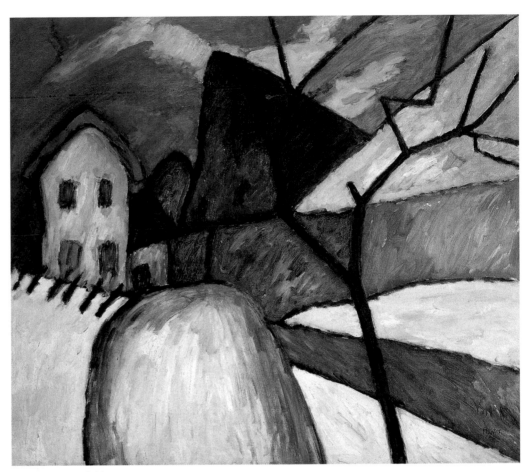

Fig. 42. *The Blue Gable*

even more, the drawings of children that likewise employ such a hieroglyphic picture language. Münter, so Kandinsky concluded, had resurrected an innocent vision and primal imagery that could be immediately, even subconsciously recognized by a viewer without recourse to what he saw as the decadent, destructive practices of illusionistic painting. She augmented this mode of instinctive communication through her use of color, which in her paintings acts less as a descriptive device than as an empathetic evocation, a means of dreamily emotive stimulation. Here, for instance, the saturated blue of the large central gable is placed in proximity to the intense, contrasting yellow glow of another house nearby, so that the two enter into a chromatic conversation, generating a pictorial harmony that totally transforms the surrounding snow's muted whites and then culminates in the unbounded arc of the clouds' pink-yellow excitation amid the winter-blue of the sky.

Kandinsky's characterization of Münter rests most heavily on his perceptions of what is feminine and what is German. Therein he recognized the values of her art, which he felt conveyed the fundamentals of her identity. If we, using his criteria, can read these qualities in her images as well, it is perhaps useful to take Kandinsky's observations a bit further. Through Münter, he postulated a German identity that he saw as inextricably fused with the feminine, with sensitivity and inward orientation. It is a remarkable conclusion that deserves further examination.
—*Reinhold Heller*

Wassily Kandinsky

1866–1944

a. *Two Riders in front of Red*, 1911
Color woodcut; 4 ¹/₁₆ x 6 ⅛ in.
Lent by the estate of Mrs. Edna Freehling, 2.2000
[Cat. no. 43]

b. *Oriental Scene*, 1911
Color woodcut; 4 ⅞ x 7 ½ in.
The estate of Mrs. Edna Freehling, 1.2000
[Not in exhibition]

c. *Great Resurrection*, 1911
Color woodcut; 8 ⅝ x 8 ⁹/₁₆ in.
Lent by the estate of Mrs. Edna Freehling, 3.2000
[Cat. no. 41]

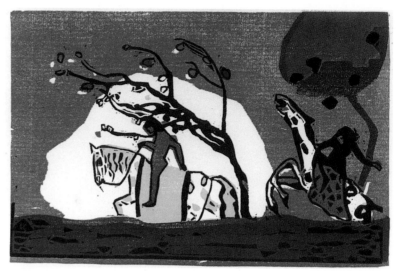

Fig. 43. *Two Riders in front of Red*

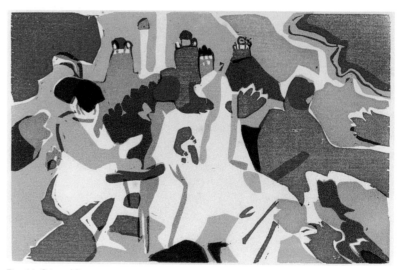

Fig. 44. *Oriental Scene*

Active in the German art world since moving from his native Russia to Munich in 1896, Wassily Kandinsky gained significant recognition following his first two publications with the Piper Verlag, *Über das Geistige in der Kunst* (*On the Spiritual in Art*), which appeared in December 1911, with an imprint of 1912; and *Der Blaue Reiter [Almanac]* (*The Blue Rider [Almanac]*), co-edited with Franz Marc, in the spring of 1912. These two publications, along with the first and second "Exhibitions of the Editors of *Der Blaue Rieter*," held in Munich in December 1911 and February 1912, just before the publication of the *Almanac*, established Kandinsky as a leading theorist and practitioner of new directions in art, soon identified with the concept of Expressionism. While the first exhibition featured works by artists associated with the forthcoming publication, such as Kandinsky, Marc, and Gabriele Münter, the second presented works by a wide range of artists, including some of the Brücke artists such as Max Pechstein and Ernst Ludwig Kirchner, and consisted exclusively of graphic media.

Although Kandinsky was not as committed to the woodcut as were some of the Brücke artists, he was prolific in the medium between 1902 and 1904, publishing a portfolio of woodcuts in 1904 entitled *Gedichte ohne Worte* (*Poems without Words*). Hand-colored woodcuts appear in deluxe editions of the *Almanac*, and black-and-white examples decorate sections of *On the Spiritual in Art*. Kandinsky's third publication with Piper, *Klänge* (*Harmonies* or *Sounds*) (late 1912, with a 1913 imprint), represents the apex of his production in the medium. The volume features fifty-five woodcuts—twelve printed in color—in conjunction with thirty-eight specially composed poems. *Two Riders in front of Red* and *Great Resurrection* frame the collection: *Two Riders* serves as the introduction, recalling the opening images of riders in the *Almanac*; and *Great Resurrection*, the last full-page image, follows the poem "Lenz" (Springtime). *Oriental Scene* is placed between sections of the poem "Glocke" (Bell). Fewer than

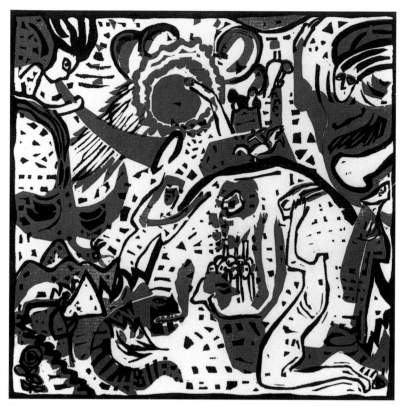

Fig. 15. *Great Resurrection*

frequently employed musical terms and analogies to discuss visual artistic processes, for example comparing the separate sounds in a verbal text to the colors and lines in a visual work. Woodcuts served this purpose well, for the technique often entails a simplification of design and reveals the artist's process. Together with the poems, the woodcuts in *Klänge* were intended to express a harmony that would reverberate in the soul of the viewer.

A contemporary reviewer of *Klänge* remarked that Kandinsky's rigorous application of theory had limited the creativity of the woodcuts. This critique, however, ignores the different origins of the images in *Klänge*. Produced between 1907 and 1912, they represent several phases of Kandinsky's work, from earlier fairytale vignettes to later abstract compositions. The woodcuts feature variations on recurrent motifs and themes, such as riders, a city on a hill, the angel Gabriel with a horn, resurrection, and revelation. The woodcuts *Two Riders*, *Oriental Scene*, and *Great Resurrection* seem to have been specifically created for *Klänge*, although they were based on earlier works in other media. *Two Riders* incorporates a motif that recurs throughout Kandinsky's work at the time, the horsemen symbolizing the battle between the spiritual and the material and rational. *Oriental Scene* adopts a motif from a 1909 painting (Städtische Galerie im Lembachhaus, Gabriele Münter Stiftung, Munich), and *Great Resurrection* derives from *All Saints' Day I*, one of Kandinsky's reverse-glass paintings (*Hinterglasbild*), a technique that he and Münter adopted from Bavarian folk tradition (Städtische Galerie im Lembachhaus, Gabriele Münter Stiftung, Munich). Here seen as isolated images removed from the context of *Klänge*, these woodcuts nonetheless reveal Kandinsky's attempt to construct, through the arrangement of shapes, lines, and color, a harmonious rhythm that resounds in the senses and awakens the spiritual. —*Celka Straughn*

350 copies of *Klänge* were published, and a strict contract with Piper disallowed further publication of the poems and woodcuts together. The examples seen here come from a later reprinting of many of the images undertaken by Kandinsky despite Piper's restrictions.

Klänge presents a constellation of Kandinsky's artistic production to date, promoting his artistic talents and identity as a visual artist, poet, and theorist, and building on concepts present in the earlier publications *On the Spiritual in Art* and the Blaue Reiter *Almanac*. He conceived of *Klänge* as a "musical album" in which the interspersed poems and woodcuts would achieve a synthetic unity, producing harmonies (rather than narratives) that would reveal the inner content or life of the works. The collection reflects Kandinsky's exploration of synaesthesia, an interest that strongly shaped his artistic development in the years 1910–12 and that led him to experiment with a range of visual, musical, and literary media. Kandinsky's writings emphasize a collaboration of the arts, and he

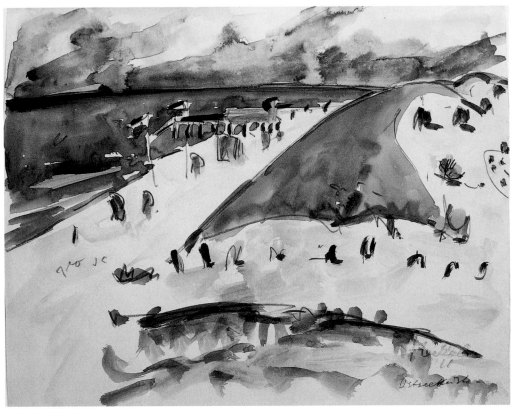

Fig. 46.

Erich Heckel

1883–1970

East Baltic Seacoast, 1911

Graphite and watercolor; 10 9/16 x 13 1/4 in.

Smart Museum of Art, University of Chicago, Bequest of
Joseph Halle Schaffner in memory of his beloved mother,
Sara H. Schaffner, 1973.93

[Cat. no. 34]

One of the founding members in 1905 of the
pioneering Expressionist artists' group Brücke
(Bridge) in Dresden, Erich Heckel developed his
art in concert with the other Brücke members as
they worked together and shared studio spaces.
The process of communal interaction was fitful,
however, as individual artists often went on trips
alone or in pairs, later sharing the results of
their forays with their fellow artists in Dresden
or in the context of a group exhibition. As a
result, while Brücke paintings and prints fre-
quently resemble one another, particularly in
terms of subject matter, the artists retained their
individual identities while nonetheless referenc-
ing their friends' works. The precarious balance
between individual and community marked
Brücke until the group finally dissolved itself
in 1913.

Heckel began to spend time on Germany's
northern shores in 1908, when he and Karl
Schmidt-Rottluff first went to the North Sea
resort of Dangast am Jadebusen (they returned
in 1909 and 1910). The next year, 1911, marked
a major turning point in the communal rela-
tionship among the Brücke artists, as they
moved from Dresden to Berlin to take advan-
tage of the exhibition and sales potentials of the
German Empire's capital city and lost some of
their cohesion in the process. Before making his
move to Berlin, Heckel spent the summer of
1911 at the Baltic Sea bathing resort of Prerow
in Pomerania on the Dass Peninsula. A former
seafaring and fishing village whose trade for-
tunes had declined drastically as steamships

replaced sailing vessels, Prerow began to exploit its five-kilometer-long beach as a bathing resort during the 1890s, and its bathing facilities were already well developed by the time Heckel visited. Its amenities included sheltered areas beyond the public beaches for nude bathing. Brücke artists habitually sought out such sites in order to study the human figure "in free and natural motion," as Ernst Ludwig Kirchner explained, in contrast to the artifice and stiffness displayed by academic artists' models.

In this watercolor rendition, Heckel did not focus on the bathers, however, but rather on the vast expanse of calm blue-green waters and on the spectacular stretch of glistening white sand that made Prerow famous, backed by the low, grassy dunes. Indeed, the image could well serve as an advertisement for the pristine white beaches, the charm and freshness of which appealed to Heckel as the restorative antithesis to the modern urban milieu of Dresden. He used the motif to develop a shift in his pictorial vocabulary as well. For all the rapidity of its execution, the watercolor exhibits a lightness of touch that is unique to the works of this summer. As Gerhard Wietek observed in a 1970 catalogue of an exhibition of Heckel's North German watercolors, these works—essentially drawings to which color has been added—reveal a fundamental gentleness of character that the excited Expressionist experiments of the earlier Brücke years kept hidden.

In 1911, however, a significantly different quality was seen in Heckel's work and a different identity was attributed to him, as attested by a contemporary critic's response: "The pictures cannot be surpassed in terms of their display of an absolute inability to draw and signify nothing more than the harshly colored scribbles of some cannibal. . . . It is high time, as one can recognize here, that serious artists throughout Germany finally proclaim an energetic 'Stop!' in response. Here it is no longer possible to work with such turns of phrase as the right to experiment, problems of development, etc.; here

one should simple announce once and for all: *écrasez l'infame!* Away with this vulgarity!" Such voices could still be countered in 1911, but they gained in vehemence and influence during the 1930s, when intolerance notoriously became the official Nazi attitude with the most drastic of consequences. —*Reinhold Heller*

Lyonel Feininger
1871–1956
The Green Bridge or *Arched Gate*, 1910–1911
Etching; 10 1/4 x 7 9/16 in.
Smart Museum of Art, University of Chicago, Gift of the Friends of the Smart Gallery, 1978, 1978.15
[Cat. no. 19]

Born in New York City, Lyonel Feininger went to Germany at age sixteen to study music. Soon he took up art instead, training in Hamburg, Berlin, and briefly in Paris. Deploying his skill as an illustrator, he became a regular contributor to satirical magazines and by the mid-1890s had earned a reputation as a leading caricaturist. However, Feininger was determined to succeed as a painter, working in a style that shows his receptiveness to the French and German vanguards, while retaining the jaunty line and fanciful exaggeration that had distinguished his draftsmanship.

The Green Bridge is a reversed and slightly altered version of a 1909 painting of the same title, exhibited in 1911 at the Salon des Indépendants in Paris (private collection). This exhibition, the first public showing of Feininger's paintings, perhaps prompted him to create the etched version that same year, which also marked his first encounter with Cubism. The etching incorporates multiple viewpoints and plays with conventional forms of spatial geometry; it also reverberates with movement, not just that of the staggering figures, but from the pulsating lines of the buildings and bridge. Feininger often reused favorite motifs, among them bridges and gates, maintaining a continuity of subject matter as he experimented with new artistic vocabularies. He adopted this com-

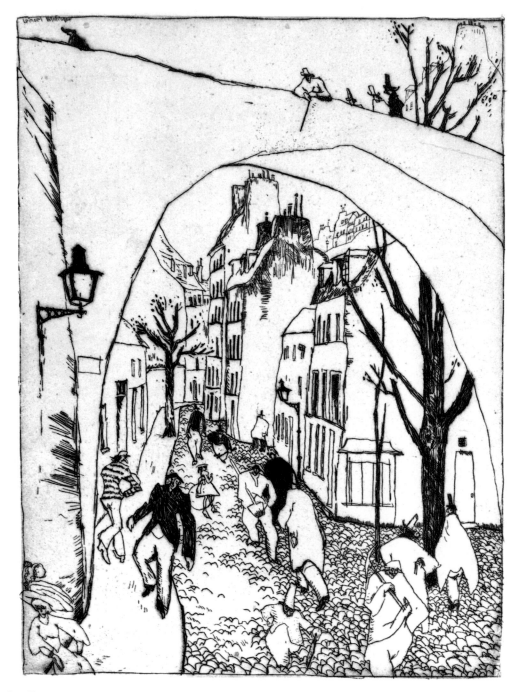

Fig. 47.

position for another painting in 1916, *The Green Bridge II* (North Carolina Museum of Art, Raleigh), which employs a more Cubo-Futurist vocabulary of rounded curves, heightening the tottering movement already apparent in the etched version.

Feininger's etching also responds to currents in Germany, where his Expressionist colleagues were actively engaged in exploring various printmaking techniques. With his experience as an illustrator, graphic media remained central to Feininger's practice, although following World

War I he focused more intensely on the wood-cut than on etching. Walter Gropius invited him to become the first printmaking master at the Bauhaus in 1919, and Feininger included this etching in a portfolio distributed to members of the Kreis graphischer Künstler und Sammler (Circle of Graphic Artists and Collectors) in Leipzig in 1922.

Etching suited Feininger's stylistic predilections, and it seems his thematic concerns, particularly during the years 1909–13. Here, areas of rich drypoint—in the lamp at the left, the figures on the bridge, and the tree branches—soften the brisk draftsmanship and, interacting with the white of the paper, help to establish a sense of color alluded to in the title. A strong play between lights and darks, as well as the large open areas of white, contribute to the image's buoyant quality.

As seen in this example, nostalgia—for a pictur-esque, properous, peaceful German homeland—is central to Feininger's work. Yet his conception of "Germanness" was conditioned by his unique background and early upbringing in the United States. Through his immigrant family, as a child Feininger absorbed a romantic image of a land of tiny, quaint, toylike villages populated by amusing, quirky inhabitants: an image that became one of his favorite motifs in all media. Feininger arrived in Germany with this picture firmly fixed in his imagination, and he con-firmed it when traveling around the Weimar area, sketching medieval churches, cobblestone streets, and old houses. As in this etching, Feininger often compressed the foreground in order to emphasize the village background. And, just as he selectively excluded twentieth-cen-tury incursions, he clothed his figures in the crinolines and top hats of the Biedermeier era.

Given Feininger's position between America and Germany, between illustration and abstraction, between past and present, the predominance of the bridge in this print points toward his unique sensibilities and aims. His particular nostalgia,

different in kind from the primitivism of Brücke, depends on his bifurcated identity and his resulting drive to create an alternate world aligned with children's fairytales, just as his line emulates the children's drawings that he greatly admired. The figures and their surroundings are perfectly integrated, responsive to nothing but the artist's imagination. Distorting proportions and perspective, elongating his figures, and playfully tilting the picture plane, Feininger expressed his version of an imagined German past with an international vanguard vocabulary.
—*Celka Straughn and Britt Salvesen*

Karl Schmidt-Rottluff

1884–1976
Three People at the Table, 1914
Woodcut; 19 5/8 x 15 3/4 in.
Smart Museum of Art, University of Chicago,
Gift of Gerhard L. Closs, 1992.66
[Cat. no. 106]

The year 1914 is regarded as the highpoint of Karl Schmidt-Rottluff's woodcut development and a moment of transition in both the formal tendencies and subjects of his art. As a founding member of the Expressionist group Brücke (1905–13) in Dresden, Schmidt-Rottluff had explored the potential of the woodcut medium early in his career. The artists of Brücke—who included Ernst Ludwig Kirchner, Erich Heckel, Max Pechstein, and (briefly) Emil Nolde, among others—sought new forms of expression that engaged life and art more immediately and inti-mately. Although the group experimented with a variety of media, the woodcut was seen to embody the direct engagement between artist and medium and to convey the powerful imme-diacy of a spiritual, emotional state. In the after-math of World War I, Expressionist woodcuts gained greater significance and prominence. Widely promoted as an art form with roots in the medieval German past, the woodcut was imbued with a mystical, regenerative aura, and portfolios of woodcuts proliferated.

Produced late in 1914, *Three People at the Table* exemplifies the profound changes in Karl Schmidt-Rottluff's art at the outbreak of World War I, particularly in his prolific woodcut production. Following Brücke's dissolution in May 1913, Schmidt-Rottluff continued to pursue some of the group's basic aims, such as the revelation of psychic intensity through an inner harmony of lines, shapes, lights, darks, and the medium's inherent expressive capacities. In a letter of around 1913 to Gustav Schiefler, an avid collector and writer on Expressionist graphics, Schmidt-Rottluff explained that he sought spiritual rather than scientific proportion in his compositions; the exaggeration of the figures' heads, therefore, served to emphasize the site of the psyche. At this time Schmidt-Rottluff began to supplement his Expressionist idiom with Cubist forms, in part influenced by the experiments of his close friend Lyonel Feininger. Schmidt-Rottluff also responded powerfully to an exhibition he saw in December 1913 that juxtaposed works by Pablo Picasso with examples of African sculpture, which he and his Brücke colleagues admired as "primitive" sources for new expression.

Three People at the Table characterizes Schmidt-Rottluff's shift toward a more reductive style intended to facilitate intense spiritual evocation. Moving away from landscapes and nudes, he focused instead on interiors and clothed figures. A tightly composed interior scene dominated by three women, this woodcut is an early rendering of the "silent conversations" or "*conversazione* pictures" that he would produce during the war. Although situated in intimate proximity around a narrow, elongated table, the three female figures remain isolated from one another; each gazes in a different direction, with tightly closed lips and faces marked by severe expressions. The sense of disconnection is formally emphasized by the sharp angles and lines radiating in various directions. These refracted lines seem to emanate from the women, creating an unearthly space. Whereas in earlier woodcuts Schmidt-

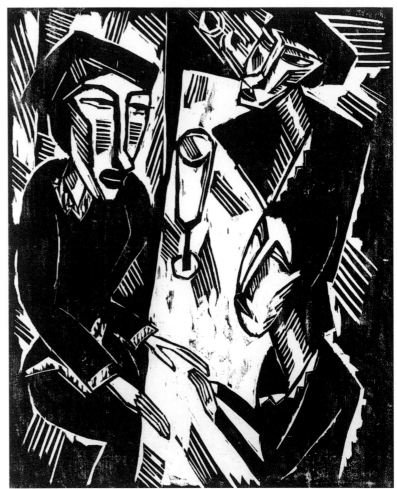

Fig. 48.

Rottluff had portrayed women with curved forms, accentuating their exotic, erotic sensuality, here he geometricized their bodies, enlarged their heads into masks, and reduced their clothing to dark blocks. The earthly evocation of spirituality has given way to a more meditative, abstract vision.

Schmidt-Rottluff continued to produce woodcuts and works in other media during the war while serving in Lithuania. Like many artists Schmidt-Rottluff took up Christian subject matter as a means of coming to terms with his war experiences. His first postwar portfolio, known as the *Christ Portfolio* (*Christusmappe*) (Leipzig: Kurt Wolff, 1918), consists of nine examples from a new series of highly acclaimed

religious woodcuts. *Three People at the Table* was published the following year in a portfolio of ten woodcuts spanning the war period, most of them depicting women. The earliest print in the series, *Three People at the Table* suggests an early attraction to Christian iconography, connoted primarily by the symbolic form of the single tall glass in the center of the picture. The woodcut also alludes, in subject and composition, to the celebration of the Mass, the Last Supper, or the Supper at Emmaus. Created at the onset of the war, *Three People at the Table* points toward an increasing preoccupation with religious imagery closely tied to Germany's experience of the war and its aftermath, marking the transformation from a more exuberant to a more somber spirituality. —*Celka Straughn*

Fig. 49.
Otto Dix (1881–1969),
Wounded Man Fleeing
(Battle of the Somme 1916),
from *War*, 1924.
Etching; 7 ½ x 5 ⁵⁄₁₆ in.
Smart Museum of Art,
University of Chicago, Marcia
and Granvil Specks Collection,
1986.256
[Cat. no. 14e]

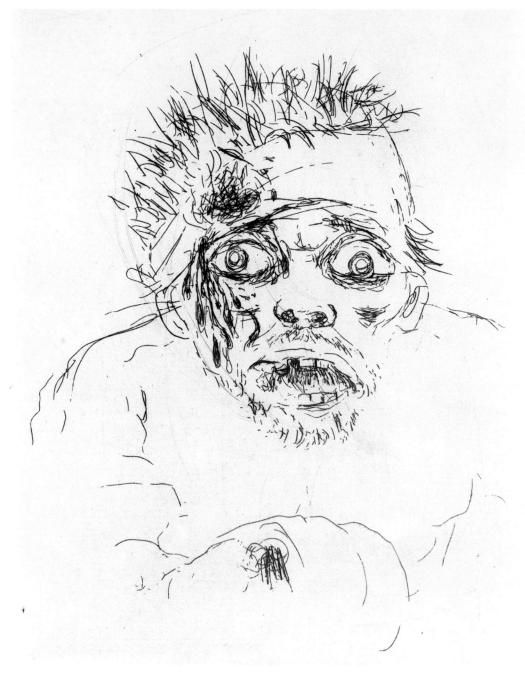

The Great War
Identity and Illusion

NAOMI HUME

A discussion of the First World War cannot be confined to the four years (1914–18) of combat. To discuss the relationship between the "Great War" and German identity, one would have to investigate the causes of the war, the course of its enactment, and its myriad effects. German identity, even European identity, and the war are interdependent, but not in a simple sense. One could look for signs of lasting German identity in the legacy of Bismarck's "blood and iron" nationalism, or in the jubilation at the war's beginning, or even in the supposedly infallible Schlieffen plan.[1] But would these explain the continuation of the war through years of impasse on the front, the perseverence and inability to come to a reasonable peace in the face of a war of attrition, or the wearing down of each entrenched side amid inhuman conditions and pervasive death? These aspects of the German experience of the war all point tellingly to illusion—the urge to see coherence in chaos, to make sense of irrational behavior by assuming it to be natural and fated. But perhaps this illusion can be conceived as the inseparable partner of identity, itself the result of layered individual impulses and collective forces. Identity and illusion, together, emerged from the projection of personal character onto a nation, the willed definition of what ought to characterize that nation, and the individual's absorption of national characteristics into him- or herself.

Illusion can be seen at work in late nineteenth-century European culture in general. The announcement of war prompted celebrations in all the European capitals involved in the conflict. Germany did not single-handedly cause the war, and "most Germans believed as fervently as most Englishmen and most Frenchmen that their country was the victim of a brutal assault."[2] Europe had been preparing for large-scale war for decades while somehow maintaining the illusion that such a war was impossible. When it did occur, the conflict changed the meaning of warfare, as industrialized nations unleashed previously inconceivable technological might upon each other. It has been said that "the war was fought with the ideas of the nineteenth century and the technology of the twentieth."[3] This simple but powerful observation suggests the true force of the resulting tragedy. Planned since the last decades of the nineteenth century and imagined as a battle of individuals fighting honorably in the service of national ideals, the First World War in fact set a wholly new precedent for anonymous annihilation and senseless destruction.

I believe it might be more useful to talk of identity as a plural term, under constant revision and redefinition. This essay will address both the war and the years that followed it, putting wartime artistic responses into dialogue with postwar reconceptions during the Weimar period. Of course in the years following the Treaty of Versailles, the causes and

consequences of the conflict and the intermingling of war and identity received more care-ful consideration than was possible while battles raged. All participating countries had to go through a period of retrospection, but in Germany there was little agreement on how to assess the recent past and plan for the future. Contention inevitably arose between extrem-ists on the radical right, who sought to justify remilitarization, and pacifists on the left, who hoped to prevent further war; neither of these positions could be assuaged by official mythologies. Beginning with the war and continuing into the 1920s and 1930s, artists explored the uncharted territory between these poles of artificial certainty, addressing or exorcising the Great War through their work and thus contributing to changing notions of German identity.

Art both expressed and promoted the fervent enthusiasm that greeted the war's beginning in August 1914. The patriotic weekly paper *Kriegszeit* (*Wartime*), founded by art dealer and publisher Paul Cassirer shortly after the outbreak of the conflict, brought together artists and critics who had previously found themselves at odds with one another. In the journal's first editorial, Julius Meier-Graefe urged consensus: "The war bestows on us a gift. Since yesterday we are different. The fight over words and programs is different. . . . Art was for many but an amusement . . . what we were missing was meaning—and that, brothers, the times now give us. . . .The war has given us unity. All parties are now agreed on the goal. May art follow!"[4] Clearly, the aim of *Kriegszeit* was to unify the German art community in support of the conflict, reflecting the rousing speech made by William II upon the declaration of war, in which the emperor announced that he no longer recognized political parties but only Germans.[5] Political and cultural leaders zealously attempted to present this unified view in 1914, but by late 1915 and certainly after the war, it was no longer possible to believe in such unanimity. The urge to express personal responses to the conflict overrode the perceived need for unity, and the identity of the individual and that of the German people as a whole would remain in tension throughout the period. In visual culture, such tension reveals itself in the heterogeneity of style and subject matter seen not only when comparing different artists, but also when examining different phases within a single artist's career.

Otto Dix had eagerly enlisted in the army in 1914, first serving in the artillery on the western and eastern fronts and then volunteering for air training in 1918. Before leaving for the front, Dix made several enthusiastically militant self-portraits. During the course of the war, he produced hundreds of drawings in a Futurist idiom, showing the dynamism of the war and testifying to his ability to maintain, even in combat, belief in the "Nietzschean themes of apocalypse and renewal, fragmentation and metamorphosis, the Dionysian cycle of death and rebirth."[6] Such popular formulations of Nietzsche's philosophy had played a part in the overwhelmingly joyous reaction to the declaration of war. From this perspective, the war was understood as a necessary rite of purification, through which the decadence of the nine-teenth century would be eradicated and from which a new and better society could emerge.

In a variation on this theme, Ernst Barlach imbued the war with mysticism in prints such as *Holy War*, published in *Kriegszeit* on December 16, 1914 [FIGURE 50].[7] A monumen-tal figure, almost immobilized by his heavy, scuptural robe, raises a blade over his shoulder and advances to attack; through the use of iconic imagery, the artist endowed the contem-

Fig. 50.
Ernst Barlach (1870–1938),
The Holy War, 1914.
Lithograph; 16 ¼ x 10 in.
Kunsthalle Bremen
[Not in exhibition]

porary conflict with the character of an eternal crusade. Although Barlach did not remain unequivocally in favor of the war, his mythologizing vision of German soldiers allowed him to continue to believe in purification by the sword.[8] Many artists—especially those who had seen the front lines—could not maintain these illusions. By the middle of 1915, or even by the end of 1914, it was clear that the conflict would not be over in a matter of months. Even artists who had had misgivings from the start had to rethink their artistic strategies to express their evolving views during the war and their shifting allegiances after it.

The contrast between Dix's celebratory war imagery of around 1914 and the horrific reality he depicted ten years later provides a striking example of the different roles that the war could play in an artist's visual vocabulary. Dix never explicitly disavowed his original enthusiasm, always insisting that although there was horror in the war, there was something "tremendous" about it as well; it was something he "had to experience, had to see."[9] The artist's persistent ambivalence pervades his extraordinary portfolio, *War*, published in 1924. Since its appearance, *War* has been variously described as a personal exorcism or a pacifist political statement.[10] In detailed depictions of every aspect of the war—from combat to death to brothels behind the front—Dix's imagery condemns the inhumanity of war, and yet seems to revel in the most gruesome specifics. *Wounded Man Fleeing* [FIGURE 49] shows a traumatized victim of 1916's Battle of the Somme, while other prints present more

Fig. 51.

Otto Dix, *Stormtroopers Advance under a Gas Attack*, from *War*, 1924. Etching, aquatint, and drypoint; 7 ½ x 11 ¼ in. Smart Museum of Art, University of Chicago, Marcia and Granvil Specks Collection, 1986.257 [Cat. no. 14g]

generalized scenes populated by figures who seem to protect themselves through indifference [SEE FIGURE 51]. The scintillating contrasts of etched line and aquatint wash that Dix achieved (after perfecting his skills with Professor Herberholz at the Düsseldorf Academy of Art) add to the images' unsettling effect, for the beauty and variety of Dix's technique cannot be reconciled with the monotony of destruction and decay that he portrayed.

If ambiguity is a hallmark of the diverse art that approached the war from a liberal or pacifist view, it is notably absent in official war imagery. This contrast is particularly evident in representations of the German soldier, who appears at his most heroicized in the work of Fritz Erler. A lithographic version of Erler's 1917 painting of a soldier in a steel helmet, enhanced with the exhortation: "Help us be victorious!" and "Purchase War Bonds!," was used in posters and handbills to advertise the government's sixth (and most successful) war loan [FIGURE 52].[11] The following year Erler's portrayal of a wounded pilot, with a similar composition and emotional appeal, served as the main poster for the seventh war loan [FIGURE 53]. These pictures fit the official need for unequivocally patriotic imagery: the soldier's glowing eyes show his determination to serve his country; the pilot returns to battle despite his injury. Erler's imagery would become emblematic of the official German line on military duty, belying the harrowing reality of the soldier's life in these late,

Fig. 52.
Fritz Erler (1868–1940),
"Help Us Be Victorious!",
1917. Color offset litho-
graph; 13 x 8 ⅞ in.
University of Chicago Library,
Special Collections Research
Center
[Cat. no. 16]

Fig. 53.
Fritz Erler, *"And You?"*, 1918.
Color offset lithograph;
13 x 8 ¾ in.
University of Chicago Library,
Special Collections Research
Center
[Cat. no. 15]

desperate years of the conflict. In such propaganda pieces, "The helmet, gas mask and barbed wire, as three key symbolic elements of the war, are fused into a highly romanti-cized representation of duty to a 'higher calling' meant to be both ennobling and inspir-ing."[12] War posters represent the official effort to define German identity during the war, in order to encourage loyalty and patriotism.

The difference between the experience of battle and the war as it was treated in government-sanctioned war posters and photographs was vast. This gulf between reality and represen-tation became even more important after 1918, when official German accounts were dominated by rightist condemnations of any supposedly "defeatist" (or non-heroic) views or actions. Disagreement on basic facts had arisen even before German soldiers returned to their home soil. The *Dolchstoß* (stab-in-the-back) theory allowed the army to convince itself that the war had been lost by the maneuverings of leftist traitors on the home front—a particularly striking manifestation of the struggle between upholding myths and destroying illusions.

Conrad Felixmüller's *Soldier in an Insane Asylum* [FIGURE 54] shows precisely the kind of disintegration and confusion that official propagandists wanted to suppress. Felixmüller's work in a military hospital may have kept him from the battle lines, but the results of the

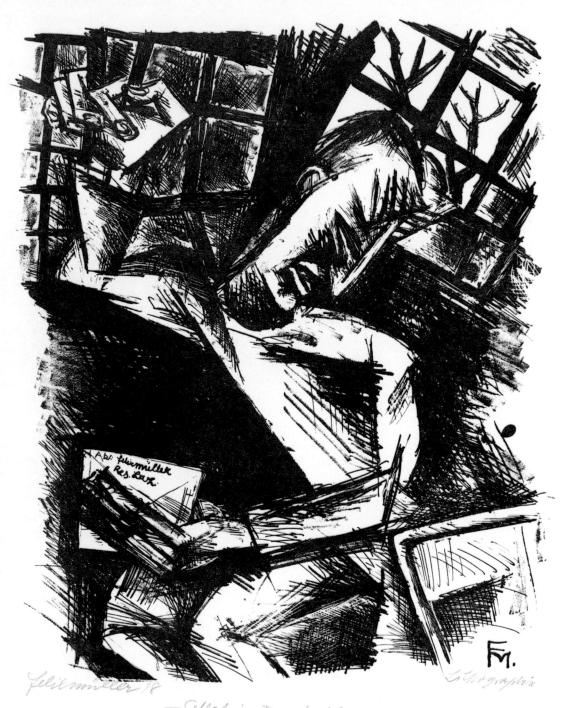

Felixmüller 18

— Soldat im Irrenhaus —

FM.

Lithographie

war that he witnessed were almost as disturbing, and his experience on the home front left him anguished, simultaneously compelled and unable to express himself artistically. In the woodcut *In the Studio, Depressed* [FIGURE 55], the houses in the background and the windowpanes create jagged frames around the artist's dislocated face.[13] In his diaries Felixmüller recorded his confused identification with the broken creatures he cared for. He could not decisively draw a line between their desperate state and his own, despite the huge chasm of experience that separated them; placing his signature on the letter in the soldier's hand in Figure 54, Felixmüller could be implying that he is the hospitalized subject, or that he has sent the letter to the poor soul in the asylum. In any case the question of the artist's identity and role remains painfully unresolved.[14]

After the war competing versions of events, as well as the appropriate way to depict them, continued to provoke fierce debate. Dora Apel has contrasted the patriots' view, centered around notions of heroism, national pride and purpose, and the vision of a new man and new nation, to the anti-militarist view, which pointed toward grotesque, meaningless death

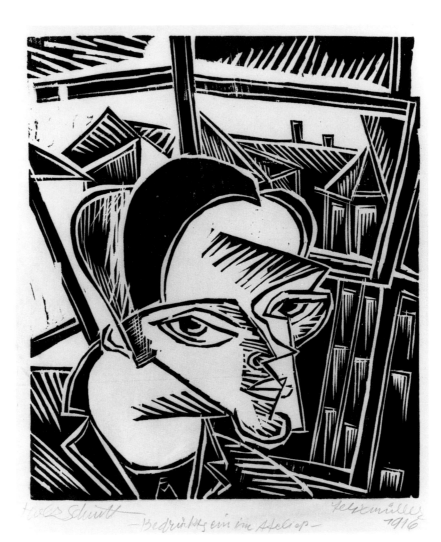

and concomitant subjective fragmentation, social chaos, and self-doubt. For each side of the debate, different issues were clearly at stake. For the patriots, representations glorifying war served as "justification for Germany's past" and as "legitimation for remilitarization," while the pacifists hoped that imagery could serve as a deterrant to prevent future wars.[15]

In some very real senses, the war continued in Germany after 1918. The Freikorps, paramilitary troops composed largely of decommissioned soldiers, continued to act based on their own right-wing convictions; they were officially called upon by the postwar social democratic government to suppress Communist and left-wing uprisings. Klaus Theweleit theorizes that the Freikorps won the battle for Fascism as early as 1923, and Apel supports this in her assessment that the pacifist movement lacked a similar practical force to implement its goals. On November 8–9, 1923, the "March on the Feldherrnhalle," or "Beerhall putsch," took place. The evening of November 8, armed members of the Nazi Party, led by Adolf Hitler, forced their way into an anti-Marxist political meeting being held in a Munich beer hall; Hitler proclaimed himself Chancellor of Germany and coerced several rightist Bavarian political leaders present to support his revolution. The next day, however, as the group marched to the center of the city, they were repelled by police gunfire, and the attempt at a coup was aborted. Theweleit calls this event the "first stage of the attempt to establish a new order in Germany—the Third Reich." Although the Freikorps and others involved in the attempted coup either fled or, like Hitler, were jailed, their activities continued underground, whereas the Communist Party ended its armed struggle in 1923—a resolution that led directly to the virtually unopposed rise of the National Socialists in 1933.[16] The right's interpretation of the First World War would thus feed into the passions that ignited the Second World War.

Alongside overtly political visions of the Great War, personal experiences also found expression. Käthe Kollwitz, like Dix, produced a portfolio of prints in 1924 to mark the tenth anniversary of the war's commencement, but her *War* series departs from Dix's formally and thematically. Inspired by Barlach's mastery of the woodcut, Kollwitz used this medium to produce seven prints, some based on earlier etchings and lithographs [see FIGURE 56], all depicting the effects of the battle upon the home front. Kollwitz initially supported the war and convinced her husband to let their younger son Peter volunteer, only to lose him in the first months of battle. Subsequently paralyzed by depression, Kollwitz was unable to work for much of the war, although beginning in December 1914 she fixated upon the idea of a sculptural monument to Peter and other fallen soldiers.[17] Attempting to believe that her son had not died in vain, Kollwitz did not speak out against the conflict until 1918.

Although most of the war was fought on foreign territory, German civilians suffered a great deal. Before the war, one third of the nation's food supply had been imported. The Allied blockade of Germany had serious consequences; attempts to regulate food production within the country led to rising tensions between urban and rural populations, as well as riots, demonstrations in front of grocery shops, and strikes.[18] The images in Kollwitz's *War* portfolio present the grief and guilt, the poverty and helplessness of those left behind when young men went to fight. These prints were used in the service of the pacifist movement—they appeared in a 1924 commemorative exhibition in Leipzig, and Kollwitz

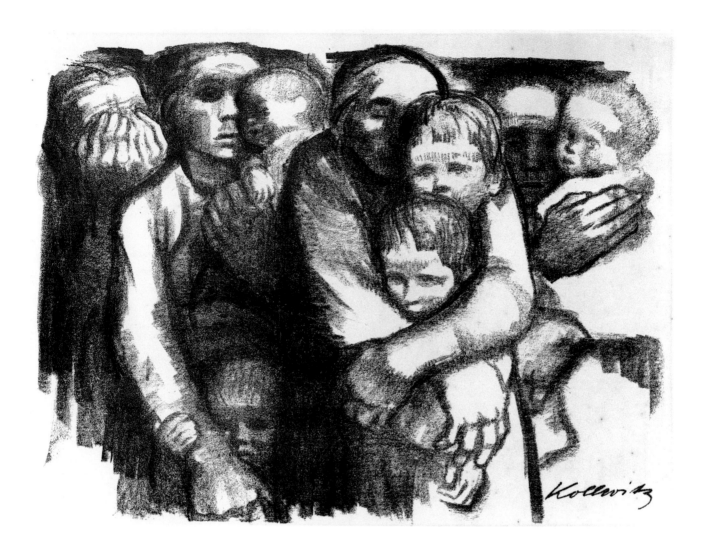

Fig. 56.
Käthe Kollwitz (1867–1945),
War Mothers (second version),
1919. Lithograph;
17 ¼ x 22 ⅞ in. Smart Museum
of Art, University of Chicago,
The Mary and Earle Ludgin
Collection, 1981, 1981.79
[Cat. no. 62]

designed a poster with the slogan "No More War!"—but the work is not radical in that it did not threaten artistic or social norms.[19] For the most part, Kollwitz focused on women passively enduring the roles assigned to them: protecting, sacrificing, somehow bearing the contradictory responsibility required of mothers both to prevent war and to remain patriotic. Kollwitz's prewar belief in revolutionary activism did not survive the personal and national devastations of the war unscathed. Her transformation during the war—from ardent supporter of German aims in the conflict, to bereaved mother, to political pacifist urging the end of all wars—personifies the identity crisis that the war brought about more generally. The need to support the imperial government's decisions in the name of an ideal of German nationhood had been undermined by the facts of war: grief, trauma, and disillusionment overwhelmed the duty to remain united. Individual identity and the need to express it meaningfully overcame the perceived duty to demonstrate shared belief in the historical rights of the German people.

Poverty and suffering on the home front did not end with the Armistice on November 11, 1918, and the abdication of William II. The burden of war reparations imposed on Germany

Fig. 57.
Oskar Kokoschka (1886–1980),
The Principle (Liberty, Equality, Fratricide), 1919, from *Die Schaffenden*, Vol. 1, Portfolio 3 (Weimar, 1919). Lithograph; 14 ⅛ x 9 ¾ in. Smart Museum of Art, University of Chicago, Gift of Andrea L. Weil and John A. Weil, 2001.60f
[Not in exhibition]

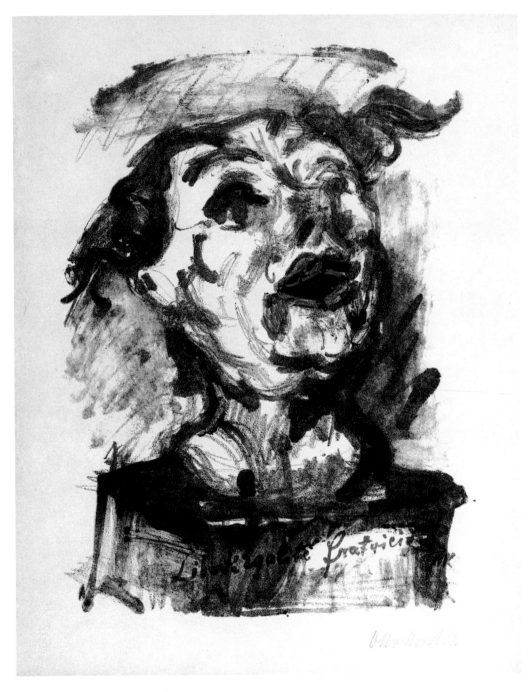

by the victorious nations was crippling. A plummeting economy and political instability created a scenario of general turbulence. Oskar Kokoschka's lithograph *The Principle (Liberty, Equality, Fratricide)* of 1919 [FIGURE 57] deals with these effects of the war. An Austrian, Kokoschka had fought against the French in the war, but continued to believe in the ideals of the French Revolution until he witnessed their perversion in Germany in 1918–19. Here, his cynical revision of the revolutionary motto, inscribed under a severed head, suggests that fighting and dying for these principles undermines their meaning.

Opposition to the mythologies of official histories could take various, often inherently contradictory, forms.[20] Felixmüller's prints attest to his inward withdrawal during the war, but despite his refusal to be drafted into battle, he was unable to escape its violence. Kokoschka's response shows the frustration of a former soldier who saw around him nothing of the ideal world for which he thought he was fighting. Dix looked more closely at the war than any other artist, focusing on gruesome details and representing what could not be imagined. One cannot help but sense that his virtuoso technique attests to and relies on a cultural tradition that has been ruptured and perhaps lost. Kollwitz evoked her own experience of the war: the sorrows and helplessness, the hunger and poverty, and above all the loss of loved ones, far away and in unknown circumstances. But her prints remain ambiguous in their refusal to assign responsibility. The mothers are virtuous in their misery and the young men are naïve in their involvement. Can such self-sacrifice possibly be justified by the actuality of war? The contradictions in these works are inherent to the attempt to represent, and to exorcise, the war.

If war ultimately defies representation, it can also be said that it requires it. Modris Eksteins writes that the First World War "supported conceptualisation and encouraged dramatisation; it emphasized action and image, not words. Language became devalued."[20] The language of certainty, of uninterrogated belief in tradition, could no longer serve to express illusory unity or unquestioned identity in the aftermath of this unprecedented horror.

1. As early as 1892, Count Alfred von Schlieffen, Chief of the German General Staff from 1891 to 1906, devised initial plans that became the strategy of a two-pronged westward invasion, violating Belgium's neutrality, outflanking the French border fortresses, and ultimately surrounding the French army; by 1914 this was still Germany's plan of attack. See John Keegan, *The First World War* (New York: Random House, 1998), 29–36; and Barbara Tuchman, *The Guns of August* (New York: Ballantine, 1962), 17–27.

2. Gordon A. Craig, *Germany, 1866–1945* (New York: Oxford University Press, 1978), 339.

3. Modris Eksteins, "Der große Krieg: Versuch einer Interpretation," in *Die letzten Tage der Menschheit: Bilder des ersten Weltkrieges*, ed. Rainer Rother (Berlin: Deutsches Historisches Museum/Ars Nicolai, 1994), 16.

4. Julius Meier-Graefe, "Editorial," *Kriegszeit*, August 31, 1914, as cited in Richard Cork, *A Bitter Truth: Avant-Garde Art and the Great War* (New Haven/London: Yale University Press, 1994), 46.

5. Craig (note 2), 340. William II made this announcement on August 4, 1914.

6. Dora Apel, *Cultural Battlegrounds: Visual Imagery and the Tenth Anniversary of the First World War in Germany* (Ph.D. diss., University of Piitsburgh, 1995; Ann Arbor, Mich.: UMI Dissertation Information Service, 1996), 97.

7. Friedrich Schult, *Ernst Barlach: Das Graphische Werk* (Hamburg: Hauswedell and Co., 1958), 55.

8. Cork (note 4), 47. Peter Paret states that "Barlach reacted to the outbreak of war without the open patriotic enthusiasm common during these weeks; but he had no doubt that Germany had warded off imminent attack and that its invasion of Belgium and France was justified"; see Paret's examination of Barlach's wartime diaries, "Field Marshal and Beggar: Ernst Barlach in the First World War," in *German Encounters with Modernism, 1840–1945* (Cambridge: Cambridge University Press, 2001), 148.

9. Dieter Schmidt, *Otto Dix im Selbstbildnis* (Berlin: Henschelverlag, 1978), 237, as cited in Cork (note 4), 93.

10. See Apel (note 6); Otto Conzelmann, *Der andere Dix. Sein Bild vom Menschen und vom Krieg* (Stuttgart: Klett-Cotta, 1983); and Dietrich Schubert, *Otto Dix mit Selbstzeugnissen und Bilddokumenten* (Reinbek bei Hamburg: Rowohlt, 1980).

11. Fritz Erler's oil painting of a German soldier in steel helmet was on display at Galerie Schulte at the time of the competition for the sixth war loan poster, and was selected as the competition's winner; see Hermann Reckendorf, "Kunst und Künstler im Dienste der 6. Kriegsanleihe," *Das Plakat* 8 (1917): 215. See also Dieter Vortsteher, "Bilder für den Sieg: Das Plakat in Ersten Weltkrieg," in *Die Letzten Tage der Menschheit* (note 3), 159.

12. Apel (note 6), 50–51; see also Peter Paret, Beth Irwin Lewis, and Paul Paret, *Persuasive Images: Posters of War and Revolution from the Hoover Institution Archives* (Princeton, N.J.: Princeton University Press, 1992), 44–46.

13. Reinhold Heller, *Stark Impressions: Graphic Production in Germany, 1918–1933*, exh. cat. (Evanston, Ill.: Mary and Leigh Block Gallery, Northwestern University, 1993), 56–57.

14. Conrad Felixmüller, "Militär-Krankenwärter Felixmüller" ("Military Orderly Felixmüller"), as cited in Dieter Gleisberg, *Conrad Felixmüller, Leben und Werk* (Dresden: VEB Verlag der Kunst, 1982), 247–49.

15. Apel (note 6), 4–5.

16. Klaus Theweleit, *Male Fantasies, Volume 1: women floods bodies history* (Minneapolis: University of Minnesota Press, 1987), 24.

17. Käthe Kollwitz, diary entry for December 1, 1914, in *The Diary and Letters of Käthe Kollwitz*, ed. Hans Kollwitz, trans. Richard and Clara Winston (Evanston, Ill.: Northwestern University Press, 1988), 63.

18. Craig (note 2), 358.

19. Apel (note 6), 25–32.

20. Apel (note 6), 191.

21. Eksteins (note 3), 17.

Heinrich Campendonk

1889–1957
The Beggars (after Brueghel), 1922
Woodcut; 5 5/8 x 6 3/4 in.
Smart Museum of Art, University of Chicago, Marcia and
Granvil Specks Collection, 1991.338
[Cat. no. 12]

Having exhibited as the youngest member of the
Blue Rider group prior to World War I, Heinrich
Campendonk is now largely known as a painter
of Fauvist-colored canvases with stylistic and
thematic affinities to the art of Franz Marc,
Auguste Macke, and, later, Marc Chagall. An
interest in animal and cosmic imagery allies his
work particularly with that of Marc, whose
mystical portrayals of animals in nature resonate
with Campendonk's interest in depicting animals
and humans in symbiotic relation to the natural
world and to each other. His graphic work was

first published in 1912, in Herwarth Walden's
periodical *Der Sturm*, and he further developed
his woodcut technique after completing two
years of military service in 1916. Campendonk's
wartime experiences, along with the deaths of his
friends Marc and Macke in combat, affected him
profoundly, leading him first to destroy much of
his previous work and eventually to shift his rep-
resentations further toward the realm of fantasy.
At the same time Campendonk returned to his
earlier applied-art training, experimenting with
the woodcut medium and later with stained glass.
The turbulent years between 1916 and 1925
were, for Campendonk, years of intense produc-
tion and positive critical reception in Germany.
He devoted his later career largely to public
stained-glass commissions, even after 1933, when
he was dismissed from his post at the Düsseldorf
Academy, after which he emigrated first to
Belgium and eventually to the Netherlands.

Fig. 58.

Although the woodcut medium bespeaks an alliance with a long Germanic artistic tradition stretching back to Albrecht Dürer, it was a 1920 trip to Italy, during which Campendonk studied Byzantine mosaics and early Renaissance frescoes, that led to an overall compositional simplification notable in woodcuts produced after 1922, such as *The Beggars*. The dark background, clearly defined, enclosed forms, and stark, black-and-white contrasts differentiate this work from Campendonk's earlier, more Expressionist graphics. He also began to incorporate color in some prints, underlining their stylistic affinities with stained glass.

Campendonk based *The Beggars* on Pieter Brueghel the Elder's 1568 panel painting of the same name (Louvre, Paris). Brueghel's tiny panel, not much larger than Campendonk's woodcut, depicts dancing figures at a carnival, supported on crutches, wearing paper hats, and sporting foxtails attached to their cloaks—signs that probably identified them as lepers. In his woodcut Campendonk further heightened the carnival atmosphere by emphasizing the decorative elements of the figures' clothing, in particular the swirling pattern of the puffed sleeve at the center of the composition. The emphasis on strong outlines and discrete forms looks forward to Campendonk's stained-glass work. But the stark contrast and flattened forms also emphasize the figures' social isolation more sharply than in Brueghel's painting; the foxtails become indelible marks, rather than removable accessories, and the solidly outlined bricks of the background wall restrict the beggars to their enclosure. The animal seen beyond the brick wall, perhaps a deer, is Campendonk's addition to Brueghel's composition, suggesting a more idyllic world beyond. This element brings the work more in line with many of Campendonk's paintings, which treat the theme of the relationship between humans and animals.

While directly referring to art of the past and evoking a kind of fairytale world, *The Beggars*

also resonates with contemporary images by Otto Dix, George Grosz, and Max Beckmann, in which mutilated veterans of the First World War support themselves on crutches, often begging on city streets. Campendonk refrained from literally depicting events of his time, but he alluded to the trauma of the war by comparing the social ostracizing of war cripples with that of lepers. Through the veil of Brueghel's carnival scene, he took an ambivalent, distanced stance toward one of the many difficult social issues that faced early Weimar Germany, perhaps in an effort to retreat into the realm of fantasy and potential harmony with nature. If only the beggars could get over the wall, Campendonk seems to suggest, their relationship with the natural world might be restored. —*Allison Morehead*

Lasar Segall

1891–1957
Aimlessly Wandering Women II, 1919
Woodcut; 9 x 11 3/8 in.
Smart Museum of Art, University of Chicago,
Gift of Mauricio Segall and Oscar Klabin Segall, 1997.49
[Cat. no. 109]

Born in 1891 in the Jewish community of Vilnius—the capital of Lithuania, then part of Russia—Lazar Segall was the son of a Torah scribe. The orthodox, scholarly atmosphere of his household remained a powerful formative influence, even though he early felt himself drawn to other cultural experiences. In 1906, at age fifteen, Segall moved to Berlin, where he encountered a hitherto unimagined prosperity and modernity. For many eastern European Jews, Wilhelmine Germany seemed to offer refuge from the political turmoil and religious persecution that had decimated the eastern outposts of the czar's empire. *Ostjuden* (eastern Jews) filled German cities, often remaining distinct—through their Hasidic clothing and Yiddish language—from the assimilated German-born Jews. Segall would choose not to differentiate himself in this manner, but he retained and

Irrende Frauen II Fassung *Lasar Segall*

Fig. 59.

expressed his Russian and Jewish origins in other ways throughout his life. He took the risky decision to study art, thereby adopting yet another outsider identity, but one that seemed to transcend ethnic and religious labels.

After four years at the Berlin Academy, Segall moved to the more liberal Dresden Academy in 1910, but he did not immediately respond to the avant-garde tendencies percolating there. Instead, for the next two years, he traveled extensively, from Vilnius to Holland to Brazil. Returning to Dresden, Segall discovered Expressionism and found his voice, forming friendships with Wassily Kandinsky, Lyonel Feininger, Otto Lange, and Conrad Felixmüller. By 1914 Segall had been singled out for the psychological intensity of his work, conveyed through faceted forms and saturated color.

The First World War violently interrupted this fruitful experimentation. As a Russian citizen, Segall was an enemy alien, and he was forced to retreat from Dresden to nearby Meissen with other Russians. There he underwent a stylistic retrenchment, reverting to a naturalistic and presumably more marketable style. In 1916 he

returned to Dresden, thanks to a special dispensation requested by his professors at the academy. Although Segall's status must have been somewhat precarious, with the war not yet over, he resumed a highly visible role in avant-garde circles. Far from hiding his Russian identity, he made a point of specifying it in catalogue listings. German critics discussed Segall alongside fellow Russians Kandinsky and Marc Chagall, considering the work of all three artists to be imbued with the lyrical mysticism and melancholy spirituality of the East.

Segall's experience of World War I is difficult to characterize. Visiting Vilnius—occupied since the beginning of the war—in 1917 and 1918, he was able to see that German occupation had imposed a sense of order and tentative renewal after years of czarist repression, yet the destruction of the city of his youth elicited strong feelings of loss. Rather than depicting his personal recollections, however, Segall focused on the present and future in universalizing terms. Thus, although an aura of anxiety entered his work, a strain of utopianism is also present— a duality common to many of the so-called second-generation, postwar Expressionists. Segall and Felixmüller emerged as the most prominent representatives of this movement in Dresden, applying a Cubo-Futurist idiom to talismanic, primitivizing forms and symbols.

The November Revolution of 1918 and the shaky beginnings of the Weimar Republic brought about greater organization among artists. Under the leadership of Felixmüller and Segall, the Dresden Secession Group formed in 1919. It was during this immensely stimulating period that Segall produced *Aimlessly Wandering Women II*. The woodcut technique—which, despite its centrality in the Expressionist aesthetic, Segall had only begun to practice in 1917 or thereabouts—fostered an extreme reduction of form. Although *Aimlessly Wandering Women* is composed of broad, flat shapes and lines that adhere to geometric rather than structural logic, the image is neither arbitrary nor abstract; rather,

it is precisely designed and richly figurative. Its internal contradictions are both formal and conceptual, beginning with the recession and relief of the carved block that produces negative and positive space. The women's large heads might suggest inner life, yet their blank eyes reveal nothing. Their bodies loom, yet are imprisoned by the composition's edges. Finally, the bisecting of their faces into light and dark suggests the phases of the moon.

This lunar symbol speaks to the core of Segall's art. *Aimlessly Wandering Women* was one of thirty-five prints shown in his first one-person show in Germany, held at the Folkwang Museum in 1920. Segall's friend the poet Theodor Däubler, who wrote an essay for the catalogue, was not alone in linking this symbolism to notions of Jewishness: endlessly wandering, as if following the moon and mirroring its mutability, Jews were linked by culture rather than by nationality. The two sides of migration, freedom and loneliness, ultimately shaped Segall's life and art.

In the 1920s Segall's commitment to Expressionism began to isolate him from other artists, who were experimenting with Dada and Neue Sachlichkeit. In his final emigration, in 1923 Segall moved to Brazil, where he exhibited actively for the next thirty years. His distance from Germany did not prevent him from being included in the Munich version of the exhibition "Degenerate Art" in 1937, and later the Holocaust victim appeared as one of the outcast, disenfranchised figures populating his ever-challenging work. Segall died in São Paulo in 1957.—*Britt Salvesen*

Ernst Barlach

1870–1938
The Reunion, posthumous cast after 1926 model
Painted cast plaster or composition; h. 18 in.
Anonymous Loan, 6.1993
[Cat. no. 3]

Despite study at the academy in Dresden and a year's stay in Paris (1895–96), Ernst Barlach did not develop his personal sculptural vocabulary until he was in his mid-thirties, after a 1906 trip to Russia. There, among the peasants, he discovered what he considered to be an originary existence, an archaic humanity and harsh yet noble reality, not yet removed from its primeval roots by the incursions of modernity. Using wood as his primary material, Barlach thereafter fashioned emotively charged figures, simplified and blocky in appearance, their bodies covered by plain and timeless gowns or robes. The figures gesture dramatically, while their incised facial features render the expressions of existentially fundamental emotions and feelings. This figural type remained constant in Barlach's sculpture for the next thirty years, as he held fast to his vision of a humanity existing and suffering in splendid, charged silence. According to the characterization offered by Bertolt Brecht, "The pose, the meaning of the expression, the genius of his craftsmanship, beauty without prettification, grandeur without histrionics, harmony without superficiality, vitality without brutality transform Barlach's sculptures into masterworks."

Barlach's *Reunion* could aptly be re-titled *The Return of the Prodigal Son*. Certainly Jesus' New Testament parable is readily recalled by Barlach's Christ-like figure. He stands erect, a sense of questioning concern and perhaps sorrow marking his face, and reaches out to lift and embrace a bent, partially crouching young man who looks up imploringly into his face. If Barlach did not conceive of the sculpture in such specifically biblical terms, many of his works persistently call forth such associations. They suggest a realm of probing psychology and fundamental spirituality often associated with bibli-

Fig. 60.

cal and other religious themes, as Barlach explained in 1918 in a letter to the publisher Reinhard Piper: "Art is something of the very deepest humanity, an exploration of the core of the spirit and the soul." Writing just after the collapse of the German Empire, when conflicting social ideologies and artistic forms loudly clamored for attention and power, Barlach then concluded with a deeply pessimistic perception of the future: "Faith and its substitute, superstition—which after all retains an inkling of the incomprehensible and a recognition of the uncanny, indeed generally of the problem 'Why humanity, to what end, for what purpose?'— will have to give way to all sorts of facile formulations now."

There is a fundamental conservatism in Barlach's attitudes, whether toward society or

toward art. Thus he never gave up the human figure as the sole motif of his sculpture, like others of his generation did, even as he submitted it to a process of subjective condensation and expressive exaggeration. To transmit emotional content, he argued, the representation of the human figure was necessary: without showing the viewer his or her own image, he could not elicit the sympathetic, empathetic response he demanded of his work. "I need to feel a sense of sympathy—feel what others are feeling, suffer what they are suffering," he wrote in another letter to Piper. "This sympathetic participation reaches the point where I find myself transported into the midst of the events visualized."

With a formal vocabulary that recalls—among other sources—German Romanesque sculpture, *The Reunion* attempts to embody the tensions and expectations of a sudden recognition and an unexpected meeting. Barlach rendered the moment as if it would never end, arresting all prior movement and lending the encounter an overwhelming sense of silence. The mouths of the two men remain firmly closed—perhaps they are about to give vocal expression to their surprise and pleasure, but have not yet arrived at that oral stage of their encounter—while their eyes are opened wide in amazement, surprise, and visual interrogation. "All in all, life's progress through changing time and space reminds me more of storming forward through a howling chaos, impelled by the urgent need to couple desire to destiny, with occasional breathing spells of stillness and repose in freedom, acceptance, and deep-moved silence," Barlach contended in his autobiography, *A Self-Told Life*. *The Reunion*, like all his sculptures, renders such a breathing spell, when stillness and silence interrupt the standard chaos and noise of daily human existence.

Barlach carved *The Reunion* in wood in 1926, the figures over a meter tall. The present smaller, more intimate version in bronzed plaster is a posthumous cast of a study made for the larger wooden sculpture. —*Reinhold Heller*

Fig. 61
Max Beckmann (1884–1950),
The Tightrope Walker, from
Carnival, 1922.
Drypoint; 9 7/8 x 9 3/4 in.
Smart Museum of Art,
University of Chicago, Marcia
and Granvil Specks Collection,
1983.136
[Cat. no. 5d]

"The Theater of the Infinite"
Performing Identity in Weimar Germany

ALLISON
MOREHEAD

The artistic responses to the Great War and its aftermath were as many and as varied as the individuals affected by the mechanized violence and destruction of the conflict, which occurred on a scale never before experienced in Europe. In Germany, the residual trauma of the war was compounded by the perceived humiliation of the Versailles Treaty, the chaos of the 1918–19 revolution, the instability of the emerging coalition government, and an extreme economic crisis. The Weimar Republic, constituted in 1919 and effectively ended with the appointment of Adolf Hitler as chancellor on January 30, 1933, encompassed these early years of chaos, as well as subsequent periods of relative political and social stability, and eventual, but not necessarily inevitable, ideological radicalization and political polarization.[1] For avant-garde artists in Germany, the Weimar period—with its upheavals and unprecedented social and cultural changes—provided a crucible for creative production. Building upon the previous chapter's examination of the national and individual crises of identity attendant upon Germany's participation in the First World War, this consideration focuses more specifically on the critical positions and stylistic idioms available to artists in the 1920s. Examining the urban environment and portraying its many sites of entertainment and display, Weimar artists devised innovative means of representing the unfixed distinctions between surface appearance and inner reality, performer and audience, alienation and complacency that inflected modern German identities.

Many artistic modes of the immediate postwar period had their roots in the strategies of the prewar avant-garde. The November 1918 revolution, which stretched into the first months of 1919, found a number of artists engaged in an Expressionist aesthetic that they felt best enabled them to convey their humanitarian and utopian hopes for a new world. While their stylistic vocabularies remained largely unchanged, Expressionist artists increasingly dedicated themselves to organized political movements, giving both the form and content of their works a contemporary urgency. Conrad Felixmüller, Erich Heckel, and Ludwig Meidner were among the founders of utopian, leftist artists' organizations such as the Novembergruppe (November Group), the Arbeitsrat für Kunst (Work Council for Art), and the Dresden Sezession Gruppe 1919 (Secession Group 1919). Within the context of these groups, artists published proclamations and original prints in the many newly founded periodicals of the time, and provided poster designs for numerous political and social campaigns.[2] Often embedding human figures in natural environments of sea and sky, artists conveyed their hopes for more intimate, meaningful relationships among indi-

viduals, and for a rejuvenated connection between humanity and nature—links seen to have been severed by the industrial development that culminated in the war's killing machines.[3] But this "second generation" of German Expressionism[4] was relatively short-lived, as utopian optimism gave way to disillusion in the wake of such events as the January 1919 murder of revolutionary leaders Rosa Luxemburg and Karl Liebknecht by paramilitary Freikorps troops allied with the embattled new government.

The Berlin Dada group, whose members took up the experiments of wartime German exiles in Zurich, had already countered Expressionist optimism with its specific brand of aesthetic and political criticism. Even before the end of the war, artists including George Grosz, Raoul Hausmann, John Heartfield, Richard Huelsenbeck, Wieland Herzfelde, and Hannah Höch, many of whom joined the German Communist Party in 1919, had given Dada a particularly political, anti-militaristic, anti-nationalistic spin in their publications and events. Their raucous activities continued into the early years of the Weimar Republic, reaching their apogee with the First International Dada Fair of 1920, after which Herzfelde and Grosz were tried and fined for defaming the military; a pig-faced dummy dressed in military uniform and Grosz's lithographic series *With God on Our Side* had especially incensed the government [FIGURE 62].[5]

As the work of postwar Expressionist and Dada artists presaged, the art of the Weimar period was to be closely intertwined with Germany's political and social landscape. Although a great variety of aesthetic modes co-existed within and among various self-defined movements or groups, the period was, for the most part, dominated by an interest in figuration and the representation of contemporary urban life, often intended as a means of critiquing German society.[6] An interest in "objective" representation (as opposed to the perceived exaggerated subjectivity of Expressionism) emerged. This tendency is often subsumed under

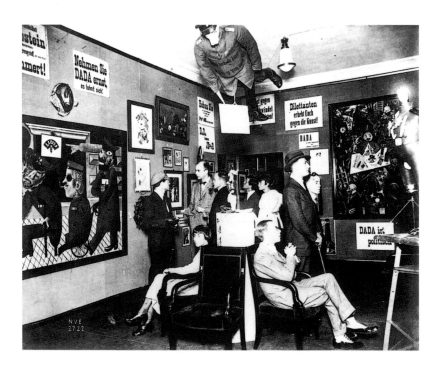

Fig. 62.
Installation view of the First International Dada Fair, Berlin, 1920
[Not in exhibition]

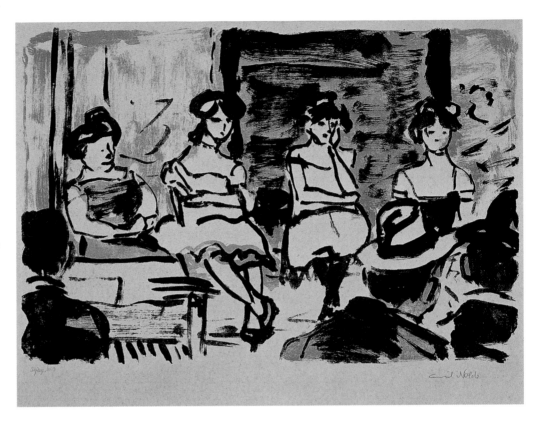

Fig. 63.
Emil Nolde (1867–1956),
Tingel-Tangel II, 1907. Color
lithograph; 12 ¾ x 19 in. Smart
Museum of Art, University of
Chicago, Marcia and Granvil
Specks Collection, 1984.74
[Cat. no. 83]

the heading "Neue Sachlichkeit" (usually translated as "New Objectivity"), a term meant to describe both a new focus on the object and a new "objective," often critical, approach to subject matter.[7] Never a cohesive movement to the extent of Expressionism or Dada, Neue Sachlichkeit should not be seen as an outright rejection of either, but rather as a reorientation of certain fundamental aspects of both: it appeals to an Expressionist willingness to distort forms for significant visual and emotional effects, and a Dada-inspired desire to critique contemporary society. Indeed, many of the artists in this exhibition should be viewed in the context of two or more of these three tendencies: George Grosz's and Christian Schad's Dada membership certainly informed their later Neue Sachlichkeit work, and Otto Dix's Expressionist heritage remained a salient feature of his art throughout his career.

During the Weimar period, diverse artists shared a preoccupation with subject matter relating to the theater, carnival, revue, cabaret, circus, and dancehall—distinctly urban spaces of performance, or spaces seen to be reflective of the chaos of modern city life. While Expressionists such as Emil Nolde had, before the war, portrayed similar themes (see, for example, Nolde's 1907 lithograph, *Tingel-Tangel II* [FIGURE 63], representing one of the bawdier forms of urban entertainment[8]), in the Weimar period artists attached new critical perspectives to such scenes.

Accelerating urbanization, and its effect on both city and country life, was much discussed in Germany after the war. Berlin came to be seen as the quintessential modern metropolis, especially after a 1920 administrative reorganization created "Greater Berlin," the western world's third largest city in population after New York and London.[9] Contemporary visi-

tors and commentators, struck by its excitement, chaos, and rapid pace, saw the city epito-
mized and reflected in the carnival, fair, and revue; indeed the revue was Berlin's most pop-
ular live entertainment.[10] Referring specifically to the German capital, Maximilian Sladek
wrote in 1924: "For the big-city dweller the true 'mirror and abbreviated chronicle of the
age' has always been the revue, that colorful, whirring, easy-going, incredibly mobile,
suggestive replica of existence aswirl in a storm."[11] A more ambiguous statement from
Siegfried Kraucauer links the urban political unrest of the Weimar Republic with the chaos
of the carnival, that "enclave of anarchy in the sphere of entertainment."[12]

The "objective" representational mode of Neue Sachlichkeit corresponds roughly to a
renewed interest in realism throughout Europe, often characterized as a "return" or "call to
order" after prewar experiments in abstraction.[13] But the supposed order of realism often
referred to and revealed disorder, in particular the chaotic disorder of the city. In depicting
scenes of entertainment, German artists frequently mobilized such "objective" modes to
expose and critique spaces of performance as reflective of the disjunctive nature of modern
experience and the ambiguities of modern identity. In images of various stages, artists
explored the notion that identity is, to a certain extent, always a performance. Their works
often reveal individuals to be actors playing a series of roles, sometimes even literally
wearing masks, suggesting relationships between individuals (and, at the extreme, an indi-
vidual's relationship to the self) to be necessarily incomplete or fragmented. And ulti-
mately, within spaces of performance, artistic identity itself could be articulated through
the negotiation of the artist's own role in the image or the manipulation of the psychologi-
cal distance between artist and subject. An engagement with images of performance and
artistic identity became, for some, a strategy for dealing with or commenting upon the
upheavals of the postwar period. As Max Beckmann, whose oeuvre includes many such
subjects, wrote in 1940, a year into the Second World War: "If one comprehends all of this,
the entire war or even all of life only as a scene in the theater of the infinite, everything is
much easier to bear."[14]

A number of works from the Weimar period include artists' implicit or explicit insertion of
themselves into images of performance, thereby collapsing the distance between artistic
identity and the depicted subject matter, and simultaneously collapsing the difference
between the artist's world (implied, through the strategy of "realistic" portrayal, to be
coextensive with the viewer's world) and the scene depicted. Beckmann represented himself
in the guise of a barker or ringmaster in the introductory print to his 1922 portfolio
Carnival [FIGURE 64], which also incorporates portraits of friends such as Reinhard
Piper, who, along with Julius Meier-Graefe, commissioned the portfolio.[15] The introductory
self-portrait signals Beckmann's ambiguous role in the scenes he creates. He rings a bell
and points to the ensuing plates, inviting his audience to enter his particular version of the
carnival; thus, as Robin Reisenfeld argues, he both participates in and comments on a
world that he sees as a microcosm of society.[16] The self-portrait also serves to heighten
the impression that all the figures in the series play roles, contributing to the confusion
between their world and the "real world" of their imagined audience. At the same time,
Beckmann suggested a disjunction among the performers themselves; the figures in *Behind
the Scenes*, *Negro Dance*, and *The Carousel* seem to stare past one another, crammed into

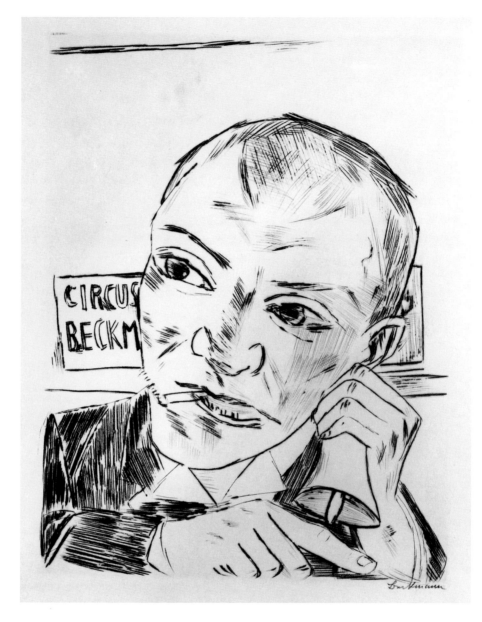

Fig. 64.
Max Beckmann, *The Barker*,
from *Carnival*, 1922. Drypoint;
13 x 9 ⅞ in. Smart Museum of
Art, University of Chicago,
Marcia and Granvil Specks
Collection, 1983.129
[Cat. no. 5u]

claustrophobic spaces in which their discomfort is obvious. In certain of the prints, especially in *The Carousel* and *The Tightrope Walkers* [FIGURE 61], this alienation from fellow performers is downright dangerous. Most of the figures on the merry-go-round seem to want nothing more than to get off the ride, and the two tightrope walkers, apparently oblivious to each other, seem fated to fall unaided to their demise. Reisenfeld points out that Beckmann dedicated *The Tightrope Walkers* to his first wife, Minna, calling it a "self-portrait of ourselves" and implying that even in the most dependent, intimate relationships, such as a marriage, identity is always to some extent a performance, and relationships thus incomplete.[17] Individuals are never fully present to one another, and anyone can be said to be playing a role in the "theater of the infinite" that Beckmann identified as the modern human condition. As a representation of himself, Beckmann's high-wire act

also suggests the artist's marginal position in society, a role elaborated on in his 1927 satirical statement, "The Social Stance of the Artist by the Black Tightrope Walker."[18]

Paul Kleinschmidt's *At the Fortune Teller's* [FIGURE 65] of 1922 posits a view of human relationships that is equally reliant on the analogy of life as a dramatic performance.[19] Like Beckmann, Kleinschmidt—the son of a theater director and an actress—had an overriding interest in depicting scenes of the stage, circus, bar, and nightclub, although his loose, painterly handling contrasts with the cool, polished technique often associated with Neue Sachlichkeit. *At the Fortune Teller's* reveals the interpenetration of the private and the public in modern life; it is a scene of private revelation played out in a carnival or side-show setting. A shriveled customer contrasts starkly with an ample fortune teller, whose costume and casual pose identify her as a seasoned entertainer. She plays the same part over and over, momentarily entering an individual's life on an intensely personal level and then rapidly moving on to the next customer. Kleinschmidt presents an image of fleeting contact, analogous to the modern experience of urban, capitalist life, in which commercial transaction provides the model for accelerated revelations and exchanges of identities and desires.

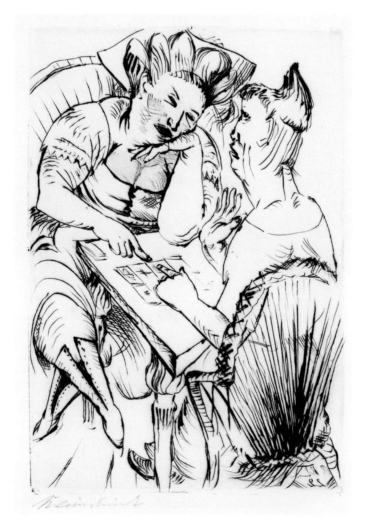

Fig. 65.
Paul Kleinschmidt (1883–1949),
At the Fortune Teller's, 1922.
Etching and drypoint;
13 x 8 ¹⁵/₁₆ in.
Smart Museum of Art, University
of Chicago, Marcia and Granvil
Specks Collection, 1998.97
[Cat. no. 54]

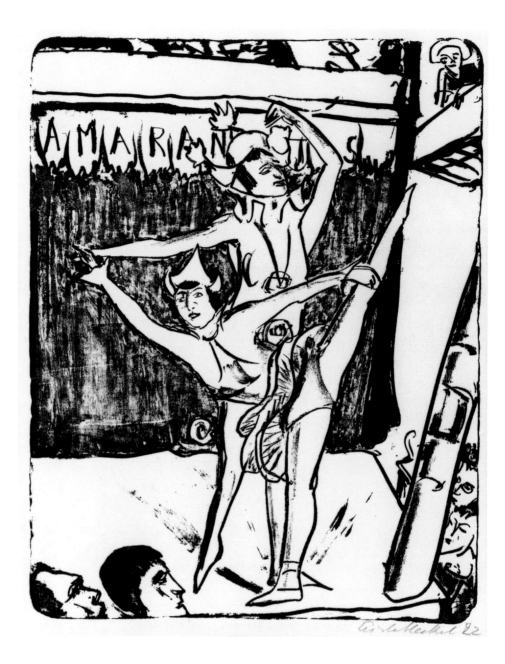

Fig. 66.
Erich Heckel (1883–1970),
Dancers, 1922. Lithograph;
19 ⅜ x 14 ¹⁵/₁₆ in. Smart
Museum of Art, University of
Chicago, Marcia and Granvil
Specks Collection, 1991.348
[Cat. no. 33]

In images of the Weimar peroid, the artist is frequently figured as an implied audience member—not explicitly a performer, but nevertheless an integral part of the performance depicted. By including onlookers in his lithograph *Dancers* [FIGURE 66],[20] Erich Heckel established a range of viewpoints on the spectacle shown: from a balcony above the stage, from below the stage, and from the wings. The artist might be imagined as an additional audience member, providing a fourth point of view that we, as viewers of the image, share. But the spectators, like the performers, have mask-like, unindividualized faces. The impassive countenances reveal no engagement with the performance, and personalities are thus subsumed by the generic identities of dancer, audience member, and even artist. The alienation that pervades the revue, Heckel implies, cannot be escaped in the wider world.

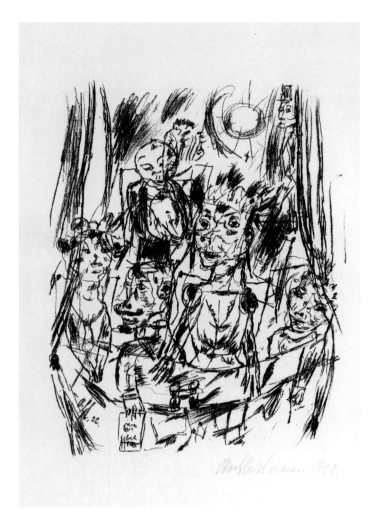

Fig. 67.
Otto Gleichmann (1887–1963),
Theater Box, 1922.
Lithograph; 12 1/16 x 9 7/16 in.
Smart Museum of Art,
University of Chicago, Marcia
and Granvil Specks Collection,
1998.83
[Cat. no. 25]

Otto Gleichmann addressed a similar thematic of alienated figures in very public spaces of urban entertainment, providing a more literal view of spectatorship by turning away from the stage to look directly at the audience. In the lithograph *Theater Box* [FIGURE 67], a bourgeois family acts out its own drama, one step removed from the theatrical performance taking place beyond the edges of the image.[21] A grotesque, over-sized mother dominates the scene, dwarfing her husband, son, and daughter, and thereby reversing "natural" gender roles. Her appearance belies her maternal identity, however: harsh lines emphasize her monstrous face and the hard contours of her form. This distinctly forbidding woman over-whelms the man, whose role as family protector is further undermined by the illegible presence of shadowy male figures in the background, who further frustrate attempts to understand any narrative content. Frenzied marks throughout the image exaggerate the characters' gestures, creating an atmosphere of dramatic movement and nervous tension. Gleichmann's print suggests that identities—whether performed in public or within the supposed privacy of the domestic sphere—are merely absurd roles, often unintelligible and potentially meaningless. The act of turning his gaze toward the audience is in itself a self-consciously critical gesture, one which, along with the profusion of harsh lines, conveys Gleichmann's pessimistic view of the contemporary bourgeois family.

The modern aristocratic classes—their societal displacement and strategies of self-presentation—form the subject of Christian Schad's portrait of Baronessa Vera Wassilko [FIGURE 68]. The Baronessa, whom Schad met and painted in Vienna in 1926, was a disaffected Ruthenian aristocrat who had sought refuge in various European capitals after the war. She appears here with two male companions in evening dress; the nocturnal view of Paris behind them suggests the beginning or end of a night on the town. But Schad casts the image in a theatrical light with his cool realist manner, applying the same fineness of detail to each element, including the city scene, which recalls a painted backdrop. Despite her diaphanous dress and plunging neckline, the Baronessa is not easily accessible as an erotic figure. The body beneath the painted fabric is flattened, and the dark flowers at the bottom

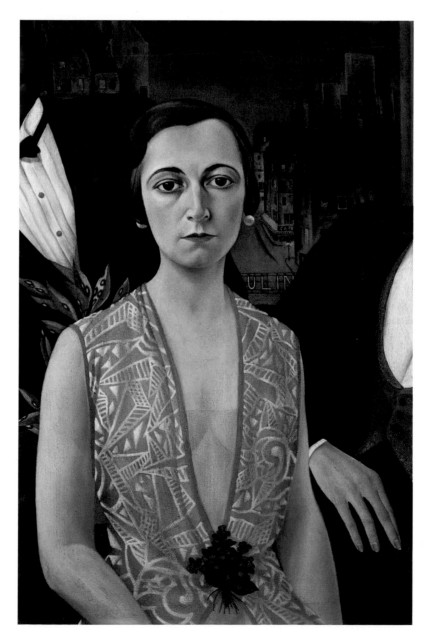

Fig. 68.
Christian Schad (1894–1982),
*Portrait of Baronessa Vera
Wassilko*, 1926.
Oil on canvas; 28 ⅝ x 18 ¼ in.
Lent by Anatole and Nancy
Gershman
[Cat. no. 101]

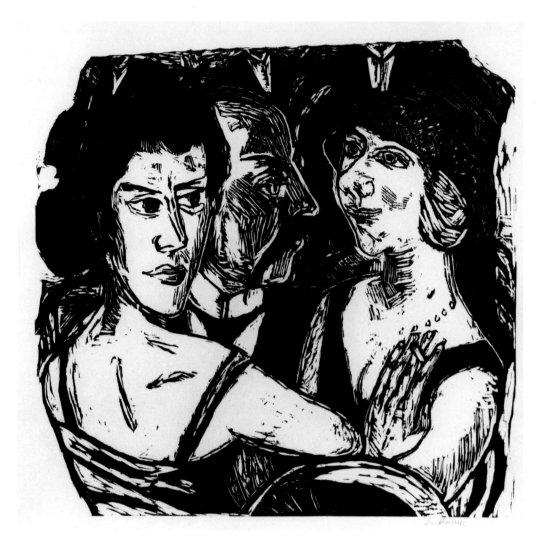

Fig. 69.
Max Beckmann, *Group Portrait,*
Eden Bar, 1923. Woodcut;
19 3/16 x 19 3/16 in.
Lent by Joseph P. Shure
[Cat. no. 6]

of her décolletage forcefully deny the viewer's gaze access to her sex. Clues to the Baronessa's personality are similarly lacking. Her expression is illegible; her eyes stare blankly out of the canvas; her smooth skin acts as a mask. The tuxedoed companions—"male fragments in evening-dress," as Schad called them, who resemble the similarly dressed figures in Beckmann's *Eden Bar* [FIGURE 69][22]—do not clearly play the role of suitors, instead acting merely as the Baronessa's mannequin-like accessories, symbolic only of her participation in a particular social milieu. Schad's style and composition serve to conceal his sitter's "real" personality and relationships, a deliberate appeal to incomprehensibility that she perhaps found necessary for the negotiation of modern society.

Although George Grosz's *Massage* and *The Butcher Shop* [FIGURES 70 AND 71] are not strictly images of entertainment venues, they draw on many of the same strategies discussed here and extend the underlying social critique to its logical conclusion. If life is theater, then Grosz's images of people walking down city streets, visiting brothels and massage parlors, or shopping at the butcher shop are scenes in an endless drama. Never pretending to be a neutral observer, Grosz inserted his own commentary through theatrical

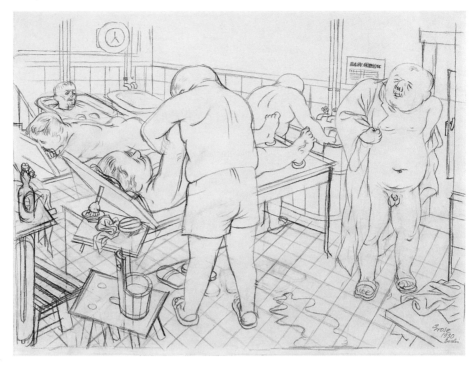

Fig. 70.
George Grosz (1893–1959),
Massage, 1930.
Graphite; 17 ⅛ x 22 ¾ in.
Smart Museum of Art, University
of Chicago, Bequest of Joseph
Halle Schaffner in memory of
his beloved mother, Sara H.
Schaffner, 1974.113
© Estate of George Grosz /
Licensed by VAGA, New York, NY
[Cat. no. 30]

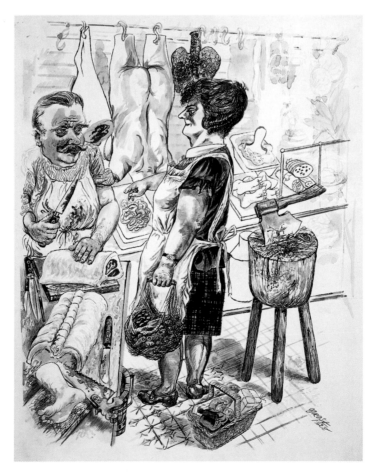

Fig. 71.
George Grosz,
The Butcher Shop, 1928.
Pen and ink with brush and
watercolor; 23 x 18 in. Lent by
Collection of Philip J. and Suzanne
Schiller—American Social
Commentary Art, 1930–1970
© Estate of George Grosz /
Licensed by VAGA, New York, NY
[Cat. no. 28]

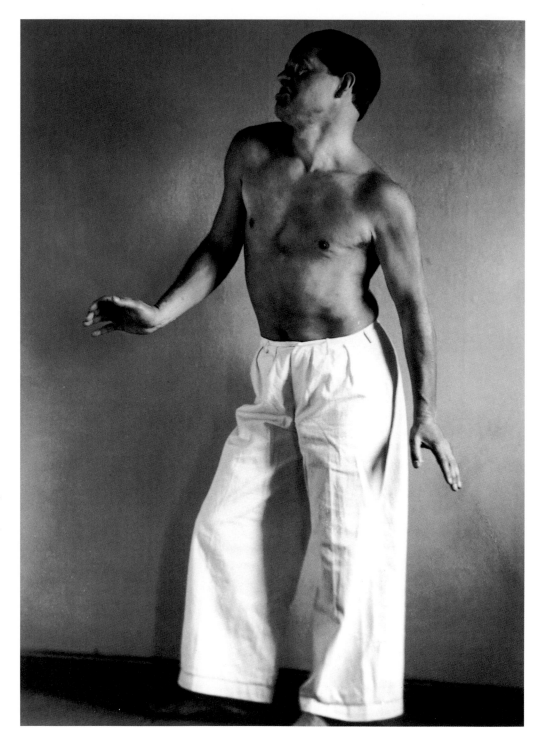

Fig. 72.
August Sander (1876–1964),
The Dadaist Raoul Hausmann,
Posing, from *Portraits of Artists*,
1930 (printed 1974).
Silver gelatin print; 11 ⅛ x 8 in.
Smart Museum of Art,
University of Chicago, Gift of
Susan and Lewis Manilow,
2000.119h
[Cat. no. 99a]

distortion and exaggeration.[23] *The Butcher Shop* initially appears to be an ordinary, if caricatural, genre scene. Its theatricality lies in the shock of recognizing the butcher's wares as human flesh, a grotesque effect that is heightened by the contrast between the saturated color of the female customer's clothing and flushed face and the pale meat that hangs around her. In Grosz's tragicomedy the bourgeois characters act out their assigned roles with deadpan seriousness: the woman buys her choice cuts and the butcher cheerfully provides them. But the viewer is forced to confront the collusive violence at the heart of such everyday interactions.

As Beckmann implied when he depicted himself and his wife as tightrope walkers, August Sander stated explicitly that artistic identity is ultimately a kind of performance, a stance which is literally a *pose*, in his 1930 portrait *The Dadaist Raoul Hausmann, Posing* [FIGURE 72]. The photograph is part of a portfolio of artists' portraits that Sander took between 1924 and 1930; this portfolio in turn belongs to an extensive, lifelong project initiated in the early 1920s entitled *People of the Twentieth Century* [SEE FIGURES 73 AND 74].[24] Photographed toward the end of the Weimar period, nearly a decade after the Berlin Dada group had disbanded, Hausmann here wears the monocle characteristically adopted by many Dadaists, and a beret-like hat, both accessories evoking a self-constructed artistic comportment. With a sneer and a self-conscious shrug, he strikes a defiant Dadaist pose, his naked torso contrasting absurdly with his fastidious monocle and bohemian beret. Hausmann could have adopted just such a pose during one of his Dada dance performances as a physical evocation of the movement's anti-establishment stance. Identified within the group as the "Dadasopher" for his examination of the "epistemologico-critical premises of Dada,"[25] Hausmann publicly rejected Dada in 1921, but continued to take a keen interest in the movement's subsequent portrayal by his former colleagues. Sander's photograph of Hausmann *as a Dadaist* seems to poke fun at his former artistic stance while simultaneously insisting that artistic identity, like any other identity, is a role to be acted. The artist, however critical, is presented as no less immune to the façades of performance.

Artists living in Germany during the Weimar Republic found a wealth of subject matter in the modern urban scene, especially in the variety of entertainments that proliferated in Berlin and other major metropolitan centers. In everyday life, many artists saw a never-ending theater fueled and dramatized by accelerating urbanization. Depicting the circus, theater, revue, and even butcher shop as spaces of performance, artists critically examined the ways in which peoples' roles affected their identities and relationships, often underlining the fragmentation of individual identity that resulted from the constant pressure of performance. Alienated from one another and from themselves, urbanites become tragicomic figures, perhaps enjoying the trappings of a "better" lifestyle, but sacrificing human connections and a sense of self to the brash chaos of a carnivalesque existence in the modern city.

1. For general overviews of the Weimar period, see Peter Gay, *Weimar Culture: The Outsider as Insider* (New York: Harper and Row, 1972); Eberhard Kolb, *The Weimar Republic*, trans. P. S. Fall (Boston: Unwin Hyman, 1988); and Detlev J. K. Peukert, *The Weimar Republic: The Crisis of Classical Modernity*, trans. Richard Deveson (New York: Hill and Wang, 1992). For primary documents see Anton Kaes, Martin Jay, and Edward Dimendberg, eds., *The Weimar Republic Sourcebook* (Berkeley: University of California Press, 1994).

2. See Reinhold Heller et al., *Art in Germany, 1906–1936: From Expressionism to Resistance: The Marvin and Janet Fishman Collection*, exh. cat. (Milwaukee: Milwaukee Art Museum, 1990); and idem, *Stark Impressions: Graphic Production in Germany, 1918–1933*, exh. cat. (Evanston, Ill.: Mary and Leigh Block Gallery, Northwestern University, 1993). For more on art in the immediate postwar period, see Ida Katherine Rigby, *An alle Kunstler! War-Revolution-Weimar: German Expressionist Prints from the Robert Gore Rifkind Foundation* (San Diego: San Diego State University Press, 1983); and Joan Weinstein, *The End of Expressionism: Art and the November Revolution in Germany 1918–19* (Chicago: University of Chicago Press, 1990).

3. For characteristic statements see the "November Group Manifesto" and the "Work Council for Art Manifesto," both reprinted in Kaes et al. (note 1), 477–79.

4. Stephanie Barron et al., *German Expressionism 1915–1925: The Second Generation*, exh. cat. (Los Angeles: Los Angeles County Museum of Art), 1988. Barron and others have argued that strains of Expressionism continued into the mid-1920s, and while this is true, especially in the realms of film and theater, most avant-garde artists had, by 1921, renounced Expressionist modes in favor of various other stylistic options and aesthetic approaches.

5. For more on Berlin Dada, see Richard Huelsenbeck, *The Dada Almanac*, ed. Malcom Green (London: Atlas Press, 1993), which was originally published in Berlin in 1920. See also Stephen C. Foster, ed., *Dada, the Coordinates of Cultural Politics* (New York: G. K. Hall, 1996);

and Hanne Bergius, *Das Lachen Dadas: die Berliner Dadaisten und ihre Aktionen* (Giessen: Anabas, 1989). The dummy dressed in military garb may be seen as a comment on the "stab-in-the-back" legend, the prevalent conservative opinion that leftist activities on the home front, as well as German negotiators' capitulation to the terms of the Versailles Treaty, constituted betrayals of the German army.

6. One of the main exceptions to this dominant interest in figuration is the work of a number of artists associated with the Bauhaus, Wassily Kandinsky and Paul Klee being perhaps the best examples, who continued and expanded their prewar experiments in abstraction.

7. Gustav Hartlaub first used the term "Neue Sachlichkeit" for a 1925 exhibition of paintings that he organized in Mannheim. Although Hartlaub subdivided the artists under the headings "verist" and "classicist" (groupings that he further characterized as left-leaning and right-leaning, respectively), the various differences among artists were largely subsumed under the single heading until the 1970s. Since then, however, research has clarified the meaning of the original term and produced a better understanding of how it pertains to the work of the different artists associated with it. For more on Neue Sachlichkeit, see Gustav Hartlaub, "Introduction to 'New Objectivity': German Painting since Expressionism," in Kaes et al. (note 1), 491–93; Fritz Schmalenbach, "The Term Neue Sachlichkeit," *Art Bulletin* 22, 3 (1940): 161–65; John Willett, *The New Sobriety, 1917–1933: Art and Politics in the Weimar Period* (London: Thames and Hudson, 1978); and Sergiusz Michalski, *New Objectivity: Painting, Graphic Art and Photography in Weimar Germany, 1919–1933* (Cologne: Taschen, 1994).

8. For more on the development of cabaret and the Tingel-Tangel, see Peter Jelavich, *Berlin Cabaret* (Cambridge, Mass.: Harvard University Press, 1993).

9. See Peukert (note 1), 181.

10. Jelavich (note 8), 154.

11. Maximilian Sladek, "Our Show," in Kaes et al. (note 1), 556.

12. Siegfried Kraucauer, *From Caligari to Hitler: A Psychological History of the German Film* (Princeton: Princeton University Press, 1947), 73.

13. On the "return to order" of the 1920s and 1930s as an articulation of realism, see Linda Nochlin, "Return to Order," *Art in America* 69 (September 1981): 74–83, 209–11, which is a lengthy review of the exhibition *Les Réalismes, 1919–1939* (Paris: Centre Georges Pompidou, 1980–81).

14. "Wenn man dies alles—den ganzen Krieg, oder auch das ganze Leben nur als eine Szene im *Theater* der Unendlichkeit auffaßt, ist vieles leichter zu ertragen": Max Beckmann, entry for September 12, 1940, in *Tagebücher 1940–1950* (Munich: A. Langen-G. Müller, 1955), 11, cited in Robin Reisenfeld et al., *The German Print Portfolio, 1890–1930: Serials for a Private Sphere*, exh. cat. (Chicago: David and Alfred Smart Museum, 1992), 95.

15. Reinhard Piper, an influential publisher of works by avant-garde artists, appears as a character in the plate *Backstage* (cat. no. 5b).

16. Reisenfeld (note 14), 97.

17. Reisenfeld (note 14), 97.

18. Max Beckmann, "The Social Stance of the Artist by the Black Tightrope Walker," in Barbara Copeland Buenger, ed., *Max Beckmann. Self-Portrait in Words*, trans. Barbara Copeland Buenger, Reinhold Heller, and David Britt (Chicago: University of Chicago Press, 1997), 279–83.

19. For more on Paul Kleinschmidt, see Barbara Lipps-Kant, *Paul Kleinschmidt 1883–1949* (Tübingen: Universität Tübingen, 1974); and Heller et al., *Stark Impressions* (note 2), 168–71.

20. This lithograph is one of a number of circus themes Heckel produced in 1922; see Annemarie Dube and Wolf Dieter Dube, *Erich Heckel: Das graphische Werk*, 3 vols. (New York: Ernest Rathenau, 1964–74).

21. Gleichmann began concentrating on scenes of the theater, cabaret, and circus in the early 1920s; see *Otto Gleichmann, 1887–1963: Zum 100. Geburtstag*, exh. cat. (Hannover: Sprengel Museum, 1987).

22. See *Christian Schad (1894–1982)*, exh. cat. (Munich: Städtische Galerie im Lenbachhaus, 1997). The partial figures of tuxedo-clad men in Schad's and Beckmann's images very much recall the work of Edgar Degas, who often included men in evening dress as shadowy opera patrons who courted the dancers backstage or as musicians whose phallic instruments rise from the orchestra pit to invade the space of the performers.

23. See, in particular, Beth Irwin Lewis, *George Grosz: Art and Politics in Weimar Germany* (Princeton: Princeton University Press, 1971); and Uwe M. Schneede, *George Grosz: His Life and Work*, trans. Susanne Flatauer (New York: Universe Books, 1979).

24. For more on Sander, see Gunther Sander, ed., *August Sander: Menschen des 20. Jahrhunderts: Portraitphotographien von 1892–1952* (Munich: Schirmer/Mosel, 1980); and Susanne Lange, Alfred Döblin, and Manfred Heitung, *August Sander 1876–1964* (Cologne: Taschen, 1999).

25. Huelsenbeck (note 5), 154. For more on Hausmann, see Timothy O. Benson, *Raoul Hausmann and Berlin Dada* (Ann Arbor: UMI Research Press, 1987).

August Sander

1876–1964

The Pastry Cook, Franz Bremer, Cologne,
ca. 1928 (negative)
Gelatin silver print from *Face of Our Time,* 1929;
10 ¼ x 7 ⅜ in.
Lent by Collection Susan and Lewis Manilow
[Cat. no. 100b]

Young Farmers, Westerwald, ca. 1914 (negative)
Gelatin silver print from *Face of Our Time,* 1929;
10 ¼ x 7 ½ in.
Lent by Collection Susan and Lewis Manilow
[Cat. no. 100d]

August Sander was born November 17, 1876, in Herdorf (Siegerland), Germany, as the fourth child of nine. He attended elementary school and then worked as a slagheap boy at a nearby mining pit. After encountering photography for the first time through observing a photographer working at the slagheaps on assignment, he became interested enough to buy equipment with the help of an uncle in the mid-1890s. During his military service in the 1890s, Sander acted as a photographer's assistant, and beginning in 1899 he assisted an itinerant photographer.

Sander initially worked in Linz, at Greif Photographic Studio, and eventually took it over himself. In 1904 he sold the Linz studio and moved with his wife and two sons to Cologne, where he made portraits of people from that city and the surrounding Westerwald. After serving in the First World War, he returned to Cologne in 1918. During the interwar years, he developed a sharp-focused style, possibly influenced by his association with the Cologne Group of Progressive Artists, an avant-garde group that emphasized objectivity, clarity, form, and geometry.

In 1929 sixty of Sander's portrait photographs were published by Kurt Wolff as *Face of Our Time* (*Antlitz der Zeit*), a book that presents a portrait of an age through portraits of individuals. Photography, a medium associated with both science (descriptive and documentary) and art (expressive and interpretive), seems particulary

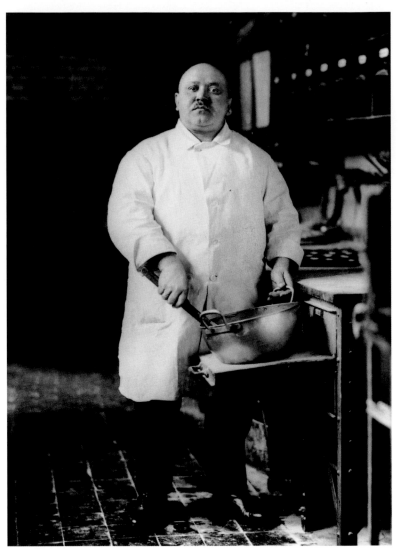

Fig. 73. *The Pastry Cook*

suited to Sander's project, in which the particularities of individual subjects both stand in for and express the specificities and generalities of entire social strata, lifestyles, and stages of life in the early twentieth century.

The Nazis disapproved of Sander's work, and after their rise to power in 1933 they seized *Face of Our Time* and the halftone plates of the images. Sander's portrait work went against the grain of the official idealizing art of the totalitarian regime, and he could continue only in private during the Second World War. Publicly he turned to another passion of his during that

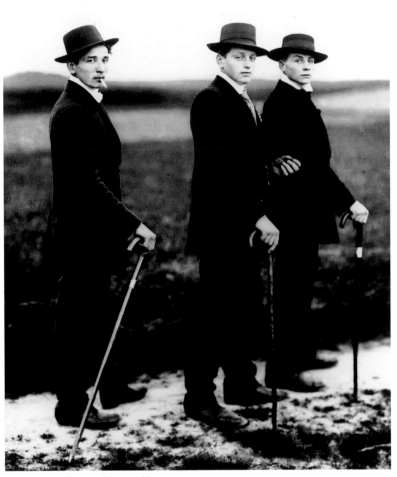

Fig. 74. *Young Farmers, Westerwald*

geois families, officials, businessmen, students, professionals, and artists, to finish with cleaners and the unemployed. There is a definite trajectory to the groupings, moving from the land to the city, from subsistence to wealth, and finally to those without means in an urban setting, those who have fallen through the holes of society's fabric. Although the categories are not declared with captions or headings, each image effectively stands in for whole groups of people, distinguished by profession, age, and status. Sander's portrait of three young farmers is the sixth plate in *Face of Our Time*, one of eight images representing those who live off the land—farmers and shepherds. *The Pastry Cook* is plate sixteen, placed after other tradesmen, the locksmith (*Schlossermeister*) and the decorator (*Berliner Tapezierermeister*).

In *People of the Twentieth Century*, six categories are clearly stated. The first, *Archetypes*, includes Farmers, Young Farmers, Farm Children, Farming Families, Country Life, Rural Characters, The Small Town, and Sport. The second category, *Workers*, includes Artisans and Craftsmen, Manufacturers, Workers, and Technicians. The third category, *Women*, includes Men and Women, Mothers and Children, Children, Families, Society Ladies, and Working Women. The fourth category, *Occupations*, includes Part-time Students (among them Sander's son Erich, later to die as a political prisoner under the Nazi regime). *Occupations* also includes Scholars, Officials, Medicine, Lawyers and Judges, Soldiers, National Socialists, Aristocrats, The Church, Teachers, Businessmen, and Politicians. The fifth category, *Artists*, includes Visual Artists, Writers, Actors, Architects, Painters and Sculptors, Composers, and Musicians. Finally, the sixth portfolio includes marginal people, those who are left behind in the anonymity of the city, or those who are unjustly judged by those in power. This last section of Sander's portraits contains Urban Life, the Circus, Itinerants, Festivities, Servants, Itinerant Tradespeople,

time, landscape photography. This genre proved less threatening to the regime than did his extensive portrait projects, which represented both highs and lows of German society, from the country to the city, from affluence to abject poverty, and in so doing subtly called attention to that society's inequities and problems.

The succinct *Face of Our Time* can be seen as a preview of Sander's more extensive *People of the Twentieth Century* (*Menschen des zwanzigsten Jahrhunderts*). *Face of Our Time* moves from farmers to tradesmen to workers, to political and spiritual representatives, through bour-

Town Characters, and finally, Jewish victims of Nazi persecution.

The most striking aspect of Sander's photographs is their combination of intimacy and distance: we are presented with people in environments and uniforms that define them, and they look straight at us, meeting our eyes. Yet we know nothing about the subjects of many of Sander's portraits beyond their occupation and, sometimes, a name, place, or date. The images are forceful, confronting the viewer with fully defined identities, yet withholding personal details. *The Pastry Cook* has become one of Sander's best-known images. Holding a mixing bowl, wearing his white coat, standing in his enormous commercial kitchen, the chef stares at the camera, proudly representing his profession. He is both individual and generalized type, ordinary man and ideal incarnation of the confectioner.

In the other image seen here, three young farmers on their way to a dance pause to face the photographer. The unfocused generality of the land—their work environment, their livelihood, their life—stretches into the distance behind them. They have exchanged their ordinary clothing for uniforms of another sort: stiff suits, jaunty hats, and fashionable walking sticks. They stare with a little curiosity, seemingly holding still for only a moment before continuing their walk, anticipating the leisure (or the discomfort?) of a dance.

Sander's attempt to classify, record, and generalize the people of his time, without losing the specifics and details of individuals, constitutes a search for German identity. The task he set himself was very much a product of the nineteenth-century urge to record, compare, classify, and thereby constitute categories of living beings. Yet Sander's portfolios transcend that context to become icons of the twentieth century's ambivalence, the new uncertainty that accompanied the modern age's technological development. Sander's portraits function in ways he could not have anticipated. They capture the modern age

in a modern medium—photography—using the most traditional of formats—the portrait. They continue to startle the viewer with the stark clarity of individualized portraits, while simultaneously producing unsettling generalities.
—*Naomi Hume*

Robert Michel
1897–1983
MEZ (Central European Time, No. 1), 1919–1920
Woodcut; 18 ⅛ x 14 ¾ in.
Smart Museum of Art, University of Chicago, Purchase, Bequest of Joseph Halle Schaffner in memory of his beloved mother, Sara H. Schaffner, 1998.16
[Cat. no. 71]

Robert Michel's overarching interest in technology can be traced to his experiences as a test pilot for the German Air Force. After being injured in a plane crash in 1916, he was sent to recuperate in Weimar, where he took fine-arts and engineering courses at the Grand-Ducal Academy of Fine Art (which later became the Bauhaus), and met the artist Ella Bergmann, who became his collaborator and wife. Although Michel's fascination with machines and his view of the artist as engineer or inventor might have allied him with the Bauhaus, and despite the fact that his works were used to demonstrate to Weimar city officials what kind of art the Bauhaus was going to advocate, he disagreed with a number of the doctrines put forth by Walter Gropius and his colleagues, particularly their emphasis on mysticism and pre-modern corporate models such as guilds.

Because Michel's early paintings, drawings, prints, and collages demonstrate a deep commitment to technology as a positive force in modern society, he might be seen as an inheritor of the prewar Futurist program. In the early 1920s, he moved to Frankfurt and eventually became closely associated with Kurt Schwitters, an artist often linked to Dada with whom he shared an interest in advertising ephemera, typographical experiments, and architectural spaces. It is in the

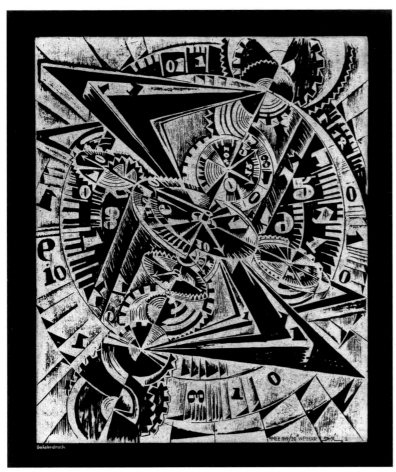

Fig. 75.

dual context of Dada and Constructivism that Michel's mature work should be considered; commentators have compared the position that Michel and Bergmann occupied at the juncture between these two avant-garde tendencies to that negotiated by Hans Arp and Sophie Taeuber. In the late 1920s, Michel became known in Germany in the fields of advertising design and architecture, and in the United States as a collage artist. Recognizing his work's incompatibility with the cultural policies of the Nazi regime, he ceased making art in 1934 and concentrated on fish breeding, not returning to artistic pursuits until a number of years after the war.

MEZ (Central European Time, No. 1), produced in 1919–20, celebrates modern technological progress and looks forward to the future prom-

ised by the newly created Weimar Republic. While utopian in spirit, Michel's artistic position is in stark contrast to that of the postwar Expressionists, whose desire to reestablish the connection between humanity and nature largely constituted a reaction against modern technology. *MEZ* is one of a series of woodcuts that Michel created at the time of the signing of the Weimar constitution, printed in both positive and negative, depicting gears, clocks, engines and tachometers, all symbolic of the modern world. Further emphasizing the work's connection with the founding city of the new German Republic, he inscribed the work "Weimar," as the place of its making, and another woodcut in the series includes the word "August," most likely signaling the month in which the new constitution was signed. The "Central European Time" of the title refers to the time zone of Weimar, and also to chronographic standardization as one of the benefits of this new world order.

The example seen here is a negative impression, printed with silver ink on black paper, mimicking steel. The work resembles an assembly drawing, an engineer's diagram providing instructions for putting together a complex piece of machinery along diagonal axes. Whirring movement is indicated by concentric circles, diagonal "force lines," and the dramatic "Z" form slashing the work. The themes of movement, speed, and time vault the viewer into the utopian future of democracy fueled by technological progress. The *MEZ* woodcuts were in fact intended by Michel as the first products of a much larger project to use models made out of wood and other materials in industrial printing, embossing, and casting. This suggests the extent to which Michel saw the artist's role in society as akin to that of the engineer or inventor and links him, formally if not ideologically, to Russian Constructivism and Productivism.
—*Allison Morehead*

Max Beckmann

1884–1950

Self-Portrait with Cigarette, 1919

Drypoint; 9 13/16 x 7 9/16 in.

Lent by Joseph P. Shure

[Cat. no. 8]

Prior to the First World War, Max Beckmann had precociously established his reputation with a number of honors, a solo exhibition at Berlin's Galerie Cassirer in 1913, and a monograph of his work published that same year. In 1915 he enlisted in the German army as a medical intern and not long afterward suffered a nervous breakdown that contributed to a radical stylistic change. Distancing himself from the painterly expressiveness of his prewar work, Beckmann developed an aesthetic of angular forms, often framed in crowded, claustrophobic compositions.

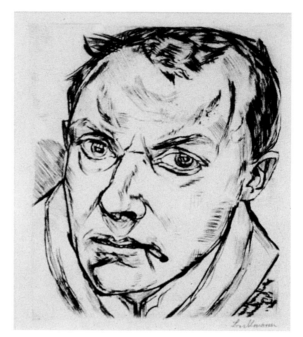

Fig. 76.

Beckmann's lifelong exploration of his own image is evidenced by the more than eighty self-portraits that he produced over the course of his career in a wide variety of media. He often adopted the guise of a circus barker [SEE FIGURE 64], tightrope walker [SEE FIGURE 61], clown, or tuxedo-clad man-about-town. In 1938 he wrote of this exploration: "One of my problems is to find the self, which has only one form and is immortal—to find it in animals and men, in the heaven and in the hell which together form the world in which we live. . . . Self-realization is the urge of all objective spirits. It is this self that I am searching in my life and in my art." Beckmann thus revealed the extent to which he regarded his self-portraiture as an attempt to understand universal aspects of being, rather than as an isolated investigation of an individual person's identity.

After his discharge from the army, Beckmann turned more attention to graphic media, in particular drypoint and etching. In this drypoint of 1919, as in many other self-portraits, Beckmann portrayed himself with an oversized head and a prominent cigarette in his mouth. He appears

not to be wearing a disguise, and he exerts a strong presence, an effect established by the cranial exaggeration and heightened by the lack of a defined setting or background. The artist stares at the viewer intensely, the slight turning of the head and the creased forehead seeming to demand an answer to a monumental question. Heavy burrs of drypoint define the deep crevices and large bags around the eyes, the lips tightly closed around the cigarette, and the jutting chin. His neck virtually obscured, Beckmann's posture exudes tension, as if the muscular effort of his outward gaze were only temporarily sustainable.

Produced as a result of the artist's concentrated observation and self-reflection, the portrait seeks to extract from the viewer a reciprocal presentation of self, particularly through the scanning motion implied by the frozen flecks of light reflected in Beckmann's eyes. In this way, the image signifies at both the individual and universal levels, in keeping with Beckmann's stated aims. The portrait therefore allies the importance of concentrated observation to Beckmann's

project of objective self-realization and under-
standing of the universal nature of being.

Works such as this self-portrait earned Beckmann
recognition as one of the most important artists
in Germany, and his art was actively collected by
German museums during the 1920s. But with
the Nazi purges of the early 1930s, his works
were removed from national collections and
many of them shown in the 1937 "Degenerate
Art" exhibition. The day that this exhibition
opened—the day after hearing a broadcast of
Hitler's speech on the occasion of the inaugura-
tion of the "German House of Art"—Beckmann
left Germany. —*Allison Morehead*

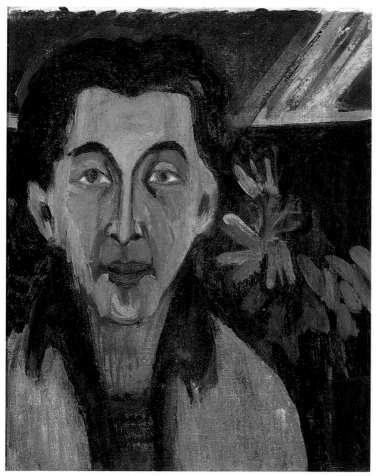

Fig. 77.

Ernst Ludwig Kirchner
1880–1938

Head with Flowers (recto), ca. 1919

Five Children in front of the House (verso), 1921–1923
Oil on canvas; 19 ⅝ x 15 ¾ in./15 ¾ x 19 ⅝ in.
Lent by Joel and Carol Honigberg
[Cat. no. 51]

Ernst Ludwig Kirchner—physically and psycho-
logically debilitated by World War I and his
desperate, drastic efforts to avoid active military
duty—fled Germany for treatment at a sanato-
rium near Davos, Switzerland, in 1917. Three
years earlier he had volunteered, "involuntarily
voluntarily" as he later described it, for a field
artillery division, thereby avoiding being drafted
into the infantry. Activated early in 1915, within
six months he was granted leave as "temporarily
unfit for service." Due to his "secret hunger
strike," his dependence on sleeping potions and
morphine, and his excessive drinking and smok-
ing, Kirchner continued to deteriorate dramati-
cally physically and mentally. Suffering additional
symptoms of fainting spells, periodic localized
paralysis, delusions of persecution, and anxiety
attacks, he finally arrived at Davos, where he
would stay for the remaining twenty years of
his life.

Although still partially lame and otherwise ill,
Kirchner entered a time of great activity at
Davos, resuming painting and printmaking with
renewed vigor and determination. He rejected
the themes of military life treated by many
artists in 1914–16 and focused instead on views
of the Swiss landscape, portraits of his peasant
neighbors, nudes, and self-portraits, as if through
his imagery he were rejecting and denying the
reality and memory of the war from which he
had escaped. In a letter he wrote, "I believe the
colors of my paintings are gaining a new force.
Simpler and even more glowing. . . . Every day
brings me something new."

Head with Flowers, previously dated to 1921–22,
employs a highly simplified composition, with

an *en face* bust portrait posed against a still life transformed into a tapestry-like pattern of flowers. The simple color harmony consists predominantly of greens, blues, pink-violet, and touches of yellows. The clarity of composition, the color combinations, the focused, patterned abstraction, and flattened forms all characterize Kirchner's work of 1919–20, during which time he lived in self-imposed isolation in a rented farmhouse called "In den Lärchen" (Among the Larches) and—during the abbreviated summers of the Davos region—in a small hut high in the Alps. With its determined close-up view of the stiffly frontal face, *Head with Flowers* is closely related to a self-portrait photograph taken by Kirchner in 1919. Indeed, the relationship between the two images is so close as to suggest Kirchner's possible use of the photograph as a model for the painting, which likely is a self-portrait, although the artist's stylizations make a positive identification difficult. Nonetheless, in its format, compositional conception, and coloration, the painting relates to several other self-portraits Kirchner painted in 1919–20, most notably *The Painter* (Staatliche Kunsthalle Karlsruhe) and *Self-Portrait with Cat* (Busch-Reisinger Museum, Harvard University, Cambridge, Mass.). Smaller in scale than these two self-portraits, *Head with Flowers* could well have served as a preliminary exercise in preparation for the more ambitious compositions. In any case *Head with Flowers* can be termed a self-portrait, based on its resemblance to the photograph and to the other self-portraits. Moreover, the opulent bouquet of flowers, with dominating large pink blooms, is identical to the bouquet seen in the painting *Studio Corner* (Nationalgalerie, Berlin), documented as having been under way in 1919 and completed prior to February 1920.

Kirchner re-used the canvas several years after completing *Head with Flowers* to depict on the reverse a study of a group of five young girls wearing short skirts or smocks, playing among the carved pillars of his house. In about

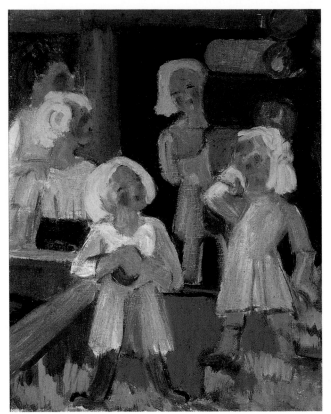

Fig. 78.

1919–23, Kirchner photographed a young girl in a similar blue-gray smock standing before his house. She was one of a group of city children sent to Davos during the summer by the Swiss *Pro Juventute* organization, and these youngsters must have served as inspiration for the painted sketch. This is an unusually playful motif for Kirchner, although he did grant the girls a formal monumentality—reminiscent of the children seen in the paintings of Romantic artist Philipp Otto Runge—that would seem to contradict the levity of tone otherwise apparent in the image. Paired with the somberly posed portrait on the other side of the canvas, *Five Children in front of the House* serves as its antithesis, but it can also be seen as an alternative route that Kirchner chose not to follow as he continued to focus his art on ambitiously conceived, grand compositions and themes that celebrate the majesty of nature, of human existence and life. —*Reinhold Heller*

Wassily Kandinsky

1866–1944

Small Worlds XI, 1922
Etching and drypoint; 9 ½ x 7 ¾ in.
Lent by Jack and Helen Halpern
[Cat. no. 42]

*Engraving for the Circle of Friends
of the Bauhaus*, 1932
Etching and drypoint; 7 ½ x 9 ¼ in.
Lent by Jack and Helen Halpern
[Cat. no. 40]

Born in Moscow to an upper-middle-class family who moved to Odessa in 1871, Wassily Kandinsky did not study art until after he finished a degree in law and economics at the University of Moscow. Offered a position at University of Dorpat in 1896, he turned it down, left for Munich, and embarked on his artistic studies. Kandinsky headed the Neue Künstler Vereinigung München (New Artists Association of Munich), and then led the secession from that organization to form the Blaue Reiter (Blue Rider) group in 1911. The 1912 publication of his first major theoretical treatise,

On the Spiritual in Art (*Über das Geistige in der Kunst*), cemented his reputation as an avant-garde leader in Munich. As a foreign national, he was forced to return to Russia during the First World War, but he returned to Munich in 1921.

In June 1922 Kandinsky was hired as a master of painting at the Bauhaus in Weimar. This innovative school was intended to foster good design at all levels of life, from the mundane to the ideological or spiritual. Its founder, Walter Gropius, conceived of a combination of art academy and arts and crafts school that would be available to industry as a consulting center for art and design. The curriculum at the Bauhaus was divided into Instruction in Crafts (incorporating study of different materials, the mastery of tools, and even book-keeping) and Instruction in Form Problems (approached through courses in Observation, Representation, and Composition, and encompassing everything from the practical study of nature, geometry, and model construction to consideration of theories of space, color, and design). Bauhaus graduates would, it was hoped, master all aspects of design—architecture,

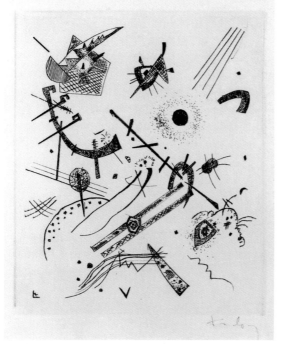

Fig. 79. *Small Worlds*

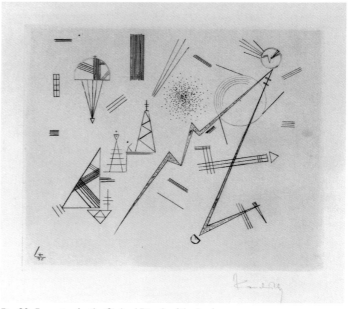

Fig. 80. *Engraving for the Circle of Friends of the Bauhaus*

city planning, furniture, textiles, applied art, typography—and thus by 1925, when the Bauhaus moved to Dessau, individual teachers had combined proficiency in fine art, craft, and industrial design.

Kandinsky had begun his second major theoretical treatise, *Point and Line to Plane*, in Switzerland, just after the outbreak of war. He was still working on it when he returned to Germany in 1921, and ultimately published it at the Bauhaus in 1926. Meanwhile, in 1922, he produced the print portfolio *Small Worlds*. He was working on the written theory when he produced the portfolio of prints, and the two illuminate each other. In *Point and Line*, Kandinsky called the point "a small world," an ultimately invisible primary unit. In Kandinsky's view, the world was always a threshold—to the very large and to the very small. In *Small Worlds* he presented self-contained yet wholly ambiguous environments; one can derive no stable sense of scale from them, nor sense their relation to the space from which we view them. The twelve plates of *Small Worlds* have no conventional captions or legends, only an introductory text which includes simple mathematical formulas: "4 x 3 = 12" and "6 + 6 = 12." The numbers refer to the three graphic media used in the portfolio: four etchings, four woodcuts, and four lithographs; six plates in color and six in black and white. In *Point and Line to Plane*, Kandinsky anticipated that "sooner or later…every composition will be capable of being expressed in numbers, even if perhaps this is true initially only of its 'outlines' and larger complexes." Perhaps he intended the banal mathematical formulas that introduce *Small Worlds* to demonstrate the still-rudimentary relationship between mathematical expression and visual composition, and to suggest the possibilities for its future development that he elaborated in *Point and Line to Plane*. In the treatise he proposed the possibility of a notation for painting, like musical notation, that would enable the simple conveyance, from one mind to another, of color and composition. Perhaps, he suggested, such communication

would occur by means of mathematical equivalences, or along the lines of certain special apparatus used "in physics" to project "sound vibrations onto a surface, thus giving musical sound a precise, graphic form. A similar method is used for color."

One can approach the prints in *Small Worlds* through Kandinsky's equations, considering their media and coloration, or one can ponder the implications of the title. The "small worlds" depicted conjure associations with the galactic scale of bodies in space and with the abstracted worlds revealed through a microscope. In either case, the title calls attention to the fact that these are worlds other than our own, worlds we would not have seen without the intervention of the artist.

The expressive, free, overlapping lines, dots, and shapes seen in the *Small Worlds* etching of 1922 contrast with the entirely geometric, ruled composition of an etching Kandinsky produced a decade later for the Friends of the Bauhaus. This group, founded in 1924, counted five hundred members by 1930, including Marc Chagall, Albert Einstein, Oskar Kokoschka, and Arnold Schönberg. Despite their evident formal differences, both prints share Kandinsky's characteristic dispersal of abstract shapes over a surface, calling up but not confirming iconographic associations from his own earlier representational work, whether microscopic, astronomical, or symbolic motifs. Moreover, both prints present Kandinsky's view of the artist leading his viewers to synthetic understanding, of a single work and of art's role in general. For Kandinsky, the future promised a utopian maturing of the language of art and its role in society—the possibility of a universal language. The Bauhaus ideology paralleled his own for a time, and the environment of the avant-garde school fostered his optimistic belief in the birth and growth of a new spirituality through art. Ultimately, however, the National Socialists dismantled the school, and many of its professors and students went into exile. Kandinsky left Germany for Paris in 1933, never to return. —*Naomi Hume*

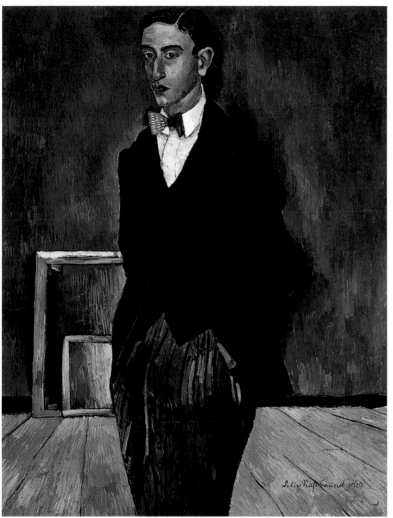

Fig. 81.

Felix Nussbaum

1904–1944

Portrait of a Young Man, 1927
Oil on canvas; 38 ½ x 28 ½ in.
Smart Museum of Art, University of Chicago, Purchase,
Gift of Mr. and Mrs. Eugene Davidson, Mr. and Mrs. Edwin
DeCosta, Mr. and Mrs. Gaylord Donnelly, and the Eloise W.
Martin Purchase Fund, 1982.10
[Cat. no. 85a]

During his student years in 1920s Berlin, Felix
Nussbaum painted this *Portrait of a Young Man*,
which depicts Karl Hutloff (b. 1896), a fellow
art student. Over a decade later, while seeking
refuge from the Nazis in Belgium, Nussbaum

used the reverse of the canvas to represent him-
self in a multiple self-portrait, *Carnival Group*
[FIGURE 93]. The canvas was one of the few
early paintings still in his possession; because it
had been in his father's collection, it had escaped
destruction in the fire set in his Berlin studio in
December 1932, presumably by Nazi sympa-
thizers. This instance of senseless vandalism
presaged a difficult future and marked the end
of the paths that seemed open during the Weimar
Republic. When embarking on his career,
Nussbaum could look to a number of successful
Jewish artists, such as Max Liebermann and
Ludwig Meidner, working in a great diversity of
styles. With the rise of power of the National
Socialists, an artist's Jewish identity resulted in
the absolute condemnation of his or her work.
Nussbaum's double-sided canvas provides a rare
opportunity to examine the alteration in his
artistic vision before and after this profound
social and political shift.

Although it is not a self-portrait, Nussbaum's
image of his colleague seems to have been
intended to demonstrate to his own family the
artistic status he himself had achieved by this
point. It has been likened to a 1912 self-portrait
by Heinrich Assmann (Kulturgeschichtliches
Museum, Osnabrück), which hung in the
Nussbaum family home until 1929, and with
which the young Felix must have been very
familiar. The similarities are striking: the figures
are posed almost identically, in a virtually
empty room, hands stuffed in trouser pockets,
gazing coolly out of the picture. In both images,
the subject is identified as an artist by the inclu-
sion of canvases in the background. The differ-
ences, however, are equally revealing. Nussbaum's
more extreme perspective, emphasized by his
inclusion of the floorboards, gives a particularly
drastic impression of isolation. In addition, his
more prominent inclusion of canvases turned
toward the wall (which oddly foreshadows
Nussbaum's later use of this canvas's reverse
side) explicitly connects this isolation with the
identity of artist, thus repeating the mytholo-

gized prototype of the marginalized, misunderstood modern artist.

Much of the commentary on this portrait has focused on the young man's proper bourgeois attire—dark jacket, pinstriped trousers, and bow tie—which contrasts with Assmann's decidedly working-class shirtsleeves. In Berlin Nussbaum was known for his proper dress, a sartorial effort probably meant to prove to his family that an artist could be a good bourgeois professional. This figure is an artist, but he is not dressed as he would be to paint. He seems ready instead to meet with dealers and collectors, and thus to engage in the respectable business side of what Nussbaum's family considered a bohemian pursuit.

Carnival Group [FIGURE 93] similarly aims to affirm Nussbaum's artistic identity, but it was produced under a more dire threat of condemnation and death. In a series of self-portraits from 1936–38, he represented himself in different guises and with varying facial expressions, influenced by Belgian artist James Ensor, with whom he was acquainted. Similar figures appear in Gert Wollheim's 1924 canvas, *Departure from Düsseldorf* (Kunstmuseum Düsseldorf), which Nussbaum could have seen in Berlin in 1925. Wollheim, like Nussbaum, was forced to flee Nazi Germany, because of his status as both a politically outspoken, vanguard artist, and (according to National Socialist policy) his Jewish ancestry.

Carnival Group brings together several of the distorted, masked faces also seen in Ensor's and Wollheim's work to project Nussbaum's conflicted and threatened identities. Each face in the picture suggests a different element of exile. Nussbaum feminizes the central figure of this painting with earrings and a necklace, emphasizing the ambiguity and necessary malleability of a persecuted refugee. A man in a beret—perhaps a symbol for Nussbaum's artistic identity— stares broodingly out over the group. To his left, a mouthless man wears a cap and a shawl, which have been likened to the garments of Jewish worship, the *yarmulke* (skull cap) and

tallis (prayer shawl). A top-hatted figure in the back may attest to Nussbaum's erstwhile reputation as a dandy. The masking or deletion of facial characteristics suggests the erasure of Nussbaum's earlier identities and his formerly assimilated status as a Jewish-German citizen. The grotesque figures in *Carnival Group* confront the viewer at eye level, while the affluent bourgeois gentleman on the other side of the canvas gazes downward from a more distanced position. Yet it is he who is part of a flourishing artistic community, that of Weimar-era Berlin, while the physically proximate clustered figures nonetheless suffer the alienation of exile and persecution.

Nussbaum and his wife, Felka Platek (1899–1944), did not survive their exile. In July 1944, exposed to the Nazis by a still-unidentified informant, they were forcibly removed from Belgium on the last deportation train to Auschwitz, where they both perished.
—*Allison Morehead and Celka Straughn*

Paul Klee
1879–1940
Genii, 1937
Graphite; 12 ¾ x 19 in.
Lent by Jack and Helen Halpern
[Cat. no. 53]

By 1937 Paul Klee had returned to Switzerland, his country of birth, after spending the bulk of his artistic career in Germany. Academically trained in Munich, Klee became involved with the Blaue Reiter group and later with the New Munich Secession. After World War I, he left Munich to take up a position at the Bauhaus, first in Weimar and then in Dessau, where he shared a house with Wassily Kandinsky. Like many artists associated with the Bauhaus, Klee was an early target of virulent Nazi criticism: in 1933, his house in Düsseldorf was searched and he was dismissed from his post at the Düsseldorf Academy, where he had taught since 1931. His career in Germany thus brought to a close, Klee returned to Berne at the end of 1933. There,

Fig. 82.

financial instability and severe illness slowed his creative activity considerably. But the year 1937 marked the beginning of a remarkably productive late phase, a renewed interest in artistic experimentation, and a new certainty of direction. *Genii*, with its purified reduction of forms and its simultaneous evocation of the human figure and landscape, is emblematic of many of Klee's formal and thematic concerns from 1937 to his death in 1940.

The "Degenerate Art" exhibition of 1937 launched a particularly perverse attack on Klee's work by emphasizing its resemblance to the "incompetent" and "debased" art of children and schizophrenics—work that Klee in fact valued among his most important influences. Like many of his contemporaries who looked for the origins of human creativity outside academic models, Klee sought to emulate in his own work the whimsy and seeming irrationality that he saw in the art of children and the mentally ill. In his late drawings, including *Genii*, Klee emulated the economy of children's drawings: curves give the slightest indication of volume, and the most reduced forms stand as signs of a tree, person,

mountain, or alphabet letter. In *Genii* graphite lines come together in two places to form the most schematic of faces, and, in the upper central portion of the work, to suggest a tree. Elsewhere, these marks remain detached from each other, as ur-forms ripe with possibilities.

Klee's enigmatic titling provides another dimension to many of his works. *Genii*—the plural of *genie*, a class of familiar spirits in Arabic folklore—suggests the extra-human capabilities of these simple forms. In other works incorporating *Genii* into the title, dance or movement is made explicit. For Klee, the perceived movement and metamorphosis of lines constituted an integral part of experiencing a work of art; he compared the viewing process with the construction of the natural world out of various elements and therefore deemed it a form of creation in itself. Works such as *Genii* reveal this dynamic process of viewing in its essentials.

With Klee's concern for the originary and metamorphic aspects of form came a renewed, and highly individual, investigation of the nature of different media. Less interested in the essential

features of drawing or painting than in exploring how *this* pencil and *this* paper interact, Klee scrutinized the expressive potential of his materials. In *Genii*, pencil and paper reveal each other: the easily smudged quality of the marks made by a soft, relatively thick pencil becomes apparent when seen against thick, textured paper stock, which in turn produces slight modifications or wavering in the lines. Ground and figure thus merge in such a way as to produce a formal harmony between two materials with the most economic of means. Klee reproduced this experiment using a variety of media (paste ink on newspaper, thin hard pencil on packing paper, oil on burlap), allowing materials to suggest forms. Most apparent in works such as *Genii*, this attention to the interaction between artist, pencil, and paper—often overlooked in favor of the rich thematic content and formal sophistication of Klee's later phase—evidences the artist's belief in the creative process as a fundamentally human endeavor.
—*Allison Morehead*

Hans (Jean) Arp

1887–1966

AA, 1948
Woodcut; 10 x 7 ⅝ in.
Smart Museum of Art, University of Chicago, Gift of Perry Goldberg, 1983.156
[Cat. no. 1]

Mask, 1948
Woodcut; 8 ⅝ x 6 ⅜ in.
Smart Museum of Art, University of Chicago, Gift of Perry Goldberg, 1983.157
[Cat. no. 2]

The complexity of Hans Arp's national identities parallels the political turmoil in Europe in the early part of the twentieth century. When he was born in Alsace, the region was part of Germany; it reverted to France after World War I. Bilingual and belonging equally to German and French cultures, Arp found himself between them for much of his life, and his cultural legacy

is today disputed by organizations in Germany, France, and Switzerland (where he lived and worked for many years). Arp's artistic career began in Germany, where he collaborated with Herwarth Walden's periodical and gallery *Der Sturm* in Berlin and participated in the Munich-based Blaue Reiter group. During the First World War, in neutral Zurich, Arp and the German exile Hugo Ball were among the founders of the Dada movement, and Arp later became a kind of Dada ambassador, exhibiting with groups in Cologne, Berlin, and Paris. His avant-garde credentials eventually supported his strong reputation in Parisian Surrealist circles and later among artists interested in Constructivism.

Arp's oeuvre, which includes painting, prints, collage, and sculpture, demonstrates his lifelong

Fig. 83. *AA*

Fig. 84. *Mask*

the prewar German avant-garde, the inclusion of the wood grain as a principal visual element calls attention to technique and process. With this gesture Arp aligned himself very deliberately with the longstanding German tradition of the woodcut, recently reinvigorated by his Expressionist colleagues. By employing simplified abstract shapes, however, Arp distanced himself from the largely representational mode of most woodcut production.

Arp's iconic forms act like multivalent signs. *AA* recalls graffiti carvings on tree trunks, while at the same time suggesting mountain peaks. It might thus be read as the imprint of a landscape representation carved into a piece of the landscape itself. As such, it conforms to Arp's desire "not . . . to reproduce but to produce." Abstract art, he argued, was better understood as concrete art, as the production of things that, rather than representing nature, take their rightful place within the natural world. "These paintings, sculptures, [and] objects," he wrote, "should remain anonymous and form part of nature's great workshop as leaves do, and clouds, animals, and men." The evident grain in Arp's woodcuts is therefore not a representation of wood grain, but the concrete mark of the grain itself, and thus signals the realigned, organic relationship between art and the world advocated by the artist.

Mask also foregrounds the grain of its original woodblock, and bears an additional referent to human activity in its title, which helps the viewer to attach meaning to the form. Arp carved a wood relief of the same name during his Dada years. The motif of a mask is emblematic of the desire to merge with and be subsumed by an abstract form—like a child who cuts a simple disguise out of paper, or like the artists who participated in Dada cabaret performances dressed in costumes that obscured the human body with abstract forms. The tension here between the German woodcut and the irreverent antics of Dada performance, between tradition and playfulness, marks Arp's early work, and indeed much of his career. —*Allison Morehead*

interests in automatism, chance, and organic forms, as well as his experimentation with unorthodox materials. He began his concerted exploration of alternate materials, and of alternate uses for traditional materials, during his Zurich Dada period, where he was largely inspired by his collaborations with Sophie Taeuber, an innovative artist originally trained in textile design who later became Arp's wife. *AA* and *Mask* date from 1948, but they hearken back to this early period of experimentation, particularly to the prints that Arp published in Dada periodicals between 1916 and 1920.

Dada is often seen as a rejection of past artistic values, but Arp's woodcuts reveal the extent to which this is an oversimplification. While their bold abstract forms constitute a definite break with the figurative Expressionism practiced by

Fig. 85.
Hans Hofmann (1880–1966),
Untitled #33, 1943.
Ink, watercolor, and gouache;
14 x 17 in.
Smart Museum of Art, University of
Chicago, From the collection of
Janice and Henri Lazarof, 2000.36
[Cat. no. 37]

Resistance and Exile
Artistic Strategies under National Socialism

REINHOLD HELLER,
NAOMI HUME,
ALLISON MOREHEAD,
& CELKA STRAUGHN

After Adolf Hitler was appointed chancellor and the National Socialists came to power on January 30, 1933, new policies threatened the artistic practices, professional identities, and indeed the very lives of many artists who had enjoyed relative freedom and even governmental support in pursuing their creative aims throughout the Weimar period. However, as the Nazis gained power in various German states during the waning years of the republic, some artists—particularly Jewish artists and those associated with leftist political groups or publications—had already felt the oppressive effects of National Socialist ideology and cultural policies. In 1930 Wilhelm Frick became the first Nazi Party member to receive a ministerial position in a state government when he was appointed Minister of the Interior and of Education in the state of Thuringia. One of his first, and farthest reaching, activities was to issue the decree *Wider die Negerkultur für deutsches Volkstum*, a typically opaque example of Nazi jargon roughly translatable as "Against Negro Culture for the German People." Initially intended as a "cleansing action" directed at musical and theatrical productions and at schools, the decree soon justified Frick's removal of works of modern art from display in Weimar's museums because these works "had nothing in common with Nordic-German being [*Wesen*], but rather limited themselves to depicting Eastern and other racially inferior subhuman types."[1] At the State College for Handicrafts and Architecture, established after the Bauhaus was forced to leave Weimar in 1926, Frick dismissed thirteen teachers; cut the budget in half; and installed the reactionary designer, critic, and ecologist Paul Schultze-Naumburg—who became a Nazi Party member in 1931—to serve as its new director. In his inaugural address, Schultze-Naumburg swore to uphold "art's links to the racially correct" and to defend it against the "cultural Bolshevism [of] subhumans."[2] A few months later, he ordered that Oskar Schlemmer's 1923 Bauhaus frescoes and wall sculptures be removed, painted over, or otherwise destroyed.

Despite the warnings that Frick's policies and actions in Thuringia should have provided, many German artists did not immediately realize the full implications of Nazi cultural and social policy, believing that they could work with the new regime as they had with prior Weimar governments. Even though Frick, the Reichsleiter (Reich cultural leader) Alfred Rosenberg, and other Nazi officials vehemently despised progressive modern art and sought to suppress it, other powerful and policy-setting party members, including Joseph Goebbels and Hermann Goering, either tolerated or openly supported Expressionism and other avant-garde movements. The periodical *Kunst der Nation* (*Art of the Nation*), published between 1933 and 1935, was founded specifically to argue that Expressionist styles were

the appropriate artistic manifestations of the "national revolution" of January 1933. During the summer of 1936, an exhibition held on the third floor of the Crown Prince's Palace in Berlin to mark the Olympic Games featured the National Gallery's eminent collection of modern German artists "from Corinth to Klee" assembled by Ludwig Justi since the end of World War I (the two floors below featured "Great Germans in Portraits of Their Time").[3] After some 63,700 international visitors attended the National Gallery exhibition and the Olympics ended, however, the third floor of the Crown Prince's Palace was closed to the general public, although privately arranged viewing of the Expressionist works there remained possible for several months longer. Soon thereafter, Hitler would end the Goebbels-Rosenberg rivalry and announce his determination to foster an "art of the National Socialist period" through political and racial suppression.[4]

Nazi Art Policies before 1935

As Frick's activities in Weimar testify, the Nazis' "cleansing of the temple of art" had begun even before they came to power in Berlin. Already in 1920 a group led by the reactionary arch-nationalist Bettina Feistel-Rohmeder in Dresden organized the German Society for Art (*Deutsche Kunstgesellschaft*), dedicated to opposing the "rotting of art" and to promoting a "pure German art" appropriate for "the nature of the German" (*dem deutschen Wesen*).[5] With money collected from far-right extremist groups after an international exhibition in Dresden in 1926, Feistel-Rohmeder founded an art news service, German Art Correspondence (*Deutsche Kunstkorrespondenz*), to deliver its aesthetic doctrines under the guise of reportage to newspapers and news organizations. The periodical *Deutsche Bildkunst* (*German Pictorial Arts*) also furthered the "struggle against cultural Bolshevism." In 1930 Feistel-Rohmeder's organization joined Alfred Rosenberg's League of Combat for National Socialist Culture (*Kampfbund für nationalsozialistische Kultur*), founded in 1928, to form the Leadership Council of the United Organizations for German Art and Culture (*Führer-Rat der Vereinigten Deutschen Kunst- und Kulturverbände*), which soon incorporated seventeen different organizations, claimed a membership of 250,000, and formally allied itself with the Nazi Party. The United Organizations expanded the *Deutsche Bildkunst* and used it as their official mouthpiece, featuring regular contributions by Paul Schultze-Naumburg. His energetic propaganda campaign against modern art also included a series of slide lectures entitled "The Struggle for Art," based on his 1928 book of the same name, in which he compared figures in Expressionist paintings to photographs of physically deformed people and inmates of mental institutions in order to demonstrate how "in the pictures of the so-called moderns the dignity of humanity is torn down, how in crudely sketched scribbles an animal-like subhumanity is depicted."[6]

Eager to prevent more tolerant voices from gaining an upper hand in the new National Socialist government, in 1933 the United Organizations published its demand that

materialism, Marxism, and Communism be politically prosecuted, outlawed, annihilated. . . . In the field of the pictorial arts, this means:

1. That all productions with symptoms of a cosmopolitan or Bolshevist nature should be removed from German museums and collections. First they can be presented collectively to the public, to make them known along with the sums expended for them and the names of

the gallery employees and the minister of culture responsible for them—after which these works of non-art can only have one remaining value: that is as heating materials to warm public buildings.

2. That all museum directors who sinned against the impoverished state [and] against the suffering German people through their unconscionable waste of public moneys during a time of extreme deprivation, who under the press-induced pressure of anti-German so-called art historians opened our art museums to everything non-German, but "placed into storage" the truly German works of art, piled them up in dank cellars—that all these museum directors be "retired" immediately and be forever declared incompetent in their profession. . . .

3. That after a designated day the names of all artists who were Marxist or Bolshevik camp followers no longer be allowed to be mentioned in any German publications. . . .

4. That in the future in our Fatherland we will no longer have to see any box-like apartment buildings, any churches that look like greenhouses with chimneys or any reconstructed Viking ships in stone, any glass boxes on stilts, any orientalish cave dwellings whose roofs leak water because of the incompetence and ignorance of their architects, any penal colonies that are supposedly worker's homes and are built with public funds. . . .

5. That all public monuments and statues that the public opinion of the German people rejects and that are the eyesores of our public parks and gardens immediately disappear, even if their originators are such "genial" people as [the sculptors Wilhelm] Lehmbruck and [Ernst] Barlach.[7]

Essentially, these are the attitudes that would be manifested later in National Socialist art policies. Prior to 1936, however, they were only fitfully implemented by the Berlin government, largely as components of broader measures that were not directed specifically at art and its institutions but at other aspects of German society and life.[8] For example, one of the outcomes of the Law for the Restoration of the Professional Civil Service, which sanctioned the dismissal of "politically unreliable" and "non-Aryan" state employees, was that more than twenty directors of public museums—who in Germany as in other European countries were and largely remain today part of the civil-service system—were forced into "voluntary retirement" or "permanent leave" in 1933 and 1934. In addition, artists such as Max Beckmann, Paul Klee, Otto Dix, and Max Pechstein were deprived of their teaching positions at publicly funded art academies, and similarly Max Liebermann, Käthe Kollwitz, Emil Nolde, Karl Schmidt-Rottluff, and Ernst Ludwig Kirchner were "invited" to resign their Prussian Academy memberships, which had been awarded by the Weimar Republic in recognition of their achievement.

In Mannheim, Dr. Gustav Hartlaub became the first German museum director to be suspended and then dismissed because he had "sponsored everything that was negative and destructive in content and form and fought against everything creatively German and of a German sensibility."[9] Immediately after Hartlaub's suspension, the first of the *Schandausstellungen* (Exhibitions of Shame) was hurriedly organized by Gebele von Waldstein, the newly installed and apparently self-appointed head (armed SS men accompanied him to the museum when he claimed his position). Before his sudden entry into museum administration, Waldstein had served as a telegraph official; his professional credentials were his membership and position in the Nazi Party. He inaugurated his

administration by allowing Marc Chagall's *Rabbi* (1923/26; Kunstmuseum Basel) to be dragged ignominiously through Mannheim in an open cart and then placed on display in a cigar-store window with the sign: "Taxpayer: You should know where your money went." The "Bolshevist Art Exhibition" opened on April 4, 1933, then traveled to Munich and Erlangen to become the prototype for other similar displays, most notably the exhibition "Degenerate Art," held in Munich in 1937. In a lengthy press release, von Waldstein proclaimed wordily and with strained syntax:

> The exhibition is intended to show the abyss into which we were driven. It should function educationally by means of the dismay caused through this destruction of our artistic nature and by means of a steady return and guidance to the old German artistic ideals of order, plastic presentation [*plastische Gestaltung*], beauty of colors, solidity of painterly technique, free construction of space [*freien Raumbildung*] or surface division, following the rules of picture making, [and not lead to] arbitrary anarchy, not to a formlessness contrary to nature.[10]

Similarly, another report concluded that "a German person walking through this exhibition will without a doubt come to the conclusion that it was Jews and Jewish art galleries" that convinced the "inept" dismissed museum director to purchase such examples of "pseudo-art" (*Afterkunst*, more literally translated as "anus art"), which necessarily must "enrage the aesthetic sensibility of a healthy human being."[11] While Frick in Weimar in 1930 had limited himself largely to removing paintings from the museum's walls, in Mannheim Waldheim inaugurated a process of defamation and ridicule through confiscation and derogatory display. This strategy tied modern art to the despised Weimar Republic, Jews, "Bolshevists," and "Asphalt Berliners," and postulated it as the antithesis to a healthy German art produced by artists with "deep roots in the soil of the homeland" (examples of which were also shown, but remained little discussed in the press). Significantly, while the Mannheim exhibition and its counterparts in other cities invariably received extensive local newspaper coverage, the national Nazi press paid minimal attention to them. The time for a concerted, centralized campaign against modern art had not yet arrived.

The actions against artists and museum personnel were but lesser reflections of the draconian emergency decrees promulgated during February and March of 1933. Wide-ranging directives ended freedom of the press and outlawed all criticism of the regime, and transformed the Nazi paramilitary SA, SS, and the allied right-wing *Stahlhelm* (Steel Helmet) organizations into auxiliary police forces. After the Reichstag fire of February 27, personal freedoms, the free expression of opinion, and the right of free assembly were further suspended, while the Enabling Act of March 23 empowered the central government to act outside constitutional limits and without parliamentary oversight. During the following months, in the further implementation of *Gleichschaltung* (the subordination of everyone and everything to the central authority), all political parties other than the NSDAP were banned, state governments and parliaments were dissolved and replaced by appointed Reich Commissioners, and labor unions as well as other trade associations were absorbed into Nazi-sponsored substitutes. Waves of mass arrests, lootings and harassment of Jewish businesses, and the construction of the first concentration camps to collect the numerous "enemies of the Reich" offered additional evidence of the ruthless suppression by the

Nazis of all actual, perceived, and potential opposition. Kollwitz recorded in her diary the varied restrictive and persecutory measures of the new regime. Although she listed them without comment, in part because she feared that her house would be searched for documents incriminating her as an enemy of the government, the stark chronological sequence nonetheless conveys her despair:

> On February 15th [the author] Heinrich Mann and I had to resign from the [Prussian] Academy [of Fine Arts]. Arrests and house searches. . . . Complete dictatorship. April 1st, Jewish boycott. . . . In all of Germany there exists now only the National Socialist Party. There is no longer a single newspaper that presents a different opinion.[12]

The noted historian of Germany, Gordon Craig, has observed that by 1934 Hitler "had freed himself from the restrictions of the democratic constitution and from the possibility of serious opposition from autonomous political or economic organizations."[13] In less than a year, Hitler established himself as Germany's totalitarian dictator with "comprehensive and total" power, "not hemmed in by conditions and controls, by autonomous preserves or shelters and jealously guarded individual rights, but . . . free and independent, exclusive and without restriction," as a Nazi political theorist proudly stated at the time.[14]

Art clearly came under Hitler's purview within this system of absolute control, and he took significant interest in it, discussing the subject in *Mein Kampf* (written 1924–26) as well as in various speeches. However, until 1937 he let the Goebbels-Rosenberg rivalry continue without a decisive intervention. Thus in Berlin, at the Ministry of Propaganda, Goebbels surrounded himself with works by Nolde and Barlach and advocated a policy favoring "Nordic Expressionism," while Rosenberg's cohorts in local chapters of the German Society for Art and the League of Combat for National Socialist Culture, supported by other Nazi Party members and municipal officials in Dresden, Chemnitz, Nuremberg, Munich, Karlsruhe, and Mannheim, began to organize exhibitions of the works of "Cultural Bolshevism" that local museums had purchased and collected during the "Regime of 1919–1933."

Despite the *Schreckenskammer* (Chamber of Horrors) exhibitions that defamed Expressionism and other progressive art styles, despite the "retirements" of numerous museum personnel and art academy teachers, and despite continuing attacks on modern art by local Nazi officials as well as by Rosenberg and his followers, the attitude of Hitler's regime toward modern art prior to 1937 has to be considered ambivalent and inconsistent. The whims of local Nazi Party leaders determined whether an artist was praised or condemned, and not infrequently actions by one official were negated by the actions of another. Oskar Schlemmer, for example, saw his paintings first installed at the Stuttgart Art Guild in March 1933, then taken down, and finally re-hung in "two back rooms accessible only to insiders of unquestionable character." A Nazi leader even wrote a letter of complaint to Hitler himself about the treatment accorded the artist. Schlemmer remained indecisive, torn between mounting an organized protest and withdrawing into private retreat: "We should enter the lists and fight the good fight. For the worst is yet to come! . . . What course should one take? Cultivate art only within one's four walls, on Sundays! Find some practical second profession? But what?"[15]

Hope, Indecision, and Exile: Nazi Policies and Artists' Responses before 1937

Such indecision plagued the majority of German artists in the early years of the Third Reich. Even if repelled by the activities of the National Socialists, they retained a desperate hope that somehow they could continue to work and to exhibit; that the worst could be kept at bay, perhaps (as Schlemmer hoped) by "decent people among the Nazis." And a few thought that the contentious arguments about art between the Rosenberg and Goebbels factions pointed toward the regime's imminent failure. The noted dealer of modern art Alfred Flechtheim expressed this view in Paris in July 1933 to Harry Count Kessler, an ardent early patron of modern art in Weimar who left Germany immediately after the March 1933 Reichstag elections.[16] In October, Kessler remained convinced that the Nazi regime was bound to collapse because Hitler was "in the final analysis nothing more than a painter's apprentice whose big mouth won him a position for which he is spiritually unfit."[17] The collapse, of course, did not come in the autumn of 1933. Instead, the Nazi regime continued its systematic suppression of remaining opposition through the imposition of stringent control on public expression and thought. If hope remained—either for the triumph of "liberal" Nazi factions or for Hitler's downfall—it was increasingly confined and circumscribed, serving as the self-deceptive mask of despair.

Erich Heckel exemplifies the ambivalent position in which many progressively oriented artists now found themselves. During the 1920s he had forsaken his Expressionist mode and evolved a more rationally based art that included some classicizing elements. Works by Heckel were among those selected by Frick for removal from the Weimar Museum, and in 1933 his works were included in the various "Cultural Bolshevism" exhibitions denigrating modern art. On June 29, 1933, at a highly publicized rally of the National Socialist Student Association in Berlin, however, Heckel was lauded along with Kirchner, Schmidt-Rottluff, Barlach, Klee, and Nolde as a precursor for a "new German art," and he was included in the exhibition "Thirty German Artists" that the Student Association sponsored at the Ferdinand Moeller Gallery in Berlin in July.[18] Later, in the autumn of 1933, after the founding of the Reich Cultural Chamber (*Reichskulturkammer*) under Goebbels's leadership to organize all aspects of German cultural life, Heckel was among the jurors selected for a series of art competitions to be sponsored by the newly founded organization Strength through Joy (*Kraft durch Freude*, known by its initials as KdF), which was intended to regulate workers' leisure activities. He did not continue to receive such official approbation, however. When Rosenberg took over the KdF in January 1934, he moved immediately to dismiss the Goebbels-approved appointments.

Caught in the middle of these vacillations of policy, Heckel retreated to the snows of the Lesser Walser Valley (Kleinwalsertal) in the Alpine border region of Austria, a small area that projects into the Allgäu area of southeastern Germany. Newly accessible by road from Germany and under German customs jurisdiction in the early 1930s, the Kleinwalsertal was already attracting large numbers of Germans seeking *Erholung*—relaxation and recreation—amid the majestic mountain landscape. (It remains today a major tourist area for winter sports and summer hiking tours.) Choosing this site, Heckel seemingly wished to distance himself physically and psychologically from the new Germany without quite

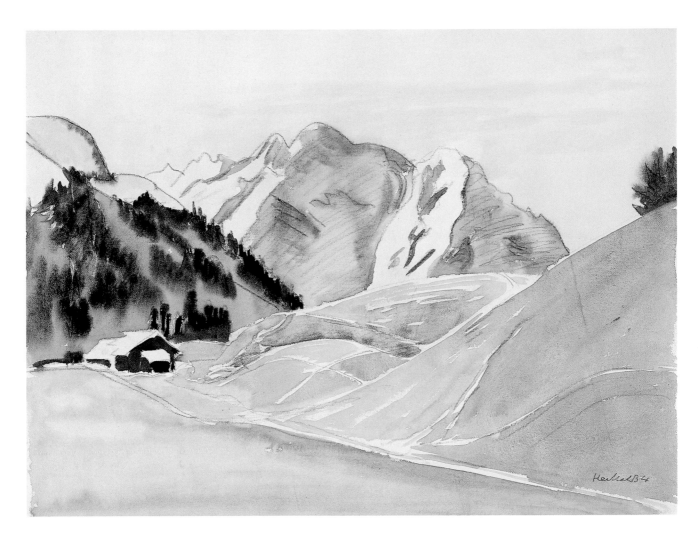

Fig. 86. Erich Heckel
(1883–1970), *Gray Slopes
(Lesser Walser Valley)*, 1934.
Watercolor, graphite, and wax
pastel; 18 ¾ x 24 ¾ in. Smart
Museum of Art, University of
Chicago, Purchase, Paul and
Miriam Kirkley Fund for
Acquisitions, 2001.42
[Cat. no. 35]

leaving it; from the Kleinwalsertal escape might be possible, if only as an arduous trek
across the Alps.

The large-scale watercolor *Gray Slopes (Lesser Walser Valley)* [FIGURE 86] is one of an
informal series of panoramic landscape vistas that Heckel produced during this period.
These watercolors suggest harmonious interaction and peaceful coexistence between nature
and humankind, a relationship formed across centuries of time and memory. In *Gray
Slopes*, the simple wooden structure of a traditional Alpine house, a quiet sepia-colored
presence prominent amid the snow's rich profusion of nuanced white and gray, echoes the
silhouette of the mountains behind it and the tones of the bushes and trees emerging from
morning mists nearby. The composition's gently flattened planar organization paradoxi-
cally suggests infinite spatial extension.

The subject matter of Heckel's watercolor would seem to align it with the Alpine adulation
seen in the popular films produced during the 1920s and early 1930s by Arnold Fanck, Luis
Trenker, Sepp Allgeier, and Leni Riefenstahl. Typically adhering to the mystical conserva-
tive ideology of Nazism, these films celebrate the power and majesty of Alpine peaks,

glistening glaciers, glittering icy caverns, and dramatically shifting clouds. Cold, impersonal nature demands subjugation through heroic human conquest. Heckel, by contrast, portrayed nature as *Heimat,* a protective homeland within which humans have sheltered since time immemorial, and which generates geographic identity for individual and community.

Moreover, Heckel's majestic Alpine winter scene readily recalls the landscape practice of German Romanticism, particularly the mystical mountain views of Caspar David Friedrich or Ludwig Richter. In recalling these emotive and stylistic concerns, Heckel allied himself overtly with established German traditions, declaring his identity as a German artist and defending himself against the Rosenberg faction's condemnation of his art as non-German, Bolshevist, and Jewish. At least implicitly, Heckel proclaimed in his watercolors that he— and not painters allied with Rosenberg's League of Combat for National Socialist Culture— was an artist with "deep roots in the soil of the homeland." Unwilling to be deprived of his German identity by Nazi defamation, in the cold snow-covered retreat of Austria's Kleinwalsertal, Heckel attempted to argue his position through the strength of his imagery. His opponents, however, employed more brutal, indeed deadly, means.

If Heckel could avoid overt political commentary and adopt a wait-and-see attitude in 1933 and 1934, other artists—those who had been associated with the political left or were Jewish—could not share such temporary illusions of potential optimism. Kollwitz, as noted earlier, lost her teaching position at the Berlin academy and found herself under constant surveillance. Since the 1890s she had consistently supported leftist causes and focused her imagery on the plights of the lower classes and of women; the First World War prompted her to add pacifist themes to her inventory [FIGURE 56].[19] During the early weeks of Hitler's chancellorship, as part of a last-ditch, futile effort to prevent a Nazi majority in the Reichstag elections of March 5, 1933, Kollwitz and Heinrich Mann—both still members of the Prussian Academy of Fine Arts at that time—along with other German artistic and intellectual notables such as Albert Einstein signed the petition "Urgent Appeal!" (*Dringender Appell!*) and posted it on advertising pillars throughout Berlin. "The annihilation of all personal and political freedom in Germany is imminent," they warned in the broadsheet, if the Socialist and Communist parties, which throughout the Weimar Republic had fervently opposed one another, did not cooperate in their election efforts. The appeal closed with the admonition: "We must see to it that the indolence of our nature and the cowardice of our hearts do not permit us to sink into barbarism!"[20] The new regime immediately condemned the appeal as "anti-German" provocation. The newly appointed Prussian Minister of Culture, Bernhard Rust, threatened to disband the entire academy if Kollwitz and Mann did not resign their memberships immediately. Both complied, "recognizing the error of [their] action," as the president of the Academy declared. Only a few days later, fearing for his life as SS and SA troops came to search his home, Mann fled to France. Kollwitz, however, rejected the possibility of exile, declaring, "I must live by the rules."[21]

Continuously vilified and harassed, Kollwitz worked on a series of eight lithographs on the theme of Death from 1934 to 1937. Death was not a new motif in Kollwitz's work, but never before had she focused on its so intensely as in these lithographs that coincided with the first years of Nazi rule. Somewhat to her own surprise, the immediate proximity of death—both internal, within her aging body, and external, from her Nazi detractors—made

Fig. 87.
Käthe Kollwitz (1867–1945),
The Call of Death, 1934–1935.
Lithograph, 19 ¼ x 17 ⁹⁄₁₆ in. (sheet).
Smart Museum of Art, University of
Chicago, University Transfer from
Max Epstein Archive, 1967.116.147
[Cat. no. 59]

Fig. 88.
Käthe Kollwitz, *Self-Portrait with
Profile from the Right*, 1938.
Lithograph; 18 ¾ x 11 ⅜ in.
Smart Museum of Art,
University of Chicago, Gift of
the Mary and Earle Ludgin
Collection, 1982.70
[Cat. no. 61]

it more rather than less difficult to render these fundamentally allegorical images. Fatalistic reflections on this dilemma threatened her with the further metaphorical death of an inability to concentrate on her work or to invent her images. "The menace is more stimulating when you are not confronting it from close up," she wrote in her diary; reality impinged too much onto the processes of fantasy and invention.[22] Speaking to this realization, *The Call of Death* [FIGURE 87] shows Kollwitz attempting to draw, only to be interrupted by the touch of Death's hand on her shoulder.[23] Fatigued, she appears to give in to the intruder, no longer offering resistance or registering horror. The same resignation suffuses Kollwitz's 1938 self-portrait [FIGURE 88], in which she is seen as an old woman, her shoulders hunched forward and her back bent. A fragile visual presence, she seems to be heading right off the page, losing contact with the very support of her graphic autobiography, tenuously heralding an identity close to evaporation.

Kollwitz's despondency and sense of helplessness did not prevent her from gestures of resistance. In other prints and sculptures, she represented women seeking to shelter their children with their bodies from the unspecified danger of powerful outside forces, mothers channeling their grief at the death of a son into powerful introspection that promises to lead to action. There were but limited opportunities to demonstrate rejection of Nazi ideology without immediate retribution, however. When an exhibition was planned to celebrate Kollwitz's seventieth birthday in 1937—it would include her *Death* lithographs and other recent works—Nazi officials refused to permit it to open. Kollwitz, like other progressive artists remaining in Germany, was definitively denied the means of presenting her art to the German public.

Many artists chose the route rejected by Kollwitz: that of exile. Some five hundred painters, sculptors, architects, designers, and photographers left Germany between 1933 and 1939, many never to return.[24] The decision to leave Germany was not an easy one. Exile was, in a sense, an admission of defeat and a submission to Nazi power, even ironically bringing with it a sense of shame.[25] In the words of the novelist Thomas Mann, Heinrich Mann's brother who was out of the country when Hitler came to power and was advised not to return, "I am too good a German, too closely involved with the cultural traditions and language of my country for the prospect of a year-long or perhaps life-long exile not to have a hard, ominous meaning for me."[26] Exile threatened the identities of these German artists; they did not freely choose to leave, and few wished to make a statement of personal conviction in this drastic manner. "One doesn't change one's country like an old shirt," wrote the art historian Ludwig Grote, who chose to remain behind and was rewarded by being drafted into Hitler's army and sent to the Eastern Front during World War II.[27]

Like Thomas Mann, several artists—most notably George Grosz and Hans Hofmann—found themselves outside Germany in 1933 and never returned. Hofmann's career is virtually unique in that he successfully broke with his German past and initiated a new phase in his art, ultimately exerting a greater impact in his new home than in the land of his birth. Hofmann had never gained a major reputation as he worked throughout the 1920s in a modified Cubist mode and taught at the private art school he founded in Munich. Interest in Wassily Kandinsky and his advocacy of abstraction prompted him to seek out Gabriele Münter in order to see her collection of the Russian artist's work,[28] but Hofmann did not immediately abandon figurative representation. Only after he emigrated to the United States did he fuse his Cubist-derived spatial ordering with Kandinsky's free formal invention to become one of the key painters of New York's avant-garde Abstract Expressionist group during the 1940s and 1950s [SEE FIGURE 85].

Vase, Furniture, and Book of 1935 [FIGURE 89] presents a rare view of the shift in Hofmann's artistic identity and affiliation. The still-life motif, as well as the flat paint application and thin, angular black outlines, clearly relate to the Synthetic Cubism he had practiced in Germany. The crystalline or prismatic effect also has a kinship to works produced by Lyonel Feininger and others in Germany (and in America) during the 1920s. The harmony of intense reds, yellows, blues, purples, and greens finds parallels in Matisse's painting and in Goethe's color theories. Like others of his new colleagues, Hofmann here

Fig. 89. Hans Hofmann,
Vase, Furniture, and Book, 1935.
Oil on masonite; 30 x 22 in.
Lent by Mr. and Mrs. Robert M.
Newbury
[Cat. no. 38a]

practiced an eclectic art that retains overt reference to myriad sources. *Vase, Furniture, and Book* speaks a consciously international language, denying overtly local or national identity as if Hofmann wished to overcome his German origins by adopting a cosmopolitanism that was the direct antithesis of the Nazis' belligerently parochial nationalism. Even in choosing the still-life genre—a seemingly neutral subject implying art's autonomy from social concerns—Hofmann posited a political position and identity opposed to Nazism.

Unlike Hofmann, most would-be émigrés had to seek ways to escape from Germany, often literally but a few steps ahead of pursuing Nazi forces. As a member of the Communist Party, John Heartfield—his given name was Helmut Herzfelde, but he anglicized it in 1915 in protest against German anti-British propaganda in an early example of the adoption of an alternate identity to counter prevailing German attitudes[29]—managed to jump from the balcony of his Berlin apartment as SS and SA troops broke through the door. He found refuge among Communist comrades, and then escaped to Czechoslovakia on foot in mid-April 1933, braving a blinding spring snowstorm. Entering into highly active exile, Heartfield fulfilled the role assigned him by the Communist Party, which orchestrated resistance to Nazism from outside.

During the Weimar Republic, Heartfield employed the technique of photomontage that he helped develop in numerous visually effective Communist Party posters, book jackets, and illustrations, and in outspoken covers for the Communist-sponsored *Arbeiter-Illustrierte-Zeitung* (*Workers' Illustrated Newspaper*, frequently identified simply through its initials as *AIZ*), of which he was the primary author as of 1930. His brother Wieland Herzfelde, who had arrived in Prague a few weeks earlier in order to continue running the left-wing Malik Verlag, publishers of *AIZ*, which had been outlawed in Germany, Heartfield resumed designing covers for the now-exiled periodical. The photomontage published in *AIZ* on March 21, 1935, with the caption "Diagnosis" [FIGURE 90] demonstrates his ability to overturn through satire the authority figures and technologies revered by the Nazis. This work deftly mocks the medical profession and its dependence upon technology, at the same time ridiculing the ceremonial Nazi salute. Two doctors discuss an X-ray, which reveals that a curved spine is hidden beneath the skin of their patient, whose arm is raised in the Hitler salute. "What caused this man to develop this curvature of the spine?" asks one doctor. "Those are the organic results of that perpetual 'Heil Hitler!'" responds the other.

Here, the X-ray may also function as an analogy for Heartfield's project, revealing the truth that lies buried under surface appearances. The montage technique allowed him to construct photographic fictions that parallel the totalitarian use of the photograph, while undermining its apparently privileged connection to the truth. The exploitation of the newest radio, photographic, and film technology was critical to the Nazi rise to power. Their emulation of Heartfield is seen in their derivatively named periodical *Arbeit in Zeit und Bild* (*Work in Time and Image*) and in varied montaged propaganda imagery. In turn, Heartfield expressed his opposition using the very same technologies that the Nazis exploited, an ironic reciprocity that resulted in highly complex and loaded imagery. "Diagnosis," for example, acquires another layer of meaning when one realizes that curvature of the spine was, according to Nazi physiognomic teachings, one of the hallmarks of a degenerate humanity and of Jews. In short, Heartfield literally turned the Nazi's own pseudo-scientific racial theories against them through mockery. Exiled in Prague, deprived of his German citizenship—the Nazi government began to withdraw citizenship from émigrés in August 1933—Heartfield distinguished his own German identity from the official one being preached in Berlin, and indeed applied the Nazis' own criteria of physiognomic degeneracy to brand them as "un-German."[30]

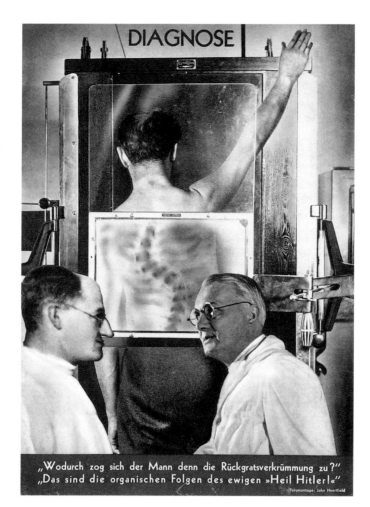

Fig. 90.
John Heartfield (1891–1968),
Untitled (Diagnosis) from *AIZ*,
1935. Rotogravure;
15 x 10 ½ in. The Art Institute
of Chicago, Wendell D. Fentress
Endowment, 1993.363
[Cat. no. 32]

Within the confines of Germany's new regime, émigrés were vilified, condemned as trai-
tors to the German people, and accused of fomenting in their host countries anti-German
sentiments, boycotts of German goods, and false rumors about arrests, beatings, and the
incarceration of political dissenters and other "social misfits" in hastily constructed concen-
tration camps. To counter this perceived threat, and to justify Germany's withdrawal from
disarmament talks and from the League of Nations, Hitler delivered a radio-broadcast
address to a select audience of thousands of vocally enthusiastic supporters at Berlin's
massive indoor sports arena, the Sportpalast, on October 24, 1933, in which he asked other
nations "not to put their faith in elements whose sole goal is to goad people into attacking
each other."[31]

Following Hitler's lead, the richly illustrated, carefully designed book *Germany between
Day and Night* chronicled the rise of a glorious, unified, new Germany from the fifteen-
year "political-egotistical division" and decried the émigrés' continued slander:

Germany recalled its true identity and expelled the seducers alien to its nature. Through its
national revolution it also performed the service for the rest of the world of banning the

dangerous specter of Bolshevism from Europe. But how does the world respond to Germany's deeds, its inner liberation, its reconstruction? The fictitious horror stories told by the émigrés are listened to and Germany's new order is rejected. Essentially, however, what is a better witness for the discipline of the German revolution than the fact that those who were most guilty of Germany's collapse are today allowed to play at being emigrants, that the German people satisfies itself with their emigration instead of holding them responsible with the appropriate severity of revolution?

What is supposed to be happening in the German Reich according to the horror stories of the émigrés and their friends? Murders and killing, torture and persecution are supposedly being meted out to those who think differently than we do; the most hair-raising reports describe in detail these brutal and bloody deeds. In virtually the entire world, the press that is allied with the émigrés or politically friendly to them placed itself at the service of the encirclement of the German people with hatred, but also respected and serious newspapers in great nations make room for this unfounded campaign to rain lies and the most despicable slander onto the self-purification of a German people already tortured beyond endurance.[32]

Such reassurances about Nazi forbearance notwithstanding, repression often took violent and bloody forms. On June 30, 1934—the Night of the Long Knives—some eighty-five high-ranking Nazi Party and SA members, army personnel, and government officials, as well as up to a thousand (the exact number remains unknown) other "mutineers and traitors" were summarily shot without trial, otherwise killed, or forced to commit suicide by SS troops who were acting completely outside the normal restraints of law or accountability in an expanded strategy of terror under Hitler's direct order. Exercising its arbitrary power daily, the SS further reduced the remaining liberties of German citizens and inculcated a reign of perpetual fear. Yet a significant number of Germans praised the new emphasis on "law and order," fully confident they themselves would not be targeted. Largely addressing non-German readers, the authors of *Germany between Day and Night* sought to hide such realities behind a curtain of accusations against émigrés while also raising the fearful specter—a standard feature of German military propaganda since before World War I—of a beleaguered Germany encircled by the belligerent, heavily armed enemy nations that housed these un-German expatriates.

Hitler's House of German Art: Nazi Art Policies after 1937

Ironically, perhaps, the émigrés in Hitler's speech as well as in the propaganda texts are endowed with more clearly defined characteristics—individualism, deceitfulness, Bolshevism, hatefulness, irresponsibility, traitorousness, disloyalty—than the "purified" Germans of the New Order. It is as if within Nazi self-perception, German identity is a virtual blank to be filled in through negation of the perceived features of alien others, whether non-Germans or Germans in opposition to the Nazi regime. Among the tools of this process were physiognomic charts identifying the features of European "races." These charts, manufactured for use in Germany's schools to inculcate Nazi racial and hygienic teachings [FIGURE 91], were often presented in special assemblies led by representatives of the newly founded National Office for Race. Typical examples identified Germany's major *Stämme* (tribes or nations), subdividing Germans into varied regional groupings and contrasting them to Frenchmen, Poles, or, most notably and strikingly, Jews. The Jews have, according to a contemporary newspaper, "'synagogue key' hooked noses, flat feet, waddling

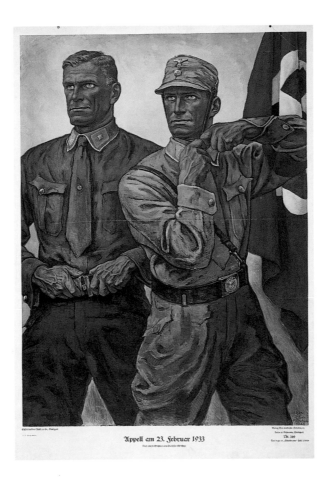

Fig. 91.
"The Races of Germany and the Remainder of Europe," 1934.
Offset print, 25 1/16 x 36 1/8.
University of Chicago Library, Special Collections Research Center
[Not in exhibition]

Fig. 92.
Elk Eber (1892–1941),
Call to Duty on 23 February 1933, 1939.
Offset print, 35 3/8 x 24 1/4 in.
University of Chicago Library, Special Collections Research Center
[Not in exhibition]

walk, drooping ears and shifty gaze"; Germans are then effectively constructed as anti-Jews.[33] Without the pejorative Jewish image, the German ideal could not be purposively visualized; it would be no more than an aesthetically pleasing amalgam of classical references. In various contexts the Nazi Party represented the healthy German youth with long limbs, straight nose, symmetrical features, keen and determined gaze, as "an emblem of community, an expression of strength, of will and obedience."[34]

Such bodies appear, for example, in the painting *Call to Duty on 23 February 1933* (*Appell am 23. Februar 1933*) [FIGURE 92] by Elk Eber, which was distributed in poster form to German schools as a pictorial prototype of heroic Nazi behavior and German physiognomy. In Eber's painting two blue-eyed SA men stare as if listening to a distant voice (the kinship to Christian iconography of saints having visions is far from accidental). Buckling their belts and strapping on their caps, they complete their transformation from individuals into Nazi Party members. Obedient to the order of assembly given on February 23, they don their brown uniforms with overt determination and melodramatic gesture before the swastika banner of the Nazi Party—on this day the SA and SS began to serve as "auxiliary police" (*Feldpolizei*) throughout Prussia, a practice soon extended to the remainder of the Reich. In the dark, dank cellars of temporary prisons and holding facilities, these policemen inaugurated a brutal rampage of intimidation, humiliation, beatings, torture, and murder. Directed at political foes, suspect Nazi Party members, various "social undesirables," and Jews, this physical repression would reach its ultimate barbaric manifestation in the Holocaust, the Nazis' massive, systematic effort to exterminate all European Jews. In a paradox with horrifying consequences, the National Socialists sought to eliminate the antithetical counterpart against which German identity was defined.

The diverse formulations of Nazi ideology were held together by the person of Adolf Hitler and by a fundamental, all-shaping anti-Semitism. In nearly all of his speeches, Hitler vilified Jews as Germany's—and ultimately, humanity's—alien others. Using a vocabulary derived from hygienics and virology, he described them as social parasites, bacilla, tuberculosis, and syphilis that had infected and threatened the lives of the German people and European civilization more generally.[35] Already in 1920 he transformed the Marxist slogan, "Workers of the world, unite," into "Anti-Semites of all lands, unite," and proposed the forced removal of Jews from Germany as the sole solution of the "Jewish Question." The persecution of the Jews began almost immediately after Hitler became chancellor, beginning with the boycott of Jewish businesses announced by the government on April 1, 1933, and followed by the dismissal of Jews from the civil service, and the introduction of varied laws limiting Jewish participation in the professions as well as the number of Jewish children in German schools.[36] "Spontaneous" violence against Jews and their property broke out constantly under this regime of perpetual intimidation, and worse was to come. During a Nazi Party rally held in Nuremberg in September 1935, the Reichstag met and passed the "Nuremberg Laws," which legally defined Jews as racially distinct from Germans or (more broadly) Aryans, stripped Jews of their German citizenship, and made marriages and extramarital relations between Jews and Germans illegal so as to "preserve the purity of German blood." The *Kristallnacht* ("Night of Crystals" or "Night of Broken Glass") of November 9–10, 1938, marked the next violent wave in the Nazi anti-Jewish

campaign. During this infamous night, nearly 100 Jews were killed, virtually all synagogues in Germany—some 1,200—were destroyed, Jewish cemeteries were desecrated, and over 7,000 Jewish businesses were ransacked and looted. Then, the government fined the German Jews one billion Reichsmark as well as the cost of the damage to their own property, and sent 35,000 Jewish men to concentration camps. Shortly thereafter, the Decree on Elimination of Jews from German Economic Life resulted in the confiscation of what limited property the Jews were still able to own. It hardly needs to be pointed out that Nazi persecution of the Jews did not end here: after the outbreak of World War II in 1939 thwarted the process of forced emigration, in July 1941 the Nazis adopted the "total solution of the Jewish Question in the German sphere of influence in Europe." Gassing facilities were installed at concentration camps, transforming them into *Vernichtungslager* (annihilation or death camps), and ultimately over five million Jews died in a "holocaust unequaled in European history."[37]

Germany's Jewish artists represented only a very small number among this totality, but even those who had achieved prominence during the Wilhelmine Empire and the Weimar Republic were not spared. Max Liebermann, as already indicated, was forced out of his teaching position in 1933 when the civil service was "purified." Resigning his membership in the Prussian Academy under duress, the eighty-six-year old painter published a letter explaining his decision:

> During my long life I have attempted with all my strength to serve German art. It is my conviction that art has nothing to do with politics or [racial] origin. Since this belief is no longer valid, I can no longer belong to the Prussian Academy, of which I was a member for over thirty years and which I served as president for twelve years.[38]

Liebermann's Nazi opponents did not share his idealistic belief in art's autonomy. In this climate even an overtly non-political art acquired a political and ideological identity. Liebermann died in 1935, two years after his resignation from the Academy. Few attended his funeral; no representatives of the city of Berlin and only four artists, among them Käthe Kollwitz, were present. Nazi hatred of the Jewish artist did not cease with his death, however. Liebermann remained the exemplar of artistic degeneracy, as the Nazi painter Hans Adolf Bühler venomously summarized in 1937:

> Max Liebermann, the greatest enemy of our German being, because of his relationship with the press but particularly as president of the Prussian Academy, understood how to carry out a poisoning of German artistic life to such a great degree that without the National Socialist renewal German character and German nature would soon have been at an end. Liebermann, the true embodiment of the most horrifying International [Bühler's reference is to both the Communist International and the perceived Jewish "international conspiracy"] recognized how the most fatal wound could be inflicted on a people and acted accordingly in everything he did.[39]

In 1943 Liebermann's eighty-five-year-old widow, frail and ill, took her own life rather than submit to the Nazi troops who had arrived with a stretcher to ship her to an extermination camp.

When the Nazis mockingly condemned Liebermann's work as *weltbürgerlich und bolschewistisch* (cosmopolitan and Bolshevist), they used adjectives that they equated,

according to crude ethnic typology, with "Jewish."[40] In this vocabulary, "cosmopolitan" connoted the prototypical "wandering Jew," who lacked a homeland and thus also lacked loyalty to any European nation-state. Similarly "Bolshevism," with its perceived intent to undermine both nation-states and national identities, was identified as a Jewish ideology. The abstracted Jew necessarily was a traitor to Germany, striving to destroy the country and the national identity of its inhabitants. Accordingly, when practiced by Liebermann, other Jews, and their modernist disciples, art was a poison directed against the German soul.

With so much at stake, the criteria that defined an artist as Jewish became all-important. Prior to the Nazi regime, this identification tended to be at issue within Jewish spheres, of concern to writers on art and artists themselves. Primarily through Zionist-affiliated publications, a Jewish artist was loosely characterized as an artist of Jewish descent or one who retained a connection to the Jewish faith; only a few Jewish artists were seen as producers of specifically Jewish art.[41] As part of the renaissance of Jewish culture that occurred during the Weimar period—particularly in centers like Berlin where both German and eastern European Jewish artists were active—a greater number of Jewish artists began to treat distinctly Jewish themes and subjects, such as eastern European *schtetl* life or synagogue scenes.[42]

The Nazis abandoned such distinctions in order to employ the terms "Jewish art" and "Jewish artist" as all-purpose invectives hurled indiscriminately against art and artists rejected by them. Hitler finally made this explicit in 1937. At his instigation, Goebbels had already outlawed art criticism in November 1936, and in December had appointed the passionately anti-modernist Munich painter Adolf Ziegler as new president of the Reich Chamber of Fine Arts. Finally and suddenly, on July 18, 1937, before a cheering throng of 30,000, in a speech marking the dedication of the new House of German Art in Munich and the opening of the Greater German Art Exhibition there, Hitler conclusively laid down his criteria for a "true German art" and threatened its "enemies" with drastic retribution:

> Jewry, with the help of so-called art criticism, understood not only how to confuse incrementally the natural understanding of the nature and purpose of art, as well as its goals, but also how to undermine the general public's healthy response in this area [i.e. art]. . . .

> Never be in doubt about this: National Socialism set itself the task of liberating the German Reich and thereby also our people and life from all those influences that are harmful to our existence. And even if this cleansing cannot take place in a single day, nonetheless none of the creatures that took part in this pollution [of the German people's sense of art] should be under the illusion that the hour of their elimination will not strike sooner or later.

> From this moment on, we shall wage a merciless cleansing war against the last remaining elements of our cultural disintegration.[43]

When Hitler spoke these words, the radical "cleansing" by governmental decree had already begun. On June 30, 1937, Goebbels commissioned Ziegler, "on the basis of a direct empowerment from the Führer," to organize an exhibition of German *Verfallskunst* (art of decay) produced since 1910 that would serve as an antithetical pendant to the Greater German Art Exhibition with its "healthy" art. Ziegler hurriedly but forcefully—even overriding the express objections of Nazi-sympathetic museum directors in some cases—confiscated some seven hundred works from 32 museums in 28 cities for shipment to Munich.

The now infamous exhibition "Degenerate Art" (*Entartete Kunst*) opened on July 19, 1937, just over two weeks after Ziegler received his command from Goebbels and the day after Hitler's speech at the House of German Art.[44]

The Greater German Art Exhibition featured Eber's *Call to Duty on 23 February 1933* and many works like it: fusions of blandly or sentimentally naturalistic representation and pathos-laden monumental form. These represented the "eternal values" of National Socialist art as envisioned by Hitler and now also propagated with submissive obedience by Goebbels. No such uniformity characterized the "Degenerate Art" exhibition, in essence a deliberately confusing, chaotically presented overview of progressive artistic developments and movements from Expressionism to Bauhaus intended to demonstrate, in Goebbels's words, "how low German art had fallen under the influence of . . . filthy molders of artistic taste."[44] Insofar as there was a logic to the definition of "degenerate art," its basic assumption was that Jewish-Bolshevist art critics and their political colleagues had devised artistic modes that were alien to the creative instincts of the German people with the purpose of undermining and debasing both art and its viewers. Through constant repetition and targeted press campaigns, this Jewish coterie—the argument continues—misled numerous German artists, supported charlatans of various sorts as serious artists, and perpetuated a constantly changing series of modish movements that denied the truth of art's eternal values. The National Socialists thus starkly politicized the question of what constituted German art and rooted it in their own racial and ethnic ideology. Art became a tool for creating and circumscribing the Nazi conception of "Aryan-ness" and Germanness. With particular delight the Nazis denounced progressive artists as Jews or the lackeys of Jews on the basis of their art. Situating an artist's work in the exhibition "Degenerate Art" in effect denied him or her identity as a German.

Further directives denied artists their professional identity as well. Inclusion among the "degenerate"—even if it meant public labeling as a talentless dauber, insane, or otherwise dangerous to the "normalcy" of Nazi Germany's communal *Volk*—did not necessarily prevent an artist from continuing to work. But when they were barred from German exhibition venues, however, artists lost their markets. Similarly, when they were ejected from or refused membership in (as were all Jews and "politically untrustworthy individuals") the Reich Chamber of Fine Arts, which controlled all artistic activity and served as the sole professional association for artists in Germany, they lost even the ability to work: a *Berufsverbot*—prohibition to practice their profession—was imposed on them.

The renowned Prussian Academy of Fine Arts had already "cleansed" itself of Jews and other politically suspect individuals such as Liebermann and Kollwitz. Now, remaining members whose works had been associated with "Degenerate Art" received letters offering them the "honorable" alternative of resigning from the Academy "in your own interest . . . as soon as possible."[46] Several artists objected, but their protests went largely unheeded. By 1937 even those progressive artists who had hoped for some reconciliation with the Nazi regime had to confront the fact that they would either have to submit to Hitler's *Gleichschaltung* or seek an alternative solution. "If the situation continues like this, and it seems to be continuing like this (in terms of my own situation: where will this senseless hatred lead?), then I will no longer be able to live or want to live in Germany," Oskar Schlemmer observed.[47]

Emigration and Despairing Resistance: Artistic Strategies after 1937

Emigration was the sole possibility: either outright escape to another country the "internal emigration" of remaining in Germany and working secretly in isolation. Even with the overt threats directed against them, many artists found foreign exile or emigration undesirable or financially impossible. For example, Schlemmer, while repeatedly expressing a longing to go to America, remained in Germany and supported his wife and three children by working variously as a decorative painter, a painter of camouflage on public buildings, and in a lacquer laboratory. But he was also plagued by feelings of guilt for staying and relinquishing his own artistic visions:

> If anything, I should have disappeared in 1933, gone to a foreign country where nobody would know me instead of presenting before the forum of artistic conscience the unworthy performance of selling my soul for a few pieces of silver.[48]

Depressed and ill with diabetes and yellow jaundice, Schlemmer died of heart failure on April 13, 1943.

Other artists, less in need of earned income, retreated into semi-seclusion and worked secretly, especially if they were among those subjected to a *Berufsverbot*. Karl Schmidt-Rottluff received this notice from Adolf Ziegler in 1941:

> In connection with the culling of works of degenerate art with which the Führer commissioned me, it was necessary to confiscate 608 works by you alone. . . . Surely from this fact you should have realized that your works do not fulfill the demand for the propagation of German culture in a manner responsible to the people and Reich. . . . Now, judging from the recent original works you send for examination, it is apparent that even today you remain alien to the National Socialist state's system of thought. . . . On the basis of this fact . . . effective immediately, I forbid you every professional—and also non-professional— activity in the areas of the pictorial arts.[49]

To escape detection and circumvent his *Berufsverbot*, Schmidt-Rottluff turned exclusively to watercolor and pastels, working on a small scale in techniques that did not produce the telltale odors of oil painting and that dried quickly. Like Schlemmer, Schmidt-Rottluff was beset by despair and self-doubt: "I am burdened by the sense of leaving only a torso behind me," he wrote in 1940, "and what I perhaps could still have achieved—in these dreadful times, it will be highly unlikely."[50] In 1944, after his house in Berlin was bombed and he moved to the home of his parents in Rottluff, near Chemnitz, Schmidt-Rottluff dared to paint a single self-portrait in oils (Kunstsammlungen Chemnitz), but otherwise submitted to his ever greater pessimism:

> Nothing remains whole. . . . Here everyone is approaching the end of their strength, we simply crawl from one day to the next, with no hope of ever escaping. . . . The painting of pictures—our immortal works, how mortal they were—will soon be superfluous since no one knows where they would be allowed to be hung.[51]

Clearly, survival through "internal emigration" within the Third Reich was a challenging prospect for artists identified as degenerate. Alienated from the nation in which they lived, under perpetual suspicion, questioning their own values and identities, in their isolation many succumbed to depression, despair, illness, and—not infrequently—death.

With Hitler's articulation of his art policies in 1937, numerous artists took the long-avoided step of escaping.[52] Although filled with some trepidation, most felt hopeful. "I feel as if I am twenty-five years younger since I know that I am going to a country where phantacy [*sic*] in art and abstraction are not considered absolute crimes, as they are here," Lyonel Feininger exclaimed as he prepared to return to the United States in 1937 after having lived in Germany since 1887.[53] For the sixty-six-year-old Feininger, however, the return to America proved less idyllic than he had imagined it would be. He was largely unknown in the United States, and the support he did receive was limited almost entirely to other German émigrés until an exhibition at New York's Museum of Modern Art in 1944 provided a breakthrough. In a publicity statement for the exhibition, he admitted, "I had to readjust myself in every respect and sometimes felt my very identity had shriveled within me."[54]

Most émigrés faced a future colored by identity crisis in one form or another. Such success stories as that of Hans Hofmann, or even of John Heartfield, were rare exceptions. Many others found themselves unable to cope with the bewilderment and professional marginality that they experienced as a result of the violent severing of ties to their former lives and identities in Germany. The Austrian Jewish writer Stefan Zweig, exiled in Brazil, admitted that "since the day that I had to live with what were after all foreign identity papers or passports, I ceased to feel as if I quite belonged to myself. A part of the natural identity with my original and essential ego was forever destroyed."[55] Zweig (like others) took this annihilating loss of identity to its ultimate conclusion; in 1942, he and his wife committed suicide together.

It can be argued that exile and its attendant loss of identity affected Jewish artists even more profoundly than others, as suggested by the contrast between the cases of Max Beckmann and Ludwig Meidner. Beckmann fled Germany for the Netherlands within days after hearing Hitler's speech in 1937, as he "recognized himself as one of the so-called *Kunstzwerge* [art dwarfs] that Hitler derided in his tirade."[56] He obtained the appropriate papers to move from Amsterdam to Paris, but the outbreak of war in 1939 made this move undesirable. He remained in Amsterdam, surrounded by a group of patrons and admirers; through various means he managed to sell his works in Germany and the Netherlands and thus retained a significant income. Although the war engendered a deep pessimism and a psychological as well as artistic sense of withdrawal, Beckmann nonetheless maintained an outlook that insisted on art's rising above its own times and surrounding events. In 1947 he emigrated to the United States, not wishing to return to a Germany "which lay in shambles and was about to be 'castrated' by the allies," as Barbara Copeland Buenger has characterized his attitude at the time.[57] If, in his introspective and self-assured world of artistic fantasy, Beckmann was troubled by questions of identity, it is not apparent in his art or diaries of the period.

Meidner, by contrast, was driven by the Nazis' extreme anti-Semitism from Berlin, where he had worked for nearly thirty years, in 1935; he took up a teaching position in Cologne in a small Jewish community. He made numerous attempts to leave Germany for South America or the United States but failed to realize them, largely owing to lack of funds. The exhibition "Degenerate Art" singled him out as a particularly vile example of the "Jewish racial soul": a 1912 self-portrait was presented in a gallery devoted to Jewish artists with

the label "Jewish, all too Jewish" appended to its surface. Already during the Weimar Republic, Meidner had turned increasingly to Jewish motifs, accenting his Jewish rather than German identity; he now also adopted the practice of signing his paintings with the Hebrew letter *mem* ("M"). With this emphatic marking of his canvases, Meidner publicly identified his works as created by a Jewish artist, in effect turning the Nazi vilification on its head and accepting the label of "Jew" as a defiant identity. Threats against him and other Jews, however, made continued existence and work in Germany untenable. In the summer of 1939, just weeks before the German invasion of Poland, Meidner and his family managed to flee to England. Unlike Beckmann, however, he was unable to establish himself as a freely working artist in his new home. At first he was confined to the Isle of Man as an enemy alien, and even after his release, he found little support in Britain; he earned what he could by producing flattering portraits, based on photographs, of recently deceased people for their surviving relatives, and he worked as a night watchman. After the war, in 1953, Meidner returned to Germany, alone, to resume his artistic career, but he found that the country was "no longer a real homeland."[58]

Felix Nussbaum represents the most extreme of fates. Shortly before Hitler came to power, Nussbaum received a prestigious national fellowship to study in Rome. While he was in Italy, fellow students at the Prussian Academy of Fine Arts—apparently Nazis themselves or Nazi sympathizers—ransacked and torched his Berlin studio, and then in May 1933 the fellowship was rescinded as one of the applications of the decrees cleansing the civil service. Nussbaum entered a peripatetic exile in Italy and France, and then settled in Belgium, only to be caught up in the German invasion in 1940 and sent to the St. Cypres internment camp in southern France. He escaped and returned to Belgium, where he went into hiding with his wife, Felka Platek, and continued to paint despite the constant threat of discovery. In July 1944 Nussbaum and Platek were betrayed, captured, and sent to Auschwitz on the last deportation train to leave Belgium. Both died in Auschwitz, only weeks before the defeat and collapse of the Third Reich.[59]

While in exile, Nussbaum produced numerous self-portraits in which he took on differing personas, costumes, and exaggerated physiognomic expressions. *Carnival Group* [FIGURE 93] is one of his most significant paintings from the first Belgian exile. In it, he depicted himself as five different personages, whose bizarre costumes, extreme expressions, and intense gestures evoke the uncertainties and fears of the artist's exiled existence. Nussbaum spoke not only to the turmoil of identity in exile, but also to its loss. *Carnival Scene*, painted on the verso of an earlier portrait from his student days in Berlin (FIGURE 81), offers a radical contradiction to the self-assured, dapper young artist who confidently faces a future he intends to shape. The five-person crowd of *Carnival Scene* instead dramatizes mutability as identity shifts from one figure to the next; the self-portrayed artist loses even his most fixed physiological identity, his male gender, as he adopts the appearance of a woman. Nussbaum may have been, at one level, mocking Nazi racial stereotypes about the Jews' lack of a fixed identity, but he translated underlying critical themes into a setting and a physiognomics of terror and impending doom. For Nussbaum, it seemed, his Jewish identity—the sole one remaining to him—was a final refuge, but the refuge was unstable, for this identity contained in itself the threat of the annihilation only too soon made reality.

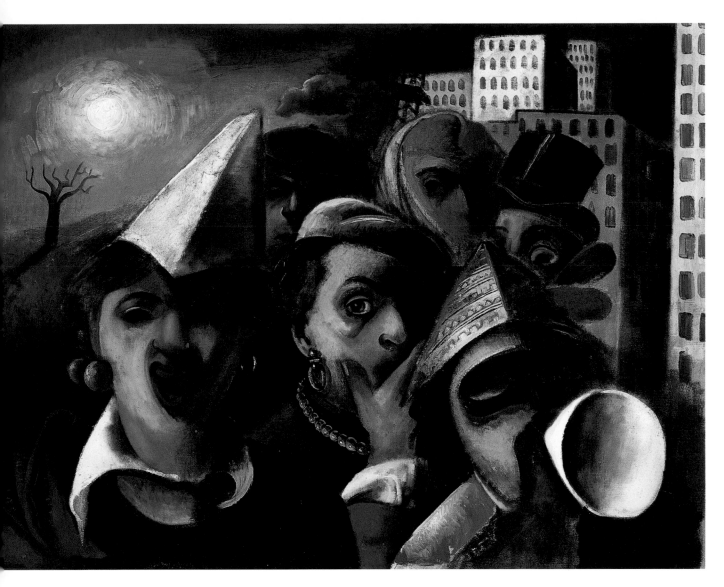

Fig. 93.
Felix Nussbaum (1904–1944),
Carnival Group, ca. 1939.
Oil on canvas; 28 ½ x 38 ½ in.
Smart Museum of Art, University
of Chicago, Purchase, Gift of
Mr. and Mrs. Eugene Davidson,
Mr. and Mrs. Edwin DeCosta,
Mr. and Mrs. Gaylord Donnelly,
and the Eloise W. Martin Fund,
1982.10
[Cat. no. 85b]

The notion of exile in this period encompassed not only the physical and emotional states of artists besieged by the National Socialist dictatorship and its persecution, but also the strategies many artists used in order to maintain individual senses of identity that were separate and distinct from the monolithic definition imposed by the Nazis. Exile could thus operate from without and from within. Artistic activity in exile, a difficult and ultimately dangerous act, constituted a statement of defiance that upheld many artists' senses of self-hood, even though it often brought about a transformed sense of artistic identity. While artists suffered a wide variety of losses—including, for some, the loss of life—the survival of works created in exile bears testimony to individual perseverance and resistance in the face of such forcible, exclusionary definitions of German art and identity.

1. Declaration of Wilhelm Frick, as *Telegraphen-Union*, November 25, 1930, as cited in Rolf Bothe, "Paul Klee und Lyonel Feininger in den Ausstellungen der Weimarer Kunstsammlungen von 1920 bis 1930," in Rolf Bothe and Thomas Föhl, eds., *Aufstieg und Fall der Moderne*, exh. cat., Kunstsammlungen zu Weimar (Ostfildern-Ruit: Hatje Cantz, 1999), 280.

2. Claus Pese, "'Der Name Schultze-Naumburg ist Programm genug!,'" in Bothe and Föhl (note 1), 386–93, offers an extensive evaluation of Schultze-Naumburg's career and his activities as director of the school. Schultze-Naumburg was dismissed as director in 1931 after a no-confidence vote resulted in a new Social Democratic government in Thuringia. Frick too lost his ministerial post. Schultze-Naumburg's dismissal became effective in April 1932, but new elections at the end of July gave the NSDAP the relative majority in the legislature, and a new, exclusively Nazi government was formed. Schultze-Naumburg was elected a Nazi delegate to the German Reichstag, and on October 1, 1932, was reinstated as director of the State Colleges for Architecture, Pictorial Arts, and Applied Arts, a position he held until his retirement in 1940. See also Christine Fischer-Defoy, "Artists and Art Institutions in Germany 1933–1945," in Brandon Taylor and Wilfried van der Wil, eds., *The Nazification of Art* (Winchester: The Winchester Press, 1990), 94–96.

3. Alfred Hentzen, *Die Berliner Nationalgalerie im Bildersturm* (Cologne/Berlin: G. Grote'sche Verlagsbuchhandlung, 1971), 19. "Von Corinth bis Klee" was the title of the second volume of Ludwig Justi's catalogue of the National Gallery collection, *Deutsche Malkunst im 19. und 20. Jahrhundert: Ein Gang durch die National-Galerie* (Berlin, 1931).

4. Adolf Hitler, "Cultural Address," September 1936, cited and translated in Elaine S. Hochman, *Architects of Fortune: Mies van der Rohe and the Third Reich* (New York: Weidenfeld and Nicholson, 1989), 276.

5. Karoline Hille, "Chagall auf dem Handwagen: Die Vorläufer der Ausstellung 'Entartete Kunst,'" in *Inszenierung der Macht: Ästhetische Faszination im Faschismus* (Berlin: Neue Gesellschaft für Bildende Kunst and Dirk Nishen Verlag, 1987), 159. See also Stephanie Barron, "1937: Modern Art and Politics in Prewar Germany," in Stephanie Barron, et al., *"Degenerate Art": The Fate of the Avant-Garde in Nazi Germany*, exh. cat. (Los Angeles: Los Angeles County Museum of Art, 1991), 11–13.

6. Report in the *Mitteilungen des Kampfbundes für Deutsche Kultur* 3 (Jan./Feb. 1931), 13, as cited in Hille (note 5), 161.

7. "Was die Deutschen Künstler von der neuen Regierung erwarten," *Deutscher Kunstbericht*, 1933, as cited in Hildegard Brenner, *Die Kunstpolitik des Nationalsozialismus* (Reinbek: Rohwolt, 1963), 173. See also Barron (note 5), 13.

8. For a detailed discussion of the shifts in Nazi art policies during 1933–34, see Hildegard Brenner, "Art in the Political Power Struggle of 1933 and 1934," in *Republic to Reich: The Making of the Nazi Revolution*, ed. Hajo Holborn (New York: Pantheon, 1972), 395–434; and Brenner (note 7).

9. "Testimonial Letter" of Prof. H. A. Bühler, Director of the College of Arts and the Kunsthalle in Karlsruhe, dated March 8, 1934, as reproduced in Hans-Jürgen Buderer, *Entartete Kunst—Beschlagnahmeaktionen in der Städtischen Kunsthalle Mannheim*, Kunst + Dokumentation 10, 2nd ed. (Mannheim: Städtische Kunsthalle Mannheim, 1990), 18. All further information concerning the events in Mannheim in 1933 derives from Dr. Buderer's detailed account and catalogue. See also Barron (note 5), 15–16.

10. "Bolschewistische Kunstausstellung," *Neue Mannheimer Zeitung*, April 13, 1933, as reproduced and cited in Buderer (note 9), 20, 22.

11. Preview discussion of the exhibition in the Mannheim Nazi newspaper *Hakenkreuzbanner*, April 3, 1933, as cited in Hille (note 5), 166.

12. Käthe Kollwitz, entries from January–July 1933, *Die Tagebücher*, ed. Jutta Bohnke-Kollwitz (Berlin: Siedler, 1989), 673; *The Diaries and Letters of Kaethe Kollwitz*, ed. Hans Kollwitz, trans. Richard and Clara Wilson (Chicago: Henry Regnery Company, 1955).

13. Gordon A. Craig, *Germany 1866–1945*, Oxford History of Modern Europe (Oxford/New York: Oxford University Press, 1980), 585. Ch. 16, "The Nazi Dictatorship and the Instruments of Power," 568–601, offers a concise account of the various means through which Nazi hegemony was established.

14. Ernst R. Huber, *Verfassungsrecht des Grossdeutschen Reiches*, 2nd ed. (Berlin, 1939), 230, as cited and trans. in Craig (note 13), 590.

15. Oskar Schlemmer, letter to Willi Baumeister, March 22, 1933, *The Letters and Diaries of Oskar Schlemmer*, ed. Tut Schlemmer, trans. Krishna Winston (Middletown: Wesleyan University Press, 1972), 303.

16. Alfred Flechtheim, July 1933, as cited in Harry Count Kessler, *The Diaries of a Cosmopolitan, 1918–1937*, ed. and trans. Charles Kessler (London: Weidenfeld and Nicolson, 1971), 462.

17. Harry Count Kessler, diary entry for October 15, 1933, as cited in Peter Grupp, *Harry Graf Kessler 1868–1937: Eine Biographie* (Munich: C. H. Beck, 1995), 302 n.52.

18. It should be noted, however, that the exhibition was closed for a week on orders of now Reich Interior Minister Frick, and that when it reopened with some works removed the student association was no longer identified as its sponsor. The opening-closing-reopening sequence is yet another indication of the lack of a single direction in Nazi art policies at the time.

19. For an extensive overview of Kollwitz's work, see Elizabeth Prelinger, ed., *Käthe Kollwitz*, exh. cat. (Washington, D.C./New Haven: National Gallery of Art/Yale University Press, 1992).

20. "Dringender Appell, 1933," reprinted in Uwe M. Schneede, comp., *Die zwanziger Jahre: Manifeste und Dokumente deutscher Künstler* (Cologne: DuMont, 1979), 290.

21. For an account of the Kollwitz-Mann affair, see Hochman (note 4), 127–40. For further discussion of the transformation of the Prussian Academy of Fine Arts under the Nazis, see Hildegard Brenner, "Ende einer bürgerlichen Kunst-Institution: Die politische Formierung der Preußischen Akademie der Künste ab 1933," *Schriftenreihe der Vierteljahrshefte für Zeitgeschichte*, no. 24 (Stuttgart: Deutsche Verlags-Anstalt, 1972).

22. Kollwitz, *Diaries and Letters* (note 12), 123–24.

23. The print in the Smart Museum collection is a posthumous impression of 1951, authorized by Kollwitz's estate and signed by her son.

24. The estimate of five hundred is provided by Luise Hartmann, "Die Zeit des Faschismus," in *Geschichte der deutschen Kunst 1918–1945*, ed. Harald Olbrich (Leipzig: E. A. Seemann, 1990), 358. Similarly, it is estimated that a total of about 30,000 intellectuals and artists of various types, 80% of them Jewish, went into exile, according to Anthony Heilbut, *Exile in Paradise: German Refugee Artists and Intellectuals in America from the 1930s to the Present* (Berkeley/Los Angeles/London: University of California Press, 1997), 24.

25. The novelist Alfred Döblin articulated this shame: "How unjust, how shabby, how pitiful to run away from here to seek one's personal safety. How awful, to be forced into the expedient of having to escape! A shameful, dishonorable fate. Who has brought me to this?":

quoted in Frederic. V. Grunfeld, *The Hitler File: A Social History of Germany and the Nazis, 1918–1945* (New York: Random House, 1974), as cited in Hochman (note 4), 243.

26. Thomas Mann, *An Exchange of Letters*, trans. H. T. Lowe-Porter (New York: Alfred A. Knopf, 1937), 110, as cited in Hochman (note 4), 242.

27. Hochman (note 4), 242.

28. In an unpublished letter to Gabriele Münter, dated December 12, 1957 (Archives of the Gabriele Münter- und Johannes Eichner-Stiftung, Munich), Hofmann recalled his conversations with her "and the pictures by Kandinsky and Jawlensky and our friendship in Munich." Among recent publications on Hofmann, see particularly James Yohe, ed., *Hans Hofmann* (New York: Rizzoli, 2002); and Helmut Friedel and Tina Dickey, eds., *Hans Hofmann*, trans. John Ormrod (New York: Hudson Hills, 1998). Hofmann's Munich career is considered in Felix Billeter, Antje Gunther, and Stefen Krämer, eds. *Münchener Moderne: Kunst und Architektur des zwanziger Jahre* (Munich: Deutscher Kunstverlag, 2002).

29. "The translation of my name into English . . . was my response to Ernst Lissauer's hatemongering song 'Gott strafe England (God Punish England)'": John Heartfield in a radio interview, Berlin, 1966, as cited in *John Heartfield*, ed. Peter Pachnicke and Klaus Honeff (New York: Abrams, 1992), 392 (in German ed.). At other times Heartfield varied his story to claim that he was protesting not the chauvinistic song, but the related practice among ultra-patriotic Germans during World War I to greeet each other with the exchange: "God punish England!"; "May God punish it!" See Michael Töteberg, *John Heartfield in Selbstzeugnissen und Bilddokumenten* (Reinbek: Rowohlt, 1978), 16–17.

30. Heartfield and his brother continued to run both *AIZ* and the Malik Verlag in Prague until shortly after the Munich Agreement of 1938, which separated the Sudeten region from Czechoslovakia and allowed Germany to annex it. Heartfield then fled to London, and continued his work criticizing capitalism, fascism, and the war throughout the entire period of his exile. In 1950 he returned to Leipzig, and later to East Berlin, in what was by then the German Democratic Republic. Maintaining his allegiance to Communism, Heartfield continued his visual work in support of the East German government until his death in 1968.

31. Adolf Hitler, "Speech at the Sportpalast, Berlin," October 24, 1933, in Friedrich Heiß, *Deutschland zwischen Nacht und Tag,* 5th expanded ed. (Berlin: Volk und Reich, 1934), 152. In April 1925 Heiß began publishing the reactionary political periodical *Volk und Reich*, which claimed to be the "leading German periodical for foreign affairs," reporting on "all current political, economic, and cultural events in Greater Germany and Central Europe"; see the advertisement in *Deutschland zwischen Nacht und Tag*, n.p. (304). Beginning shortly after Hitler gained power in 1933 and continuing almost to the end of World War II, the publishing house of *Volk und Reich* released well-designed, richly illustrated books such as *Deutschland zwischen Nacht und Tag*, most of them edited or authored by Heiß, that glowingly recorded the history of the Nazi Party and the Third Reich for distribution both within and outside Germany. Whether or not Friedrich Heiß of *Volk und Reich* is identical with *SS-Standartenführer* Friedrich Heiß is not known, although it seems probable.

32. Werner Wirth, "Einkreisung durch Haß und Verleumdung," in Heiß (note 31), 100.

33. *Mainfränkische Zeitung* (Würzburg), October 9, 1941, as cited in Konrad Kwiet, "Der gelber Stern," in *Das Dritte Reich: Ein Lesebuch zur deutschen Geschichte 1933–1945,* comp. Christoph Studt (Munich: C. H. Beck, 1997), 194. For further considerations of Nazi racial physiognomics, see notably Sander L. Gilman, *The Jew's Body* (New York: Routledge, 1991); and *"Der Schejne Jid": das Bild des "jüdischen Körpers" in Mythos und Ritual,* ed. Sander L. Gilman, Robert Jütte, und Gabriele Kohlbauer-Fritz (Vienna: Jüdisches Museum Wien/Picus, 1998).

34. Heiß (note 31), 134.

35. For a discussion of such anti-Semitic vocabulary, see Alexander Bein, "'Der jüdische Parasit'. Bemerkungen zur Semantik der Judenfrage," *Vierteljahresschrift für Zeitgeschichte* 13 (1965): 121–49. On Hitler's

anti-Semitism and his employment of anti-Semitic vocabulary in his oratory, see Ian Kershaw, *Hitler 1889–1939: Hubris* (New York: W. W. Norton, 1998, 2000), 124–52.

36. Kershaw (note 35), 470–75, offers a summation of anti-Jewish policies inaugurated in 1933. In the extensive literature on Nazi policies and actions against the Jews, the study by Lucy S. Dawidowicz, *The War against the Jews, 1933–1945* (New York: Holt, Rinehardt, and Winston, 1975), remains a standard, accessible account.

37. Goering's July 1941 order to Reinhard Heyrich (*Trial of the Major War Criminals before the International Military Tribunal* [Nuremberg, 1947–49], xxvi, 266–67), cited and discussed by Craig (note 13), 748–50.

38. Max Liebermann, in *Central-Vereins-Zeitung*, May 11, 1933, as cited and translated in Peter Adam, *Art of the Third Reich* (New York: Harry N. Abrams, 1992), 59–60.

39. Hans Adolf Bühler, in *Das Bild*, 1937, as cited in Wolfgang Hütt, *Deutsche Malerei und Graphik im 20. Jahrhundert* (Berlin: Henschelverlag Kunst und Gesellschaft, 1969), 396. Bühler was appointed director of the Karlsruhe art academy in 1933, and there organized the exhibition "Governmental Art 1918–1933," another of the early precursors of the 1937 exhibition "Degenerate Art."

40. See Bein (note 35).

41. The rise of the Zionist movement, more particularly cultural Zionism, around the turn of the century helped produce the notion of the Jewish artist as an exemplar of an existing and developing Jewish culture. See Inka Bertz, *"Eine neue Kunst für ein altes Volk": Die jüdische Renaissance in Berlin 1900 bis 1924* (Berlin: Jüdisches Museum, 1991); and Michael Berkowitz, *Zionist Culture and Western European Jewry Before the First World War* (Chapel Hill: The University of North Carolina Press, 1996). Early publications on Jewish artists include: *Ost und West: Illustrierte Monatsschrift für Modernes Judentum* (East and West: Illustrated Monthly for Modern Jewry) (Berlin: S. Calvary and Co., 1901–23); and publications by the Juedischer Verlag, such as *Juedische Kuenstler* (Jewish Artists), ed. Martin Buber (1903) and the early volumes of

the *Juedischer Almanach* (1902–04). See Gavriel Rosenfeld, "Defining 'Jewish Art' in *Ost und West*, 1901–1908: A Study in the Nationalization of Jewish Culture," *Leo Baeck Institute Year Book* 39 (1994): 83–110. Ernst Cohn-Wiener's *Die Jüdische Kunst: Ihre Geschichte von den Anfangen bis zur Gegenwart* (Jewish Art: Its History from the Beginnings up to the Present) (Berlin: Martin Wasservogel Verlag, 1929) seems to be the first book on Jewish art published in Germany. For more recent literature on Jewish art in Germany, see Emily Bilski, ed., *Berlin Metropolis: Jews and the New Culture 1890–1918* (Berkeley: University of California Press, 1999); and Ziva Amishai-Maisels, "Problems of Identity in the Art of German Jews, " in Moses Rischin and Raphael Asher, *The Jewish Legacy and the German Conscience* (Berkeley: The Judah L. Magnes Museum, 1991). Concerning pre-Nazi vilificatio of modern art as "Jewish," see Peter Paret, "Modernism and the 'Alien Element in German Art,'" in *German Encounters with Modernism, 1840–1945* (Cambridge: Cambridge University Press, 2001), 60ff.

42. On the Weimar Jewish Renaissance, see Michael Brenner, *The Renaissance of Jewish Culture in Weimar Germany* (New Haven: Yale University Press, 1996).

43. Adolf Hitler, speech inaugurating the Great Exhibition of German Art, July 18, 1937, reprinted in *Nationalsozialismus und "Entartete Kunst": Die Kunststadt München 1937*, ed. Peter-Klaus Schuster (Munich: Prestel, 1987), 243, 252. An extensive excerpt of the speech is translated in Herschel B. Chipp, *Theories of Modern Art: A Source Book by Artists and Critics* (Berkeley/Los Angeles: University of California Press, 1968), 474–83.

44. On the Munich "Degenerate Art" exhibition, see especially Barron (note 5), and Schuster (note 43).

45. Joseph Goebbels, quoted in the *New York Times*, July 17, 1937, 7, as cited in Hochman (note 4), 302.

46. Georg Schumann (representative of the President of the Academy of Fine Arts), letter to Christian Rohlfs, August 2, 1937, in *Schriften deutscher Künstler des zwanzigsten*

Jahrhundert, vol. 2, *In letzter Stunde 1933–1945*, comp. Diether Schmidt (Dresden: VEB Verlag der Kunst, 1964), 114.

47. Oskar Schlemmer, letter to Gerhard Marcks, December 7, 1937, in *Oskar Schlemmer, Idealist der Form: Briefe, Tagebücher, Schriften 1912–1943*, ed. Andreas Hünecke (Leipzig: Reclam, 1990), 318–19.

48. Oskar Schlemmer, diary entry for December 15, 1940, in *Oskar Schlemmer* (note 47), 331. For an alternative translation, see *Letters and Diaries of Oskar Schlemmer* (note 15), 385.

49. Adolf Ziegler, President of the Reich Chamber of Pictorial Arts, Berlin, letter to Karl Schmidt-Rottluff, April 3, 1941, in *Schriften deutscher Künstler* (note 46), 239–40. The letter is preserved in the Brücke-Museum, Berlin.

50. Karl Schmidt-Rottluff, letter to Alexei Jawlensky, March 24, 1940, in *Karl Schmidt-Rottluff—Retrospektive*, ed. Günther Thiem and Armin Zweite (Munich: Prestel, 1989), 99.

51. Karl Schmidt-Rottluff, letter to Otto Herbig, March 22, 1944, in *Karl Schmidt-Rottluff—Retrospektive* (note 50), 100.

52. Many artists included in this exhibition, but not mentioned in this essay, endured various forms of internal or external exile. Hans (Jean) Arp had left Germany before World War I and eventually became a French citizen. In the midst of World War II he planned to leave Europe for the United States, but his wife, the Swiss artist Sophie Taeuber-Arp, died just as they were about to leave, and Arp remained in Switzerland. Heinrich Campendonk left Germany for Belgium in 1933 after being dismissed from his teaching position in Dusseldorf. In 1935 he took a position in Amsterdam, where he remained until his death. Recognizing the polarized political climate, George Grosz left Germany in 1932, just before Hitler seized power, and went to the United States. In 1959 he returned to Germany on a visit and died while there. After a career of more than thirty years, spent largely in Germany, Wassily Kandinsky left for Paris in late 1933, recognizing the Nazis' antagonism toward modern art, particularly with the early closure of the Bauhaus, where he had been a professor. Still, he and his wife, Nina, planned to return after a year. Instead, like many artists, Kandinsky spent the remainder of his career in exile, although unlike many, his work continued to receive critical and financial success. Ernst Ludwig Kirchner moved to Switzerland during World War I, in 1917, to recover from physical and mental collapse, as well as a drug addiction. In June 1938, after the Nazi purge of his works from German museums and their vilification in the "Degenerate Art" exhibition, Kirchner, who continued to believe that his work belonged to the greatest of German art, committed suicide. Paul Kleinschmidt left for France sometime after his works were included in the "Degenerate Art" exhibition and remained there for most of the war. Austrian artist Oskar Kokoschka in 1931 returned from Paris to his native Vienna, but found the politics there reactionary, and moved to Prague in 1934. In 1937 all of his works were removed from museums in Germany, and in 1938, after the Munich Agreement allowed Hitler's armies to occupy Czechoslovakia, he fled to London, where he remained critical not only of fascist governments, but of all politics, which had led to suffering in the Second World War. Forty of Conrad Felixmüller's works were included in the "Reflections of the Decline of Art" (*Spiegelbilder des Verfalls der Kunst*) exhibition, held in September 1933 in Dresden. He moved from Dresden to Berlin in 1934 and became a member of the Berlin Artists Association. However, he was forced to leave the Association after a newspaper defamation campaign against him in 1937. Seven of his works were exhibited in the "Degenerate Art" exhibition and by 1938, 151 of his works had been removed from public collections. Felixmüller remained in Germany despite losing his apartment and studio, and in 1944, he was called for military service. He was captured outside Berlin and sent to a Soviet prisoner-of-war camp, where he remained until the end of the war. Fritz Erler's work corresponded with National Socialist art ideals, unlike that of the artists named above. He received commissions for portraits and decorative work from both private collectors and public institutions after 1933, when he was invited to decorate the rooms of the famous Löwenbräu cellars for the occasion of the "Day

of German Art" in Munich. Erler continued to receive official commissions and prizes until his death in July 1940.

53. Lyonel Feininger, letter to Lux Feininger, May 31, 1937, in *Schriften deutscher Künstler* (note 46), 109. Feininger spent the summer of 1936 teaching at Mills College, Oakland, California; returned to Germany until June 1937; and then came back to the United States.

54. Press release, Museum of Modern Art Archives, New York, as cited in Sabine Eckmann, "The Loss of Homeland and Cultural Identity: George Grosz, Lyonel Feininger," in *Exiles and Émigrés: The Flight of European Artists from Hitler*, exh. cat. ed. Stephanie Barron with Sabine Eckmann (Los Angeles: Los Angeles Museum of Art, 1997), 297.

55. Stefan Zweig, *The World of Yesterday: An Autobiography* (New York: Viking, 1943), 412. The translation is slightly altered to match Zweig's German text more closely; see Stefan Zweig, *Die Welt von Gestern: Erinnerungen eines Europäers* (Vienna: Fischer, 1952), 374.

56. Dagmar Grimm, "Max Beckmann," in Barron (note 5), 202.

57. The phrase summarizes Beckmann's diary entries of April 13, 1945, and August 3, 1945. See Barbara Copeland Buenger, "Max Beckmann," in Barron/Eckmann (note 54), 63.

58. Meidner wrote in a letter to Franz Landsberger, June 28, 1960: "This country is no longer a real homeland, after all that has happened" ("hierzulande keine rechte Heimat mehr, nach allem was passierte"). Cited in Gerda Breuer, "Biographie Ludwig Meidner," in Gerda Breuer and Ines Wagemann, eds., *Ludwig Meidner: Zeichner, Maler, Literat 1884–1966* (Stuttgart: Gerd Hatje, 1991), 32.

59. For biographical information and critical commentary on Nussbaum's work, see particularly Emily D. Bilski, *Art and Exile: Felix Nussbaum 1904–1944* (New York: The Jewish Museum, 1985); Eva Berger et al., *Felix Nussbaum: Art Defamed—Art in Exile—Art in Resistance: A Biography*, 4th ed. (New York: Overlook Press, 1997); and Karl Georg Kaster, *Felix Nussbaum: Eine biographische und ikonographische Deutung seines Werks* (Cologne: Vista Point Verlag, 1989). See also Reinhold Heller et al., *Art in Germany: From Expressionism to Resistance* (Munich: Prestel, 1990), entries 122–25. On the double-sided painting in the collection of the David and Alfred Smart Museum of Art, see entry in Portfolio IV, in this catalogue; and Sura Levine, catalogue entry in *The David and Alfred Smart Museum of Art: A Guide to the Collection* (New York: Hudson Hills Press, 1990), 121. The city of Osnabrück, with a combination of remorse, shame, and pride in recognition of its native son and his fate, recently dedicated a museum, designed by Daniel Liebeskind, to the formerly defamed artist and his work.

Gallery: German Art after 1945

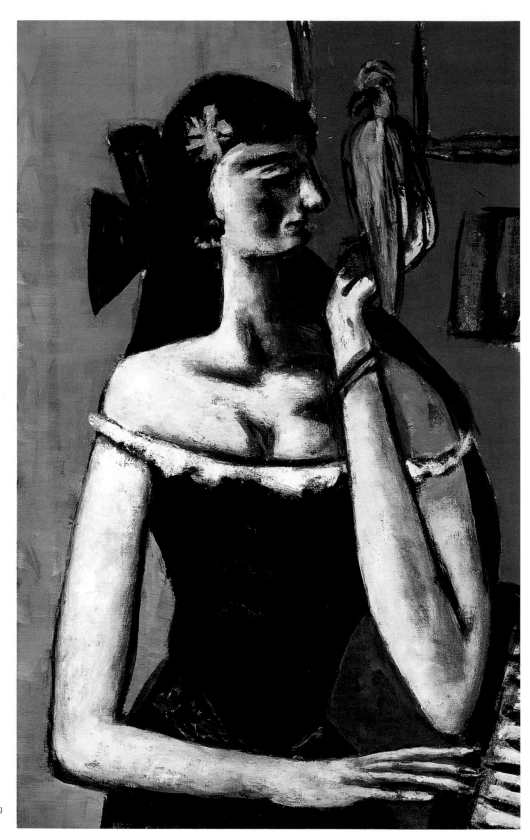

Plate 1
Max Beckmann (1884–1950),
*Woman with Bird in Black and
Gray*, 1946. Oil on canvas;
37 ¼ x 23 ¾ in.
Lent by Joel and Carol Honigberg
[Cat. no. 9]

Plate 2
Max Ernst (1891–1976),
Clarière, 1962.
Gouache on artist's board;
13 3/16 x 10 5/16 in.
Lent by Jack and Helen Halpern
[Cat. no. 17]

Plate 3
Hans Richter (1888–1975),
Head in Profile, 1968.
Colored pencil, photocollage,
and collage; 9 7/8 x 6 11/16 in.
Lent by Jack and Helen Halpern
[Cat. no. 96]

Plate 4
Georg Baselitz (b. 1938),
The Drinker, 1982.
Color woodcut; 39 ½ x 31 ½ in.
Lent by Marcia and Granvil
Specks Collection
[Cat. no. 4]

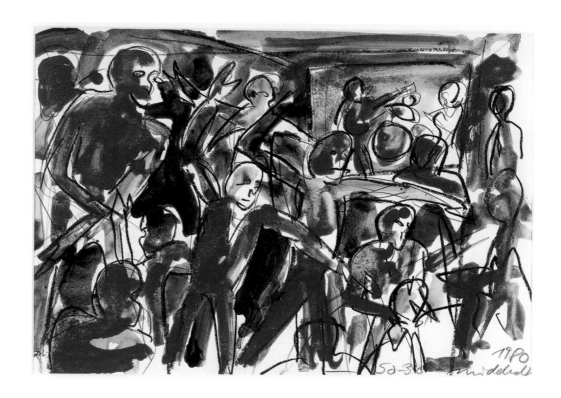

Plate 5
Helmut Middendorf (b. 1953),
Night Club, 1980. Watercolor,
gouache, graphite, and
crayon; 13 ⅞ x 17 ¾ in.
Lent by Marcia and Granvil
Specks Collection
[Cat. no. 74]

Plate 6
A. R. Penck (Ralf Winkler)
(b. 1939), *Untitled (Figuration)*,
1987. Gouache; 12 ¾ x 18 in.
Lent by Laura and Marshall Front
[Cat. no. 90]

Plate 7
Martin Kippenberger (1953–1997),
Untitled, 1989.
Collage, hotel stationery, and silver
felt-tip pen; 20 ¼ x 16 ⅛ in.
Lent by Laura and Marshall Front
[Cat. no. 48]

Plate 8
Anselm Kiefer (b. 1945),
Heavy Water, 1991. Book of
gelatin silver prints heightened
with metallic paint, bound with
lead cover; 27 ½ x 19 ⅝ x ⅝ in.
The Art Institute of Chicago,
Gift of Susan and Lewis
Manilow, 2000.715
[Cat. no. 45]

Plate 9
Anselm Kiefer, *Meadow
Saffron*, 1996.
Book of original photographs
with emulsion, paint, and sand;
19 ⅝ x 21 ¾ x 2 ⅜ in.
Lent by Collection Susan and
Lewis Manilow
[Cat. no. 47]

Plate 10
Thomas Ranft (b. 1942),
Allegory, from *Homage to
Edvard Munch*, 1999.
Color etching; 15 ⅜ x 11 ½ in.
Smart Museum of Art,
University of Chicago, Gift of
the Kunstsammlungen
Chemnitz, Germany, 2000.60f
[Cat. no. 113d]

Checklist

Unless otherwise noted, prints are in black ink; signatures and inscriptions on works on paper are in graphite; signatures and inscriptions on paintings are in oil. Full citations to catalogues raisonnés are found on pp. 177–78. Height precedes width precedes depth; dimensions for prints refer to image size unless otherwise noted; dimensions for other objects refer to maximum overall size.

Hans (Jean) Arp
French (Alsatian), 1887–1966

1. *AA*, 1948
Woodcut on wove paper
Arntz 123
Signed l.r.: *Arp*; inscribed l.r.: *#49/50*
10 x 7 ⅝ in. (25.4 x 19.4 cm)
Smart Museum of Art, University of Chicago, Gift of Perry Goldberg
1983.156

2. *Mask*, 1948 (after a 1923 sketch)
Woodcut on wove paper
Arntz 124
Signed l.l.: *Arp*; inscribed l.r.: *#49/50*
8 ⅝ x 6 ⅜ in. (22 x 16.2 cm)
Smart Museum of Art, University of Chicago, Gift of Perry Goldberg
1983.157

Ernst Barlach
German, 1870–1938

3. *The Reunion (Das Wiedersehen)*, posthumous cast after 1926 model
Painted cast plaster or composition, mounted on walnut base
Inscribed on base: *E. Barlach*
Height 18 in. (45.7 cm) (without base)
Anonymous Loan
6.1993

Georg Baselitz
German, b. 1938

4. *The Drinker (Trinker)*, 1982
Color woodcut on heavy white paper
Signed in black ink l.r.: *G. Baselitz*;
dated in black ink l.l.: *17/III/82*
39 ½ x 31 ¼ in. (100.4 x 79.4 cm)
Lent by Marcia and Granvil Specks Collection

Max Beckmann
German, 1884–1950

5. *Carnival (Jahrmarkt)*, 1922
Four drypoints (selected from a set of ten)
Smart Museum of Art, University of Chicago, Marcia and Granvil Specks Collection

a. Plate 1. *The Barker (Der Ausrufer)*
Drypoint on Bütten paper
Gallwitz 163, Hofmaier 191
Signed l.r.: *Beckmann*
13 x 9 ⅞ in. (33 x 25.1 cm)
1983.129

b. Plate 3. *Backstage (Hinter den Kulissen)*
Drypoint on wove paper with a deckel edge
Gallwitz 165, Hofmaier 193
Signed l.r.: *Beckmann*
7 ¾ x 11 ¾ in. (19.7 x 29.9 cm)
1983.131

c. Plate 7. *The Carousel (Das Karussell)*
Drypoint on Bütten paper
Gallwitz 169, Hofmaier 197
Signed l.r.: *Beckmann*
11 ¼ x 10 in. (28.6 x 25.4 cm)
1983.135

d. Plate 8. *The Tightrope Walker (Die Seiltänzer)*
Drypoint on Bütten paper
Gallwitz 170, Hofmaier 198
Signed l.r.: *Beckmann*
9 ⅞ x 9 ¾ in. (25.1 x 24.8 cm)
1983.136

6. *Group Portrait, Eden Bar (Gruppenbildnis, Eden Bar)*, 1923
Woodcut on rough wove paper
Gallwitz 261, Hofmaier 277
Signed l.r.: *Beckmann*
19 3/16 x 19 3/16 in. (49 x 49 cm)
Lent by Joseph P. Shure

7. *Self-Portrait (Selbstbildnis)*, 1914
Drypoint
Gallwitz 51, Hofmaier 74; trial proof before the edition
Signed l.r.: *Beckmann*
8 ¾ x 6 ¾ in. (22.2 x 17.2 cm)
Lent by Joseph P. Shure

8. *Self-Portrait with Cigarette (Selbstbildnis mit Zigarette)*, 1919
Drypoint on wove paper
Gallwitz 124, Hofmaier 153
Signed l.r.: *Beckmann*
9 3/16 x 7 9/16 in. (24.9 x 19.2 cm)
Lent by Joseph P. Shure

9. *Woman with Bird in Black and Gray (Frau mit Vogel in Schwarz und Grau)*, 1946
Oil on canvas
Göpel 720
Signed and dated verso: *Beckmann A 46*
37 1/4 x 23 3/4 in. (94.6 x 60.3 cm)
Lent by Joel and Carol Honigberg

Joseph Beuys
German, 1921–1986

10. *Felt Suit (Filzanzug)*, 1970
Felt
Schellman 26; ed. 87/100
67 1/2 x 30 1/4 x 8 1/2 in.
(171.5 x 76.8 x 21.6 cm)
Collection Museum of Contemporary Art, Chicago, Partial gift of Dr. Paul and Dorie Sternberg

Karl Blechen
German, 1798–1840

11. *Figure amidst the Ruins of a Gothic Abbey (Figur bei Gotischer Ruine)*, ca. 1825
Pen and sepia ink and wash over graphite on wove paper
6 x 7 7/8 in. (15.3 x 20 cm)
Milwaukee Art Museum, Purchase, René von Schleinitz Memorial Fund
M1996.50

Heinrich Campendonk
German, 1889–1957

12. *The Beggars (after Brueghel) (Die Bettler [nach Brueghel])*, 1922
Woodcut on laid paper
Engels 62
Signed l.l.: *Campendonk*
5 5/8 x 6 3/4 in. (14.3 x 17.2 cm)
Smart Museum of Art, University of Chicago, Marcia and Granvil Specks Collection
1991.338

Lovis Corinth
German, 1858–1925

13. *In the Studio (Im Atelier)*, 1920
Plate 1 from the portfolio *At the Corinths' (Bei den Corinthern)*
Etching and drypoint on Bütten paper
Schwarz 380 XII
Inscribed l.c. in plate: *CL / Selbstporträt*; inscribed l.r. in plate: *ATELIER / 1919. September.*; signed l.r.: *Lovis Corinth*
12 1/2 x 9 5/8 in. (31.8 x 24.8 cm)
Smart Museum of Art, University of Chicago, Marcia and Granvil Specks Collection
1985.41

Otto Dix
German, 1881–1969

14. *War (Der Krieg)*, 1924
Twenty-four prints (selected from a set of fifty)
Published by Karl Nierendorf, Berlin, 1924; printed by Otto Felsing, Berlin; ed. 10/70
Smart Museum of Art, University of Chicago, Marcia and Granvil Specks Collection

a. *Death by Gas (Templeux-La-Fosse, August 1916) (Gastote [Templeux-La-Fosse, August 1916])*
Etching on Bütten paper
Karsch 72
Signed l.r.: *Dix*; numbered l.l. and l.c.: *10/70* and *III*
7 1/2 x 11 13/16 in. (19.1 x 28.4 cm)
1986.253

b. *Field of Craters near Dontrien, Illuminated by Rocket Flares (Trichtenfeld bei Dontrien, von Leuchtkugein erhellt)*
Aquatint on Bütten paper
Karsch 73
Signed and dated l.r.: *Dix 24*; numbered l.r. and l.c.: *14/70* and *IV*
7 1/2 x 10 in. (19 x 25.8 cm)
1984.48

c. *Wounded Man (Spring 1916, Baupaume) (Verwundeter [Herbst 1916, Baupaume])*
Etching and aquatint on Bütten paper
Karsch 75
Signed and dated l.r.: *Dix 24*; numbered l.l. and l.c.: *6/70* and *VI*
7 1/2 x 11 in. (19.1 x 27.9 cm)
1986.254

d. *Near Langemarck (February 1918) (Bei Langemarck [Februar 1918])*
Etching on Bütten paper
Karsch 76
Signed and dated l.r.: *Dix 24*; numbered l.l. and l.c.: *10/70* and *VII*
9 9/16 x 11 11/16 in. (24.2 x 29.4 cm)
1984.50

e. *Wounded Man Fleeing (Battle of the Somme 1916) (Fliehender Verwundeter [Sommeschlacht 1916])*
Etching and drypoint on Bütten paper
Karsch 79
Signed and dated l.r.: *Dix 24*; numbered l.l. and l.c.: *10/70* and *X*
7 1/2 x 5 5/16 in. (19.1 x 13.5 cm)
1986.256

f. *Abandoned Position near Neuville (Verlassene Stellung bei Neuville)*
Etching on Bütten paper
Karsch 80
Signed and dated l.r.: *Dix 24*; numbered l.l. and l.c.: *10/70* and *I*
7 5/8 x 5 5/8 in. (19.3 x 14.3 cm)
1984.52

g. *Storm Troops Advance under a Gas Attack (Stormtruppe geht unter Gas vor)*
Etching, aquatint, and drypoint on Bütten paper
Karsch 81
Signed l.r.: *Dix*; numbered l.l.: *10/70*
7 ½ x 11 ¼ in. (19.1 x 28.6 cm)
1986.257

h. *Mealtime in the Trenches (Loretto Heights) (Mahlzeit in der Sappe [Lorettohöhe])*
Etching, aquatint, and drypoint on Bütten paper
Karsch 82
Signed and dated l.r.: *Dix 24*; numbered l.l. and l.c.: *10/70* and *III*
7 ⁹/₁₆ x 11 ³/₁₆ in. (19.2 x 24.4 cm)
1986.258

i. *Corpse in a Wire Entanglement (Flanders) (Leiche im Drahtverhau [Flandern])*
Etching and aquatint on Bütten paper
Karsch 85
Signed and dated l.r.: *Dix 24*; numbered l.l. and l.c.: *10/70* and *VI*
11 ½ x 9 ½ in. (29.2 x 24 cm)
1986.259

j. *A Rocket Flare Lights up the Monacu-ferme (Leuchtkugel erhellt die Monacu-ferme)*
Aquatint on Bütten paper
Karsch 86
Signed and dated l.r.: *Dix 24*; numbered l.l. and l.c.: *10/70* and *VII*
5 ¹¹/₁₆ x 7 ⅝ in. (14.4 x 19.4 cm)
1984.55

k. *Dance of Death, the Year 17 (Dead Man's Hill) (Totentanz anno 17 [Höhe Toter Mann])*
Etching, aquatint, and drypoint on Bütten paper
Karsch 88
Signed l.r.: *Dix*; numbered l.l. and l.c.: *10/70* and *IX*
9 ½ x 11 ½ in. (24.1 x 29.2 cm)
1986.261

l. *Dead Man in Mud (Toter im Schlamm)*
Etching and aquatint on Bütten paper
Karsch 92
Signed and dated l.r.: *Dix 24*; numbered l.l. and l.c.: *10/70* and *III*
7 ½ x 10 in. (19.1 x 25.4 cm)
1986.263

m. *Grenade Crater with Flowers (Spring 1916) (Granattrichter mit Blumen [Frühling 1916])*
Etching on Bütten paper
Karsch 94
Signed and dated l.r.: *Dix 24*; numbered l.l. and l.c.: *10/70* and *IV*
5 ⁹/₁₆ x 7 ⁹/₁₆ in. (14.2 x 19.2 cm)
1984.58

n. *Evenings on the Wiitschäte Plain (Abends in der Wijtschäte-Ebene)*
Etching and aquatint on Bütten paper
Karsch 96
Signed and dated l.r.: *Dix 24*; numbered l.l. and l.c. : *10/70* and *VII*
9 ½ x 11 ½ in. (24.1 x 29.2 cm)
1986.266

o. *Skull (Schädel)*
Etching on wove paper
Karsch 100
Signed l.r.: *Dix*
9 ⅞ x 7 ⁷/₁₆ in. (25.1 x 18.9 cm)
1984.61

p. *Lens Is Destroyed by Bombing (Lens wird mit Bomben belegt)*
Etching and drypoint on wove paper
Karsch 102
Signed l.r.: *Dix*; numbered l.l.: *10/70*
11 ½ x 9 ⅜ in. (29.2 x 23.8 cm)
1986.268

q. *Frontline Fighter in Brussels (Frontsoldate in Brüssel)*
Etching and drypoint on Bütten paper
Karsch 103
Signed l.r.: *Dix*; numbered l.l.: *10/70*
11 x 7 ¾ in. (28.8 x 19.8 cm)
1986.269

r. *A Visit to Madame Germaine in Méricourt (Besuch bei Madam Germaine in Méricourt)*
Etching, aquatint, and drypoint on Bütten paper
Karsch 105
Signed l.r.: *Dix*
10 x 7 ½ in. (25.4 x 19.1 cm)
1986.271

s. *Transplant (Transplantation)*
Etching and aquatint on Bütten paper
Karsch 109
Signed l.r.: *Dix*; numbered l.l.: *10/70*
7 ⅝ x 5 ⅝ in. (19.4 x 14.2 cm)
1984.66

t. *Food Reconnoiterer near Pilkem (Essenholer bei Pilkem)*
Etching and aquatint on Bütten paper
Karsch 112
Signed l.r.: *Dix*; numbered l.l.: *10/70*
9 ½ x 11 ¼ in. (24.1 x 28.6 cm)
1986.273

u. *Surprise Attack of a Reconnoitering Patrol (Überfall einer Schleichpatrouille)*
Etching and aquatint on wove paper
Karsch 113
Signed l.r.: *Dix*; numbered l.l.: *10/70*
7 ⅝ x 5 ⅝ in. (19.4 x 14.3 cm)
1984.68

v. *Fox Hole (Unterstand)*
Etching, aquatint, and drypoint on Bütten paper
Karsch 114
Signed l.r.: *Dix*; numbered l.l.: *10/70*
7 ⁹/₁₆ x 11 ⅛ in. (19.2 x 28.3 cm)
1986.274

w. *The Trench Sentries Must Maintain the Fire during the Night (Die Sappenposten haben nachts das Feuer zu unterhalten)*
Etching, aquatint, and drypoint on Bütten paper
Karsch 117
Signed l.r.: *Dix*; numbered l.l.: *10/70*
9 ½ x 11 ½ in. (24.1 x 29.2 cm)
1986.275

x. *Corpses before the Position near Tahure (Tote vor der Stellung bei Tahure)*
Etching, aquatint, and drypoint on Bütten paper
Karsch 119
Signed l.r.: *Dix*; numbered l.l.: *10/70*
7 ½ x 10 in. (19.1 x 25.4 cm)
1986.276

Fritz Erler
German, 1868–1940

15. *"And You?" Underwrite the War Loan ("Und Ihr?" Zeichnet Kriegsanleihe)*, 1918
Handbill for the Seventh War Loan
Color offset lithograph
Signed on stone l.l.: *Erler*; inscribed on stone l.l. and l.r.: *ENTWURF: FRITZ ERLER, MÜNCHEN* and *DRUCK: ECKSTEIN & STÄHLE, STUTTGART*
13 x 8 ¾ in. (33 x 22.2 cm) (sheet)
University of Chicago Library, Special Collections Research Center

16. *"Help Us Be Victorious!" Underwrite the War Loan ("Helft uns Siegen!" Zeichnet die Kriegsanleihe)*, 1917
Handbill for the Sixth War Loan
Color offset lithograph
Inscribed on stone l.l. and l.r.: *ENTWURF: PROF. FRITZ ERLER, MÜNCHEN* and *DRUCK: ECKSTEIN & STÄHLE, STUTTGART*
13 x 8 ⅞ in. (33 x 22.5 cm) (sheet)
University of Chicago Library, Special Collections Research Center

Max Ernst
German, 1891–1976

17. *Clairière*, 1962
Gouache on artist's board
Spies 3623
Signed in gouache l.r.: *Max Ernst*
13 ³⁄₁₆ x 10 ⁵⁄₁₆ in. (33.5 x 26.2 cm)
Lent by Jack and Helen Halpern

Hanns Fechner
German, 1860–1931

18. *Portrait of Agnes Samson*, 1896
Pastel and brushed pastel, over charcoal underdrawing, on artist's board, mounted on canvas
Signed and dated in pastel l.l.: *Hanns Fechner, B[erlin] 96*
49 ¼ x 40 ¾ in. (125.1 x 103.51 cm)
Smart Museum of Art, University of Chicago, Gift of Mr. W. R. Magnus
1983.116

Lyonel Feininger
American, 1871–1956; worked in Germany 1887–1936

19. *The Green Bridge (Die grüne Brücke)* (also known as *Arched Gate [Torbogen]*), 1910–1911
Etching on wove paper
Prasse E22
Signed l.l.: *Lyonel Feininger*
10 ¼ x 7 ⁹⁄₁₆ in. (26 x 19.2 cm)
Smart Museum of Art, University of Chicago, Gift of the Friends of the Smart Gallery, 1978
1978.15

20. *Street in Paris (Strasse im Paris)* (also titled by the artist *Tall Houses, Paris [Hohe Häuser, Paris]* and *Houses in Paris [Häuser im Paris]*), 1918
Prasse W97 II
Woodcut on paper
Signed l.l.: *Lyonel Feininger*; inscribed l.r.: *Street in Paris*
21 ⅜ x 16 ⅛ in. (54.3 x 41 cm)
Smart Museum of Art, University of Chicago, Gift of Mrs. Eugene Davidson, 1974
1974.50

Conrad Felixmüller
German, 1897–1977

21. *In the Studio, Depressed (Bedrücktsein im Atelier)*, 1917
Woodcut on laid paper
Söhn 99a; ed. 10
Signed and dated l.r.: *Felixmüller/1916*; inscribed l.c.: *Bedrückstein im Atelier*; inscribed l.l.: *Holzschnitt*
11 ¾ x 9 ¹³⁄₁₆ in. (29.9 x 24.9 cm)
Smart Museum of Art, University of Chicago, Marcia and Granvil Specks Collection
1991.345

22. *Soldier in an Insane Asylum (Soldat im Irrenhaus)*, 1918
From *Die Schaffenden*, Vol. 1, Portfolio 2 (Weimar: Paul Westheim, Gustav Kiepenheuer Verlag, 1919), printed by W. Drugulin, Leipzig
Lithograph on *Halblienen-mappe*
Söhn 150a
Inscribed along bottom: *Felixmüller 18 / – Soldat im Irrenhaus – / Lithographie*; monogrammed on stone l.r.: *FM*; blindstamped: *DIE / SCHAF / FEN / DEN*
13 ⅜ x 10 ¹⁵⁄₁₆ in. (34 x 27.8 cm)
Smart Museum of Art, University of Chicago, Gift of Andrea L. Weil and John A. Weil
2001.59f

Caspar David Friedrich
German, 1774–1840

23. *Woman with Raven at the Abyss (Frauen mit dem Raben am Abgrund)*, 1803
Wood engraving on buff wove paper
Börsch-Supan 61
6 ¾ x 4 ¹¹⁄₁₆ in. (17.2 x 11.9 cm)
Milwaukee Art Museum, Purchase, René von Schleinitz Memorial Fund
M2001.54

W. Georgi
German, dates unknown

24. *War Loan: "Aid the Guardians of Your Happiness"* (*Kriegsanleihe: "Helft den Hütern Eures Glückes"*), 1918
Handbill for the Tenth War Loan
Color offset lithograph
Signed and dated in stone r.c.: *W Georgi / 1919*
13 ⅛ x 9 in. (33.3 x 22.9 cm) (sheet)
University of Chicago Library, Special Collections Research Center

Otto Gleichmann
German, 1887–1963

25. *Theater Box* (*Theaterloge*), 1922
Lithograph on wove paper
Signed and dated l.r.: *Otto Gleichmann, 1922*
12 ¹⁄₁₆ x 9 ⁷⁄₁₆ in. (30.6 x 24 cm)
Smart Museum of Art, University of Chicago, Marcia and Granvil Specks Collection
1998.83

Rudolf Grossman
German, 1882–1941

26. *The Dance* (*Der Tanz*), 1923
Etching and drypoint on laid paper
Signed l.l.: *R Grossman*
6 ⅞ x 9 ¼ in. (17.6 x 23.5 cm)
Smart Museum of Art, University of Chicago, Purchase, Gift of Carl Rungius, by exchange
2000.120

George Grosz
German, 1893–1959

27. *Amalie*, 1922
Pen, brown ink, gouache, and graphite on cream wove paper
Inscribed in ink r.c.: *Amalie*
20 ¾ x 16 ¼ in. (52.7 x 41.3 cm)
Smart Museum of Art, University of Chicago, The Joel Starrels Jr. Memorial Collection
1974.140

28. *The Butcher Shop* (*Fleischerladen*), 1928
Pen and ink with brush and watercolor on paper
Signed and dated in blue ink and watercolor l.r.: *Grosz / 1928*
23 x 18 in. (58.4 x 45.7 cm)
Lent by Collection of Philip J. and Suzanne Schiller—American Social Commentary Art, 1930–1970

29. *Ecce Homo*, 1923
Bound portfolio with paper covers consisting of 84 black-and-white offset lithographs and 16 color offset lithographs
Published by Malik-Verlag, Berlin; Edition C
Dückers SI
Signed and dated on title page: *George Grosz / 1930 / Berlin / April*
13 ⅞ x 10 ⅜ in. (35.8 x 26.4 cm) (each sheet)
Smart Museum of Art, University of Chicago, Gift of Mr. and Mrs. Arthur Mason
1994.101

30. *Massage*, 1930
Graphite on wove paper
Signed and dated l.r.: *Grosz / 1930 / Berlin*
17 ⅛ x 22 ¾ in. (43.5 x 57.8 cm)
Smart Museum of Art, University of Chicago, Bequest of Joseph Halle Schaffner in memory of his beloved mother, Sara H. Schaffner
1974.113

Friedrich Wilhelm Gubitz
(after Lucas Cranach the Elder, German, 1472–1553)
German, 1786–1870

31. *Christ Blessing*, ca. 1830s
Color woodcut and wood engraving on wove paper
10 ¾ x 6 ¹³⁄₁₆ in. (27.3 x 17.3 cm)
Smart Museum of Art, University of Chicago, University Transfer from Max Epstein Archive
1976.145.196

John Heartfield
German, 1891–1968

32. *Untitled* (*Diagnosis*) (*Diagnose*), 1935
From *AIZ* 14, 12 (Mar. 21, 1935)
Rotogravure of photomontage
Printed along top: *DIAGNOSE*; printed along bottom: *"Wodurch zog sich der Mann denn die Rückgratsverkrümmung zu?" / "Das sind die organischen Folgen des ewigen >>Heil Hitler!<<"*; printed l.r.: *Fotomontage: John Heartfield*
15 x 10 ½ in. (38.1 x 26.7 cm)
The Art Institute of Chicago, Wendell D. Fentress Endowment
1993.363

Erich Heckel
German, 1883–1970

33. *Dancers* (*Tänzerinnen*), 1922
Lithograph on wove paper
Dube 270
Signed and dated l.r.: *Erich Heckel 22*
19 ⅜ x 14 ¹⁵⁄₁₆ in. (49.2 x 38 cm)
Smart Museum of Art, University of Chicago, Marcia and Granvil Specks Collection
1991.348

34. *East Baltic Seacoast* (*Ostseeküste*), 1911
Graphite and watercolor on wove paper
Signed and dated in watercolor l.r.: *Heckel / 11*; inscribed l.r.: *Ostseeküste*
10 ⁹⁄₁₆ x 13 ¼ in. (26.8 x 33.6 cm)
Smart Museum of Art, University of Chicago, Bequest of Joseph Halle Schaffner in memory of his beloved mother, Sara H. Schaffner
1973.93

35. *Gray Slopes (Lesser Walser Valley)*
(*Graue Hänge [Kleines Walsertal]*),
1934
Watercolor, graphite, and wax pastel
on paper
Signed and dated l.r.: *Heckel 34*
18 ¾ x 24 ¾ in. (47.7 x 63 cm)
Smart Museum of Art, University of
Chicago, Purchase, Paul and Miriam
Kirkley Fund for Acquisitions
2001.42

Hans Hofmann
American, born in Germany, 1880–1966

36. *House on the Hill*, 1943
Ink and watercolor on wove paper
Signed and dated in ink l.r.: *VIII-10-
43 HH*
17 ⅝ x 24 in. (44.8 x 61 cm)
Smart Museum of Art, University of
Chicago, From the collection of
Janice and Henri Lazarof
2000.35

37. *Untitled #33*, 1943
Ink, watercolor, and gouache on
paper
Signed and dated in ink l.r.: *VIII-10-
43 HH*
14 x 17 in. (35.6 x 43.2 cm)
Smart Museum of Art, University of
Chicago, From the collection of
Janice and Henri Lazarof
2000.36

38. a. *Vase, Furniture, and Book* (recto),
1935
b. *Untitled (Still-Life)* (verso), 1935
Oil on masonite
30 x 22 in. (76.2 x 55.9 cm)/22 x 30 in.
(55.9 x 76.2 cm)
Lent by Mr. and Mrs. Robert M.
Newbury

Jörg Immendorff
German, b. 1945

39. *Hail Victory (Heil Sieg)*, 1983
Color linocut with gouache on paper
Inscribed and dated in gouache verti-
cally along r. edge: *Heil Sieg 83*
33 x 23 ¼ in. (83.7 x 59.1 cm)
Lent by Marcia and Granvil Specks
Collection

Wassily Kandinsky
Russian, 1866–1944; worked in Germany
1896–1914, 1921–33

40. *Engraving for the Circle of Friends
of the Bauhaus (Radierung für den
Kreis der Freunde des Bauhauses)*,
1932
Etching and drypoint on wove paper
Roethel 197; ed. 100
Monogrammed and dated in plate
l.l.: $\frac{IK}{32}$; signed l.r.: *Kandinsky*
7 ½ x 9 ¼ in. (19.1 x 23.5 cm)
Lent by Jack and Helen Halpern

41. *Great Resurrection (Grosse
Auferstehung)*, 1911
Color woodcut
Roethel 138, I
8 ⅝ x 8 ⁹⁄₁₆ in. (21.9 x 21.8 cm)
Lent by the estate of Mrs. Edna
Freehling
3.2000

42. *Small Worlds XI (Kleine Welten XI)*,
1922
Published by Propyläen Verlag,
Berlin
Etching and drypoint on laid paper
Roethel 174
Monogrammed in plate l.l.: IK; signed
l.r.: *Kandinsky*
9 ½ x 7 ¾ in. (24.1 x 19.7 cm)
Lent by Jack and Helen Halpern

43. *Two Riders in front of Red (Zwei
Reiter
vor Rot)*, 1911
Color woodcut
Roethel 95
4 ¹⁄₁₆ x 6 ⅛ in. (10.3 x 15.6 cm)
Lent by the estate of Mrs. Edna
Freehling
2.2000

Anselm Kiefer
German, b. 1945

44. *Grane*, 1980
Woodcut, oil, and varnish on paper
mounted on canvas
117 x 120 ¾ in. (297.2 x 274.5 cm)
Lent by Collection Susan and Lewis
Manilow

45. *Heavy Water (Schweres Wasser)*,
1991
Book of gelatin silver prints height-
ened with metallic paint, bound with
lead cover
27 ½ x 19 ⅝ x ⅝ in. (70 x 50 x 0.6
cm) (closed)
The Art Institute of Chicago, Gift of
Susan and Lewis Manilow
2000.715

46. *Light Trap (Lichtfalle)*, 1999
Shellac, emulsion, glass, wood, and
steel trap on linen
156 x 216 in. (380 x 560 cm)
Inscribed in chalk (?) u. l. : *Lichtfalle*
Lent by Collection Susan and Lewis
Manilow

47. *Meadow Saffron (Herbstzeitlosen)*,
1996
Book of original photographs with
emulsion, paint, and sand
19 ⅝ x 21 ¾ x 2 ⅜ in. (50 x 54 x 6
cm) (closed)
Lent by Collection Susan and Lewis
Manilow

Martin Kippenberger
German, 1953–1997

48. *Untitled*, 1989
Collage, hotel stationery, and silver
felt-tip pen
Signed and dated in ink l.r.: *M.K. 89*
20 ¼ x 16 ⅛ in. (51.4 x 41 cm)
Lent by Laura and Marshall Front

49. *Untitled (Hotel Restaurant Goldener
Adler)*, 1991
Colored pencil, crayon, graphite, and
vinyl letters on hotel stationery
Signed and dated l.r.: *M.K. 91*
11 ⅝ x 8 ⅛ in. (29.5 x 20.6 cm)
Smart Museum, Purchase, Gift of
Carl Rungius, by exchange
2001.32

Ernst Ludwig Kirchner
German, 1880–1938

50. *Dodo in the Studio (Dodo im Atelier)*, 1910
Pastel, charcoal, and crayon partially worked with wet brush
Signed in charcoal l.r.: *E L Kirchner*
19 x 22 ¾ in. (48.3 x 57.8 cm) (sight)
Lent by the estate of Mrs. Edna Freehling
4.2000

51. a. *Head with Flowers (Kopf mit Blumen)* (recto), ca. 1919
b. *Five Children in front of the House (Fünf Kinder vor dem Haus)* (verso), 1921–1923
Oil on canvas
Gordon 695 and 695v
Incised verso u.r.: *K*
19 ⅝ x 15 ¾ in. (49.5 x 39.5 cm)
Lent by Joel and Carol Honigberg

52. *Japanese Acrobats (Japanische Akrobaten)*, 1912
Woodcut on paper, handcolored in watercolor
Dube 194
Inscribed l.l.: *Handdruck*; signed and dated l.r.: *E L Kirchner 11* [sic]
10 ⅞ x 9 ¾ in. (27.6 x 24.8 cm)
Courtesy of Mrs. Wallace Landau

Paul Klee
Swiss, 1879–1940; worked in Germany 1906–33

53. *Genii (Genien)*, 1937
Graphite on paper, mounted on card
Signed in ink u.l. on sheet: *Klee*; dated l.l. on card: *1937 T4*; inscribed l.r. on card: *Genien*
12 ¾ x 19 in. (32.4 x 48.3 cm)
Lent by Jack and Helen Halpern

Paul Kleinschmidt
German, 1883–1949

54. *At the Fortune Teller's (Bei der Kartenschlägerin)*, 1922
Etching and drypoint on wove paper
Signed l.l.: *Kleinschmidt*
13 x 8 ¹⁵⁄₁₆ in. (33 x 22.7 cm)
Smart Museum of Art, University of Chicago, Marcia and Granvil Specks Collection
1998.97

Max Klinger
German, 1857–1920

55. *Days in March I (Märztage I)*
Plate 8 from the portfolio *Dramas (Dramen)*, *Opus IX*, 1883
Engraving and aquatint on paper
Singer 154
16 ¾ x 12 ¹⁵⁄₁₆ in. (42.6 x 32.9 cm)
Private Collection

56. *Intermezzi, Opus IV*, 1881
Six engravings with aquatint on paper (selected from a set of twelve)
University of Chicago Library, Special Collections Research Center, Gift of Bertold and Else Regensteiner

a. Plate 1. *Bear and Elf (Bär und Elfe)*
Singer 53
Inscribed l.l. and l.r. in plate: *MAX KLINGER* and *I*.
15 ⁹⁄₁₆ x 9 in. (40.5 x 22.9 cm)

b. Plate 4. *Moonlit Night (Mondnacht)*
Singer 57
Inscribed l.l. and l.r. in plate: *MAX KLINGER* and *IV*.
14 ¼ x 10 ⅜ in. (36.2 x 26.4 cm)

c. Plate 7. *Simplicius's Writing Lesson (Simplici Schreibstube)*
Singer 58
Inscribed l.l. and l.r. in plate: *MAX KLINGER* and *VII*.
11 ⁵⁄₁₆ x 9 in. (28.7 x 22.9 cm)

d. Plate 8. *Simplicius at the Grave of the Hermit (Simplicius am Grabe des Einsiedlers)*
Singer 59
Inscribed l.l. and l.r. in plate: *MAX KLINGER* and *VIII*.
11 ½ x 9 ⅛ in. (29.2 x 23.2 cm)

e. Plate 11. *Fallen Rider (Gefallener Reiter)*
Singer 62
Inscribed l.l. and l.r. in plate: *MAX KLINGER* and *XI*.
12 ¹¹⁄₁₆ x 7 ¾ in. (32.2 x 19.7 cm)

f. Plate 12. *Love, Death, and the Future (Amor, Tod und Jenseits)*
Singer 63
Signed and dated l.r. in plate: *Max Klinger / comp. 1879 rad. 1881*; inscribed l.l. and l.r. in plate: *MAX KLINGER* and *XII*.
6 ⅛ x 16 ⅛ in. (15.6 x 41 cm)

57. *A Love (Eine Leibe), Opus X*, 1907 (fourth edition, first published 1887)
Six prints in brown ink on English etching paper (selected from a set of ten)
Smart Museum of Art, University of Chicago, Purchase, Unrestricted Funds

a. Plate 1. *Dedication (Widmung)*
Etching and engraving
Singer 157
Inscribed l.l. and l.r. in plate: *MAX KLINGER* and *OPUS X, 1*.
16 ½ x 12 ⅞ in. (41.9 x 32.7 cm)
1983.49a

b. Plate 2. *First Encounter (Erste Begegnung)*
Etching, engraving, and aquatint
Singer 158
Inscribed l.l. and l.r. in plate: *MAX KLINGER* and *OPUS X, 2*.
16 x 9 ⁵⁄₁₆ in. (40.6 x 23.7 cm)
1983.49b

c. Plate 5. *Happiness (Glück)*
Etching, engraving, and aquatint
Singer 161
Inscribed l.l. and l.r. in plate: *MAX KLINGER* and *OPUS X, 5*.
16 ⅛ x 11 in. (41 x 27.9 cm)
1983.49e

d. Plate 6. *Intermezzo*
Etching and engraving
Singer 162
Inscribed l.l. and l.r. in plate: *MAX KLINGER* and *OPUS X, 6.*
7 3/8 x 16 3/8 in. (18.7 x 41.6 cm)
1983.49f

e. Plate 9. *Scandal (Schande)*
Etching, engraving, and aquatint
Singer 165
Inscribed l.l. and l.r. in plate: *MAX KLINGER* and *OPUS X, 9.*
16 5/16 x 10 1/2 in. (41.5 x 26.7 cm)
1983.49i

f. Plate 10. *Death (Tod)*
Etching, engraving, and aquatint
Singer 166
Inscribed l.l. and l.r. in plate: *MAX KLINGER* and *OPUS X, 10.*
12 5/16 x 17 3/4 in. (31.3 x 45.1 cm)
1983.49j

Georg Kolbe
German, 1877–1947

58. *Study for "Travel in the Clouds" (Vorstudie zu "Wolkenfahrt"),* ca. 1924
Cast bronze
Monogrammed on base: *GK*
Height 12 in. (30.5 cm)
Smart Museum of Art, University of Chicago, The Joel Starrels Jr. Memorial Collection
1974.176

Käthe Kollwitz
German, 1867–1945

59. *The Call of Death (Der Ruf des Todes),* posthumous (1951) impression from 1934–1935
Lithograph on paper
Klipstein 263c
Inscribed l.l.: *40/200;* signed by the artist's son l.r.: *Hans Kollwitz*
19 1/4 x 17 9/16 in. (48.9 x 44.6 cm) (sheet)
Smart Museum of Art, University of Chicago, University Transfer from Max Epstein Archive
1967.116.147

60. *Pensive Woman (Nachdenkende Frau),* 1922
From the *Arno Holz Portfolio (Arno-Holz-Mappe)* (Berlin: Fritz Gurlitt, 1922)
Transfer lithograph on paper
Klipstein 146d
Signed l.r.: *Käthe Kollwitz*
11 1/2 x 10 3/4 in. (29.2 x 27.3 cm)
University of Chicago Library, Special Collections Research Center, Gift of Bertold Regensteiner

61. *Self-Portrait with Profile from the Right (Selbstbildnis im Profil von rechts),* 1938
Lithograph on wove paper
Klipstein 265
18 3/4 x 11 3/8 in. (47.6 x 28.9 cm)
Smart Museum of Art, University of Chicago, Gift of the Mary and Earle Ludgin Collection
1982.70

62. *War Mothers (Kriegsmütter),* 1919 (second version)
Lithograph on laid paper
Klipstein 135 II/II
Signed l.r. in plate: *Kollwitz*
17 1/4 x 22 7/8 in. (43.8 x 58.1 cm)
Smart Museum of Art, University of Chicago, The Mary and Earle Ludgin Collection, 1981
1981.79

63. *Working-Class Woman in Profile, Facing Left (Arbeiterfrau im Profil nach Links),* 1903
Lithograph on paper
Klipstein 67 II; ed. 25/50
Signed l.r.: *Kathe Kollwitz;* inscribed l.l.: *25/50*
17 3/8 x 12 13/16 in. (44.1 x 31 cm)
Lent by Jack and Helen Halpern

Bodo Korsig
German, b. 1962

64. *Timechange,* 2000
Four woodcuts printed in oil on paper
Three signed and dated l.c.: *"Timechange" / 2000 / B. Korsig;* one signed and dated l.c.: *2000 / B. Korsig*
55 5/8 x 39 3/4 in. (141.3 x 101 cm) (each)
Lent by the artist

Max Liebermann
German, 1847–1935

65. *Portrait of Albert Einstein (Bildnis Albert Einsteins),* 1922
From the portfolio *Artists' Donation for the German Book Museum (Künstler-Spende für das Deutsche Buchmuseum)* (Leipzig: Breitkopf & Härtel, 1922)
Lithograph on paper
Signed on stone l.l.: *M Liebermann;* signed l.r.: *M Liebermann*
11 3/4 x 9 1/8 in. (29.9 x 23.2 cm)
University of Chicago Library, Special Collections Research Center, Gift of Bertold Regensteiner

Ludwig Meidner
German, 1884–1966

67. *Ernst Rathenau*, 1922
Drypoint on paper
Signed and dated l.r.: *L. Meidner/1922*; inscribed l.l.: *Probedrück*
9 ¹¹/₁₆ x 9 ¹¹/₁₆ in. (24.6 x 24.6 cm)
Smart Museum of Art, University of Chicago, Gift of John F. Peloza
2000.71

68. *Interior (The Artist's Bedroom) (Interiör [Des Künstlers Schlafzimmer])*, 1909
Oil on canvas
23 ⅝ x 23 ⅝ in. (60 x 60 cm)
Smart Museum of Art, University of Chicago, Gift of Ruth Mayer Durchslag, from the Robert B. Mayer Collection
1991.405

Adolph Menzel
German, 1815–1905

69. *An Elderly Man in a Military Topcoat*, 1881
Graphite on off-white paper
Signed and dated l.r.: *A.M. 81.*
7 ⅞ x 4 ¹⁵/₁₆ in. (20 x 12.5 cm)
Courtesy of the Fogg Art Museum, Harvard University Art Museums, Bequest of Meta and Paul J. Sachs
1965.0347

Johann Georg Meyer von Bremen
German, 1813–1886

70. *Young Girl Reading (Lesendes Mädchen)*, 1868
Oil on canvas
16 ½ x 13 in. (41.9 x 33 cm) (sight)
Smart Museum of Art, University of Chicago, University Transfer
1967.29

Robert Michel
German, 1897–1983

71. *MEZ (Central European Time, No. 1) (MEZ [Mitteleuropäische Zeit, No. 1])*, 1919–1920
Woodcut printed in silver ink on black wove paper (as a negative impression)
Inscribed and monogrammed in blue and red ink l.r.: *MEZ 1919/1920 Weimar RMIL 1*; inscribed l.l. in block: *Umkehrdruck*
18 ⅛ x 14 ¾ in. (46 x 37.5 cm)
Smart Museum of Art, University of Chicago, Purchase, Bequest of Joseph Halle Schaffner in memory of his beloved mother, Sara H. Schaffner
1998.16

Helmut Middendorf
German, b. 1953

72. *Dual Head (Study for "Night") (Doppelkopf [Studie zu "Night"])*, 1982
Watercolor, gouache, pencil, and crayon on white watercolor paper
Signed and dated l.r.: *Middendorf / 82*; inscribed along bottom: *Study for "Night"*; inscribed l.r.: *Doppelkopf*
15 x 10 ¼ in. (38.1 x 26 cm)
Lent by Marcia and Granvil Specks Collection

73. *Embrace of the Night (Die Umarmung der Nacht)*, 1982
Watercolor, gouache, and charcoal on white watercolor paper
Inscribed along bottom: *Die Umarmung der Nacht*; signed and dated l.r.: *Middendorf 82*
18 ¾ x 14 in. (47.7 cm x 35.6 cm)
Lent by Marcia and Granvil Specks Collection

74. *Night Club*, 1980
Watercolor, gouache, graphite, and crayon on white paper
Dated and signed l.r.: *1980 Middendorf*; inscribed along bottom: *So-So*
13 ⅞ x 17 ¾ in. (35.2 x 45.1 cm) (sight)
Lent by Marcia and Granvil Specks Collection

Gabriele Münter
German, 1877–1962

75. *The Blue Gable (Blauer Giebel)*, 1911
Oil on canvas
Signed and dated l.r.: *Münter. / 1911.*
34 ¹⁵/₁₆ x 39 ⅝ in. (88.8 x 100.7 cm)
Krannert Art Museum and Kinkead Pavilion, University of Illinois, Urbana-Champaign, Gift of Albert L. Arenberg
1956.13.1

76. *Yellow Still Life (Stilleben, Gelb)*, 1909
Oil on paperboard
Signed l.r.: *Münter.*
16 ½ x 13 in. (41.9 x 33 cm) (sight)
Milwaukee Art Museum, Gift of Mrs. Harry Lynde Bradley
M1975.156

77. *Fall Landscape, Study (Yellow Trees) (Herbstlandschaft, Studie [Gelbe Bäume])*, 1908
Oil on paperboard
13 x 17 ⅛ in. (33.1 x 44.8 cm) (sight)
Private Collection

Oscar Nerlinger
German, 1893–1969

78. *Contrast Paper (Contrast Papier)*, ca. 1928/1930
Vintage gelatin silver print with paint mounted on thick paper
7 x 9 in. (17.8 x 22.9 cm)
Smart Museum of Art, University of Chicago, Purchase, Gift of Carl Rungius, by Exchange
2000.22

79. *Woods of the World* or *World Matches (Welthölzer)*, c. 1928/1930
Vintage gelatin silver print with paint mounted on thick paper
Inscribed l.l. in negative: NERLINGER
7 x 9 ⅜ in. (17.8 x 23.9 cm)
Smart Museum of Art, University of Chicago, Purchase, Gift of Carl Rungius, by Exchange
2000.23

Eugen Napoleon Neureuther
German, 1806–1862

80. *Memorial Print in Remembrance of the Munich Artists' Masked Procession (Der Albrecht Dürer-Verein, Seinen Mitgliedern für das Verwaltungs-Jahr 1843–44)*, 1841–1843
Steel engraving on off-white wove paper
Bredt, pl. 59 (as 1841)
Inscribed in plate l.c.: *Eugen Neureuther invenit et fecit. / Der Albrecht Dürer-Verein seinen Mitgliedern / für des Verwaltungs-Jahr 1843–44 / Druck v. Carl Mayer*
21 ⅝ x 16 ½ in. (54.9 x 41.9 cm)
Milwaukee Art Museum, Purchase, René von Schleinitz Memorial Fund
M1996.256

Emil Nolde
German, 1867–1956

81. *Portrait of a Girl (Mädchenbildnis)*, 1924
Etching on paper
Schiefler-Mosel 230 II/II
Signed l.r.: *Emil Nolde*
5 ⅞ x 4 ¼ in. (14.9 x 10.8 cm)
Lent by Jack and Helen Halpern

82. *Self-Portrait with Pipe (Kopf mit Pfeiffe [Selbstbildnis])*, 1907
Transfer lithograph on wove paper
Schiefler-Mosel 5
Signed and dated l.r.: *Emil Nolde 07*
15 ¾ x 11 ¼ in. (40 x 28.6 cm)
Lent by Joseph P. Shure

83. *Tingel-Tangel II*, 1907/1915
Color lithograph
Schiefler-Mosel 27 II
Inscribed l.l.: *Auflage Nr. 3*; signed l.r.: *Emil Nolde*
12 ¾ x 19 in. (32.5 x 48 cm)
Smart Museum of Art, University of Chicago, Marcia and Granvil Specks Collection
1984.74

84. *Two Girls*, ca. 1929
Watercolor on wove paper
Signed l.r.: *Nolde*
18 ⅜ x 13 ⅞ in. (46.7 x 35.2 cm)
Smart Museum of Art, University of Chicago, Gift of the Mary and Earle Ludgin Collection
1982.71

Felix Nussbaum
German, 1904–1944

85. a. *Portrait of a Young Man (Karl Hutloff) (Bildnis eines Jungen Mannes [Karl Hutloff]) (recto)*, ca. 1939
b. *Carnival Group (Narrengruppe or Mummenschantz) (verso)*, 1927
Oil on canvas
Junk/Zimmer 23 (recto) and 227 (verso)
Signed and dated verso l.r.: *Felix Nussbaum 1927*
38 ½ x 28 ½ in. (97.8 x 72.4 cm)/ 28 ½ x 38 ½ in. (72.4 x 97.8 cm)
Smart Museum of Art, University of Chicago, Purchase, Gift of Mr. and Mrs. Eugene Davidson, Mr. and Mrs. Edwin DeCosta, Mr. and Mrs. Gaylord Donnelly, and the Eloise W. Martin Fund
1982.10

Ernst Ferdinand Oehme
German, 1797–1855

86. *Nocturnal View of Meissen in Winter (Blick auf das nächtliche Meißen im Winter)*, 1854
Oil on canvas
Signed and dated l.l.: *E. Oehme / 1854*
27 x 23 in. (68.6 x 58.4 cm) (sight)
Milwaukee Art Museum, Gift of the René von Schleinitz Foundation
M1962.105

Max Pechstein
German, 1881–1955

87. *Head of a Girl (Mädchenkopf)*, 1910
Oil on canvas
Signed and dated l.r.: *M. Pechstein / 1910*
20 ½ x 20 in. (52.1 x 50.8 cm)
Smart Museum of Art, University of Chicago, Gift of Mr. and Mrs. Joseph Randall Shapiro
1992.19

88. *Sorrow (Leid)*, 1907–08
Lithograph on wove paper
Krüger L26
Signed and dated l.r.: *HMP 07*
13 ½ x 15 ¾ in. (34.3 x 40 cm)
Smart Museum of Art, University of Chicago, Gift of Edward Stowe Akeley, estate executed by his widow
1995.17

A. R. Penck (Ralf Winkler)
German, b. 1939

89. *The Work Goes On (Die Arbeit geht weiter)*, 1982
Woodcut on paper
Signed l.r.: *A R Penck*; inscribed l.l.: *49/50*
35 ¼ x 27 ¼ in. (89.5 x 69.2 cm)
Lent by Marcia and Granvil Specks Collection

90. *Untitled (Figuration)*, 1987
 Gouache on paper
 Signed in black ink l.l. and l.r.: *a r
 penck*
 12 ¾ x 18 in. (32.4 x 45.7 cm)
 Lent by Laura and Marshall Front

Sigmar Polke
German, b. 1941

91. *Partially on This Side, Partially on
 the Other Side (Teils disseits/Teils
 jenseits)*, 1979
 Sprayed acrylic on paper, with linear
 cutouts
 Signed and dated l.r.: *S. Polke / 79*
 39 x 27 ½ in. (99.1 x 69.9 cm)
 The Art Institute of Chicago, Gift of
 Susan and Lewis Manilow
 2000.714

92. *Untitled*, 1967
 Gouache, watercolor, and spraypaint
 on paper
 Signed in watercolor l.l.: *S. P.*
 39 x 29 ⅜ in. (99.1 x 74.6 cm)
 Lent by Laura and Marshall Front

Domenico Quaglio
German, 1786–1837

93. *Ruin of the Church of Our Lady
 with the Tombstone of Genevieve
 and the Count Palatine Siegfried in
 the Mosel Valley near Andernach
 (Ruine Frauenkirche mit dem
 Grabmale der Genofeva und des
 Pfalzgrafen Siegfried im Moselthale
 unweit Andernach)*, 1821
 Lithograph on ivory wove paper
 Signed and dated l.l. in plate:
 Dominic Quaglio del. fec. 1821;
 inscribed below image in plate: *Ruine
 Frauenkirche mit dem Grabmale der
 Genofeva und des Pfalzgrafen
 Siegfried im Moselthale unweit
 Andernach.*
 15 ⅞ x 12 ⁷⁄₁₆ in. (40.3 x 31.6 cm)
 The Art Institute of Chicago, Gift of
 the Print and Drawing Club
 1948.120

Lorenzo Quaglio
German, 1793–1869

94. *Figure Study for "At the Lattice
 Gate" (Vorstudie su "Am
 Gattertor")*, 1821
 Watercolor over graphite on tan
 wove paper
 Inscribed l.l.: *Kaspf Bauer von
 Schlierfen / den 14. August 1821 / L.
 Quaglio*
 9 ⁷⁄₁₆ x 8 ¹⁄₁₆ in. (24.9 x 20.5 cm)
 Milwaukee Art Museum, Purchase,
 René von Schleinitz Memorial Fund
 M1996.6

Gerhard Richter
German, b. 1932

95. *Abstract Picture (836-3)
 (Abstract Bild [836-3])*, 1996
 Oil on linen
 Inscribed verso: *836-3 Richter 1996*
 18 ⅛ x 20 ⅛ in. (46 x 51.1 cm)
 Lent by Mr. and Mrs. Robert M.
 Newbury

Hans Richter
German, 1888–1975

96. *Head in Profile (Kopf in Profil)*, 1968
 Colored pencil, photocollage, and col-
 lage on paper
 9 ⅞ x 6 ¹¹⁄₁₆ in. (25 x 17 cm)
 Signed and dated l.l.: *Hans Richter 68*
 Lent by Jack and Helen Halpern

Christian Rohlfs
German, 1849–1938

97. *Death (Der Tod)*, 1919
 Woodcut printed in blue ink
 on wove paper
 Vogt 64
 Inscribed l.l.: *Tod;* signed l.r.: *Chr.
 Rohlfs*
 8 x 9 ½ in. (20.3 x 22.9 cm)
 Smart Museum of Art, University of
 Chicago, Gift of John F. Peloza
 1988.5

98. *The Spirit of God above the Waters
 (Der Geist Gottes über den Wassern)*,
 1915–1916
 Tempera on wove paper
 Vogt 91
 Signed on image: *Rohlfs*
 22 ⁵⁄₁₆ x 18 ⁹⁄₁₆ in. (56.7 x 47.2 cm)
 Smart Museum of Art, University of
 Chicago, Marcia and Granvil Specks
 Collection
 1984.78

August Sander
German, 1876–1964

99. *Portraits of Artists
 (Künstlerporträts)*, 1924–1930
 Two gelatin silver prints (selected
 from a portfolio of twelve)
 Printed in 1974 from original glass
 negatives by the artist's son Gunther
 Sander; ed. 52/75 (plus 6 artist's
 proofs)
 Smart Museum of Art, University of
 Chicago, Gift of Susan and Lewis
 Manilow

 a. *The Dadaist Raoul Hausmann,
 Posing*, 1930
 Embossed with the artist's seal
 11 ⅛ x 8 in. (28.3 x 20.3 cm)
 2000.119h

 b. *The Dadaist Raoul Hausmann,
 Sitting*, 1930
 Embossed with the artist's seal
 11 ¼ x 8 ⅛ in. (28.6 x 20.6 cm)
 2000.119g

100. *Face of our Time (Antlitz der Zeit)*,
 1929
 Four gelatin silver prints
 Printed later from original glass
 negatives by the artist's grandson
 Gerd Sander
 Lent by Collection Susan and Lewis
 Manilow

 a. *Farming Family (Bauernfamilie)*,
 ca. 1914
 10 ¼ x 7 ½ in. (26 x 19 cm)

b. *The Pastry Cook, Franz Bremer, Cologne (Der Konditor, Franz Bremer)*, ca. 1928
10 ¼ x 7 ⅜ in. (26 x 18.7 cm)

c. *Peddler (Hausierer)*, n.d.
10 ¼ x 7 ¼ in. (26 x 18.4 cm)

d. *Young Farmers, Westerwald (Jungbauern, Westerwald)*, ca. 1914
10 ¼ x 7 ½ in. (26 x 19 cm)

Christian Schad
German, 1894–1982

101. *Portrait of Baronessa Vera Wassilko*, 1926
Oil on canvas
Signed and dated l.r.: *Schad 26*
28 ⅝ x 18 ¼ in. (72.7 x 46.4 cm) (sight)
Lent by Anatole and Nancy Gershman

Karl Friedrich Schinkel
German, 1781–1841

102. *A Gothic Cathedral behind Trees (Gothischer Dom hinter Bäumen)*, ca. 1813/1815
Pen and gray ink and watercolor over graphite on ivory wove paper, mounted on gray wove backing sheet
9 ¾ x 9 in. (24.7 x 22.8 cm)
Milwaukee Art Museum, Purchase, René von Schleinitz Memorial Fund
M1995.285

Karl Friedrich Schinkel (designer)
German, 1781–1841
Friedrich Anton König (sculptor)
German, 1794–1844

103. a. *Prince Gebhard Leberecht von Blücher (1742–1819) (obverse)*, 1816
b. *The Archangel Michael (reverse)*, 1816
Cast iron
Diameter 3 ⅛ in. (7.9 cm)
Smart Museum of Art, University of Chicago, Purchase, the Cochrane-Woods Collection
1977.113

Johann Wilhelm Schirmer
German, 1807–1863

104. *Mill near a Forest (Die Mühle am Wald)*, n.d.
Etching on gray chine appliqué
Bergquist 24 II/II
Monogrammed in plate l.c.: *JWS*; blindstamped on platemark l.c.
9 ⅜ x 13 ½ in. (23.7 x 34.2 cm)
Milwaukee Art Museum, Purchase, René von Schleinitz Memorial Fund
M1996.45

Karl Schmidt-Rottluff
German, 1884–1976

105. *Self-Portrait (Selbstbildnis)*, 1913
Watercolor and graphite on brown paper
Signed and dated l.l.: *S Rottluff 1913*
16 ¾ x 13 in. (42.6 x 33 cm)
Courtesy of the Busch-Reisinger Museum, Harvard University Art Museums, Gift of Mr. and Mrs. Lyonel Feininger
BR54.0119

106. *Three People at the Table (Drei am Tisch)*, 1914
From the portfolio *Ten Woodcuts by Schmidt-Rottluff (Zehn Holzschnitte von Schmidt-Rottluff)*, 1919; published by J.B. Neumann, Berlin
Woodcut on wove paper
Schapire 167; ed. 75
Signed l.r.: *S Rottluff*
19 ⅝ x 15 ⅝ in. (49.9 x 39.7 cm)
Smart Museum of Art, University of Chicago, Gift of Gerhard L. Closs
1992.66

Julius Veit Hans Schnorr von Carolsfeld
German, 1794–1872

107. *The Sleep of Emperor Frederick Barbarossa (Der Schlaf des Kaisers Friedrich Barbarossa)*, ca. 1835–1837
Oil on wood panel
18 ¾ x 14 in. (47.6 x 35.6 cm)
Smart Museum of Art, University of Chicago, Purchase, the Cochrane-Woods Collection
1980.3

Wilhelm Schulz
German, 1865–1962

108. *War Loan: "Resisting the Enemy, Protecting the Homeland" (Kriegsanleihe: "Den Feinden zum Trutz, der Heimat zum Schotz")*, ca. 1917/1918
Handbill for a War Loan
Color offset lithograph
Signed on stone: *Schulz*
13 x 9 ¼ in. (33 x 23.5 cm)
University of Chicago Library, Special Collections Research Center

Lasar Segall
Brazilian, born in Lithuania, 1891–1957; worked in Germany, 1906–1914, 1916–1923

109. *Aimlessly Wandering Women II (Irrende Frauen II)*, 1919
Woodcut on heavy wove paper
Signed l.r.: *Lasar Segall*; inscribed l.l.: *Irrende Frauen II Fassung*
9 x 11 ⅜ in. (22.9 x 28.9 cm)
Smart Museum of Art, University of Chicago, Gift of Mauricio Segall and Oscar Klabin Segall
1997.49

Nepomuk Strixner
(after Jan von Melem, Dutch, 16th century)
German, 1782–1855

110. *Portrait of a Man,* 1837
Mezzotint and stipple engraving on tan wove paper mounted on white wove paper
Inscribed l.c. in plate: *ECCE • DUOS • ANOS • ET • SEPTEM • / LUSTRA • GERENTIS: HUIC • TA / BULE • E • MELEM • FCRMA • IOAM / IS • INEST • / HOC • OPUS • ECCE • NOVUM • / CONSTRUXIT • VALDE • / PERITUS •;* inscribed below image in plate: *J. v. Melem pinxt. Lithographirt unter der Direction von Strixner gedr. u. d. Direct. v. Selb in München. N. Strixner u. Freymann an. 1837*
16 7/8 x 10 5/8 in. (42.9 x 27 cm)
Smart Museum of Art, University of Chicago, University Transfer from Max Epstein Archive
1976.145.389

Rosemarie Trockel
German, b. 1952

111. *Untitled,* 1996
Four works on paper
Lent by Laura and Marshall Front

a. Cibachrome
11 3/8 x 11 3/8 in. (28.9 x 28.9 cm)

b. Ink on paper
11 1/8 x 8 1/8 in. (28.3 x 20.6 cm)

c. Gouache on paper
17 3/8 x 13 7/16 in. (44.1 x 34.2 cm)

d. Black-and-white photograph
11 3/8 x 11 3/8 in. (28.9 x 28.9 cm)

Fritz Winter
German, 1905–1976

112. *Figure (Gestalt),* 1964
White crayon and oil on paper
27 1/2 x 19 5/8 in. (70 x 49.9 cm)
Signed and dated l.r.: *F. Winter 64*
Lent by Jack and Helen Halpern

Various artists

113. *Homage to Edvard Munch (Hommage à Edvard Munch)*
Six prints (selected from a portfolio of twelve), ed. 14/40
Chemnitz: Stadt Chemnitz Kulturamt, 1999
Smart Museum of Art, University of Chicago, Gift of the Kunstsammlungen Chemnitz, Germany

a. Michael Morgner
German, b. 1942
Untitled (Ohne Titel), 1999
Etching, engraving, and aquatint with lavage on paper
Signed and dated l.r.: *Morgner '99;* inscribed l.l.: *14/40*
19 5/8 x 12 11/16 in. (49.9 x 32.2 cm)
2000.60c

b. Michael Morgner
Untitled (Ohne Titel), 1999
Etching, engraving, and aquatint with lavage on paper
Signed and dated l.r.: *Morgner '99;* inscribed l.l.: *14/40*
12 5/8 x 19 5/8 in. (32.1 x 49.9 cm)
2000.60d

c. Thomas Ranft
German, b. 1942
Alpha and Omega (Alfa og Omega), 1999
Color etching on paper
Inscribed l.l.: *Alfa og Omega;* signed and dated l.r.: *Ranft 99.;* inscribed l.r. corner of sheet: *14/40*
15 3/8 x 11 1/2 in. (39.1 x 29.2 cm)
2000.60e

d. Thomas Ranft
Allegory (Allegorie), 1999
Color etching on paper
Inscribed l.l.: *Allegorie;* signed and dated l.r.: *Ranft 99.;* inscribed l.r. corner of sheet: *14/40*
15 3/8 x 11 1/2 in. (39.1 x 29.2 cm)
2000.60f

e. Dagmar Ranft-Schinke
German, b. 1944
The Kiss (Der Kuss), 1995–1999
Two-color etching and aquatint on paper
Monogrammed and dated l.r. in plate: *RS 95;* inscribed below image: *Der Küss 14/40 aqua. D. Ranft-Schinke '95/'99 I.;* inscribed l.l. and l.r. of sheet: *Hommage à E. Münch* and *.Z*
9 3/8 x 12 5/8 in. (23.9 x 32.1 cm)
2000.60g

f. Dagmar Ranft-Schinke
Alpha and Omega (Alpha und Omega), 1999
Two-color etching and aquatint on paper
Monogrammed and dated l.r. in plate: *RS 99;* inscribed below image: *Alpha und Omega 14/40 aqua. D. Ranft-Schinke '99 II.;* inscribed l.l. and l.r. of sheet: *Hommage à E. Münch* and *.Z*
11 5/8 x 11 5/8 in. (29.5 x 29.5 cm)
2000.60h

Bibliography of Catalogues Raisonnés

Hans (Jean) Arp
Arntz, Wilhelm F., ed. *Hans (Jean) Arp: Das graphische Werk, 1912–66*. The Hague: Gertrud Arntz-Winter, 1980.

Georg Baselitz
Jahn, Fred. *Baselitz: Peintre-Graveur: Werkverzeichnis der Druckgraphik*, 2 vols. Bern/Berlin: Gachnang and Springer, 1983–87.

Max Beckmann
Gallwitz, Klaus, ed. *Max Beckmann: Die Druckgraphik*. Karlsruhe: Badischer Kunstverein Karlsruhe, 1962.

Göpel, Erhard. *Max Beckmann: Katalog der Gemälde*. 2 vols. Bern: Kornfeld, 1976.

Hofmaier, James. *Max Beckmann: Catalogue Raisonné of His Prints*. Bern: Galerie Kornfeld, 1990.

Joseph Beuys
Schellmann, Jörg. *Joseph Beuys: Die Multiples. Werkverzeichnis der Auflagenobjeckte und Druckgraphik 1965–1986*. Munich/New York: Schellmann, 1992.

Heinrich Campendonk
Engels, Mathias T. *Heinrich Campendonk: Das graphische Werk*. New ed. Gerhardt Söhn. Düsseldorf: Edition GS, 1996.

Lovis Corinth
Schwarz, Karl. *Das graphische Werk von Lovis Corinth*. Berlin: Fritz Gurlitt, 1922. Rev. ed. San Francisco, 1985.

Otto Dix
Karsch, Florian, ed. *Otto Dix: Das graphische Werk*. Hannover: Fackelträger-Verlag Schmidt-Küster, 1970.

Max Ernst
Spies, Werner. *Max Ersnt, Oeuvre-Katalog*. Houston/Cologne. Menil Foundation/M. DuMont Schaubert, 1975.

Lyonel Feininger
Prasse, Leona E. *Lyonel Feininger: A Definitive Catalogue of His Graphic Work: Etchings, Lithographs, Woodcuts*. Cleveland: Cleveland Museum of Art, 1972.

Conrad Felixmüller
Söhn, Gerhart. *Conrad Felixmüller: Das graphische Werk, 1917–1977*. Dusseldorf: Graphik-Salon Gerhart Söhn, 1987.

Caspar David Friedrich
Börsch-Supan, Helmut. *Caspar David Friedrich: Gemälde, Druckgraphik und bildmäßige Zeichnungen*. Munich: Prestel, 1975.

George Grosz
Dückers, Alexander. *George Grosz: Das druckgraphische Werk*. Frankfurt: Propyläen, 1979.

Erich Heckel
Dube, Annemarie, and Wolf-Dieter Dube. *Erich Heckel: Das graphische Werk*. 3 vols. New York: Ernst Rathenau, 1974.

Wassily Kandinsky
Roethel, Hans Konrad. *Kandinsky: Das graphische Werk*. Cologne: M. DuMont Schauberg, 1970.

Ersnt Ludwig Kirchner
Dube, Annemarie, and Wolf-Dieter Dube. *Ernst Ludwig Kirchner: Das graphische Werk*. 2 vols. Munich: Prestel, 1980.

Gordon, Donald E. *Ernst Ludwig Kirchner*. Cambridge, Mass.: Harvard University Press, 1968.

Max Klinger
Singer, Hans Wolfgang. *Max Klingers Radierungen, Stiche und Steindrucke*. New York: Martin Gordon, 1978.

Käthe Kollwitz
Klipstein, August. *Käthe Kollwitz: Verzeichnis des graphischen Werkes*. Bern: Klipstein, 1955.

Eugen Napoleon Neureuther
Bredt, Ernst Wilhelm. *Das Neurether-Album*. Munich: Hugo Schmidt, 1918.

Emil Nolde
Schiefler, Gustav. *Emil Nolde: Das graphische Werk*. Ed. Chirstel Mosel; expanded Martin Urban. Cologne: DuMont, 1995.

Felix Nussbaum

Junk, Peter, and Wendelin Zimmer. *Felix Nussbaum: Leben und Werk*. Cologne: DuMont, 1982.

Max Pechstein

Krüger, Günter. *Das druckgraphische Werk Max Pechsteins*. Tökendorf: R. C. Pechstein, 1988.

Christian Rohlfs

Vogt, Paul. *Christian Rohlfs: Oeuvre-Katalog des Gemälde*. Recklinghausen: Bongers, 1978.

Karl Schmidt-Rottluff

Schapire, Rosa. *Karl Schmidt-Rottluff, graphisches Werk bis 1923*. New York: E. Rathenau, 1987.

Image Credits

Every effort has been made to contact rights holders for all reproductions. Additional rights holders are encouraged to contact the Smart Museum. Photography by Tom Van Eynde unless otherwise noted below.

ANON.: Fig. 91: photo by Ted Lacey.
HANS (JEAN) ARP: © 2003 Artists Rights Society (ARS), New York/VG Bild-Kunst, Bonn.
ERNST BARLACH: Fig. 50: photo courtesy Kunsthalle Bremen.
GEORG BASELITZ: © Georg Baselitz.
MAX BECKMANN: © 2003 Artists Rights Society (ARS), New York/VG Bild-Kunst, Bonn. Plate 1 [cat. no. 9]: photo by Michael Tropea.
JOSEPH BEUYS: © 2003 Artists Rights Society (ARS), New York/VG Bild-Kunst, Bonn. Fig. 6 and cover [cat. no. 10]: photo © Museum of Contemporary Art, Chicago.
KARL BLECHEN: Fig. 18 [cat. no. 11]: photo courtesy Milwaukee Art Museum.
HEINRICH CAMPENDONK: © 2003 Artists Rights Society (ARS), New York/VG Bild-Kunst, Bonn.
OTTO DIX: © 2003 Artists Rights Society (ARS), New York/VG Bild-Kunst, Bonn.
ELK EBER: Fig. 92: photo by Ted Lacey.
FRITZ ERLER: Fig. 52 [cat. no. 16], and Fig. 53 [cat. no. 15]: photos by Ted Lacey.
MAX ERNST: © 2003 Artists Rights Society (ARS), New York/ADAGP, Paris.
LYONEL FEININGER: © 2003 Artists Rights Society (ARS), New York/VG Bild-Kunst, Bonn.
CONRAD FELIXMÜLLER: © 2003 Artists Rights Society (ARS), New York/VG Bild-Kunst, Bonn.
CASPAR DAVID FRIEDRICH: Fig. 29 [cat. no. 23]: photo courtesy Milwaukee Art Museum.
GEORGE GROSZ: © Estate of George Grosz/Licensed by VAGA, New York, NY.
JOHN HEARTFIELD: © 2003 Artists Rights Society (ARS), New York/VG Bild-Kunst, Bonn. Fig. 90 [cat. no. 32]: photo courtesy The Art Institute of Chicago.
ERICH HECKEL: © 2003 Artists Rights Society (ARS), New York/VG Bild-Kunst, Bonn.
HANS HOFMANN: © 2003 Estate of Hans Hofmann/Artists Rights Society (ARS), New York.
JÖRG IMMENDORFF: © Jörg Immendorff.
WASSILY KANDINSKY: © 2003 Artists Rights Society (ARS), New York/ADAGP, Paris.
ANSELM KIEFER: Courtesy Anselm Kiefer. Plate 8 [cat. no. 45]: photo courtesy The Art Institute of Chicago. Plate 9 [cat. no. 47]: photo by Michael Tropea.
MARTIN KIPPENBERGER: © The Estate of Martin Kippenberger Courtesy Galerie Gisela Capitain, Cologne.
ERNST LUDWIG KIRCHNER: Figs. 77, 78 [cat. no. 51]: photos by Michael Tropea.
PAUL KLEE: © 2003 Artists Rights Society (ARS), New York/VG Bild-Kunst, Bonn.
PAUL KLEINSCHMIDT: Courtesy of Richard A. Cohn, Ltd.
MAX KLINGER: Fig. 24 [cat. no. 56d] and fig.25 [cat. no. 56f]: photos by Ted Lacey.
OSKAR KOKOSCHKA: © 2003 Artists Rights Society (ARS), New York/Pro Litteris, Zurich.

GEORG KOLBE: © 2003 Artists Rights Society (ARS), New York/VG Bild-Kunst, Bonn.
KÄTHE KOLLWITZ: © 2003 Artists Rights Society (ARS), New York/VG Bild-Kunst, Bonn.
BODO KORSIG: © 2003 Artists Rights Society (ARS), New York/VG Bild-Kunst, Bonn.
ADOLPH MENZEL: Fig. 32 [cat. no. 69]: photo by Katya Kallsen, © President and Fellows of Harvard College. Fig. 39: photo courtesy Bildarchiv Preußischer Kulturbesitz.
ROBERT MICHEL: Courtesy Städtische Galerie am Abdinghof.
HELMUT MIDDENDORF: Fig. 5 [cat. no. 73] and Plate 5 [cat. no. 74]: photos by Michael Tropea.
MICHAEL MORGNER: © 2003 Artists Rights Society (ARS), New York/VG Bild-Kunst, Bonn.
GABRIELE MÜNTER: © 2003 Artists Rights Society (ARS), New York/VG Bild-Kunst, Bonn. Fig. 41 [cat. no. 76]: photo courtesy Milwaukee Art Museum. Fig. 42 [cat. no. 75]: photo courtesy Wilmer Zehr, Zehr Photography, Champaign, Ill.
EUGEN NAPOLEON NEUREUTHER: Fig. 31 [cat. no. 80]: photo courtesy Milwaukee Art Museum.
EMIL NOLDE: © Nolde-Stiftung Seebüll.
FELIX NUSSBAUM: © 2003 Artists Rights Society (ARS), New York/VG Bild-Kunst, Bonn.
ERNST FERDINAND OEHME: Fig. 15 [cat. no. 86], and Fig. 17 [cat. no. 102]: photo courtesy Milwaukee Art Museum.
MAX PECHSTEIN: © 2003 Artists Rights Society (ARS), New York/VG Bild-Kunst, Bonn.
A. R. PENCK: © A. R. Penck.
SIGMAR POLKE: © Sigmar Polke. Fig. 7 [cat. no. 91]: photo courtesy The Art Institute of Chicago.
THOMAS RANFT: © 2003 Artists Rights Society (ARS), New York/VG Bild-Kunst, Bonn.
DAGMAR RANFT-SCHINKE: © 2003 Artists Rights Society (ARS), New York/VG Bild-Kunst, Bonn.
GERHARD RICHTER: Courtesy of the artist and Marian Goodman Gallery. Fig. 3 [cat. no. 95]: photo courtesy Christie's Images Inc. [1998].
AUGUST SANDER: © 2003 Artists Rights Society (ARS), New York/VG Bild-Kunst, Bonn. Fig. 73 [cat. no. 100b] and fig.74 [cat. no.100d]: photos by Michael Tropea.
CHRISTIAN SCHAD: © 2003 Christian Schad Stuftung Aschaffenburg/ARS, New York/VG.
KARL FRIEDRICH SCHINKEL: Fig. 17 [cat. no. 102]: photo courtesy Milwaukee Art Museum.
LASAR SEGALL: © Lasar Segall Museum.
KARL SCHMIDT-ROTTLUFF: © 2003 Artists Rights Society (ARS), New York/VG Bild-Kunst, Bonn. Fig. 37 [cat. no. 105]: photo by Katya Kallsen, © President and Fellows of Harvard College.
ROSEMARIE TROCKEL: © 2003 Artists Rights Society (ARS), New York/VG Bild-Kunst, Bonn.
FRITZ WINTER: © 2003 Artists Rights Society (ARS), New York/VG Bild-Kunst, Bonn.